P9-DGC-819

HUNGRY?
SAN FRANCISCO

THE LOWDOWN ON

WHERE THE

REAL PEOPLE

EAT!

Edited by David Wegbreit

Printed in Canada

First Printing: January, 2008

10 9 8 7 6 5 4 3 2 1

Library of Congress Cataloging-in-Publication Data
Hungry? San Francisco:
The Lowdown on Where the Real People Eat!
by Hungry City Guides
320 pages
ISBN 10: 1-893329-38-0
ISBN 13: 978-1-893329-38-6
I. Title II. Food Guides III. Travel IV San Francisco

Production by e-BookServices
Cover Production by Bonnie Yoon

Visit our Web sites at www.HungryCityGuides.com
and www.HungryCity.com

To order Hungry? or our other Hungry City Guides,
or for information on using them as corporate gifts,
e-mail us at Sales@HungryCity.com. or write to:
Hungry City Guides
P.O. Box 86121
Los Angeles, CA 90086

Hungry City Guides are available to the trade
through SCB Distributors:
(800) 729-6423
www.SCBDistributors.com

THANKS A BUNCH

...To Our Contributors
LeAnn Joy Adam, Pamela Ames, Lily Amirpour, Bill Anderson, Amber Bagwell, Sara Benson, Michelle Belanger, George Brandau, Ana Cabrera, Caitlin Cameron, Victor Goldgel Carballo, Cate Czerwinski, David Christopher Dubin, Victoria E, Michele Ewing, Ben Feldman, Aimee Fountain, Rana Freedman, Ellen A. Goodenow, Amber Griffin, Sylvia Clark Hooks, Saul Isler, Laura Jacques, Shioun Kim, Melissa Kirk, Majkin A. Klare, Katie Klochan, Jackie Kortz, Megan Kung, Karen Kramer, Kathrine LaFleur, Sandra Lai, Anh-Minh Le, Richard D. LeCour, Shannon Lee, Kenya Lewis, Jeremy Lipps, Tara Little, Di Liu, Anne Macdonald, Tim Madsen, Kelly McFarlane, Brookelynn Morris, Maeve Naughton, Catherine Nash, Valerie Ng, Chenda Ngak, Mimi Novak, Louis Pine, Mary Poffenroth, Natasha Ravnik, Go Reyes, Maria Richardson, Bill Richter, Michelle Rogers, Liz Scott, Nicole Spiridakis, Ian J. Strider, Andrew Vennari, Kathryn Vercillo, Kristin Viola, Nick Walsh, Catherine Wargo, Alexa Watkins, Sarah Wells, Robyn White, James Wigdel, Laura Wiley, Andrea Wolf, Jenna Wortham, Melinda Wright, Bonnie Yeung, Benny Zadik, Gil Zeimer, Rui Bing Zheng, Judy Zimola

...to all the people that lent suggestions and support
SCB Distributors, and the helpful folks who provide childcare, office space, and cocktails at Baxter Montessori, The Petroleum Building, and the City Club on Bunker Hill

...and to the people who helped make it all happen
Mari Florence (the mastermind behind the Hungry? guides), Dhiraj Aggarwal and e-BookServices (for efficient and highly professional book production), and Jennifer Chang, Kaelin Burns, Emily Coppel, Janel Healy, and Bonnie Yoon (who took the book through the final stages).

— *The Hungry? Editors*

CONTENTS

Peninsula

South Bay Area

KEY TO THE BOOK

ICONS

Most Popular Menu Items

 Great Breakfast spot

 Great Lunch spot

 Great Dinner spot

 Fish or Seafood

 Vegetarian or Vegan-friendly

 Desserts/Bakery

 Beer

 Cocktails

 Tea

 Coffee

Ambience

 It's early and you're hungry

 It's late and you're hungry

 Sleep is for the weak

 Nice places to dine solo

 Get cozy with a date

 Live Music

 Patio or sidewalk dining

 In business since 1976 or before

 Editor's Pick

 Food on the run

Cost

HUNGRY?

Cost of the average meal:

$	$5 and under
$$	$9 and under
$$$	$14 and under
$$$$	$15 and over

Payment

Note that most places that take *all* the plastic we've listed also take Diner's Club, Carte Blanche and the like. And if it says cash only, be prepared.

 Visa

MasterCard

 American Express

Discover

Tipping Guide

If you can't afford to tip, you can't afford to eat. Remember, if the food is brought to your table, you should probably leave a some sort of tip. Here's a guide to help you out:

Cost of Meal	Scrooge <15%	17.5%	Hungry? 20%	22.5%	Hungry! 25%	27.5%	Sinatra >40%
$ 15	<2.25	2.63	3	3.38	3.75	4.125	>6
$ 25	<3.75	4.38	5	5.62	5.62	6.88	>10
$ 35	<5.25	6.13	7	7.88	8.75	9.63	>14
$ 45	<6.75	7.88	9	10.12	11.25	12.38	>18
$ 55	<8.25	9.63	11	12.38	13.75	15.12	>22
$ 65	<9.75	11.38	13	14.62	16.25	17.88	>26

MAP OF THE TOWN

SAN FR

㉓ ⑰

Ⓐ SAN FRANCISCO (see inset on next page)
1. Fisherman's Wharf / Telegraph Hill
2. Marina / Presidio / Cow Hollow
3. North Beach
4. Russian Hill
5. Pacific Heights / Laurel Heights
6. Hayes Valley / Lower Haight
7. NOPA / Western Additions
8. Inner Richmond / Outer Richmond / Seacliff
9. Haight Ashbury / Cole Valley
10. Castro / Noe Valley
11. Mission
12. Potrero Hill
13. Sunset / Inner Sunset
14. West Portal
15. Downtown San Francisco
 - Chinatown
 - Union Square / Financial District
 - Nob Hill
 - Civic Center / Tenderloin
 - SOMA (South of Market)

Ⓑ NORTH BAY / WINE COUNTRY
16. Napa
17. Santa Rosa / Healdsburg
18. Petaluma
19. Novato
20. Fairfax / San Rafael
21. Mill Valley / Larkspur
22. Sausalito
23. Sebastapol

Ⓒ EAST BAY / OAKLAND
24. Oakland
25. Richmond / El Cerrito
26. Walnut Creek / Concord
27. Berkeley
28. San Ramon
29. Dublin
30. Fremont / Union City
31. Hayward
32. San Leandro
33. Albany

Ⓓ PENINSULA
34. South San Francisco
35. Daly City / Brisbane
36. San Bruno / Burlingame
37. San Mateo / Foster City
38. San Carlos / Belmont
39. Menlo Park / Atherton
40. Redwood City
41. Palo Alto
42. Woodside

Ⓔ SOUTH BAY AREA
43. Mountain View
44. Sunnyvale
45. Milpitas
46. Santa Clara / Los Altos
47. Campbell
48. Cupertino
49. Los Gatos / Saratoga
50. Santa Cruz
51. San Jose

CISCO BAY AREA

San Francisco Bay

Pacific Ocean

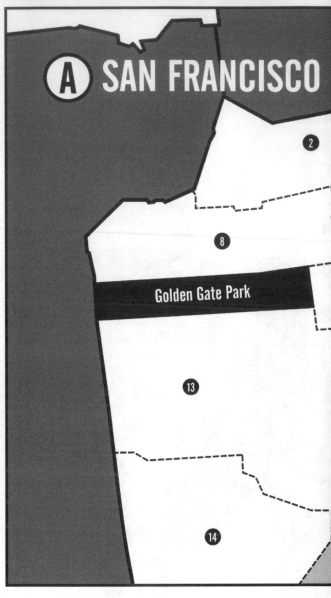

A SAN FRANCISCO

Golden Gate Park

San Francisco
Bay

PLEASE READ

Disclaimer #1

The only sure thing in life is change. We've tried to be as up-to-date as possible, but places change owners, hours and menus as often as they open up a new location or go out of business. Call ahead so you don't end up wasting time crossing town and arrive after closing time.

Disclaimer #2

Every place in Hungry? Los Angeles is recommended, for something. We have tried to be honest about our experiences of each place, and sometimes a jab or two makes its way into the mix. If your favorite spot is slammed for something you think is unfair, it's just one person's opinion! And remember, under the Fair Use Doctrine, some statements about the establishments in this book are intended to be humorous as parodies. Whew! Got the legal stuff out of the way.

And wait, there's more!

While we list hundreds of eateries in the book, that's just the beginning of the copious eating and drinking opportunities in Los Angeles. Visit HungryCity.com for additional reviews, eating itineraries, updates, and all the information you need for your next dining out adventures.

Tip, Tip, Tip.

If you can't afford to tip you can't afford to eat and drink. In the United States, most servers make minimum wage or less, and depend on tips to pay the rent. Tip fairly, and not only will you get better service when you come back, but you'll start believing in karma (if you don't already).

Road Trip!

And, next time you hit the road, check the Glove Box Guides to destinations including: Seattle, Las Vegas, Chicago, Boston, New York City, and many, many more!

Don't Drink and Drive.

We shouldn't have to tell you this, but we can't say it enough. Drink responsibly. Don't drive after you've been drinking alcohol, period. If a designated driver is hard to come by, take the bus or call a cab to take you home. Split the costs with your friends to bring the cost down.

Share your secrets.

Know about a place we missed? Willing to divulge your secrets and contribute to the next edition? Send your ideas to "Hungry? Los Angeles Update" c/o Glove Box Guides, P.O. Box 86121, Los Angeles, CA 90086 or e-mail Updates@HungryCity.com.

INTRODUCTION

If you've grown up in the Bay Area, it's easy to take for granted how good you have it. You can go a lifetime without realizing that people just about anywhere else can't boast of having world-class calzones, unbeatably fresh salads and authentic pho at their doorstep.

My own awakening came when I made the mistake of ordering a salad at a café while traveling through eastern Wyoming. For those who grew up outside of our arugula-loving enclave what I got will come as no shock, but, for a guy lucky enough to have been raised on Berkeley Portabello burgers and Chinatown egg-rolls, it came as a sorry surprise when a bowl full of iceberg lettuce topped with a half-frozen tomato and soaked in bleu cheese arrived at my table.

A Hundred Locals in Your Pocket

Here, you could pull into hundreds, if not thousands, of cafes and get focaccia and salad with fresh (and often locally-grown) ingredients. But the down side of having so many great choices for where to eat can be daunting. Even if you are a Bay Area native, venturing outside your neighborhood can be like going to a new country.

Hungry? San Francisco is designed as a guide for the perplexed eater. By bringing together nearly 100 locals across the Bay to share hundreds of their favorite haunts in their own 'hood, Hungry? shows you great spots to eat at every day. Neighborhood-by-neighborhood, the Hungry? writers take you through some of the best eats the Bay (and, sometimes the world) has to offer. The Hungry? team can take you from the best place to grab a latte and scone before you hop on the BART (or coffee and a breakfast burrito before you hit the single track) to the best place to grab old-school post-drinking greasy-spoon grub. They've even got you covered for a hangover curing pho should you over indulge.

The Hungry? Spirit

Southern California has the unforgettably un-hip Huell Howser on "California's Gold". We've got Doug McConnell and "Bay Area Back Roads". And, like our eternally safari-shirt-clad Doug, Hungry? is all about having adventures. Hungry? is also about finding great values and sharing the lowdown. These writers don't just share where to grab pupusas in the Mission or brunch at a Thai temple in Berkeley, they let you know where to park (or how to get there on public transit or by peddle power), what to order when you get there, and sometimes even tell you a little about the folks taking your order. Between these covers you won't find an arbitrary rating system devised by embittered professional gastronomes, but a sincere guide by folks who love food for folks who love food. Between the reviews you'll find sidebars on everything from foods invented here (and where to get 'em) to guides on how to blend in and talk like a local. Hungry? is designed to give you everything you need to know to feel like a local across the Bay Area's thriving food scene.

We're Growing, Too

By its nature, Hungry? San Francisco is limited. There are far too many towns with far too many great spots to

include everyone's favorites. Fortunately,
HungryCityGuides.com is a growing community for like-mind-
ed foodies. If there's something we've missed that's just got to be
in the book, let us know about it. While you're there, check out
the Hungry guides for other cities across America, because even
if the Bay Area is one of the greatest places on the planet, there's
a whole lot out there to see and eat.

—*David Wegbreit*

SAN
FRANCISCO

FISHERMAN'S WHARF/THE EMBARCADERO/TELEGRAPH HILL

Caffé Sport

Old school Italian among the
jumbled wares of a Sicilian fisherman.
$$
574 Green St., San Francisco 94133
(between Grant Ave. and Columbus Ave.)
Phone (415) 981-1251

HOURS	Tues-Sat: Noon-2:30 PM; 5 PM-10:30 PM
CATEGORY	Italian-American
GETTING THERE	Pay lot on Vallejo next to Police Station. Muni lines 15, 30, 39, 41
POPULAR DISH	Creamy Pesto with Penne, topped with grated Parmigiano. This is the pasta that keeps them coming back.
UNIQUE DISH	Garlic used with reckless abandon: Shrimp or Scampi *Al'Antonio* smothered in a silky garlic sauce. Make sure your date isn't faint of taste, vampires beware!
SEATING	Seats are limited so don't show up too late if you want a table quickly. A slower lunch will have you seated faster and eating off a more economical menu. The room is a dim lit and wood clad refuge, covered floor to ceiling with rustic paintings and Sicilian folk art; the collected belongings of chef/founder Antonio La Tonna (RIP).
AMBIANCE/CLIENTELE	The place is a North Beach blend of long time locals, tourists, and the occasional celebrity. Hoity-toity and foodie focused this is not. Likely to find native San Franciscans soused in carafes of red wine and tucking into mounds of steaming seafood.
EXTRAS/NOTES	Long time staple of seafood in North Beach, for over 30 years the Café Sport has welcomed hungry citizens out of the fog and into a nice plate of pasta. Served family style.

—Andrew Vennari

Boudin at the Wharf

A tourist restaurant that actually
tastes good.
Since 1849
$$$$
160 Jefferson St., San Francisco 94133
(between Mason St. and Taylor St.)
Phone (415) 928-1849 • Fax (415) 928-8879
www.boudinbakery.com

CATEGORY	The only tourist trap locals secretly like.
HOURS	Sun-Thurs: 11:30 AM-9 PM (bar open 'til Midnight) Fri/Sat: 11:30 AM-10:30 PM (bar open 'til 1 AM)
GETTING THERE	There is plenty of lot parking but it is pricey, pricey, pricey. Street parking not too far away is a better option. The Historic F line runs down to this area as do the cable cars. MUNI #47 makes the closest stop.

PAYMENT	VISA MasterCard Cards
POPULAR DISH	They were made famous by their sourdough bread, so soup in a bread bowl is the most commonly ordered dish, but the fresh fish at this place is actually a better bet. Also, make sure to order the mashed potatoes on the side—they are perfectly creamy.
UNIQUE DISH	San Francisco is known for its sourdough bread bowls and this is the place that got them started. They have bread making demonstrations, a history museum and sourdough bread tasting to compliment this area treat.
DRINKS	Full bar and an array of wines to choose from.
SEATING	Large, expansive room with extra seating at the bar. Great for any size group.
AMBIENCE/CLIENTELE	Tourists flock to San Francisco from all over the world and this is the place where they congregate. There are rural farm families seated amongst international business executives in this restaurant. The feeling that you are sitting in an airport lobby is diminished by the amazing view of the Bay and the light music coming from the piano player near the bar. The menu is comprised of fairly standard American dishes with a bit of San Francisco seafood flair.
EXTRAS/NOTES	For those people who are merely looking to enjoy the historic sourdough bread bowl, skip the main restaurant and go to the Boudin Café downstairs, where the clam chowder bowl is half the price of the restaurant version. For a true experience of the restaurant, ask to be seated by the expansive window overlooking Alcatraz in the bay and then use your wait time to explore the history museum and bread-making demonstrations on site. A pianist performs most nights.
OTHER ONES	• Corte Madera: 1734 Redwood Highway, 94925, (415) 737-1849

—Kathryn Vercillo

Hog Island Oyster Company

Bustling oyster restaurant in the perfect setting for enjoying these bivalve beauties.
$$$
1 Ferry Bldg., San Francisco 94111
(the Embarcadero near Market St.)
Phone (415) 391-7117
www.hogislandoysters.com

CATEGORY	High class oyster shack
HOURS	Mon-Fri: 11:30 AM-8 PM
	Sat/Sun: 11 AM-6 PM
GETTING THERE	The H.I.O Bar is conveniently located in the North end of the Ferry Building and accessible by MUNI, BART, Ferry Boat and the historic F-line trolley car.
PAYMENT	VISA MasterCard Cards

POPULAR DISH As the name implies, this is the place for Oysters. The magnificent mollusks are best served freshly shucked and on a bed of ice, unadorned except for a squirt of lemon and a dip in "Hog Wash," a mignonette brightened up with a bit of cilantro. The other preparations are also worth trying: Oysters Rockefeller, Oysters Casino and Oysters with Buerre Blanc all put a smile on your face.

UNIQUE DISH The H.I.O. Co. takes advantage of its strategic location in the heart of San Francisco's finest farmer's market. To break from the seafood smorgasbord, try some other local gems, like the Cowgirl Creamery Grilled Cheese sandwich or any of the organic salads.

DRINKS Try one of the local beers on tap from the North Coast Brewing Co. or a San Francisco's own Anchor Steam. The small wine list has many choices that go perfectly with oysters and are reasonably priced. Or go traditional and pair your bivalves with a glass of bubbly.

SEATING A big U-shaped bar creates an arena to watch the talented shuckers practice their craft. There are a few tables as well, and seating outside, weather permitting. Some of the best patio seating in the bay. On the rare fogless day, sit outside and take in the beautiful view of the Bay.

AMBIENCE/CLIENTELE Hog Island attracts all types and guests are generally pretty casual and toting bags overflowing with swag scored at the farmer's market. The room is spacious, modern and full of light from the huge windows over-looking the bay. Happy Hour on Mondays often draws a big Industry crowd and you never know what big-time chef or sommelier you will be slurping oysters next to.

EXTRAS/NOTES Visit the farm nine miles north of Point Reyes on Tomales Bay and pick up your own oysters or just check out the sustainable aquaculture. Or just check out the happy hour: Mondays and Thursdays from 5 PM to 7 PM. Come early to snag a coveted seat at the bar for $1 Sweetwater Oysters and $3.50 pints of beer.

—*Andrea Wolf*

"The Bay Area is so beautiful, I hesitate to preach about heaven while I'm here. "

—*Billy Graham*

MARINA/PRESIDIO/COW HOLLOW

Barney's Gourmet Hamburger

(see p. 160)
Hamburger joint
3344 Steiner St., San Francisco 94123
Phone (415) 563-0307

Betelnut
Feast on fusion.
$$
2030 Union St., San Francisco 94123
(at Webster St.)
Phone (415) 929-8855 • Fax (415) 929-8894
www.betelnutrestaurant.com

CATEGORY	Pan-Asian fusion
HOURS	Sun-Thurs: 11:30 AM-11 PM
	Fri-Sat: 11:30 AM-Midnight
GETTING THERE	Parking here on the weekends is impossible at best, so save time and opt for a parking garage or one of the many valet services that are offered. Weekday diners may have better luck; Union St. has metered parking and side streets allow two-hour parking.
PAYMENT	
POPULAR DISH	Small plates are the way to go here—and they are all amazing. Standouts include: Duck Dumpling—soft dumplings filled with tender pulled duck and served with a zingy marmalade for dipping. Chili-crusted calamari gets spicy right with light, crispy calamari and a sweet chili-infused dipping sauce. The firecracker shrimp lives up to their name. Tiny jewels of crispiness and intense spice that really do set off fireworks. A savory and creamy sambal sauce is served alongside to mellow the spices—just enough to make you want another…and another. When it comes to salads, there is nary an iceberg leaf in sight—combinations like green papaya, shrimp, and grapefruit, or Kyoto garden greens and miso keep this sometimes-boring course very interesting.
DRINKS	Mixed drinks are wildly popular here. Betelnut bartenders know how to make a mojito right, using just a touch of simple syrup, quality rum, and mint that is always fresh and incredibly fragrant. Fans of the Mai Tai be forewarned- the concoctions here definitely pack a punch, and go down like…well, punch. Served in a kitschy Tiki glass with pineapple garnish and the nostalgic paper umbrella, they are so cute that you just may want to order another…or three. Scorpion bowls blend a healthy dose of rum and brandy with fruit juices, and make the prefect starter for a girl's (or any old) night out.
SEATING	A great selection of seating options: outside at

the two-person café tables under heaters, in the front just opposite the bar at one of the three lively 4-person round tables, counter seating with a great view of the fast-paced open kitchen where the food's exotic fragrances abound, or in the quieter and more mellow back dining room where booths and table are available. The perfect date spot—casual but stylish, great food and ambiance. Also very popular with singles for a drink or a couple small plates, and fun enough for large celebrations.

AMBIENCE/CLIENTELE Betelnut is a good time. Given its location in the Marina/Cow Hollow neighborhood, the look here is young and stylish, yet refreshingly void of pretension. A feel of exoticism prevails, spices permeate the air, rich colors abound, and there is a sense of calm amid all the activity. The bar is an ideal place to grab a yummy drink while waiting for your table, or just a fun stopover on your night out. The counter is a smooth, brilliant red, and the subtly swaying fans overhead make you feel like a guest at some hopelessly romantic tea plantation in a fictitious part of Asia. With cushy booth and plush carpet to mute conversational noise, the comfy back dining room makes it all to easy to sink back into your chair and slip into a post-meal hibernation. Servers here are truly among the best in the city, effortlessly blending that elusive combination of efficiency, availability, and a technical term I like to call not-hovering-over-ness.

—*Sarah Jane Roberts*

Brazen Head

Speakeasy feel with great food to boot!
$$$$
3166 Greenwich St., San Francisco 94123
(at Buchannan St.)
Phone (415) 921-7600
www.Brazenheadsf.com

CATEGORY Neighborhood steak joint
HOURS Daily: 4 PM-1 AM (bar open 'til 2 AM)
PAYMENT Debit and cash only
GETTING THERE It is in mostly residential area so parking is just a matter of what time of day. Late night is easier, but just be persistent, something always pops up.
POPULAR DISH Signature dish is the 12 oz. New York Strip Pepper Steak topped with Brandy and Veal Demi Glaze Cream Sauce. If you can imagine, it actually tastes better than it sounds. Good cut of beef coated with just enough of a spicy black pepper crust to blend perfectly with the savory rich flavors in the sauce. Each bite just makes you more excited for the next one. Toss in a

small bite of the mashed potatoes and vegetables that accompany the dish and your conversation will now have a ten minute time out so that no time is wasted letting dinner get cold.

UNIQUE DISH When I think classic steak joint, I'm not expecting anything out of the desserts. The creme brulee here changed my thought process immediately. Perfect texture, not too thick, not too thin with a good brulee job and a cylindrical wafer cookie sticking out of it as if it were a landmark and the dessert was just constructed around it. Definitely a must upon the first visit.

SEATING Great bar seating about twelve and due to the compact design, creates a very personable feel. Get something that makes you feel like one of the Rat Pack, like a Manhattan straight up or a martini of some kind. Mostly setting for parties of two, there is only one table suitable for parties over four. Call ahead or make sure it's late enough if you are attempting that party of six. Very cozy, calm, comfortable vibe makes this a great place for a date or just some one-on-one time.

AMBIANCE/CLIENTELE Clientele ranges from 20-somethings up to the old timer who has a regular table. Walking into the place makes you feel like a zoot suit or three piece is missing from your closet, but one look around at everyone else and you relax. Nothing too fancy, casual dress all around. Just dress comfortably, without going the pajama pants and wife beater route. Definitely the place to take a date or loved one for some intimate eye contact to remind you of why you are with that person in the first place. A good place to escape the nouveau, trendy new age vibes drowning out some of San Francisco.

EXTRAS/NOTES Eddie the bartender will make your trip worthwhile.

—Don Saliano

Fuzio Universal Pasta

(see p. 65)
Hip pasta spot
2175 Chestnut St., San Francisco 94123
Phone (415) 673-8804

Three Seasons

(see p. 220)
Vietnamese
3317 Steiner St., San Francisco 94123
Phone (415) 567-9989

Zushi Puzzle
Sushi that feeds the soul.
$$$$
1910 Lombard St., San Francisco 94123
(at Buchanan St.)
Phone (415) 931-9319
www.zushipuzzle.com

CATEGORY	Japanese sushi
HOURS	Daily: 5 PM-10:30 PM
GETTING THERE	Parking is very difficult in this area, but you can get there by public transit—take the Powell-Hyde cable car or the 30.
PAYMENT	VISA
POPULAR DISH	If you leave matters to Chef/Owner Roger, you basically cannot go wrong (assuming you enjoy sushi). He will provide you with an assortment of incredibly fresh, flavorful sashimi, and he'll steer away you from the less exciting items on the menu. The Beth's The Best Hand Roll is one of my personal favorites, as it provides a tremendous burst of flavor.
UNIQUE DISH	In the mood for Kobe beef? Look no further. Chef/Owner Roger makes an exquisite Kobe sashimi that has been deemed "my last meal on Earth" by many.
DRINKS	An extensive selection of sake, along with Japanese beer and traditional Japanese green tea.
SEATING	Seating is sparse, as there are about fifteen tables in the entire restaurant, along with about eight seats at the sushi bar. They will accommodate small groups.
AMBIENCE/CLIENTELE	Although the 70's-style décor could be upped a notch or two, the sushi draws in a diverse crowd, ranging from foodies who have traveled across the city to get there to the typical Marina crowd. The restaurant is not in the most scenic part of town, so reservations are strongly recommended.
EXTRAS/NOTES	The sushi bar is the ideal location, as you can watch Roger work his magic. Complementary shots of sake are usually given at the end of the meal on the house.

—*Kristin Viola*

NORTH BEACH

Caffe Trieste
A Taste of Old Italy in
San Francisco's most historic café.
Since 1956
$$
601 Vallejo St., San Francisco, 94133
(at Grant St.)
Phone (415) 392-6739
www.caffetrieste.com

CATEGORY	Historic Italian coffeehouse
HOURS	Sun-Thurs: 6:30 AM-10 PM
	Fri/Sat: 6:30 AM-Midnight
GETTING THERE	Metered parking and street parking. Parking is difficult.
PAYMENT	Cash only
POPULAR DISH	Italian pastries, bagels, muffins, antipasti (cold cuts, olives, and cheese), salads, sandwiches, pizza, and desserts are all available.
DRINKS	What else but the espresso!
SEATING	A few small tables are available outside and inside there is ample seating.
AMBIENCE/CLIENTELE	Think of a place where the Godfather would go for his espresso, combined with a Bohemian essence and old school Italian music, and this is what Caffe Trieste feels like.
EXTRAS/NOTES	The owner, Papa Gianni, is just as famous as the cafe itself! Energetic and charming, you can catch him belt out jazz, opera, and show tunes with others at the weekly "Saturday Night Concert". This is the first espresso coffeehouse on the West Coast! The coffeehouse has been used as the movie set for many feature films and has been the subject in many documentaries around the world. It is adorned with celebrity photos and is a common tourist attraction.
OTHER ONES	• Sausalito: 1000 Bridgeway St., 94965, (415) 332-7660
	• Berkeley, 2500 San Pablo Ave., 94702, (510) 548-5198

—Thy Pham

Gelateria Naia

(see p. 66)
Gelato

520 Columbus Ave., San Francisco 94113
Phone (415) 677-9280

The Best Italian Food of North Beach

When talking about North Beach, it's almost impossible to avoid also discussing Italian food. Long known as the Little Italy of the city by the bay, North Beach is popular with tourists and native San Franciscans alike. Many Italian restaurants and cafés have opened in the area over the years, catering to the neighborhood's heritage and the volume of traffic it sees. Today, North Beach is bursting at the seams with restaurants and cafés that claim to be Italian, and, due to the sheer number of them, it can be difficult to know which are genuinely good and which focus more on the green dough than the pasta dough. Lucky for you, dear reader, Hungry City has done the dirty work for you; we've narrowed it down to five restaurants that we believe offer an above-average dining experience.

Here they are, in no particular order:

Caffe DeLucchi: Open for lunch and dinner, plus brunch Friday – Sunday, Caffe DeLucchi is the perfect place to stop for a meal while out and about in North Beach. Because of the restaurant's location near the intersection of Columbus and Stockton, the outdoor seating is a prime location for people watching.

Cinque Terre: The atmosphere at this restaurant is nothing like the crowded hustle-and-bustle of Columbus and Broadway streets. Cinque Terre operates as though it were actually in Italy, providing delicious, home-cooked meals in a very relaxed setting. Not a great choice if you're in a hurry, but a very fulfilling experience if you have the time to enjoy it.

Firenze By Night: The pasta at Firenze By Night has won several awards. If that's not enough to draw you in, maybe the wine list will do the trick; the varietals are carefully chosen to compliment menu items in an effort to give diners a well-rounded meal. The restaurant is also conveniently located and is appropriate both for large groups and small, intimate gatherings.

L'Osteria del Forno: Reservations are not taken and seating is limited, therefore patrons often must wait upwards of 30 minutes for a table. Did I mention that the restaurant only accepts cash? The fact that, despite these less-than-desirable factors, tables at L'Osteria del Forno are in high demand speaks for itself. The food is *good*.

Tommaso's North Beach: A neighborhood institution, this restaurant has been around since 1935. They claim to have the oldest brick oven in San Francisco, and the Neapolitan-style pizzas that come out of it are phenomenal. Tommaso's is a great place for group dining, because of both the layout of the tables and the fact that it gets a little too loud to create an intimate or romantic experience.

—Katie Klochan

Giordano Bros.
All In-One Sandwiches

Whoever said you can't put fries on your sandwich?
$
303 Columbus Ave., San Francisco 94133
(at Broadway St.)
Phone (415) 397-2767 • Fax (415) 397-2797
www.giordanobros.com

CATEGORY	East Coast-style deli
HOURS	Sun-Thurs 11:30 AM-11:30 PM Fri/Sat: 11:30 AM-1:30 AM
GETTING THERE	This place is right off Broadway so street parking is very limited. I recommend walking if you live nearby or taking a cab. You can also take the MUNI Surface Line Buses.
PAYMENT	VISA
POPULAR DISH	Giordano Bros most popular dish is their All-In-One Sandwich (hence the name) that features your choice of meat, hand cut, seasoned French fries and oil and vinegar slaw all crammed in between two thick pieces of deli style white

bread. Even though all of the sandwiches are prepared in this same style, you get to decide your pick of meat. Meat lovers eat your heart out, literally, because they pile it on. The meat choices include pastrami, smoked turkey, Italian sausage, steak, coppa, hot cappiacola and even egg and cheese if you're feeling more like breakfast. My favorite meat is definitely the coppa which is also the recommendation from the cook. Coppa is commonly used in east coast deli sandwiches and is a typical Italian sausage made from the cured, raw collar or loin of a pig. It is a salty meat but Giordano Bros knows how to prepare it. To prepare the sandwich the cook slaps your cut on a sizzling grill for a few minutes and then smothers it in provolone cheese until it melts. Once the cheese is nearly bubbling, the cook places the meat on two slices of fluffy white bread and then covers that with a handful of homemade seasoned fries. The fries are fried right in front of you while your meat cooks and then they are seasoned with a house mixture. Even though they come on the sandwich, I like to order a side for my date and I because they are so tasty and I love the crispy texture. The slaw is the final touch and secret ingredient that makes this sandwich so flavorful and unique. The tangy oil and vinegar mixture is the best-kept secret of Giordano Bros and with good reason. You can also order this as side. Once the sandwich is put together, the chef cuts it in half and hands you a 6-inch high sandwich heaping with meat and trimmings.

UNIQUE DISH The vegetarian chili gives vegetarian or non-meat lovers an option of a hearty and fulfilling meal. My cook was kind enough to fulfill my request of pouring my chili over my side of fries. It is kind of a spin off on chili cheese fries minus the cheese. Alone or with fries, this chili is delicious.

DRINKS Sodas, iced tea, lemonade and coffee. They also have a range of bottled beers from Bud Light to Fat Tire. Red and white wine is also available. Happy hour from 3 PM-6 PM.

SEATING Mainly bar style with a large counter facing the kitchen and several tables and stools lining the wall opposite of it. I prefer to sit at the bar because you can see how they prepare the food and the cooks are always friendly and willing to chat if you're in the mood.

AMBIANCE/CLIENTELE A family run restaurant that originated in Pittsburg, Giordano Bros is not afraid to express their love for the Pittsburg Steelers and football. Steelers' jerseys, photos, and paraphernalia hang on red walls and a large TV above the bar broadcasts football games and other sports channels. Local musicians set up next to the bar Tuesday through Saturday nights and play all types of genres. Giordano Bros. is definitely a warm and lively atmosphere. Everyone who works here seems to know their customers and I can't help but feel like part of the family when I'm eating here. The clientele is very broad but I notice a lot of regulars around the bar chatting

it up with the bartenders and cooks. They really know how to make you feel at home here no matter who you are.

—Amber Griffin

Meat
You don't have to go to Omaha...

San Francisco is the city that sleeps quite a bit, since they're all getting up for a 20-mile bike ride tomorrow morning. The inhabitants of our fair city by the freezing Bay take their health seriously, and for a number of them it means watching their diet. Enter the bane of any circle of friends' existence: The Vegetarian. Before you know it, a dinner out has to be a research project, assuring that the restaurant has vegetarian, vegan, wheat-free, gluten-free, and sugar-free options. Such restaurants are becoming increasingly easier, and those that serve veal parmigiana harder to find. Vegan biscuits and gravy? Wheat-free spaghetti and tofu balls? Carnivores, I hear your cries. Proceed directly to the fine establishments listed below to get exactly what you want: MEAT.

BEST SAUSAGE
Rosamunde Sausage Grill
Varieties include duck and fig, chicken, pheasant and cherry, beer bratwurst, all-beef. As for toppings, try the wasabi mustard or ask for the not-on-the-menu mango chutney. There are only about two seats, so take it down to the street to one of the neighborhood pubs and have a beer. Just don't forget to bring back their little red basket. (545 Haight St. San Francisco, (415) 437-6851)

BEST SURF AND TURF
The Brazenhead
Don't tell anyone I told you about this place. Seriously. Tucked away on an unassuming corner in the very assuming Marina neighborhood, you'll find only locals at the bar. Monday night's surf and turf - $25 for a pepper steak and two lobster tails. In keeping with its speakeasy spirit, it's CASH ONLY. Say hello to Jimmy, the bartender, for me. Shhhh. (3166 Buchannan, San Francisco, (415) 926-7600)

BEST VALUE
Brother's Korean BBQ
For about $20 a person (including beer and sake,) you can walk out of Brother's stuffed the gills with not only meat, but strange Korean pickled things that you couldn't identify, but were good. Each table has a grill in the center for cooking the enormous platter of beef or pork that arrives, raw, at your table with a pair of scissors (to cut it into manageable pieces.) Cook over hot coals, mix with pickled unknowns, eat. Mmmmm. (4128 Geary Blvd., San Francisco, (415) 387-7991)

BEST DELI
Moishe's Pippic
Corned beef, pastrami, Chicago-style hotdogs, and beef brisket on Fridays. Meat, meat and more peat - with a side of a huge, spicy pickle. (425 Hayes St., (415) 431-2440)

BEST BURGER
Magnolia Pub & Brewery
Straight from Niman Ranch, these juicy burgers are cooked just the way you ask for them and surrounded with tasty fries. Home-brewed beers help wash it down easily. Fixings are plentiful, with one exception: the kitchen only has chipotle aioli, instead of regular mayo, for those who like their burgers and fries Belgian-style. (1398 Haight St. San Francisco, (415) 864.PINT)

BEST D-I-Y
The Ferry Building Farmer's Market
Farmers from all over Northern California assemble to peddle their wares here a couple of times a week. Though mostly fruit and vegetables, there are several farm stalls that bring fresh beef, lamb, and pork to market. Get there early on a Saturday and take your pick of the litter. Bring it home and cook to your personal perfection. (The Embarcadero at Market St., Tues: 10 AM–2 PM, Thurs: 4 PM –8 PM (spring-fall), Sat: 8 AM-2 PM, Sun: 10 AM 2 PM (spring-fall))

BEST ALL YOU CAN EAT MEAT
Espetus Churrascaria
Following the Brazilian tradition of "churrascaria," this restaurant serves fire roasted meat until you surrender. Literally. For a fixed price, each diner gets access to the salad bar and unlimited cuts of meat and seafood (including chicken liver, duck heart, beef brain, etc.). The waitstaff arrives at your table with swords of skewered meat, and until you flip your plate-side card from green (GO) to red (STOP) they'll keep slicing off mighty portions. Not for the faint of heart. (1686 Market St., San Francisco, (415) 552-8792)

—*Catherine Wargo*

Kennedy's Irish Pub and Curry House

Irish and Indian: All I's satisfied.
$$$
1040 Columbus Ave., San Francisco 94133
(at Chestnut St.)
Phone (415) 441-8855

CATEGORY	Irish Pub with great Indian food
HOURS	Daily: 11:30 AM-2:30 PM; 4:30 PM-1:30 AM (food served 'til 1 AM)
GETTING THERE	Street parking with meters is limited, pay lots nearby, otherwise take the #30 MUNI.
PAYMENT	VISA ●
POPULAR DISH	Start with *samosas*—they do a great job with them. Move on to *dal* (lentil soup) with garlic *naan*. For an entrée, try the *aloo gobhi* or the chicken *tikka masala*. For those people who have someone in their group who isn't interested in Indian food, there are bar snacks available – the mozzarella cheese sticks are the thing to order there.
UNIQUE DISH	It's Indian dining in an Irish pub in the Italian part of town. That says it all.
DRINKS	Wine and beer, no hard alcohol. They are known

for their beer selections, especially the good prices of pitchers at happy hour. Sangria goes well with all of the Indian food. The restaurant part also serves Mango Lassi, a traditional Indian beverage similar in consistency to a milkshake.

SEATING The dining area holds about fifteen tables in a fairly intimate setting. However, it is surrounded by the bar and you can get your food and take it over to various tables and stools all throughout the establishment, so there's a place for everyone. There is also a small sidewalk seating area outside the front of the restaurant and a larger deck area with tables in the back.

AMBIENCE/CLIENTELE The unique combination of offerings at this place draws in a unique clientele. College kids snack on *samosas* while playing pool. Older groups of loud men cheer at the games on TV. Families dine together beneath colorful cloth ceilings, although kids are only allowed in the restaurant area and not the rest of the bar. There's a music venue across the street so sometimes the snazzy fashion fans headed there stop in to Kennedy's for a drink before a show. The scent of the cooking Indian spices dominates which is a nice change of pace from the standard bar smell. Nobody will blink an eye no matter who turns up at the door because it's the kind of place where everyone is welcome.

EXTRAS/NOTES Look out for daily bar specials, including $2 pitchers of PBR. If you're bringing Jr., you sit in the main dining area and he can sometimes play the games in back (if it's not a crowded time of day). Women should make sure to stop in at the bathroom just to check out the sink there. It can't be described but you'll know as soon as you see it that this unique piece of architecture just adds to the strange ambience of a place that combines so many different tastes in to one atmosphere. Both bathrooms also have major super-high-power hand dryers that are kind of interesting to see. Travelers interested in picking up San Francisco souvenirs need only step out the back door because another component to this place is a souvenir stand in the back.

—*Kathryn Vercillo*

Quit Stealin' Our Slang!

Hella slang we use today, such as 'off the hook', 'hyphy', and 'hella tight', originated in NorCal, particularly in Oaktown where there is a strong and thriving hip hop culture. For example, 'fa shizzle' has been Snoop Dogg's signature phrase for years, but it was an Oakland rap group named 3X Krazy that really started it all. And the huge 'hyphy' movement that is sweeping the nation? That began right here, by a Yay Area rapper named Keak Da Sneak. Bet you didn't know that?

Some Bay Area slang:

Yay Area:
Bay Area: San Francisco, San Jose, Oakland, Vallejo, Hayward, Richmond, etc.
Derived from: Bay Area rappers frequently using the slang
"Yay Area!! Like that, tell the people that 40 Water is back"

NorCal
Bay Area, see: 'Yay Area'. Geographic range from Vallejo, Richmond, Oakland down to Hayward, Milpitas, San Jose
Derived from: Northern + California
"SoCal kids hate it when NorCal kids say 'hella'"

Oaktown
The city of Oakland, California
Derived from: Oakland+ town, twist is that it's no Mayberry.
"Dude, they went cruising through Oaktown last night."

San Ho
San Jose, California
Derived from: san ghetto because there are parts of the city that can be dumb
"You can get hella cheap Pho in San Ho."

Hella/Hecka
Lots of, very
Derived from: helluva, hell of a lot, heck of a lot
"We had hella food at Thanksgiving!"

Tight
Off the hook, stylish, cool; close
Derived from: unity between friends
"That sushi restaurant was hella tight!"

Off the Hook
Out of control, outrageous
Derived from: a series of slang, related to 'off the chain'
"That drink was off the hook! It made me all stupid."

Get Stupid
Having fun; to become intoxicated
Derived from: stupid, knowing better but doing it anyway
"You were gettin hella stupid at the club."

Marinating
Chillin', soaking up the good times, hanging out
Derived from: marinating a piece of meat
"I be hella marinating with the fam this weekend."

Hyphy
Crazy, goofy, out of hand, get stupid,
Derived from: hyperactive; hype and fly
"Down south, y'all get crunk. Up in the Bay, we get stupid, hyphy, and dumb."

—Sandra Lai

Mojito
Salsa and sangria sounds scrumptious!
$$$
1337 Grant Ave., San Francisco 94133
(at Green St.)
Phone (415) 398-1120
www.mojitosf.com

CATEGORY	Latin inspired restaurant and cocktail bar
HOURS	Tues-Sun: 11 AM–2 AM (limited menu 10 PM-1 AM)
GETTING THERE	Metered street parking although parking in this neighborhood is always difficult. MUNI #15, #30 and #45 run nearby as does the Powell-Mason cable car.
PAYMENT	*VISA*
POPULAR DISH	They feature a tortilla soup as an appetizer that is large enough to be a main meal and tastes absolutely delicious. For an actual appetizer, get the quesadillas.
UNIQUE DISH	Mojitos and sangrias are the name of the game at this place so all of the food is just secondary, but as far as bar food goes, they have some of the best in the area.
DRINKS	Full bar with mojitos being the specialty. Try the vodka mojitos for a treat. Sangria pitchers are also great for groups here.
SEATING	Bar seating in one room and small table seating in the area. Intimate during the week but crowded on weekends.
AMBIENCE/CLIENTELE	During the week, this place tends to be more casual, with people stopping in on their way to tourist attractions. On the weekends, the place is brimming over with people. A whole mixture of types floods in to this place, from middle-aged couples enjoying a casual dinner to large parties of co-eds looking for the weeknight dance scene. Twenty one year olds mingle with much older types who have likely been in the neighborhood since the Beats made it famous. No type of person is unwelcome.
EXTRAS/NOTES	The DJ on Saturday nights plays an interesting mixture of salsa and hip hop which sounds like it doesn't go together but this guy, who looks like he's probably been DJ'ing since before that was a word, knows how to mix it so that it absolutely works. If you're up for it, try Happy Hour 3 PM-5 PM daily.

—*Kathryn Vercillo*

Mo's Gourmet Hamburgers

Bistro burgers at affordable prices.
$$
1322 Grant Ave., 94133
(Vallejo and Green)
Phone (415) 788-3779
www.themenupage.com/mos

CATEGORY	Burger

HOURS Mon-Thurs: 11:30 AM-9 PM
Fri: 11:30 AM-11:30 PM
Sat: 9 AM-11:30 PM
Sun: 9 AM-10:30 PM

GETTING THERE Walking, cab or public transportation recommended. Street parking is very limited. Take the #39 Muni bus for public transportation.

PAYMENT VISA MasterCard Cards

POPULAR DISH Although the selection of burgers at Mo's runs a wide gauntlet, I was impressed with the California burger made with jack cheese and avocado. I don't know what their secret is, but Mo's burger patties are grilled to perfection with a whole lot of juicy flavor. For this burger, they melt a generous portion of cheese over the patty before layering on thick slices of avocado sandwiched between two grilled buns. There is a little too much bun for me, but once you have a bite of the meat you forget about all the bread and dig in. I also recommend Blue Cheese Burger or for a real belt stretcher the Belly Buster made with cheddar cheese sautéed mushrooms and onions. All burgers include lettuce, tomatoes, onions, house mayo and pickles upon request. I especially love how they put all of these toppings on the side to allow you to prepare your burger with your fixings of choice. Pair any of these delicious entrées with a side of freshly cut fries and you have a true American masterpiece. The fries are incredibly fresh and they don't hold a lot of grease so they feel lighter and less rich to the taste. I appreciate this because the burgers are so flavorful and hearty. Any burger on the menu paired with fries or onion rings will make you thank yourself that you opted out of fast food and chose the real deal instead.

UNIQUE DISH Even though I try to stay healthy, I must admit that once in a while I have a craving for the best tasting, worst dishes for the body. That's when I go on a late night quest for something like chili cheese fries. If you love this dish as much as I do, Mo's is your place. Mo's takes their homemade fries and covers them with their house chili, then tops it off with thinly shredded cheddar cheese that melts beautifully over the piping hot chili. The chili has a little kick of spice and the chef is always generous with the cheese. I can honestly say that they are some of the best I've ever had and are definitely worth every bit of guilt for those of us who count our calories.

DRINKS Mo's serves soda, iced tea, lemonade and coffee.

SEATING Seating is moderate to large. There is no outdoors seating and on a busy night and the weekend it can sometimes be difficult to get a table right away. But don't be discouraged; you will get a seat eventually.

AMBIENCE/CLIENTELE Mo's atmosphere is a traditional diner style with metal tables and chairs and a counter with stools. There are pictures of American icons covering the walls and you can watch the cook at work behind the counter and from the front window.

The clientele in Mo's is very diverse but you will often see locals from the neighborhood and many North beach bar hoppers stopping by to satisfy their hunger after an evening of drinks.

—Amber Griffin

Palermo Delicatessen

My nonni would be proud.
$$
1556 Stockton St., San Francisco 94133
(at Union St.)
Phone (415) 362-9892 • Fax (415) 362-0564

CATEGORY	Italian Deli
HOURS	Mon-Fri: 9 AM-7 PM
	Sat: 8 AM-6 PM
	Sun: 9 AM-5 PM
GETTING THERE	Parking in north beach isn't too bad, you just might have to make a couple circles to find that spot. There are all kinds of twists and turns in the neighborhood, so get a little creative when looking. If you are not in the mood to park and near the 45 muni line it takes you right to their front door.
PAYMENT	VISA
POPULAR DISH	The napoli special is as Italian as it gets. Sliced meats of coppa, sopressata are accompanied by provolone and roasted sweet bell peppers to round out this classic of meat and cheese. That's all you really need in my book. Good fresh ciabatta, a little olive oil and the other ingredients should speak louder than words.
UNIQUE DISH	Going with the San Francisco style, Palermo throws out a sandwich called the San Francisco Pride, consisting of crab salad, roasted sweet bell peppers, Monterey jack cheese on a nice grilled focaccia loaf. Tastes like best of Italy and San Francisco coming together in a wonderful little package of sandwich goodness.
DRINKS	No booze, just sparkling waters, some juice selection, but not much in the way of beverages. If you are going to take your sandwich across the street to Washington Square Park anyway, grab a tall can on your way.
SEATING	Two tables inside and a tiny table outside. You can tell they don't really want too many people to grind the sandwich there, so lets go with the flow and take it to go.
AMBIANCE/CLIENTELE	Right as you walk in the door you are transported half way across the world. Cured meats dangling from the ceiling in every direction, surrounding you as you make your selection. A smaller place to configure with the old traditions of Italian style of simple yet affective with just a dash of style provided by whoever is working behind the counter. It has just enough room to get the job done and plenty of fresh Italian ingredients, olive oils, cheeses, etc. to keep you busy while they

make your sandwich. You can usually catch a conversation in Italian either inside or just out the door adding to the experience.

—*Don Saliano*

Rogue's SFO Public House
Brewery where the food is as good as the beer.
$$$
673 Union St., San Francisco 94133
(at Columbus Ave.)
Phone (415) 362-7880
www.rogue.com/locations-sanfran.html

CATEGORY Brewery with surprisingly upscale dining

HOURS Daily: 11 AM–Midnight

GETTING THERE Some metered street parking, pay lots within walking distance, right off of the routes for the #15, #30 and #45 MUNI buses.

PAYMENT VISA

POPULAR DISH This is hard to believe, but the best item on the menu is the clam chowder. This is unbelievable because there are so many great places to get that item nearby, but they do it up right with bacon and spices and thinned out broth, giving it a unique flavor. They are also well-known for their KOBE burgers; as an appetizer, try the KOBE Bleu Balls (large meatballs stuffed with bleu cheese).

UNIQUE DISH They use their own brew to make a number of the food dishes, all of which are good. The Rogue Hazelnut Ale Bread compliments sandwiches or works well as an appetizer. Beer cheese soup is another option. Even the chicken is sometimes marinated in Irish Lager. The beer is the trick to enjoying the food. They don't even forget beer for dessert. Try the Chocolate Stout Float!

DRINKS They have a full bar but are known for their beer. They have nearly forty-five ales on tap. They also have their own home brewed root beer. Try an ice cream float with either root beer or the real stuff; they have a chocolate beer, which goes well in a float.

SEATING This is a multi-room restaurant with additional seating at the bar, so there's a spot for everyone.

AMBIENCE/CLIENTELE Who is in here tends to depend greatly on the day and time of day. In the early afternoons, a lunch crowd comprised primarily of travelers comes in and enjoys a drink with their meal. In the evenings, there is a more raucous college-aged crowd, watching games on TV and getting their drinking started. On Thursday nights, the place is jam-packed with loud and active participants in a multi-hour bar trivia game (during which you can win $50 off your bar tab!) This has a definite sports bar quality to it but a quality, which has been transplanted in to a slightly more adult or family-oriented version of the bar than

is generally experienced in a sports bar. Topped off with good food, this is a casual place where everyone is welcome to enjoy the fun.

EXTRAS/NOTES If you're bringing wee ones, they offer a kid'-sized version of chicken strips and fish 'n chips as well as grilled cheese, mac and cheese and even PB&J. If you're not a breeder, or if you have a babysitter there is an afternoon happy hour from 3 PM– 5 PM and a nighttime happy hour from 10 PM to Midnight, Monday through Friday.

—*Kathryn Vercillo*

Tommaso's

Wood-fired brick oven pizza.
Since 1935
$$$$
1042 Kearny St., San Francisco 94133
(at Broadway St.)
Phone (415) 398-9696 • Fax (415) 989-9415
www.tommasosnorthbeach.com

CATEGORY Landmark North Beach Italian restaurant

HOURS Tues-Sat: 5 PM-10:45 PM
Sun: 4 PM-9:45 PM

GETTING THERE Except for a brief late afternoon/early evening window, parking will be difficult.

PAYMENT

POPULAR DISH Despite many tempting traditional red sauce and pasta dishes, calzones and parmigiana options, any first-time Tommaso's diner and most return customers should by all means go with pizza. This is perhaps the city's finest traditional thin crust pie. This is a place where I enjoy the savory simplicity of the oregano, garlic and basil pizza. Cheese optional on this one, but go with the cheese.

UNIQUE DISH Most of the menu is pretty typical of home-style Italian restaurants, but there are some interesting pizza toppings. Variations include fresh spinach and shaved parmesan and a seafood pizza that includes scallops and prawns. Instead of getting a salad, mix it up a little and go with the vegetarian antipasto (enough food for two).

DRINKS Beer and wine. The beer choices include Italian favorites Moretti and Peroni while the wine list is a mix of Italian and Northern California selections. House wines are available by the glass, 1/2 carafe and full carafe.

SEATING The side walls are lined with nine tables for four to six, separated almost booth-like by wooden partitions, while eight tables for two are lined up down the middle. The center tables add a nice communal vibe and if you want to gab with your neighbors, they'll be close by.

AMBIENCE/CLIENTELE Step down from the porn shop and strip club filled block of Kearney into one of the San Francisco's near-Old World experiences. Tommaso's remains a family-run North Beach institution with its mural of the Bay of Naples, dimmed lamp post

light fixtures and Italian chatter all enhancing the
charm. Popular among both locals and tourists.

—*Bill Richter*

RUSSIAN HILL

Frascati
*Neighborhood restaurant shines among
San Francisco eateries.*
$$$$
1901 Hyde St., San Francisco 94109
(at Green St.)
Phone (415) 928-1406
www.frascatisf.com

CATEGORY	Neighborhood Mediterranean
HOURS	Mon-Sat: 5:30 PM-10:30 PM
	Sun: 5 PM-9 PM
GETTING THERE	Parking is a disaster in this neighborhood; take the Powell-Hyde cable car or the 41 bus instead.
PAYMENT	VISA ● ● ●
POPULAR DISH	Dishes are hearty and savory, melding European flavors with a California twist. Stand out dishes include the fresh prawns, comforting risotto, and the stick-to-your-ribs pork loins.
UNIQUE DISH	The highly touted bread pudding is the perfect indulgence for anyone who appreciates sweets.
DRINKS	The wine list offers a diverse array of over 180-bottles, ranging from the Italian classics to the rare boutique California wine.
SEATING	The downstairs section of this tiny restaurant gives guests a glimpse of the open kitchen, and the upstairs 12-seat part is rife with hideaways, perfect for couples in the early stages.
AMBIENCE/CLIENTELE	The restaurant has an intimate, laidback yet refined vibe that makes it an ideal locale to take a date or enjoy a celebratory night out with close friends. Service is seasoned and eager to please. Although Frascati has more than its fair share of loyal patrons, all guests are made to feel right at home.
EXTRAS/NOTES	Frascati's quaint charm makes it stand out from the typical neighborhood spots and join the ranks of San Francisco's finest.

—*Kristin Viola*

Pesce
*Neighborhood approach to very
fresh seafood, with an Italian rustic
Nouvele style.*
$$$
2227 Polk St., San Francisco 94109
(at Vallejo St.)
Phone (415) 928-8025

CATEGORY	Ultra fresh Mediterranean
HOURS	Mon-Thurs: 5 PM-10 PM
	Fri/Sat: 5 PM-11 PM
	Sun: Noon-4 PM
GETTING THERE	Street parking, metered, parking tends to get difficult after 8 PM.
PAYMENT	VISA ● ▢ Cards ●
POPULAR DISH	Seafood is the specialty here, with amazing hot and cold *cicchetti's* (small plates) to share in addition to entrée portion size daily specials. The oyster selection while small, is the freshest available and shucked per order.
UNIQUE DISH	A sure hit dish here is the whole Thai Snapper de-boned at your table. Simply divine!
DRINKS	The drink list is quite extensive offering classic drinks such as Mint Juleps or a slowly stirred Manhattan to Brazilian Caipirinhas. The wine list offers a diverse selection of global wines. Try the *Sgroppino*, a sweet finish is a shot of lemon sorbet with vodka and Prosecco.
SEATING	The dining area is rather small and cozy. Not and ideal place for large groups. Great date spot and gathering with friends.
EXTRAS/NOTES	On any night of the week you will find members of the neighborhood dining at the bar.

—Ronda Priestner

Polker's

Good old American food with a hometown feel and a side of curly fries.

$$

2226 Polk St., San Francisco 94109
(at Green St.)
Phone (415) 885-1000

CATEGORY	American, specializing in burgers
HOURS	Daily: 8 AM-11 PM
GETTING THERE	Mostly street parking but not easy to find. Best to walk or take the 19 Polk St. bus.
PAYMENT	VISA ●
POPULAR DISH	The burgers are the main attraction (Avocado, mushroom swiss, all are above and beyond) However for brunch a skillet or omelets seem to be the most attractive choices.
UNIQUE DISH	Nothing unique about a burger unless you get it at Polker's. Fresh ingredients and quality meat, what more can you ask for?
DRINKS	Several beers are available on tap. A nice cold Anchor Steam would certainly compliment a messy San Francisco Burger. Also sodas and wine available.
SEATING	The eight booths running along the wall give this casual burger joint a nice diner feel. You can fit several more on the five tables running along the center. At Polker's you seat yourself, except on weekends where there is a long waiting list.
AMBIENCE/CLIENTELE	Nice tall ceilings and a ranch feel complements this Russian Hill hangout. The burgers are stacked high with the freshest ingredients. No dress code;

definitely a relaxed feel, and even the wait staff
thinks so.

EXTRAS/NOTES Polker's walls have large paintings to admire
or purchase as you dine. Every place in San
Francisco serves as some kind of gallery.

—*Fabrice Beaulieu*

Zarzuela

A taste of Spain.
$$$$
2000 Hyde St., San Francisco 94109
(at Union St.)
Phone (415) 346-0800

CATEGORY Neighborhood Spanish eatery
HOURS Tues-Thurs: 5:30 PM-10 PM
Fri/Sat: 5:30 PM-10:30 PM
GETTING THERE Although street parking is available, it is not
the easiest to find, so your best bet is to take
the Powell-Hyde St. Cable Car for a truly SF
experience or the 41 Bus.
PAYMENT VISA
POPULAR DISH The Grilled Eggplant with Goat Cheese brings a
delicious punch of flavor, the Papas Bravas are
the perfect consistency without being too greasy
(as they tend to be at other restaurants) and the
hearty Tortilla Espanola is a must-try. To end your
night on a sweet note, definitely try the bread
pudding.
UNIQUE DISH The Paella (which you must order 30 minutes in
advance) is the best in the city, and rivals those
in Spain.
DRINKS The sangria is delicious and refreshing – and will
have you ordering more than you bargained for in
no time.
SEATING The best seats in the house are to be found by the
windows, offering a glimpse of cable cars passing
by. There is additional seating in the back, which
offers more space for larger groups.
AMBIENCE/CLIENTELE The bright yellow awning marks this small yet
lively restaurant. The lively, inviting atmosphere
makes Zarzuela the perfect place to celebrate a
friend's birthday, go for an intimate first date or just
grab a few quick bites prior to going out for the
night. The clientele primarily consists of friends
and couples in their 20's and 30's. The friendly
servers, who are from Spain and are more than
happy to carry a conversation with guests in their
native tongue, will make you feel right at home.
EXTRAS/NOTES Zarzuela's upbeat vibe, its charming servers and
its savory tapas provide a truly authentic Spanish
experience. The servers are more than happy to
give you some sangria to make the long wait fly
by. End your night on a sweet note by grabbing
some Swenson's ice cream (some of the best in
town) just across the street.

—*Kristin Viola*

PACIFIC HEIGHTS/LAUREL HEIGHTS

Café Kati

East meets West and then some.
$$$$
1963 Sutter St., San Francisco 94115
(between Steiner St. and Webster St.)
Phone (415) 775-7313
www.cafekati.com

CATEGORY	Neighborhood Asian fusion
HOURS	Mon: 5:30 PM-10 PM
	Tues-Sat: 5:30 PM-10 PM
GETTING THERE	Validated parking available at the nearby Kabuki Theater lot, and valet service can be found on the weekends for $7. Also, Muni Lines 2, 3, 4, 5, 22 and 36 run right by the restaurant.
PAYMENT	
POPULAR DISH	Once you bite into the Dragon Roll, you will see why this dish is labeled as a Signature - its explosive combination of flavors is delightful.
UNIQUE DISH	Although Asian fusion is pretty played out on the Left Coast, Cafe Kati manages to stand out from the crowd, due to the exquisite presentation and diversity of flavors in its dishes.
DRINKS	The restaurant has a very good, reasonably priced wine list.
SEATING	Cafe Kati is quite small and cozy, with the tables very close to one another.
AMBIENCE/CLIENTELE	The restaurant is primarily frequented by neighborhood locals, and Chef Kirk is familiar with the majority of them. Cafe Kati's intimate yet unpretentious vibe makes it great for a first date. The servers are very warm and accommodating.
EXTRAS/NOTES	Tuesdays are BYOB (Bring Your Own Bottle) blind tastings.

—*Kristin Viola*

Café la Mediterranee

(see p. 183)
Hip Mediterranean
2210 Fillmore St., San Francisco 94115
Phone (415) 921-2956

Eliza's

(see p. 90)
Low-key Chinese
2877 California St., San Francisco 94115
Phone (415) 621-4819

Fresca

In the mood for fresh ceviche and tasty sangria?
Look no further.
$$$$
2114 Fillmore St., San Francisco 94115
(between Sacramento and California)
Phone (415) 447-2668
www.frescasf.com

CATEGORY	Peruvian
HOURS	Mon-Fri: 11 AM-3 PM; 5 PM-10 PM
	Sat/Sun: 5 PM-10:30 PM
GETTING THERE	Street parking is available, but it is not so easy in this neighborhood, so your best bet is to take the 1 California.
PAYMENT	VISA
POPULAR DISH	Fresca is a spirited modern Peruvian restaurant, with the best selection of ceviche in the city. Vegetarians be warned: this is really a place for seafood and meat-lovers, as there are no vegetarian options available.
UNIQUE DISH	I can't get enough of the Ceviche Chino. It is very light and refreshing with just the right kick to it.
DRINKS	Fresca offers a variety of wines and a number of Latin beers and cocktails, but the real stand out is its delicious sangria.
SEATING	Fresca is medium-sized and although it can get quite crowded, it also accepts walk-ins. A bar at the kitchen provides a great view of the chefs in action.
AMBIENCE/CLIENTELE	Fresca is the place to go if you are in a fun, upbeat mood (or looking to get in one) - the crowd is lively and service is very friendly. The vibrant, warm décor adds to the laidback, cheerful mood. The restaurant is very accommodating to small groups, and it is also a great place to take a date.
OTHER ONES	•West Portal: 24 West Portal Ave., San Francisco 94127, (415) 759-8087
	• Noe Valley: 3945 24th St., San Francisco 94114, (415) 695-0549

—Kristin Viola

Kyoto

Want beer? There are no raw deals, at Kyoto.
$$$
1233 Van Ness Ave., San Francisco 94109
(between Post St. and Sutter St.)
Phone (415) 351-1234 • Fax (510) 452-2448

CATEGORY	Japanese sushi
HOURS	Sun-Thurs: 10:30 AM-10:30 PM
	Fri/Sat: 10:30 AM-11 PM
GETTING THERE	There is almost always metered parking on Van Ness. After seven at night, the meters shut down, and it is usually not hard to find a spot within two blocks in either direction.
PAYMENT	VISA
POPULAR DISH	Everything here is above average. People generally order off of the sushi menu, which provides all

standard sorts of rolls and fish, as well as two menu pages of Special and combination rolls. I enjoy the Crazy Horse (tuna, avocado, salmon roll, with roe).

UNIQUE DISH All the recipes are fairly standard, whatever sort of sushi combination you like, get it here. Once a month, the chef invents a new roll. He then holds a naming contest for the new roll (the winner of which gets a gift certificate). Also, each night, one of the special rolls is discounted two dollars.

DRINKS Drinks are what separates Kyoto from the many other above average sushi restaurants in San Francisco, more specifically, dollars beers. Dollars Beers (99 cent Kirin) are available at Kyoto all day, every day, with no limit or restrictions. Also available are some sakes and some other Japanese beers.

SEATING Tables, stools at the sushi bar and booths; it's never hard to find a seat no matter what time of day or night.

AMBIENCE/CLIENTELE There is no sort of consistent clientele at Kyoto. The regulars include businessmen, and twenty somethings.

EXTRAS/NOTES Kyoto is located right in the middle of one of the busiest streets in SF, but it is almost rendered invisible by its prominent location. Its semi-grungy environs, and garish blue "Dollar Beer" banner seems to give people pause. Don't let this frighten you, the sushi is great.

—Ben Feldman

Vivande Porta Via

A neighborhood trifecta: Southern Italian trattoria, wine bar and deli in one.
$$$$
2125 Fillmore St., San Francisco 94115
(at Sacramento St.)
Phone (415) 346-4430 • Fax (415) 346-2877
www.vivande.com

CATEGORY Upscale Southern Italian and wine bar with to-go deli

HOURS *Restaurant*
Daily: 11:30 AM-10 PM
Deli
Daily: 10:30 AM-7 PM

GETTING THERE Moderate to difficult metered street parking. Garage nearby.

PAYMENT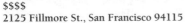

POPULAR DISH Chef, owner, and cookbook author Carlo Middione has done his Sicilian family proud. The pastas are made fresh in house, as is the fennel sausage, which is based on a 150-year-old family recipe; fettuccine con *salsiccia* shows off both. Venus' jewel box is an appropriate name for a beggar's purse of pasta gathered around a sultry combination of spinach pasta, ham and peas, all

served with a healthy shot of béchamel. *Secondi piatti* are for the more cholesterol-conscious: think chicken cooked under weights and drizzled with a balsamic vinegar reduction. Lunch is simpler plates of pasta like the *aglio i olio* with garlic, red pepper and olive oil. Small plates of antipasti are perfect for grazing all day long – don't miss the spicy stuffed peppers or, on a cold day, *cannellini* beans with tomato and pancetta. Indulge your sweet tooth with the lemon tart or the "earthquake cake," a chocolate-and-butter bomb. If you're stuffed but can't bear to forego the Italian version of Mexican wedding cookies, they'll wrap the *palle di neve* to go.

UNIQUE DISH Sicily reigns supreme at Vivande, and nearly everything is made in house, from the pasta to the sausage to the candied orange peel. Daily specials typically feature two starters and two entrées.

DRINK Very reasonably priced selection of beers and Italian wines. Barberas, Chiantis and the occasional Brunello (most under $35) satisfy Italy's reputation for reds, and the Vin Santo dessert wine pairs well with the apple tart.

SEATING Though the room is large and the tables farther apart than in a French bistro, the air in Vivande is undeniably intimate. Couples can cozy up in a corner, large groups can spread out on church pews, and solo diners might like a window seat to watch the hustle and bustle of popular Fillmore Street. Additional seating is at the wine bar, where nibbles are served.

AMBIENCE/CLIENTELE From ceramic pig heads to baskets and Venetian masks, the brick walls are hung with eclectic Italian relics. The hum of dinner conversations and the rapid click of chef's tongs on hot plates compose the room's only music. Most diners live or work in the neighborhood, so you'll find a mix of work attire and San Francisco casual – jeans slightly dressed up. Brown butcher paper tablecloths and a friendly, casual wait staff maintain the rustic feel.

EXTRAS/NOTES Long before artisanal cooking methods and local seasonal ingredients came into vogue, Vivande Porta Via embraced both. It first became known for its gastronomia, selling prepared foods like roast chicken, fresh pasta, truffles (when in season) and, more recently its own olive oil. In 1998 the Italian government awarded the restaurant the L'Insegna del Ristorante Italiano for its use of authentic foods and recipes.

—*Catherine Nash*

HAYES VALLEY/LOWER HAIGHT

Chilli Cha Cha Thai Noodle and Food Cafe

That's a spicy thai food restaurant!
$$$
494 Haight St., San Francisco 94117
(at Fillmore St.)
Phone (415) 552-2960 • Fax (415) 552-2962
www.chillichacha.com

CATEGORY Neighborhood Thai noodle house

HOURS Daily: 11 AM-11 PM

GETTING THERE Street parking is available in this neighborhood, but be aware of what street you choose to park on because the neighborhood (Lower Haight) is a cross between hip and trendy, and ghetto and nasty. Parking can be difficult at times, but nothing to be concerned about. Public transportation is quite easy on either the 22-Filmore line or the 7, 71, or 9 buses which run up and down Haight St., and is easily accessible from downtown.

PAYMENT VISA MasterCard

POPULAR DISH No matter what your fancy is for an entrée, I recommend to everyone to try the Tom Kha Khai soup, a delicious soup offered at almost any Thai restaurant, but Chilli Cha Cha has an extra twist that most Thai restaurants don't provide. The Basic Tom Kha soup broth is made of coconut milk and lemongrass as the two major flavors. Generally mushrooms, onions, and chicken or shrimp make up the majority of ingredients that hearty-up the soup and absorb the flavors of the broth. What's great about Chilli Cha Cha's Tom Kha is how incredibly spicy the kitchen will make it per the customers request, and the additional sweet flavor of tomato wedges, balancing out the flavors.

UNIQUE DISH The specialty of Chilli Cha Cha is the spiciness they put in all their food, which really shows its strength in Chilli Cha Cha's soups, curries, and pan-fried noodle dishes. Depending on the customer's tolerance of heat, all dishes can be ordered mild, medium, hot, or extra hot. I say go for it and ask for it extra hot. I guarantee even the most tolerant of patron will find a bite bursting with unquenchable heat that'll have anyone begging for more Thai Iced Tea.

DRINKS Thai Iced Teas or Thai Iced Coffees are the best drink options on the menu. However, the Singha (Thai beer) is a great alcoholic option. Another interesting drink to try would be the Coconut Palm Juice. Besides that, Chilli Cha Cha's offers standard drink options, but there is no wine on the menu.

SEATING The seating is somewhat cozy and limited, but very elegant and comfortable. However, a lot of Chilli Cha Cha's business comes from delivery and to-go orders, so getting a seat is usually relatively easy and without any type of wait.

There aren't a lot of big tables so I'd suggest calling ahead for a party of more than 5 people.

AMBIENCE/CLIENTELE Chilli Cha Cha provides a very warm and inviting dining room. Simple Thai art sits on the walls as a very friendly family-style wait staff serves the delicious food. The atmosphere is incredibly relaxed and casual, but maintains an air of elegance. And if it isn't homey enough for patrons to eat at Chilli Cha Cha, their free delivery with a minimum purchase of $15 makes it super easy to get everything they have to offer in the comfort of one's own home. Of course a great way to finish any Thai dinner is with a traditional Thai dessert of Fried Bananas and Ice Cream, or Sweet Sticky Rice and Mango. Both desserts are guaranteed to leave patrons smiling for the rest of the evening.

EXTRAS/NOTES If patrons can't get to the restaurant they provide fast and free delivery to most surrounding areas.

—Ian J. Strider

Citizen Cake
(see 'Citizen Cupcake' p. 104)
Bakery, cupcakes
399 Grove St., San Francisco 94102
Phone (415) 861-2228

Espetus Churrascaria
Vegetarians need not apply.
$$$$
1686 Market St., San Francisco 94102
(at Gough St.)
Phone (415) 552-8792
www.espetus.com

CATEGORY Very hip Brazilian steakhouse

HOURS Mon–Thurs: 11:30 AM-3 PM; 5 PM-10 PM
Fri: 11:30 AM-3 PM; 5 PM-11 PM
Sat: Noon-3 PM; 5 PM-11 PM
Sun: Noon-9 PM

GETTING THERE Street and metered parking are reasonably easy to find.

PAYMENT

POPULAR DISH Well, there's really only one option. There are no menus or anything, you just get the salad bar access (with beans, fish, rice, salad, deviled eggs, tomatoes and mozzarella) and the *churrascaria*, which is a merry-go-round of roast meats, including chicken hearts, prime rib, tenderloin, grilled shrimp, and chicken wrapped with bacon. Oh, yeah, and they're served to you on swords by cute waiters. A small disc on the table can be turned to green "Bring it on," or red "I surrender."

DRINKS The *caipirinha*, the national drink of Brazil, is a must-try and made properly here. Otherwise, their wine selection is extensive and the staff helpful.

SEATING Although I wouldn't call it particularly good for

large groups, many of them seem to end up in this practically bowling alley shaped restaurant. It's medium sized, with probably 25 tables. Not romantic, but lots of couples there.

AMBIENCE/CLIENTELE Clientele seems to be many Brazilians in for a taste of their home country's food, birthday gatherings, dates, and adventurous diners. The restaurant is warmly lit and inviting given the slightly shady atmosphere of the Market/Gough location. The food is amazing—as close as I have ever come to an authentic Brazilian churrascaria in the U.S. Since it's all you can eat, unless you are someone with an intense amount of self-discipline, expect to be stuffed full to bursting and slightly drunk when you leave here. Clientele is a mix of people dressed up for a special occasion and those who just stopped by for a bite (or 97 bites, if you will.) It's a bit loud, but sounds more festive than obnoxious. The entire restaurant is filled with the amazing smells of roasted meat and as soon as you walk in your mouth starts to water.

EXTRAS/NOTES Cute bartender and waiters in traditional Brazilian clothing. They look like swashbucklers, complete with the swords that they serve the meat on. The Brazilian community in San Francisco seems to congregate here.

—*Catherine Wargo*

Paxti's Pizza

Say "pah-cheese".
$$$
511 Hayes St., San Francisco 94102
(at Octavia Blvd.)
Phone (415) 558-9991
www.patxispizza.com

CATEGORY Casual, Chicago-style pizza

HOURS Tues–Sun: 11 AM–10 PM

GETTING THERE: Patxi's doesn't have a parking lot and street parking is both difficult and metered. Public transportation is convenient to the restaurant, though; the 21 Hayes, bus drops off less than a half block from the restaurant.

PAYMENT: VISA 🌐 🔲 Cards

POPULAR DISH The Chicago-style pizza is definitely a popular item on the menu at Patxi's. Authentic deep-dish pizza is almost impossible to come by in San Francisco, but Patxi's has it figured out. The crust is just the right thickness, the sauce is well balanced, and the toppings are just right.

UNIQUE DISH The California specialty pizza is unique to Patxi's. Featuring a whole-wheat crust, low-fat mozzarella, red onions, and spinach, it's a healthy alternative to traditional pizza.

DRINKS Beer and wine are on the menu at Paxti's. They've got four beers on tap, three of which are micro-brews, and six more available by the bottle. The

wine list has three white offerings and six red, available by the glass or bottle.

SEATING The dining room doesn't have the feel of being particularly large, but in actuality it can fit a lot of people. It's ideal for couples and small groups, but would also be able to accommodate a large group if necessary.

AMBIENCE/CLIENTELE The crowd is casual at Patxi's. There are nice, new LCD-screen TVs on the wall, so the sports crowd has something to watch on weekends. Though the clientele consists mostly of locals, some patrons come from a bit farther away for the authentic-tasting pizza.

EXTRAS/NOTES Patxi's merchandise and clothing are available, as are their homemade sauce and pizza dough. Inquire with your server or over the phone.

OTHER ONES • Palo Alto: 441 Emerson St., 94301, (650) 473-9999

—Katie A. Klochan

Suppenküche

*Cozy German joint that makes drinking two
liters of beer out of a boot seem like a fantastic idea.*

$$$$

525 Laguna St., San Francisco 94102
(at Hayes St.)
Phone (415) 252-9289 • Fax (415) 252-8661
www.suppenkuche.com

CATEGORY German

HOURS Mon-Sat: 5 PM-10 PM
Sun: 10 AM-2:30 PM; 5 PM-10 PM

GETTING THERE Street parking is difficult in Hayes Valley but Suppenküche offers valet parking Wednesday through Saturday 5:30 PM to 10 PM for $7 a car.

PAYMENT VISA MasterCard Card AMERICAN

POPULAR DISH For first timers and those looking to recreate a classic German meal, go for the Jägerschnitzel (literally Hunter's schnitzel.) A generous piece of lightly breaded, tenderized pork pan fried and swaddled in a rich and decadent creamy mushroom sauce. The schnitzel comes with a fresh green salad and spätzle (literally translated: little sparrows), which are tender little dumplings pan-fried with a bit of butter before hitting the plate. For an appetizer, a traditional must-try are the potato pancakes served warm and crispy with applesauce.

UNIQUE DISH While it is tempting to stick with all the mouthwatering meat dishes, those looking for something a bit less hearty should opt for the pan-seared trout with a luscious lemon and butter sauce served with boiled potatoes and spinach.

DRINKS Beer, beer and more beer. Suppenküche boasts an impressive list of German beers on tap and offers diners the option of quaffing by the tiny 0.3 liter, to the one-liter Ma (what you may have seen revelers enjoying at Munich's Oktoberfest,)

to the belly-busting two-liter boot. They also have a small, but well-chosen, wine list consisting of German, Austrian and California choices. To end the meal, try an Underberg Bitters, a strong digestive to help your schnitzel settle comfortably.

SEATING The dining area consists of two rooms filled with long pine tables. Just like in Germany, people are often sat at the same table with strangers to maximize the space, but those that are looking for privacy shouldn't be put off. There is often enough room to choose whether you would like to make new friends or limit conversation to "Would you please pass the salt?" They also can accommodate large parties in the back room, but make sure to plan in advance.

AMBIENCE/CLIENTELE Suppenküche is always bustling with a generally young, hip Hayes Valley crowd. The bare white walls and long pine tables are a perfect representation of German minimalist sensibility. There is a small candle-lit bar space with sexy red walls that invites you to relax with your beer while you wait for a table. The diners are pretty casual and often several languages can be over heard, as this place tends to draw a bit of an international crowd.

EXTRAS/NOTES Fabrizio West, owner, was born in Heidelberg and raised in Mengkofen, a small town in Bavaria, and wanted to bring the food, beer and warm dining culture of his home to San Franciscans.

—Andrea Wolf

Thep Phanom

San Francisco's Victorian Thai experience.
$$$$
400 Waller St., San Francisco 94117
(at Fillmore St.)
Phone (415) 431-2526
www.thepphanom.com

CATEGORY Neighborhood Thai

HOURS Daily: 5:30 PM-10:30 PM

GETTING THERE Street parking only and it is usually going to be pretty tough. The 7, 22 and 71 buses all come within a block of here if you don't want to deal with the parking.

PAYMENT VISA 💳 💳 💳

POPULAR DISH With ninety-nine items on the menu, plus specials, zeroing in on the top dishes is a little tougher here. Anything with curry or peanut sauce is going to be good. More specifically, on the meat side of things, the chicken yellow curry, the pad Thai and the basil prawns (basil sauce and crispy basil) all get singled out. On the vegetarian side, they make excellent crispy tofu and do a very good job with the vegetables so just decide which sauces and tastes you want to go with.

UNIQUE DISH Most of the menu consists of traditional Thai

dishes, but there are more options here that include salmon and portabello mushrooms than I've seen on other Thai places. The crispy fried portabello mushroom (with crispy tofu and eggplant in basil sauce) I had recently was excellent.

DRINKS The beer selections are pretty basic, but include Singha Thai beer. The wine list is more extensive and of the non-alcoholic drinks, the Thai iced tea is a good choice.

SEATING The capacity is about fifty and it can get a little crowded. There are about ten tables for four and a few others for two. These are put together to accommodate larger groups, but a group with more than eight to ten people will be pushing it and will definitely need a reservation. In general, reservations are a good idea.

AMBIENCE/CLIENTELE A cheerful, casual and tasteful restaurant well known beyond the Lower Haight, Thep Phanom is housed in the bottom floor of an old Victorian. Entering this place is like walking into a converted living room, one filled to the brim with attractive art, figurines and objects from Thailand. Add in the aromas and flavors from the multitude of dishes and the professional, if occasionally impersonal service, and the result is one of San Francisco finest Thai restaurants.

EXTRAS/NOTES While worth every penny, Thep Phanom can be a little more pricey than your average Thai spot. If you're used to cheap Thai, be prepared to splurge or come on a special occasion.

—Bill Richter

Toronado

San Francisco beer lovers' biggest and best selection of draught and bottled brews.
$$
547 Haight St., San Francisco 94117
(at Fillmore St.)
Phone (415) 863-2276 • Fax (415) 621-0322
www.toronado.com

CATEGORY Bar

HOURS Daily: 11:30 AM-2 AM

GETTING THERE Metered parking on Haight St. or 2-hour residential parking on other surrounding streets. The 22 Fillmore Bus stops right at the corner and numerous buses go past on Haight St. (6, 7, 66, and 71)

PAYMENT Cash Only

POPULAR DISH Beer, obviously. For something with a bit more nutritional value, head next door to Rosamunde for a fresh, house-made sausage served hot off the grill on freshly baked rolls topped with homemade sauerkraut.

DRINKS Beer is obviously the only beverage that should be considered, but that decision is not so easy. The beer list can be a bit intimidating for even

seasoned beer drinkers. With dozens of beers on tap and possibly hundreds offered by the bottle, this place is not for the ill-informed. Making the perfect choice can be daunting, but whatever you do, do not ask the bartenders for a recommendation. The somewhat surly beer experts don't take kindly to those who cheerfully inquire "What's your favorite?" The selection of Belgian, German and West Coast brews is impressive and it is a great place to try some new brews and even take some bottles to go. The best bet is to be adventurous and maybe you will find a new favorite beer.

SEATING With a long bar and two rooms of tables, Toronado can pack in a good number of beer drinkers.

AMBIENCE/CLIENTELE Mostly filled with self-described beer geeks, this is definitely a local watering hole. Lower Haighters pack in at all hours to take advantage of one of the most extensive beer bars in the country. The clientele is generally somewhat grungy guys in hoodies and various degrees of facial hair, but the beer-loving girl feels right at home as well. The only aspect that surpasses charmingly gritty and ventures more into gross are the graffiti-covered bathrooms. Sometimes the music and bar patrons can be a bit too loud, but what is a good bar without a jovial atmosphere? The walls are lined with hundreds of beer taps and beer paraphernalia and a jukebox cranks out rock and roll.

EXTRAS/NOTEA Chugalug early. Daily happy hour from 11:30 AM until 6 PM. Most beers are $2.50 a pint.

—*Andrea Wolf*

NOPA/WESTERN ADDITIONS

The Blue Jay Café

An actual neighborhood joint with good food. No, I'm serious.
$$$$
919 Divisadero St., San Francisco 94117
(at McAllister St.)
Phone (415) 447-06066

CATEGORY Café with it all (breakfast, lunch, dinner, desserts, beer, homemade pies and cakes...)

HOURS Mon-Fri: 11 AM-10 PM
Sat/Sun: 10 AM-10 PM

GETTING THERE Parking is reasonable, check on the side streets off Divisadero

PAYMENT VISA [cards]

POPULAR DISH Fried chicken! Best in the city.

UNIQUE DISH Biscuits and vegetarian (mushroom) gravy. Also, the avocado, mango, and candied walnut salad.

DRINKS Beers (like fat tire, sierra, Big Daddy) and limited wine selection

SEATING	Large old-fashioned U-shaped bar is the coolest place to sit. Allows couples to snuggle up and intimate conversations to take place, while larger parties are more comfortable at the tables lining the walls.
AMBIENCE/CLIENTELE	If you're not in a hurry and want some good soul food at a good price in an environment decorated by local artists, you can't find anything better than the Blue Jay.
EXTRAS/NOTES	The owners of this restaurant also own the Alamo Square Grill and the more recent Farmer Brown.

—*Catherine Wargo*

Club Waziema

It's cool to eat with your fingers at Waziema!
$$

543 Divisadero St., San Francisco 94117
(between Hayes St. and Fell St.)
Phone (415) 346-6641
www.clubwaziema.com

CATEGORY	Low-key Ethiopian
HOURS	Mon–Weds: 6 PM–Midnight
	Thurs–Sat: 6 PM–2 AM
	(Dinner served nightly 'til 10 PM)
GETTING THERE	Parking at Waziema is difficult; there is no lot and the street spots, which are metered, are usually taken. Taking public transportation is probably the best way to get there, since the 21 Hayes bus drops off less than a block away, as does the 24 Divisadero bus.
PAYMENT	*VISA*
POPULAR DISH	The vegetarian combo is a popular dish. The food at Waziema is designed for sharing and all of the dishes ordered are served on as few plates as is possible, though each diner gets a plate of Injera. The vegetarian combo is a great deal because it includes a portion of each of the vegetarian dishes on the menu and only costs about $1.50 more than the individual plates. Discounts on the vegetarian platters are available for groups of two or more.
UNIQUE DISH	All of the food on the menu is unique when compared to American fare, but Waziema stands out even amongst the seemingly endless selection of restaurants and types of cuisine available in San Francisco. In a so-called "foodie" city with thousands of restaurants, it is one of only a handful that serves Ethiopian cuisine.
DRINKS	Club Waziema has a full bar, plus a selection of Ethiopian bottled beers. Prices are reasonable: $4 for a pint of draft beer and $5.50 for a mixed drink.
SEATING	Seating along the bar can accommodate around fifteen people, and the ten or so small tables in the bar area each fit three or four comfortably. There is a second room in the back of the restaurant that has bigger tables and would be

best for large groups. A loft-like area, also in the back, holds a couple of pool tables.

AMBIENCE/CLIENTELE With regard to attire, anything goes at Waziema. It's very casual and laid-back. Jeans are the norm, but occasionally, especially on the weekends, you'll see people there that stop in on the way to Madrone lounge or NOPA, both across the street, wearing dressier clothes. Most of the patrons are locals in their mid-to-late twenties and early thirties. With one television, which usually shows sporting events, and a jukebox, Waziema is a great place to meet a friend for a drink or dinner. The low lighting and bold wallpaper create a unique atmosphere, which can be good for a casual date, hanging out with friends, and even eating alone at the bar.

EXTRAS/NOTES At Waziema, they pride themselves on the healthy and delicious house-made bread called "Injera," which is made from the only grain native to Ethiopia: Teff. On the second Tuesday of the month, local artists display their work in the back room at Waziema, and occasionally they feature a musical act instead of an art show. If all that weren't enough, Happy Hour at Waziema runs from 6 PM to 8 PM Monday through Saturday. The prices are exceptional: $2.50 draft beers, $4 glasses of wine, and well drinks for $3.50.

—*Katie Klochan*

Little Star Pizza

Pizza pies for hipsters.
$$$$
846 Divisadero St., San Francisco 94117
(at McAllister St.)
Phone (415) 441-1118 • Fax (415) 441-8358
www.littlestarpizza.com

CATEGORY Hipster pizzeria
HOURS Sun-Thurs: 5 PM-10 PM
Fri/Sat: 5 PM-11 PM
GETTING THERE Moderate to difficult metered street parking.
PAYMENT VISA
POPULAR DISH Arguably some of the best pizza in the city, here it comes both thick and thin. The deep dish has a buttery cornmeal crust blanketed with a thick ribbon of cheese, then toppings like the classic sausage, peppers and onions, followed by a layer of chunky tomato sauce. The sweet tomato sauce rocks your mouth with robust flavor, and it's refreshing to have it hit your taste buds first. Thin crust pies, shatteringly crisp, excel equally. Try the pesto chicken with mushrooms and onions, or build your own from a mix of traditional and California-style toppings. Little Star also makes a mean salad with Gorgonzola, walnuts, cherry tomatoes and red pepper (the small feeds two easily). Cheesecake is made in house and is worth sharing if you can squeeze it in.

UNIQUE DISH	It's pizza with attitude and a crowd to match. Plenty of hip twenty- and thirty-somethings and families that wait for up to an hour in line. Those who live nearby take it to-go and skip the deafening roar.
DRINKS	A short, inexpensive list of wine and beer, from ciders to microbrews to cans of Pabst Blue Ribbon. Sweet champagne cocktails are infused with a sense of nostalgic whimsy, like the Hey Kool Aid! with cherry soda and maraschino cherries.
SEATING	Little Star has only about 10-15 tables depending how they're set up, so expect a wait. Early birds who don't snag a table can nab one of the few stray armchairs near the bar while they kick back and wait.
AMBIENCE/CLIENTELE	Super casual with a spare interior. One slate blue wall adds a sense of drama and, with the flare of tabletop votive candles, keeps things dark and brooding, much like the clientele. The jukebox is crammed full of eclectic indie hits and vintage favorites. When it's playing to a full house, bring out the lozenges to soothe your throat. It's bound to get hoarse from shouting across the table.
EXTRAS/NOTES	$1 Pabst Blue Ribbons, and $1 off other drinks during the first and last hour of every day (note: closing time varies).

—*Catherine Nash*

NOPA

The gentrification point of no return in Western Addition: California cuisine.
$$$$
560 Divisadero St., San Francisco 94117
(at Fell St.)
Phone (415) 864-8643

CATEGORY	Ultra-hip dinner spot
HOURS	Daily: 5 PM–1 AM
GETTING THERE	Street parking is medium difficult to nightmare grade. Best bets? Hayes (#21) bus or Divisadero (#24) bus
PAYMENT	VISA MasterCard
POPULAR DISH	Any fresh fish they have on the menu for that day. Also, amazing flatbread – great to share for an appetizer. Also, courses are huge – great idea to share with fellow diners.
UNIQUE DISH	Amazing, do not miss the Bourbon Crème Brule.
DRINKS	Full bar, specializing in an extensive wine list. If the owner is around, he'll be happy to recommend something for you, but the waitstaff seems to be instructed to pretend they know about wine rather than be truthful, so beware.
SEATING	Extensive bar for seating, as well as first come, first serve communal bar table for immediate seating. Not great for groups – good luck getting your name on the list for a table of ten. Hipsters spill onto the streets while waiting for their tables.
AMBIENCE/CLIENTELE	NOPA is hopping. All the time. Monday nights, there's an hour wait for a table and every single barstool is filled. Clientele is a mix of casual and

dressy—some people just from work, but they definitely work somewhere cool—somewhere they can wear expensive jeans and an Armani blazer over an ironic Urban Outfitters tee. For women, a mix of thrift shop twenty-something chic and sophisticated thirty-something cougars. (Cougars = older women lying in wait at the bar for unsuspecting younger men.) The walls are covered with locally-designed cartoon art, and the three owners are usually running around someplace if you want to say hi. The waitstaff does their best to be friendly, but they're always so busy, getting attention can be difficult. The open kitchen in the back provides some previews of the food to come, and it's definitely the type of restaurant where you're so close to the next diner you can look over their shoulder and decide you want what they're having. The food is rich and tasty, made mostly from locally sourced ingredients.

—Catherine Wargo

"The Bay Area is so beautiful, I hesitate to preach about heaven while I'm here. "

—Billy Graham

Powell's Place

Delicious soul food in the heart of the Fillmore District
$$$$
1521 Eddy St., San Francisco 94115
(at Fillmore)
Phone (415) 409-1387 • Fax (415) 409-1387

CATEGORY	Neighborhood eatery that serves authentic soul food
HOURS	Daily: 8 AM-10 PM (take out 'til 11 PM)
GETTING THERE	Street parking only. Parking is relatively easy, but the neighborhood surrounding Powell's can be a little rough, so exercise caution when you park.
PAYMENT	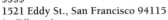 VISA ●● ■Cards
POPULAR DISH	Powell's fried chicken is universally praised and it's what I witnessed nearly all of the other diners consuming. However, I left feeling that my companion's dishes – the short beef ribs - were superior. The beef was succulent and juicy, covered in a delicious BBQ sauce that was not at all reminiscent of the red sugar water most places pass off as barbecue sauce. Sides include greens, mashed potatoes, corn muffins, mac & cheese, and yams. Powell's offers traditional American cuisine as well, although I can't imagine why you'd want to order a grilled cheese sandwich here when there is so much delicious food to be had.

UNIQUE DISH Powell's is one of the few restaurants in San Francisco that serves authentic, un-doctored soul food and as such is one of the few places one can consume delicacies such as oxtail & chitterlings. While many restaurants in San Francisco try to appeal to the city's vegetarians, Powell's is no such place and makes no apologies for its large portions and calorie-laden meals.

DRINKS Wine & beer

SEATING The restaurant recently got an upgrade, and its new location is enormous and would be great for groups. There is a separate room for receptions.

AMBIENCE/CLIENTELE After all I'd heard about Powell's and their reputation for delicious "down home" cooking, I was expecting to find a hole in the wall covered in grease, but instead was very surprised to find myself seated in a large, well-lit dining room decorated with pictures of Mr. Powell with various local celebrities including San Francisco mayor Gavin Newsom. A jukebox is available with music ranging from traditional gospel (Mr. Powell, the owner, is an internationally-renowned gospel singer) to hip hop like Kanye West. Diners were diverse: a group of pretty boys who looked like they got lost on their way home from the gym and several couples eating a quiet dinner. On a Tuesday night, the mood was very low key. Mr. Powell himself was present, in fact, he seated my companion and I but then, went and quietly ate dinner in the back of the restaurant. Service is a bit slow, but friendly and worth the wait. The food was delicious and when I left, the smell of fried chicken did not stay with me.

EXTRAS/NOTES Be sure to check out Gospel music on Sunday night gospel buffet. If you go at the right time, you may get to see some fabulous hats, courtesy of the church going ladies who visit this restaurant.

—Maria M. Diaz

Tsunami Sushi
Fresh, innovative sushi in a trendy,
upscale neighborhood setting.

$$$$
1306 Fulton St., San Francisco 94117
(at Divisadero)
Phone (415) 567-7664
www.tsunami-sf.com

CATEGORY Trendy, neighborhood sushi

HOURS Mon-Weds: 6 PM-Midnight
Thurs-Sat: 6 PM-1 AM
(bar open 'til 2 AM)

GETTING THERE Tsunami doesn't have a parking lot and street parking is both difficult and metered. Public transportation is convenient to the restaurant, though; the 21 Hayes, 24 Divisadero, and 5 Fulton buses drop off within a block of the restaurant.

PAYMENT VISA Mastercard

POPULAR DISH The Chef's Choice Nigiri is ideal because the chef chooses the freshest, best-tasting ingredients of the day, so you know that what you're getting is what the chef himself would have ordered.

UNIQUE DISH The specialty rolls are all unique combinations that showcase the creativity and skill of the chef. They're a bit on the pricey side, but the flavor combinations and artful presentation are worth the cost.

DRINKS Tsunami boasts the biggest sake selection in the city, all of which they import from Japan. Try one of the flights to get a taste of the different types of sake, or opt for one of Tsunami's cocktails to see how the flavors of sake are complemented by various juices and spices.

SEATING The dining room is not particularly extensive, but it certainly is stylish. Low, comfy couches line one side of the room and are ideal for small groups or couples. The couches are complemented by short, wide tables, and extra chairs are provided to make room for more diners. Several rows of tables in the middle of the room make for slightly cramped dining, but the intimate lighting does help make the lack of space seem less stifling and more romantic. Stools line the bar, where diners can either watch the chef create his artful presentations (and snag the occasional "free sample"), or the bartenders work their magic with the sake cocktails. One large booth in the corner is ideal for larger groups. Note that reservations are always recommended.

AMBIENCE/CLIENTELE Tsunami is very trendy. The host staff, servers, and bartenders are always dressed fashionably and the restaurant's décor is modern and chic, with a dark, sexy flair. The clientele tends to be the gainfully employed, late-twenties and early-thirties crowd, and the vibe in the restaurant is trendy and intelligent. Not recommended for kids or for those in a rush.

EXTRAS/NOTES For $3 cocktails check out their Happy Hour every night from 6 PM to 7 PM. The owners, the Dajani Group, also own Café Abir, which is adjacent to Tsunami, Bar 821, just around the corner from Tsunami and Abir, and the Nihon Whiskey Lounge, located in SOMA.

—*Katie Klochan*

Ziryab
Friendly neighborhood restaurant with an outdoor patio and hookahs.
$$$$
528 Divisadero St., San Francisco 94117
(between Hayes St. and Fell St.)
Phone (415) 522-0800
CATEGORY Casual Mediterranean
HOURS Daily: 11 AM-1 AM

GETTING THERE There is no parking lot available at Ziryab and the street spots, which are metered, are usually taken. Public transportation is very convenient, though, with both the 21 Hayes and 24 Divisadero buses dropping off less than a block away.

PAYMENT VISA MasterCard

POPULAR DISH The maza appetizer plate is very popular. It comes with house-made hummus, babaghanouge, tabouli, cucumber yogurt, dolmah, feta cheese, and falafel. It's a great deal, especially if you just get the portion for two. It's plenty for two people to share.

UNIQUE DISH While not technically a dish, the most unique item on Ziryab's menu is the hookah. An outdoor eating area is rare in San Francisco, even though the weather here seems ideal for open-air dining. Ziryab takes the experience one step further, though, and offers guests to their outdoor patio the opportunity to rent a hookah, with the choice of several different fruit-flavored tobaccos.

DRINKS Ziryab incorporates a nice selection of Belgian beers into their beer list, plus they serve wine. Several of their wines are priced by the glass.

SEATING Ample seating is available inside and the ambiance is ideal for couples and small groups. Seating for fifteen or so is provided on the heated, outdoor patio, and a second patio is slated to open soon in the back of the restaurant.

AMBIENCE/CLIENTELE Ziryab is a pretty casual place to eat. The clientele consists mostly of locals, and, while flip-flops are acceptable, the atmosphere is a little bit dressier than the average café or bar-and-grill. The lighting inside is somewhat low except over the grill, which is located to the right of the restaurant's entrance. The chef usually greets guests from his position there, which is a nice, personal touch.

EXTRAS/NOTES They should be opening up another outdoor patio in the back of the restaurant soon. Also, it's locally owned. The owners also have a convenience store across the street on the corner of Divisadero and Fell.

—*Katie Klochan*

INNER RICHMOND/OUTER RICHMOND/SEACLIFF

Assab Eritrean Restaurant

Where's Eritrea? Who cares –
the food's awesome.
$$$
2845 Geary Blvd., San Francisco 94118
(at Collins St.)
Phone (415) 441-7083

CATEGORY Eritrean restaurant (basically, Ethiopian)

HOURS	Mon-Sat: 11 AM-9:30 PM
GETTING THERE	Street parking, metered or non-metered. Fairly easy if you leave Geary and look in the neighborhoods.
PAYMENT	VISA Cards
POPULAR DISH	Assab specializes in vegetarian food, but I found their meat to be succulent and tasty. If you go for both the meat sampler and the vegetable sampler, you get the best of all they offer. Ask for extra injera (bread) – you'll need it.
UNIQUE DISH	Not so often do you find Eritrean restaurants just lying around here and there. Even in a culinary capital such as San Francisco, Eritrean are few and far between. A unique option? The Ethiopian honey wine, which is just what it sounds like, and sweet enough to wither even the most resolute sweet tooth.
DRINKS	Ethiopian honey wine, as mentioned above, as well as some Ethiopian beer (get it just for the experience).
SEATING	There are only about ten tables, but it's not like there's a line around the corner. At 7:30 PM on a Saturday night we were able to be seated right away. It filled up as the meal went on, much to the dismay of the only waitress in the place.
AMBIENCE/CLIENTELE	Very casual come-as-you-are atmosphere. No people watching, everyone basically minding their own business (or trying to, at least, since the tables are so close together.) It's very relaxed, so if you're in a rush, this is the wrong place to stop for a quick bite. The restaurant is also oddly extremely quiet – no music or ambient noise, which seems to encourage patrons to keep their conversation to a hush. Despite whether the preceding paragraph sounds appealing to you or not, the food is wonderful. Rich and flavorful, family style plates have something for everyone. Due to the nature of the menu and the presentation of the food, you probably won't always know what exactly it is that you're eating, but you will know that it all tastes amazing. Skip dessert – or at least, that's what the extremely honest waitress told us.

—*Catherine Wargo*

Burma Superstar

A Taste of China, Thailand, India, and Laos.
$$$
309 Clement St., San Francisco 94118
(at 4th Ave.)
Phone (415) 387-2147
www.burmasuperstar.com

CATEGORY	Pan-Asian
HOURS	Sun-Thurs: 11:30 AM-3:30 PM; 5:30 PM-9:30 PM Fri/Sat: 11 AM-10 PM
GETTING THERE	Difficult metered and street parking
PAYMENT	VISA Cards
POPULAR DISH	The Rainbow Salad (made with 22 different ingredients) and the Pumpkin Pork Stew are

amazing! For starters order either the samusas or the samusa soup. To wash it all down, order fresh coconut juice for a little tropical flare.

UNIQUE DISH All of the dishes have a hint of Chinese, Thai, Indian, and/or Laoation flavor to them.

DRINKS Tea, juice, smoothies, soda, beer

SEATING Medium size restaurants with a lot of tables packed in closely together. One round table for a large group.

AMBIENCE/CLIENTELE The food here is so good it makes the restaurant seem more upscale when it is actually pretty casual. The décor is Asian inspired, but needs a little updating.

EXTRAS/NOTES Burma's neighboring countries Laos, Thailand, India and China all influence the Burmese cuisine. Singer Chris Isaac ate there when I was there in May.

—*Thy Pham*

Chapeau!

Charming French bistro with
aristocratic service at bourgeois prices.

$$$$

1408 Clement St., San Francisco 94118
(at 15th Ave.)
Phone (415) 750-9787 • Fax (415) 750-9677
www.bistrochapeau.citysearch.com

CATEGORY Elegant French neighborhood bistro

HOURS Tues-Thurs: 5 PM-10 PM
Fri/Sat: 5 PM-10:30 PM

GETTING THERE Easy street parking

PAYMENT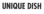

POPULAR DISH The menu has a few classics to anchor it in the French bistro tradition – French onion soup and steak/frites, for instance – but most of it changes regularly based on which local fish, meats and produce are best. The seared foie gras puts M&M's "melt-in-your-mouth" claims to shame, and the cassoulet comes in a clay dish stuffed with earthy white beans, fork-tender lamb shoulder, sausage and duck confit. Recent highlights include seared sweetbreads in a porcini mushroom crust, leg of rabbit with mustard sauce, and striped bass with a fricassee of meaty hedgehog mushrooms and artichokes. Vegetarians are never without an option, often a layered napoleon. Finish with ice cream stuffed profiteroles or the sinus-opening cheese plate.

UNIQUE DISH To cleanse your palate before the entrée, choose one of two bracing drinks: the Trou Normand, green apple sorbet with a shot of Calvados (apple brandy) or the Colonel, lemon-ginger sorbet with citrus-infused vodka. Everything in the cassoulet is homemade, from the sausage to the confit.

DRINKS Chapeau! is equally passionate about food and wine. Start with a glass of champagne or a *kir royale* while you peruse the wine list. Clocking

in at 50 pages, it provides numerous suggestions under $40. French and California wines compete for attention and Philippe loves to be asked for a recommendation at any budget. Don't begrudge him a small sip; he tastes every bottle to ensure the wine has kept well.

SEATING Chapeau! is authentically cozy with tables pushed close together. Large groups are welcome, but they add to the decibel level. Ask to sit either in the front window or back corner if you're with your sweetie.

AMBIENCE/CLIENTELE Chapeau! is warm and inviting, and not just because velvet curtains at the door keep out the cold. Owners Philippe and Ellen Gardelle rush to greet everyone with a kiss on each cheek. Inside, conversations in a mix of French and English ebb and flow as Laguiole knives cut through thick steaks. Moments after Ellen whisks your coat to the back you're sipping champagne, buttering still-warm bread and enjoying an amuse bouche like a teacup of silken cauliflower soup with truffle oil.

EXTRAS/NOTES Chapeau is fancier than you might expect; jeans are appropriate, but pair them with a nice shirt and jacket. Also be sure to make reservations. The French-trained staff adheres to tradition, serving each course with precision, and only brings the check when asked (so speak up!) It is served in a hat, a play on the word "chapeau" which means hat without the exclamation point, or "wow!" with it. The prix fixe is one of the best values in town, complete with a complimentary amuse bouche to start the meal. You can order a la carte or build your own 3-, 4- or 5-course tasting menu ($33, $40 and $44). The early bird 3-course prix fixe is a steal at $21.25 (5–6 PM Tuesday–Thursday and Sunday).

—Catherine Nash

Gordo Taqueria

Simple, basic Mexican food,
with money left for the bus.
$$
5450 Geary Blvd., San Francisco 94121
(at 19th Ave.)
Phone (415) 668-8226

CATEGORY	Taqueria
HOURS	Daily: 10 AM-10 PM
GETTING THERE	Street parking is available, but limited; the 38 bus runs right by, so it is the best choice. Buses 1, 2, 28, 29 run nearby as well.
PAYMENT	Cash only
POPULAR DISH	Most folks (myself included) order a burrito, but tacos are available as well. The menu is very small, as are the prices.
UNIQUE DISH	Honestly, there is nothing unique here – just basic Mexican food.

DRINKS Just like their regular menu, their drink list is pretty small: no alcohol, but fountain sodas, bottled water, Mexican soda, orange juice, and milk are available.

SEATING Twelve two-person tables are scattered around the front of the eatery, though you can easily move the chairs around if you need to.

AMBIENCE/CLIENTELE The simple food and drink menus extend to the eating area as well. The small TV hanging in the corner is usually tuned to the Spanish news station and there is one bathroom in the back. The notable feature is the mural hanging on one wall – a nice scene of what we all hope Mexico would look like if we visited (though most of us know better).

OTHER ONES • Outer Richmond: 2252 Clement St., San Francisco 94121, (415) 387-4484
• Inner Sunset: 1239 9th Ave., San Francisco 94122, (415) 566-6011

—*Victoria Everman*

Some of Our Favorite Folks from the East Bay...

1. Bruce Lee (all around bad ass)
2. Daniel Clowes (Comic book artist, "Ghost World", etc)
3. Del tha Funkee Homosapien (Musicanian)
4. Sonny Barger (Hell's Angels' Motorcycle Club founder)
5. Mark Hamil (Luke)
6. Russ Meyer
7. Gertrude Stein

Katia's Russian Tea Room

From Russia with love.
$$$$
600 Fifth Ave., San Francisco 94118
(Balboa Ave.)
Phone (415) 668-9292
www.katias.com

CATEGORY Traditional Russian

HOURS Weds-Fri: 11:30 AM-2:30 PM; 5 PM-9 PM
Sat/Sun: 5 PM-9 PM

GETTING THERE Difficult street parking. Lunch: paid parking lot on Geary/5th. Evening valet service coming soon.

PAYMENT VISA ⬤ ▦ Cards ▦

POPULAR DISH You can't say "nyet" to blini, thin pancakes that come to the table brushed with butter. Load them up with herring or glistening salmon roe and a dollop of sour cream. The zakuski tasting platter gives you "little bites" of Russian favorites like salade Olivier (a mayonnaise-y potato salad), silken eggplant caviar, marinated mushrooms and smoked salmon. Beef stroganoff in a mild, creamy mushroom sauce is familiar, but don't miss the lamb shashlik marinated in garlic, lemon juice and wine. Another must is the vareniki, pillowy

ravioli filled with potatoes and topped with caramelized onions.

UNIQUE DISH Katia's is one of the few Russian restaurants in San Francisco, and definitely the best. The homemade apricot preserves, when available, are a babushka's gift to fruit. Beef-filled dumplings called pelmeni are served in broth with plenty of sour cream.

DRINKS Wine, Russian beers, Russian port. Soju, a liquor similar to vodka, is served in elegant decanters. The tea comes in a filigree "podstakannik" and makes an excellent post-prandial nip.

SEATING Small yet comfortable and romantic.

AMBIENCE/CLIENTELE Though you're sure to hear a few "do svidanya's" when you leave, the crowd is an even mix of American locals and Russian ex-pats who flock to this inner Richmond joint to experience Mother Russia. Owner Katia Troosh spends most of the meal greeting customers, making recommendations and sharing stories or laughs. On weekend nights an accordion player sits in one corner, jovially playing a mix of maudlin Russian folk songs and modern tunes. The tables are set with white tablecloths, fresh flowers and votive candles, and window seats offer a view of city streets.

EXTRAS/NOTES If you're into that kind of thing check out the live accordion player on Friday and Saturday nights. In December, Katia bakes whole pies that you can take home for the holidays. Cranberry/apple, pumpkin and pecan all come with her signature cookie crust.

—Catherine Nash

Pizzetta 211
Tiny restaurant. Thin crust. Big love.
$$$$
211 23rd Ave., San Francisco, CA 94121
(at California St.)
Phone (415) 379-9880
www.pizzetta211.com

CATEGORY Neighborhood storefront pizzeria

HOURS Mon: 5 PM-9 PM
Weds-Fri: Noon-2:30 PM; 5 PM- 9 PM
Sat/Sun: Noon-9 PM

GETTING THERE Street parking and it will usually take at least a few minutes to find a spot, especially at night.

PAYMENT Cash only

POPULAR DISH Delicious thin crust pizza is the specialty here and there is very little on the menu besides pizza and salads. A light, savory, crispy crust is topped with regularly changing combinations of toppings atypical for pizza. Yes, this is what some would consider fancy yuppie pizza, but you shouldn't let that hold you back. For a more traditional pie, the excellent tomato sauce, mozzarella and basil pizza is a regular menu item.

UNIQUE DISH It is the topping combinations that help separate

Pizzetta from much the pack. Examples include caramelized onions, olives and anchovies and another with butternut squash puree, Gruyere cheese and parsley. They have also received attention for pizza with various egg toppings. I haven't tried one of those, but people say they are really good.

DRINKS Beer and wine only and the selections for each are few, but thoughtful and discerning.

SEATING It is very much in the small and cozy realm. Some would say tiny. Inside there are four tables, two of which are fine for up to four people and the other two fine for up to three. A small bar has four stools and there are two outside tables, each of which can work for up to four. This is definitely not a good idea for large groups.

AMBIENCE/CLIENTELE The setting is quaint and rustic, with the décor consisting of little more than dimmed lighting, some pottery and a couple of photographs. It is like being in a small wine tasting room or corner of a farmhouse. Although very small, the high ceilings and large storefront windows help open the atmosphere. Jeans and t-shirts are just fine, but it is best to bring a coat, as there is a good chance you'll have to wait outside.

—Bill Richter

The Richmond Restaurant and Wine Bar

Serious foodie heaven without pretension.
$$$$
615 Balboa St., San Francisco 94118
(between 6th and 7th Aves.)
Phone (415) 379-8988
www.therichmondsf.com

CATEGORY California bistro with local and organic ingredients

HOURS Mon-Thurs: 6 PM-9:30 PM
Fri/Sat: 5:30 PM-10 PM

GETTING THERE Parking is residential and can be a little tricky but a few trips around the block usually pay off. Several buses drop you off near by: the 31 and the 44.

PAYMENT VISA

POPULAR DISH Pan seared scallops and tender whisky-braised oxtail with a creamy polenta. Ravioli with Short Rib meatballs. Organic Beet Salad with Laura Chanel goat cheese-stuffed pastry. Crispy Banana Fritters with vanilla ice cream and chocolate sauce.

UNIQUE DISH The crispy sweetbreads with a bulgur risotto are good enough to convert the sweetbread-phobic.

DRINKS The most notable aspect of the Richmond is the remarkable wine list containing gems such as Opus One and Château Laffite Rothschild. However, the list also carries numerous bottles under $40 that are delicious and a great value.

SEATING There are only two small dining rooms, but diners don't feel at all cramped.

AMBIENCE/CLIENTELE The tiny dining rooms have vaulted ceilings that make it feel more spacious and the walls are adorned with local art and black and white photographs of turn-of-the-century San Francisco. The Richmond is like a secret that has been passed around the rest of the industry folks in the city and more often than not you will be sitting next to local chefs, sommeliers and wait staff reveling in a sumptuous meal. Although completely appropriate for a special occasion, patrons are just as comfortable in jeans and T-shirts.

EXTRAS/NOTES Chef John Owyang is as humble and gracious as he is talented. When there is a lull behind the line he can be seen checking in with diners, greeting regulars and even pouring water and clearing plates.

—*Andrea Wolf*

Poison-Free Food
A Guide to San Francisco's Organic and Locally Grown Goodness

As one of the food capitals of the world, it is no surprise that San Francisco restaurants have embraced the organic and local food movements. I'm not sure about you, but I prefer having my food without a side of pesticides. Fair warning to anyone was hasn't visited these places before: the cost is slightly higher than what you would pay for a "traditional" salad or sandwich, so keep your health in mind while you are spending that extra dollar or two and it will be worth it.

The largest collection of restaurants featuring organic and lo-cally-grown foods is, without fail, in the Financial District. **Sellers Market** (see p. XXX) serves breakfast and lunch with all local ingredients, and damn tasty ones too. Salads, soups, rotisserie, individual pizzas, and delectable sandwiches for lunch are the name of the game here. A few blocks away is **Mixt Greens**, featuring unique salads with funky names, as well as an expansive menu that you can use to compile your own greenery dream. Savory sandwiches are on the menu along with organic drinks and fresh-made coffee. Having "one of those days"? You can get wine with your meal here too—don't worry, we won't tell your boss. If basic greens aren't doing it for you, then the **Ferry Building** is your mecca of choices. **DELICA rf1** is a Japanese deli; **MIJITA** has your Mexican craving covered; **Prather Ranch's** 100% organic all-beef hot dogs will please your palate, while **Mistral Rotisserie** has the best home-cooking this side of the Mediterranean. You won't find any better dessert than right here either: **Capay Organic** has tasty fruits, **Scharffen Berger** is the chocolate-lovers dream, and you can't find a better organic French patisserie than **Mietta**.

If you happen to be in the posh Marina area, two tasteful options await you. **Greens** was a pioneer in vegetarian cuisine when it first opened, and to this day it is still one of the premiere restaurants in the country. Even if you are a meat-lover, this place will make you love your veggies. If you have a busy day planned, stop in to

the Greens To Go area and get something quick. **Lettus Cafe** does have, well, lettuce, but much more as well. A Grab & Go menu is available for the busy sort, but if you want to savor your food, which is always recommended, you have a lot of choices here. All day breakfast, full lunch/dinner menu, specialty salads, fresh juice & smoothies, desserts, coffee/tea/beer/wine/cocktails, and a daily specials menu await you here.

During an afternoon of thrifting in the Mission, you are likely to get hungry; planet-friendly options tempt you here as well, so save some cash. One of the three **Cafe Gratitude** locations can be found in this area, with the others in Inner Sunset) and over the bridge in Berkeley. Another vegetarian establishment, it is popular among flesh-eaters as well, in-part thanks to their "gratifying" dish names. Their menu is filled with all the usual fare: breakfast, appetizers, soups, salads, entrees, pizza, grains, sides, smoothies, milkshakes, organic coffee & tea, fresh juice, and desserts. For something offbeat for dinner, head to **Minako** or organic Japanese food. Though the dining room isn't very fancy (OK, it's a whole-in-the-wall joint), the dishes more than make up for it. Anything on the menu can be adjusted to be vegetarian or vegan, so don't be too shy to ask. Their sushi is their most popular, but the rest of their dishes are worth diving into as well.

Though in two completely different neighborhood, these next places are very much worth venturing to. **Magnolia Pub & Brewery** is the pride and joy of the Haight, nestled in an historic building that once was a bustling *(legal)* pharmacy. As the name suggests, their ales are hand-crafted in the cellar below the pub in a custom-built brewery; they also made their own sodas. Many of the menu items are organic and as much as possible is bought from local growers. Too tempting to leave anything out, I'll trust you to explore their menu yourself. Lunch, dinner, and late-night menus are featured, as well as desserts and an "infamous" brunch on Saturdays and Sundays. Last but by no means least, **Feel Real Organic Vegan Cafe** in Outer Sunset is worth the trip. If you happen to be out exploring Ocean Beach or the Zoo, then this is the place to hit up as well. Though the menu is relativity small, the comfort level in this place is through the roof—you feel like someone is cooking for you at home.

Victoria Everman

Spices

Szechwan cuisine, neon lights, and "spicy gurls".

$$

291 6th Ave., San Francisco 94118
(at Clement St.)
Phone (415) 752-8885

CATEGORY	Low-key Szechwan Chinese
HOURS	Daily: Noon-Midnight
GETTING THERE	Street parking only
PAYMENT	
POPULAR DISH	Special chow mein, and hot pots for two.
UNIQUE DISH	Choose a 3-pepper dish and prepare for nuclear fusion in your mouth.

49

DRINKS	Free tea and full bar service.
SEATING	Seats about 60 people.
AMBIENCE/CLIENTELE	"Spicy Gurl" as the place is better known, describes both the food and the attractive waitresses, living up to its name by dishing out hot hot hot Szechwan fare. This is not only the coolest Chinese restaurant in SF, but prepares some of the city's most amazing Asian food. It's best enjoyed with friends as you're going to want to share multiple dishes while exchanging witty comments about the Sino-pop television shows in the background.
EXTRAS/NOTES	The Chinese-Elvis owner is the coolest man in the Richmond.
OTHER ONES	• Inner Richmond: 294 8th Ave., San Francisco 94118, (415) 752-8884

—Benny Zadik

Spices

(see p. 49)
Low-key Szechwan Chinese
294 8th Ave., San Francisco 94118
Phone (415) 752-8884

Turtle Tower

(see p. 110)
Pho
5716 Geary Blvd., San Francisco 94121
Phone (415) 221-9890

HAIGHT ASHBURY/COLE VALLEY

Cha Cha Cha

Small plates. Big food.
$$$$
1801 Haight St., San Francisco 94117
(at Shrader St.)
Phone (415) 386-7670 • Fax (415) 386-0417

CATEGORY	Funky, hip Caribbean restaurant
HOURS	Sun-Thurs 11:30 AM-11 PM Fri/Sat: 11:30 AM-11:30 PM
GETTING THERE	There is a reasonably priced pay lot across the street from Cha Cha Cha, which can be convenient if it's necessary for you to drive to the restaurant. Street parking is extremely limited and metered. Public transportation is the best way to get there; the 7, 71, 33, and 66 buses drop off less than a block away, and the 43 bus and N Judah metro line both stop about 3 blocks from the restaurant.

PAYMENT VISA (MasterCard)

POPULAR DISH Most people that visit Cha Cha Cha come for the so-called "small plates", which are meant to be shared. The Fried Calamari and Fried New Potatoes are popular to start off with, as are the Black Mussel, accompanied, of course, by the house bread (for soaking up the broth).

UNIQUE DISH The Jamaican Jerk chicken is H-O-T! The chicken effortlessly pulls off the bone, and the black beans and rice that accompany the dish are the perfect complement. It's hearty and delicious, if you can handle the heat.

DRINKS Sangria is definitely the number one beverage served at Cha Cha Cha. It's powerful and delicious, and most guests enjoy a pitcher (or several) in the bar area while waiting for a table. They also offer a few microbrews and California wines, if you're not in the mood for sangria. Note: They serve complimentary chips and salsa with the drinks, but you might have to ask for it.

SEATING It gets crowded, especially on weekends and especially in the bar, where people pack in to wait for tables and get drinks. It's great for groups, although they don't take reservations, so be prepared to wait a little longer for one of the few big booths.

AMBIENCE/CLIENTELE One of the great things about Cha Cha Cha is that anything goes. For the most part, people get a little bit dressed up, possibly in part to impress the trendy 20-something crowd that makes up most of the clientele. Some groups head to Cha Cha Cha before a night on the town, and tend to be dressed for the occasion (read: club-going outfits). To some area residents, for whom it's just a neighborhood joint, an old t-shirt (preferably one that's old in the trendy, "vintage" manner of speaking), jeans, and flip-flops are the preferred attire.

EXTRAS/NOTES There are elaborate Santeria altars arranged around the restaurant, which always make for good conversation. Visitors should be warned that, although they advertise "small plates," the portions are big. For example, for two people, two tapas dishes would probably be plenty. They also cater and do private parties.

OTHER ONES • Mission: 2327 Mission St., San Francisco 94110, (415) 648-0504

—Katie A. Klochan

Cuco's

Best veggie burrito in the city.
Maybe the world.
$
488 Haight St. San Francisco, 94117
(at Fillmore St.)
Phone (415) 863-8187

CATEGORY	Teeny hole-in-the-wall neighborhood taqueria
HOURS	Mon-Fri: 11 AM-9 PM
GETTING THERE	Difficult street parking. Some meters.
PAYMENT	Cash Only
POPULAR DISH	Cuco's plantain burrito is my favorite vegetarian burrito. It's also a burrito that could satisfy even the most stubborn carnivore. I think the secret is its freshness. She slices up and pan-fries an entire plantain as you order it, so it hits your burrito piping hot. If you're really lucky, Mrs. Cuco will cook it long enough for the edges to get caramelized—chewy, sweet goodness. You'll wait about seven minutes for your plantain to cook, so grab one of the ten or so seats and have some chips that will likely be served to you by one of the kids when they take a break from their homework.
UNIQUE DISH	The plantain burrito is the only one I've found in SF. The *pollo asado* is actually taken right off the bone, another unique offering. On average, I would say Cuco's plantain burritos weigh about 2.5 pounds. If you're in the mood for a lighter meal, the regular vegetarian is great as well, owing to the overall quality of her base ingredients. Carnivorous friends rave about the *pollo asado* (grilled chicken). She makes a great rendition of *huevos rancheros*, too.
DRINKS	Serve the normal offerings for a taqueria: sodas, water, bottled beer (Corona, Dos Equis, etc), Jarritos. No *aguas frescas*, however they have amazing homemade *horchata* on occasion.
SEATING	Small, only 10-12 seats. Mostly meant for take-out.
AMBIENCE/CLIENTELE	This place is fantastically homey. I have a pronounced emotional attachment to Cuco's. It's a popular neighborhood spot, family run and friendly. I lived a few blocks away during my first year in the city, so Cuco's sort of holds a special place in my heart as my first go-to burrito spot. On my first Christmas Eve in the city, I brought Mrs. Cuco (maybe not her real name) and her children homemade cookies.
EXTRAS/NOTES	Beware the spicy pico de gallo; the spice level varies every day. If you ask for hot and Mrs. Cuco raises an eyebrow and says "You sure?—heed the warning. Didn't listen to our advice? Take your burrito down to the Toronado and enjoy it with a nice, hoppy IPA.

—Cate Czerwinski

Hama-Ko

What?! Tempura?! No sushi for you!
...Beware the Sushi Nazi.
$$$$
108B Carl St., San Francisco 94117
(between Cole and Shrader)
Phone (415) 753-6808

CATEGORY	Japanese sushi

HOURS	Tues-Sun: 6 PM-10 PM
GETTING THERE	Hama-Ko is less than one block from the Muni's N-Judah Cole & Carl stop. The 43 and 6 busses also stop nearby. Walking distance from Haight St. (four blocks) Definitely recommend taking public transportation. There is some metered and street parking, but it is a very busy area and you could be waiting for a while.
PAYMENT	VISA
POPULAR DISH	This is the city's hidden sushi jewel. Sushi fanatics and chefs come from all around to experience this husband/wife duo's fantastically fresh sashimi. You won't find very many cooked items on the menu; only serious sushi lovers need apply.
UNIQUE DISH	There is no sign marking the restaurant's entrance. In fact, if you don't know the address, you may not be able to find it at all. On most nights, steam fogs up the windows outside and completely disguises the restaurant's presence!
DRINKS	Tea, sake, beer, wine
SEATING	Tiny! Only two small tables, and some seating at the bar. Get there early, it fills up fast.
AMBIENCE/CLIENTELE	This is not your typical city social scene sushi restaurant like Blowfish or Tsunami. The lighting is rather stark, and in the Japanese tradition, chef-owner Ted Kashiyama will probably not warm up to you until three or four visits in. At that point, though, he may begin to serve you items from the unprinted specials menu: only the best of the best. Do not be deterred—this seemingly abrupt style of customer service is considered the norm in Japan, and the fish is flown in fresh from around the world every day—it's worth it!
EXTRAS/NOTES	Mind your sushi manners! No tapping chopsticks or feet up on the chairs! You will be scolded by Kashiyama's wife, the restaurant's only other staff member. No reservations accepted, and all members of party must be present to be seated. —*Pamela Ames*

Kan Zaman

*Middle Eastern fare that will have
you loving the Haight.*
$$$
1793 Haight St., San Francisco 94117
(at Shradder St.)
Phone (415) 751-9656
www.exhalecafe.com

CATEGORY	Casual and fun Middle Easter restaurant that's as sedated as Haight habitués
HOURS	Mon-Thurs: 5 PM-Midnight Fri: 5 PM-2 AM Sat: Noon-2 AM Sun: Noon-Midnight
GETTING THERE	Parking in the Haight is infamously difficult. If you are unable to find a space, there is a parking lot on Stanyan St., near Kezar Stadium.

PAYMENT VISA ⬤ ▨ Cards ▰

POPULAR DISH *Mesas*, or appetizer plates are most popular here. The Middle-Eastern version of tapas, these small plates can be ordered in various combination plates, depending on the number of hot and cold dishes you choose. They can also be ordered a la carte. The *dolmas* are fantastic—short-grain rice and currants infused with olive oil ad lemon juice, then wrapped in soft grape leaves. Their *kibbi* is the best- tender ground lamb blended with bulgur wheat and fried in olive oil. Perfect for dipping into their minty cucumber yogurt salad. Meat pies—ground lamb encased in phillo dough—are satisfyingly sweet and savory, thanks to the good-quality lamb, jeweled currants, and flakey crust. Their Hummus is a testament to the beautiful simplicity of Mediterranean fare, consisting of only pureed chickpeas, *tahini*, garlic, and lemon—a perfect accompaniment to every dish. Eggplants' natural spiciness shines through in their *babba gannoush*, of pureed roasted eggplant, *tahini*, lemon juice, and garlic.

DRINKS The warm, spiced wine takes center stage here. A tart red wine is heated, infused with cloves and anise, and then lightly sweetened with honey. Delicious. Available by the glass or—even better—by the carafe. Their Turkish coffee is an ideal way to complete your middle- eastern feast. Just beware to not tip you head back for those last drops—traditional Turkish means that bitter coffee grains lie at the bottom. For a mellower post-dining vibe, a fresh-mint tea, lightly sweetened with sugar, is great.

SEATING Good luck finding a table here on weekend evenings. This restaurant is well known for its long waits, but you can turn it into an experience by putting your name down on the (ever-growing) list, then making your way to the (packed) bar for drink and people watching. Two huge, round tables sit at the front and are ideal for large groups. Couples prefer the smaller tables and pillow-covered banquettes. Either way, you will have a good practice at lip reading, as the restaurant manages to reach voice decibels previously unknown to any other institution.

AMBIENCE/CLIENTELE The restaurant is cloaked in rich reds and golds. Smooth wooden tables, long banquettes, mounds of pillows, soft candles, and the subtle fragrance of flavored tobacco are soothing despite the large crowd, high energy, and even higher conversation levels. Dress is casual (this is the Haight after all), but dates tend to dress up a bit more - bottom line, it's anything goes.

EXTRAS/NOTES One of the main draws to this restaurant is their hookahs. Traditional in the Middle East, hookahs are essentially towering pipes from which one smokes flavored tobacco. You can have a hookah brought to your table after 10 PM, or saddle up to the bar anytime during business hours. Popular flavors include strawberry, apple, and vanilla. On

weekend nights, belly dancers liven the already
lively scene by winding their ways (sometimes
gracefully, sometimes not) between and around
the tables, shimmying and shaking next to your
kebabs and kibbi. Tips gladly accepted (…make
that "expected").

—*Sarah Roberts*

Magnolia Pub & Brewery

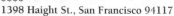

*Tasty food with hippy morals
and urban prices.*
$$$$
1398 Haight St., San Francisco 94117
(at Masonic Ave.)
Phone (415) 864-PINT
www.magnoliapub.com

CATEGORY	Eco-conscious pub
HOURS	Mon-Thurs: Noon-Midnight
	Fri: Noon-1 AM
	Sat: 10 AM-1 AM (brunch 10 AM-2:30 PM)
	Sun: 10 AM-11 PM (brunch 10 AM-2:30 PM)
GETTING THERE	Street parking is available, but by no means guaranteed. Public transportation is the key here; the 6, 7, 37, 43, 66, and 71 buses run right past the eatery, along with the 21, 24, and 33 nearby.
PAYMENT	VISA ●● ▬ Cards ▬
POPULAR DISH	Niman ranch beef burgers top the list, accompanied with their house-cut French fries. Make sure to save some room for dessert if you are a chocolate fan: the Warm Scharffen-Berger Chocolate Cake is baked right when you order it and more than worth the 12-minute wait.
UNIQUE DISH	Daily specials are available Sun-Thurs after 5 PM. Hungry but looking to save a little money? Have a "plate to share" with your friends.
DRINKS	The choice is yours! Wine, beer, coffee, soda, tea…they've got it all. While you can go with your old stand-by, trying one of their home brewed beers or sodas will enhance your experience.
SEATING	Though the bar and restaurant share the same space, and intimate feel is still the norm. This is not a place for large groups, but smaller ones (4-8 people) can be accommodated. If you visit in the afternoon or later and the door is open, be careful where you sit – the front corner gets a chilly breeze.
AMBIENCE/CLIENTELE	Youngins and old farts, tourists and die-hard locals – they all eat here. Huge windows lining two walls provide nearly all the lighting. When you first walk in, look slightly upward and check out the huge mural by Jon Weiss the covers the other half of the place; that in and of itself is worth a visit. No need to worry about a particular wardrobe.
EXTRAS/NOTES	Daily happy hour from 4 PM-7 PM with all pints

(20 oz.) for $3.50. On Tuesdays, pints are $3.50 all day long! T-shirts, pint glasses and art posters also available.

—Victoria Everman

Crab Louis
A San Francisco Specialty

There is some debate as to the original inventor of Crab Louis but those people who worked at Solari's Restaurant in San Francisco at the turn of the twentieth century say that there is no doubt in their minds that the popular San Francisco seafood salad was first created there. It is known for sure that it was being served in that restaurant by 1914, as evidenced by historical epicurean reports from the time.

The debate may be due to the fact that Crab Louis is a salad which uses a number of different ingredients, so different versions of the salad may have been invented around the same time. What they all share in common is the Louis dressing (which is strikingly similar to Thousand Island but has a bit of a different spice to it) and the use of Dungeness Crab, a popular item in San Francisco at the turn of the century.

Solari's may have been the place to get Crab Louis back when it was first invented, but this San Francisco treat quickly spread all over the city and can now be found on the menus of nearly every seafood-serving restaurant there is. From the street vendors of Fisherman's Wharf to the tourist restaurants at Pier 39, all of the bay view restaurants feature this dish. For a special experience of the Crab Louis salad, head out to the Cliff House, located at 1090 Point Lobos on the Pacific Ocean. Not only will you get an excellent dish (which has a shrimp variation for those who don't want traditional crab), but you will get a view of the sea lions playing in the ocean, a historic understanding of the Sutro Baths and Cliff House restaurants and a find dining experience.

—Kathryn Vercillo

Reverie Café

Delicious coffee and food!
Get comfortable!
(But not too comfortable.)
$$
848 Cole St., San Francisco 94117
(between Carl and Frederick)
Phone (415) 242-0200

CATEGORY	American bistro and café
HOURS	Mon: 6:30 AM-7 PM
	Tues-Thurs: 6:30 AM-8:30 PM
	Fri-Sun: 7:30 AM-8:30 PM
GETTING THERE	N-Judah Muni line and 43 bus both stop at this block (Cole & Carl). Metered parking can be hectic. Muni or bus is best bet.
PAYMENT	Cash only

POPULAR DISH The most popular items here are of course the caffeinated drinks, breakfast foods, great pastries, bagels, egg scrambles, omelets and eggs benedict concoctions. The curried chicken salad is my personal favorite. They give you a heaping portion over a mixed green salad with avocados. It is seasoned perfectly; not too creamy and not too much curry. The food is always very fresh, and don't be afraid to try the specials. There is a great mix of Mexican, Mediterranean and French flavors!

UNIQUE DISH The cafe has excellent breakfast burritos, and other interesting specials like crab, tomato & avocado salad, and a corned beef reuben with salad. The pastries and bagels are always fresh and delicious, and the coffee is always hot and *strong*.

DRINKS All kinds of coffee drinks and lattes (including Thai Iced Tea and excellent hot chocolate). Also serves beer and wine.

SEATING There are plenty of small tables inside the restaurant if you want to enjoy the cozy, bustling atmosphere with a friend (and hide from the sometimes-chilly San Francisco climate). But there is also a lovely back patio with ample seating. Many students and professionals come here to study and relax with newspapers. BEWARE: there is no WiFi available, and there are a couple of mangy-looking cats roaming around. Don't be scared, they're friendly. But if you want to check your MySpace page you better head to Starbucks, or Tully's around the corner.

AMBIENCE/CLIENTELE This place is a gem! The atmosphere is very relaxed and low-key. The staff is very professional, fast and competent. Reverie is always busy, especially for the morning caffeine rush, but you never have to wait in line for more than a few minutes. Many people take their coffee and food out to the back patio to relax, and many professionals and students can be found reading and working at any given time.

EXTRAS/NOTES Celebrity sightings: Craig Newmark, founder of craigslist.org and Benjamin Bratt have been spotted dining in Reverie Cafe! The absence of WiFi is deliberate. The owner did not want to attract customers that only buy a cup of coffee, and then "squat" in the cafe all day. Also, it is cash only, but there is an ATM machine inside Doug's Suds Laundromat, just a few doors down toward Carl Street.

—*Pamela Ames*

Rosamunde Sausage Grill

*Sausage that would make my
Polish ancestors proud.*

$

545 Haight St., San Francisco 94117
(at Fillmore St.)
Phone (415) 437-6851

CATEGORY	Takeout sausage counter with uncooked sausages to take home
HOURS	Daily: 11:30 AM-10 PM
GETTING THERE	Difficult street parking
PAYMENT	Cash Only
POPULAR DISH	Um…Sausage?
UNIQUE DISH	Wild boar sausage!
DRINKS	Canned sodas, sparkling water, no alcohol.
SEATING	Not really meant for dining in, but there are four seats at the slender bar in the front window.
AMBIENCE/CLIENTELE	Rosamunde Sausage Grill, as the name would suggest, does one thing and does it extremely well. The links are plucked raw from the fridge as you order and grilled over an open flame while you wait. They are served up on a crusty bun with your choice of condiments – sweet and hot grilled peppers, grilled onions, or sauerkraut. You top it off with one of the several mustard offerings. The menu consists of ten or so varieties, including standards like polish, andouille, and brats, as well as more exotic options such as wild boar and roasted duck with figs. They even offer a vegan sausage, which is enjoyable as a vehicle for the condiments. Chips and German potato salad round out the menu. Rosamunde is the teeniest of storefronts, with just enough room for the grill, two employees, the counter and about six starving customers. It's a brightly lit, welcoming space that offers a short respite from what can be an abrasive block of Haight St. Most of the patrons are either on their way to, in the middle of, or on their way home from a night of drinking at one of the neighboring bars. Personally, my favorite way to enjoy a Rosamunde sausage is with a few friends next door at the Toronado.
EXTRAS/NOTES	The young German woman who works most nights is sort of an anonymous local celebrity. There used to be graffiti dedicated to the "sausage girl" on the bathroom wall of the bar next door.

—*Cate Czerwinski*

Zazie
A French bistro in the heart of Cole Valley.
$$$$
941 Cole St., San Francisco 94117
(between Parnassus Ave. and Carl St.)
Phone (415) 564-5332
www.zaziesf.com

CATEGORY	Neighborhood French bistro.
HOURS	Mon-Thurs: 8 AM– 9:30 PM
	Fri: 8 AM-10 PM
	Sat: 9 AM–10 PM
	Sun: 9 AM–9:30 PM
GETTING THERE	Zazie doesn't have a parking lot and street parking is both difficult and metered. Public transportation is convenient to the restaurant,

though; the N-Judah Muni Metro line stop a half block away, as do the 43 and 37 bus lines.

PAYMENT VISA ⬤

POPULAR DISH The prix fixe menu is available for dinner every night and is an incredible value, provided there are available menu items that suit your tastes. Many entrées alone cost about as much as the entire prix fixe meal, which includes an appetizer, entrée, and dessert for $19.50, although there aren't many items on the menu that are eligible for prix fixe pricing.

UNIQUE DISH Brunch at Zazie is a unique experience if you have the time to wait for a table. With such offerings as gingerbread pancakes and a very authentic croque monsieur, the depth of the menu and the consistency and quality of the flavors keep the locals coming back weekend after weekend, and, often, waiting 45 minutes or more for a table.

DRINKS The wine list at Zazie is well selected and presents a range of prices so that a diner on any budget can enjoy a nice glass of wine with their meal. For breakfast, a soju Bloody Mary is available, in addition to Mimosas and two variations on the Mimosa, the Sunshine and the Poinsetta. Coffee and cappuccino drinks are also a specialty at Zazie.

SEATING Zazie is small and cozy, perfect for couples seeking a romantic dinner together or for small groups looking for an intimate setting. The outdoor patio is better for larger groups and is wonderful for brunch on a nice weekend morning.

AMBIENCE/CLIENTELE There is an air of sophistication at Zazie; the food is prepared elegantly and the menu offerings are thoughtful and balanced. That being said the brunch crowd is much more casual than the dinner crowd, and the brunch menu is much more laid-back and traditional than the dinner menu. Happily, the staff is very friendly and unpretentious, so no matter what crowd you find yourself amidst, you're made to feel right at home.

EXTRAS/NOTES They recently installed outdoor heaters on the patio, so it's now possible to have dinner outside, as long as it's not raining. Since the heater installation, Monday nights have become "Bring Your Doggie to Dinner" nights. Patrons can bring their canine friends with them to dine on the outdoor patio, and Greyser Vineyards "Ruff Red" Zinfandel is $10 off. Additionally, Tuesday nights at Zazie are "No Corkage" nights, during which patrons can bring bottles of wine with them and no fee is charged.

—*Katie A. Klochan*

Bacco

A taste of North Beach in Noe Valley.
$$$$
737 Diamond St., San Francisco 94114
(at 24th St.)
Phone (415) 282-4969 • Fax (415) 282-1315
www.baccosf.com

CATEGORY	Neighborhood Italian restaurant
HOURS	Mon–Sat: 5:30 PM-10 PM Sun: 5 PM-9:30 PM
GETTING THERE	Parking can be difficult here, but tends to be a little easier than much of San Francisco.
PAYMENT	VISA Cards
POPULAR DISH	Both the gnocchi and risotto come highly recommended and are popular among Bacco's diners. The risotto changes daily so make sure to check the specials menu for that. On a recent visit, the Quattro Formaggio risotto was both rich and excellent. Among meat eaters, the fish of the day and flat iron steak get high marks.
UNIQUE DISH	This is another one of those places were there isn't much out of the ordinary, but everything is well prepared and presented. The emphasis here is on Northern Italian cooking. You will find delicious pastas, meat dishes as well as sides and salads. The menu also has some seasonal changes. They are a little light on the meatless dishes, but if requested, they will take the meat out of the pasta dishes.
DRINKS	Beer and wine are the main drinks here. A few bottled microbrews and imported beers are available while the wine list has some nice Northern California and Italian selections, a few available by the glass.
SEATING	There are around a dozen tables for four, several others for two, and a couple areas where these can be arranged for groups up to ten or twelve. It is usually not overly crowded, but reservations are recommended for larger groups.
AMBIENCE/CLIENTELE	Tucked around the corner and just off of Noe Valley's main drag, Bacco is a quintessential neighborhood restaurant. It is a little upscale, but remains casual, comfortable and satisfying. The Italian waiters are real pros and the interior lends a nice Tuscan feel and look to the place. The clientele still seem to be largely Noe Valley denizens and this place remains relatively undiscovered, keeping Bacco a nice alternative, if a bit of a pricey one, to some of the more touristy North Beach choices.

—*Bill Richter*

AT&T PARK
A Giant Food Affair

If you live in the Bay Area, chances are you're a Giants fan. And if you're visiting the Bay Area, a Giants game at AT&T Park can be a great way to experience the spirit of San Francisco. Built in 2000, AT&T Park features breathtaking views of the Bay, an 80-foot Coca Cola bottle, and mass public transit that rivals any other baseball stadium's in this country. But my favorite part? The food.

Bay Area residents love food, and AT&T Park is no exception. The home of the Giants features delectable choices that you just won't find in any other ballpark. The fan favorite? Gilroy Garlic Fries, big enough to share with a friend and packed with so much garlic, you'll need to roll the windows down on your drive home. If hot dogs are your thing, skip the Giant's dog and spring for a Superdog—a full quarter-pound of god-knows-what, and worth every penny.

AT&T Park features loads of choices beyond your usual stadium fare. My personal favorite is the Cha-Cha Bowl: a hearty helping of chicken, black beans, rice, shredded vegetables, and pineapple salsa. In the mood for seafood? Head over to the Centerfield area, where you'll find the Fresh Catch stand. Here you can supplement your San Francisco experience with a Fisherman's Wharf-style crab sandwich.

Baseball stadiums aren't known for cheap beer, but at AT&T you can at least get what you pay for: Microbrews like Anchor Steam are available in abundance throughout the park, which makes the $7 tab seem a bit more worthwhile. And of course, with the Napa Valley just an hour's drive north, decent wine is available as well. Try pairing a Cha-Cha bowl with a California Sauvignon Blanc, or wash down your meatball sandwich with a lovely Shiraz.

And of course, it wouldn't be San Francisco without the signature Boudin bread bowl—clam chowder served in a crusty bowl of sourdough bread. This tasty tourist delight is also served within the stadium's walls. And for dessert? Nothing beats a sundae topped with Ghirardelli chocolate—truly a San Francisco classic.

—*Emily Coppel*

Barney's Gourmet Hamburger
(see p. 160)
Hamburger joint
4138 24th St., 94114
Phone (415) 282-7770

Barracuda Japanese Restaurant

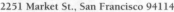

Peruvian Japanese fusion…who knew?

$$$$

2251 Market St., San Francisco 94114
(at Sanchez St.)
Phone (415) 558-8567
www.barracudasushi.com

CATEGORY	Upscale Peruvian Japanese sushi fusion
HOURS	Sun-Thurs: 11:30 AM-3:30 PM; 5 PM-11 PM Fri/Sat: 11:30 AM-3:30 PM; 5 PM-Midnight
GETTING THERE	The Muni F-Line or Church St.l Station (any train) will get you there. Parking is on the street and will tax your driving creativity. If you're driving, allow plenty of time and be prepared for a walk.
PAYMENT	
POPULAR DISH	I can definitely say that the Miso Marinated Black Cod was the best fish dish I have ever tasted. Tasty, sweet, tender and above all fresh. It was so orgasmic to the taste buds that I felt like I needed a cigarette when I finished my meal (and I don't even smoke).
UNIQUE DISH	Owner Nam Kim has perfected Japanese and Peruvian fusion to a point where every bite is an explosion of flavor. Imagine a lovely ceviche with sushi overtones. I tried the Hamachi Ceviche with Ponzu Ginger Sauce and it was brilliant. Even the traditional sushi rolls are infused with unique blends of cabbage, mango, fish and mint sauces. The variety is incredible and everything fresh. If you're bringing someone special, don't skip the dessert menu. I almost guaranteed the romance will continue long after the last bite of Sake Chocolate Truffle.
DRINKS	There is a full bar but I wouldn't count on getting plastered unless you take out a second mortgage on your home. My recommendation is if you insist on having a buzz, enjoy a cocktail elsewhere and save your cash to enjoy a glass of wine from the very nice selection.
SEATING	Seats about 75, including several stools at the sushi bar. The host wisely distributed patrons to allow for the greatest amount of separation of church and state.
AMBIENCE/CLIENTELE	If I didn't know better, I would swear I was enjoying an evening in an upscale spa. The soft and gentle color scheme blended perfectly with the low-key jazz-esque music. It was easy to forget I was surrounded by strangers eating raw fish. With the pricing and the ambience, this place could escalate into full scale uppityness but the good new is that it most certainly doesn't. My server was very helpful and answered all my questions about the menu with enthusiasm, like she couldn't wait for me to try the things I was about to order. Then there is the food. Like the ambience of the place, the flavors all seemed to blend perfectly with the texture of

the food. Everything I tried, such as the Lollipop Scallops Tempura, was a pleasant and delicious adventure.

EXTRAS/NOTES Barracuda's owner left a dot-com to open a restaurant ... this guy is definitely not risk averse. This location has seen a few restaurants come and go since the demise of Tin Pan in 2003, however, with a winning combination of great food and great atmosphere I get the feeling that Barracuda is here to stay. The owner is considering adding such things as a brunch menu and a happy hour so check the Website for updates.

OTHER ONES • Burlingame: 347 Primrose Rd., 94010, (650) 548-0300
• Daly City: 127 H Serramonte Blvd., 94015, (650) 558-8567

—*James T. Wigdel*

"I'm proud to have been a Yankee. But I have found more happiness and contentment since I came back home to San Francisco than any man has a right to deserve. This is the friendliest city in the world."

—*Joe DiMaggio*

Eric's Restaurant

SF's best Chinese – and it's not even in China Town!
$$$
1500 Church St., San Francisco 94131
(at 27th St.)
Phone (415) 282-0919 • Fax (415) 282-9989
www.erics.citysearch.com

CATEGORY Upscale Chinese (Hunan and Mandarin)

HOURS Mon-Thurs: 11 AM-9:15 PM
Fri/Sat: 11 AM-10 PM
Sun: 12:30 PM-9:15 PM

GETTING THERE Depending on the time of day, free street parking can usually be found within fifteen minutes and a within a few blocks of the restaurant. An alternative is to take the J Church MUNI, which stops right in front of the restaurant.

PAYMENT VISA ●

POPULAR DISH Take it from a true hot and sour soup connoisseur: this hot and sour soup is without a doubt the best you'll find in San Francisco. Not too vinegary and not too watery, the soup is chock full of fresh ingredients and flavors. The potstickers are also a must-order; generously filled with pork, ginger, and spices and pan-fried perfectly so the dough is not too tough. The sautéed string beans, served with pork, are also addictive, if a bit on the salty side.

DRINKS As you take your seat, the servers promptly serve ice water with lemon and hot jasmine tea for

you to sip while you peruse the menu. A wide array of domestic and imported beers and wines that specially complement spicy Asian meals are offered from the bar.

SEATING The quarters are charming, but fairly tight, making Eric's a good place for small groups and couples. The owners have found innovative ways to jam a few extra tables in what seem like impossibly tight spaces. Take out is a great option to avoid the wait.

AMBIENCE/CLIENTELE The décor has a pleasant, airy Indochinese colonial flair that is surprisingly rare for Chinese restaurants in San Francisco. People either love or hate the service; the wait staff brings your dishes to the table in a steady stream. Those diners looking for a relaxed, drawn-out dining experience, where the server becomes your friend for the evening, hate Eric's. But those diners looking for a fast, business-only attitude, with or without a smile, have no complaints.

EXTRAS/NOTES This small, storefront dining room is one of the busiest in San Francisco. If you decide to eat in, don't even bother to try to flag down a busy server in some vain attempt to get a table. Just go directly to the small armoire in the middle of the restaurant, near the ornate wooden screens. You'll find a waiting list on a clipboard with yellow notepaper. Just add your name to the list and a server will call you as soon as a table is ready. And you'll automatically jump ahead in line of those other uninformed customers who are still trying to catch the eye of one of the servers.

—Go Reyes

Fattoush

You won't propose here but
you might settle into life together here.
$$$$
1361 Church St., San Francisco 94114
(at Clipper St.)
Phone (415) 41-0678 • Fax (415) 641-0557
www.fattoush.com

CATEGORY Middle Eastern with weekend brunch
HOURS Mon: 9:30 AM–2:30 PM; 5 PM-10 PM
Weds-Fri: 9:30 AM–2:30 PM; 5 PM-10 PM
Sun: 9:30 AM–3 PM; 5 PM-9 PM
GETTING THERE Metered street parking and neighborhood parking.
PAYMENT VISA
POPULAR DISH The hummus plate and lentil soup are really good.
UNIQUE DISH A lot of what you might expect on a Middle Eastern menu (shish kebab and shawarma) and some surprises (*sambusask dajaj*—filo dough stuffed with diced chicken, mushrooms and almonds, served with a spinach sauce; and m'shakaleh—layers of mushroom, eggplant, cauliflower, tomato and rice served with a yogurt tomato sauce.)

DRINKS There's a so-so wine list, including half-bottles. Beer, some fresh juices and coffee and mint tea are available. Plus, all the regular soda options.

SEATING Fattoush is on the small side but accommodates families and small groups well.

AMBIENCE/CLIENTELE Fattoush is an old-fashioned style neighborhood hang out. The owner greets most patrons by name as they arrive but is quick to greet those he doesn't know as well. He also thanks people for coming as soon as they walk in.

—*Robyn White*

Fuzio Universal Pasta

Carbs and cute guys galore.
$$$$
469 Castro St., San Francisco 94114
(at 18th St.)
Phone (415) 863-1400
www.fuzio.com

CATEGORY Hip little spot with delicious pasta and delicious men

HOURS Sun-Thurs: 11 AM-10 PM
Fri/Sat: 11:30 AM- 11 PM

GETTING THERE If driving, street parking is all you will find. Your best bet is public transportation; the Castro BART station is less than a block away, as well as stops for the F, 33, 24, and 35.

PAYMENT

POPULAR DISH Despite the name, you can also find grilled sandwiches and salads here (for those that aren't having a carb-tastic day). The Asian appetizers and dinners are served with chopsticks, though you don't *have* to use them. The Fuzio Firecracker Pork Fusilli and classic Angel Hair & Fresh Tomatoes are recommended by many.

UNIQUE DISH Though there are some great taquerias in the neighborhood, the Barbwire Chicken is a damn good mix of pasta, Southern and Mexican flavor all-in-one.

DRINKS Keeping in mind the neighborhood you are in, a varietal selection can be found here. A mix of wines, vodkas, gins, and house specialties are available. Not ready to "party"? Water, sodas, coffee, and espresso are stocked as well.

SEATING Whether having a night out with a few friends, on a date, or munching alone, this is a good place to be. Though usually too busy to accommodate a large group, they do have a party menu available that you can order from before your next event.

AMBIENCE/CLIENTELE No matter the volume of people, the atmosphere here is intimate, calm, and casual. Warm brown walls, adorned with pasta-inspired art surround you. Most of the seating is set against one wall, anchored with a long booth. Low lighting and candles galore help to round out the mood. The main action here is each table's individual conversation or the open kitchen, bustling with fresh fun.

EXTRAS/NOTES Be sure to check out Happy Hour Mon-Fri 3-6 PM for $2 off appetizers and $1 off Fuziotinis.

OTHER ONES • Marina: 2175 Chestnut St., San Francisco 94123, (415) 673-8804

• Financial Center: 1 Embarcadero Center, San Francisco 94111, (415) 392-7995

• Dublin: 4930 Dublin Blvd., 94568, (925) 833-7124

—*Victoria Everman*

Gelateria Naia

I scream. You scream.
We all scream for gelato!
$$
451 Castro St., San Francisco 94114
(at 18th St.)
Phone (415) 864-6670
www.gelaterianaia.com

CATEGORY Artisanal Italian ice cream, offering fun, classic, and innovative flavors

HOURS Sun-Thurs: Noon-11 PM
Fri/Sat: Noon-1 AM

GETTING THERE Metered street parking can be difficult.

PAYMENT

POPULAR DISH You just cannot go wrong with whatever you choose, but if you want to play it safe the classic flavors, such as chocolate, vanilla, hazelnut, and pistachio are always good.

UNIQUE DISH Vegans and non-dairy eaters rejoice! They also offer fruit sorbets and soy-based gelato!

DRINKS Coffee and Italian soda

SEATING The gelato is so good here it may make you weak in the knees, but you better be strong since there are only two small standing tables. Be prepared to stand or take a walk with your gelato.

AMBIENCE/CLIENTELE Gelateria Naia is hip and stylish with bright florescent walls and modern ice cream cases. The atmosphere is casual, but don't be surprised if you see someone all dolled up for the night, remember, you *are* in the Castro!

EXTRAS/NOTES The servers are always incredibly nice and they allow you to taste as many flavors as you want before you order. They also have kiddie-sized portions for wee ones.

OTHER ONES • North Beach: 520 Columbus Ave., San Francisco 94113, (415) 677-9280

• Berkley: 2106 Shattuck Ave., 94704, (510) 883-1568

• Berkley: 2475 Bancroft Way, 94720, (510) 642-3825

• Walnut Creek: 1245 N. Broadway, 94596, (925) 943-1905

—*Thy Pham*

No Name Sushi a.k.a. Yokosa Nippon

A sushi place so good it doesn't even need a sign.
$$

314 Church St., San Francisco 94114
(at 15th St.)

CATEGORY	Low-key Japanese Sushi
HOURS	Mon-Sat: Noon-10 PM
PARKING	Street parking only, and can be difficult evenings, but the MUNI J tram stops right outside.
PAYMENT	Cash only
POPULAR DISH	Vegetable-stuffed *miso* soup and huge portions of sushi
UNIQUE DISH	Crazy rolls, for those who aren't sane enough to hold traditional sushi
DRINKS	Free green tea and BYOB from the liquor store next door.
SEATING	Seats about 24 people
AMBIENCE/CLIENTELE	Cramped and simple, this place is where the cash-strapped gourmands bring their friends. Locals want to keep the place their secret, but can't help but tell everyone they know.
EXTRAS/NOTES	After 30 years "No-Name" sushi has finally acquired a name (officially), but still has no sign, no phone, no reservations, and no alcohol license. The prices are ridiculously low and the sushi so fresh that it doesn't need those extra frills. Pick up a pint from the liquor store next door, line up on the sidewalk, and come hungry.

—*Benny Zadik*

Savor

Great for brunch, even on a Wednesday afternoon.
$$$

3913 24th St., San Francisco 94114
(at Sanchez St.)
Phone (415) 282-0344

CATEGORY	Popular neighborhood brunch spot
HOURS	Sun-Thurs: 8 AM-10 PM
	Fri/Sat: 8 AM-11 PM
GETTING THERE	Street parking available, both at meters on 24th St. and in the surrounding neighborhood. Just down 24th St. from the J-Church Muni line. The closest BART station is about a 10-minute walk away (24th St. at Mission).
PAYMENT	
POPULAR DISH	Savor is popular for its sweet and savory crepes and omelets, but everything on the menu is good. Lots of vegetarian options.
UNIQUE DISH	Spicy Cornbread with Jalapeno Jelly is a great way to get started.
DRINKS	Beer and wine are offered, as well as the usual sodas, juices, coffees and iced tea.
SEATING	Lots of tables inside and out. Larger groups may fit outside more comfortably but there is some room in the back too. The space works well for just about everyone—couples, families, groups of friends.

AMBIENCE/CLIENTELE	Savor is a very comfortable, wear-what-you-like kinda place. The space has hints of Spanish Colonial style but not really caught up in any style. Large outdoor patio in back that is heated during the winter. The wait staff is very friendly. Gets crowded and loud on weekends. The food tastes like the cook cares about what his customers are eating.
EXTRAS/NOTES	Lots of neighborhood regulars and young families here, so don't worry about bringing the kids.

—Robyn White

Sparky's 24 Hour Diner

Real San Francisco neighborhood diner food at any hour.
$$$
242 Church St., San Francisco 94114
(at Market St.)
Phone (415) 626-8666

CATEGORY	24/7 Diner
HOURS	24/7
GETTING THERE	Half a block from the Church St. Muni or Number 22 Bus. Parking ain't easy unless the gods are with you.
PAYMENT	VISA MasterCard
POPULAR DISH	It's a diner … everything is popular but for a special treat, try the Meatloaf Sandwich with jack and chipotle mayo.
UNIQUE DISH	Sparky's boasts an everyday brunch with killer Bloodies and Mimosas. Mostly diner food otherwise with a few nightly specials served 5 PM-9:45 PM. One of the nice things about the place is while you order Sparky's famous Heart Stopper hamburger (two patties, bacon, cheese and onions) your date can order the more healthy Yolk-o-No-No, which is an egg white, tofu and spinach omelet. They have a good balance of low-carb and artery-choking fare.
DRINKS	Beer, wine, espresso or hip-development shakes, you can find it at Sparky's.
SEATING	Comfortably seats about 90 or so, with stools available at the counter for Dagwood fans.
AMBIENCE/CLIENTELE	Two words: anything goes! This diner is so totally unpretentious I'm surprised I haven't seen the waitstaff show up in curlers and pajamas (or have I?). The pierced and tattooed crowd is equally welcomed with all two members of the San Francisco Conservative Club and it's nice to see them sharing a meal together now and again.
EXTRAS/NOTES	Everyone should go home with a Sparky's T-shirt. It demonstrates you're not afraid to venture into the hood and break bread with the locals. This is not your father's Bob's Big Boy, instead you get good food, good service and a reliable cup of coffee at any hour.

—James T. Wigdel

Taqueria Zapata
Burritos as big as your head.
$$$
4150 18th St., San Francisco 94114
(at Collingwood)
Phone (415) 861-4470 • (415) 701-8965

CATEGORY	Mexican Taqueria
HOURS	Daily: 10 AM–Midnight
GETTING THERE	A metered parking lot is nearby, but is often full. Street parking is your only other option if you bring a vehicle. Public transportation is favored, with the 24, 33, 35, and 37 buses run close by, and the Castro underground station in two blocks away.
PAYMENT	VISA
POPULAR DISH	Though their variety is huge, burritos are their feature. Meaty, vegetarian, tofu, breakfast…the options are abound, as are the fixings you can add on.
UNIQUE DISH	I've never seen so many seafood options at a taqueria before.
DRINKS	Their drink list is just as plethoric as their food menu: sodas, bottled water, Orangina, SOBE, Odwalla juice, Vitamin Water, Snapple, apple juice, Mexican sodas, their own fresh fruit drinks, and beer (imported and domestic).
SEATING	Not the best for large groups, but four to six folks can gather around one table. Five small tables are lined up along the Collingwood side of the restaurant, with seating for one to three people. Four larger tables sit in a row near the counter, able to fit up to six people, albeit tightly.
AMBIENCE/CLIENTELE	The first thing that will hit you when you walk in is the smell – so fresh you can almost taste it. All of the food preparation areas, as well as the tables and bathroom, as clean and well kept. The background Mexican music only serves to put you more in the mood for their tasty vittles. The walls are painted in shades of yellow and red, with a number of painted portraits and photographers of Zapata hanging on the back wall. A great place to people watch, folks of all kinds pass by and come to eat here.

—*Victoria Everman*

MISSION

Arinell Pizza

Floppy, foldable slices at a nice price.
$
509 Valencia St., San Francisco 94110
(at 16th St.)
Phone (415) 255-1303

CATEGORY	Italian and pizzeria
HOURS	Mon-Weds: 11:30 AM-10 PM Thurs-Sat: 11:30 AM-Midnight Sun: Noon-10 PM

GETTING THERE Metered street parking can be difficult, but it's a mere one block from 16th Mission BART.

PAYMENT Cash Only

POPULAR DISH Skip the puffy Sicilian deep-dish and order a huge slice of classic thin crust New York-style Neopolitan. Standard toppings are available to customize the plain cheese pie that sits on display behind the counter. Slices are cut, heated in a deck oven, and served on parchment squares, which makes transportation difficult as the crisp, papery crust barely supports a drenching of oregano tomato sauce and a blanket of mozzarella. Pull up a stool at the grease-stained counter, but don't dig in too quickly--the slices are usually molten hot.

UNIQUE DISH The menu offerings are few and familiar, but it's the simplicity of the concept that makes it remarkable. Delicious no-frills pizza joints are a rarity in this gourmet pizza saturated city. Come here for your East Coast pizza fix or for a quick, cheap meal while cruising the neighborhood. Whole pies are also available, though it is best to call ahead.

DRINKS Sodas and two recycling fountains of lemonade and a fruity concoction called Tango Punch comprise the beverage selections.

SEATING This tiny storefront affords little seating: six barstools line the mirrored walls. Convert the window ledges into perches or fold your slice for a walk down Valencia. The occasional noontime line out the door marks peak service hours.

AMBIENCE/CLIENTELE Metal blares from a boombox behind the counter where skinny boys in sleeveless t-shirts bake and serve pies. From the walk-up counter, customers can watch pizzas being prepared during their brief wait. If a counter seat is available, the mirrored walls provide a disorienting people-watching distraction. Arinell attracts locals on their lunch breaks, punks from the 16th St. scene, and shoppers talking a break from the boutiques on Valencia. The occasional vagrant wanders in, as a cartoon sign reading "No Ice for Crack Headz!" attests. Service is always friendly and speedy but with a decidedly apathetic air.

OTHER ONES • Berkeley: 2119 Shattuck Ave., 94704

—Majkin A. Klare

Atlas Café

Neighborhood café and gourmet sandwich shop in one.
$$
3049 20th St., San Francisco, 94110
(at Alabama St.)
Phone (415) 648 - 1047
www.atlascafe.net

CATEGORY Very casual neighborhood café

HOURS Mon-Fri: 6:30 AM-10 PM
Sat/Sun: 8 AM-8 PM

GETTING THERE	Parking is easy.
PAYMENT	Cash only, but there's an ATM inside
POPULAR DISH	Portobello Mushroom: toasted whole grain with roasted sage-tomato pesto, roasted scallions, goat cheese and baby greens
UNIQUE DISH	Baked Tofu on toasted whole grain with nori, tomato, red onion and tamarind vinaigrette. Vegan and wonderful.
DRINKS	Full service coffee house with sodas and a yummy ginger infused lemonade.
SEATING	Full patio and plenty spacey inside.
AMBIENCE/CLIENTELE	The clientele here is friendly and respectful. Atlas has the full feel of a neighborhood café, so feel free to bring your books and board games. A lot of the regulars know each other and dogs are welcome company on the patio.
EXTRAS/NOTES	The food is served fast and the quality is much more than you pay for. Customers bus their own tables.

—Tara Little

Boogaloos

Say yes to breakfast at noon.
$$
3296 22nd St., San Francisco 94110
(at Valencia)
Phone (415) 824-4088
www.boogaloossf.com

CATEGORY	Brightly colored hipster diner with a lot of heart.
HOURS	Daily: 8 AM–3 PM
GETTING THERE	Street parking is easy enough.
PAYMENT:	VISA ⬤ Cards
POPULAR DISH	You must try the temple o' spuds. It's just what the doctor ordered.
UNIQUE DISH	Well this is a Cuban-styled breakfast/ lunch place, so there are plenty of unusual dishes. Like the Desayuno Tipico: eggs, grilled plantain cake topped with tamarind sour cream, black beans and corn tortillas.
DRINKS	The good folks at Boogaloos call their beers and champagne cocktails Mood Elevators. Yes sir.
SEATING	Spacious enough for a large group, but expect a wait for a large group.
AMBIENCE/CLIENTELE	An affair for the young and stylishly dressed. Not the time to leave out that creative twist on your outfit.
EXTRAS/NOTES	Boogaloos displays artwork by developmentally disadvantaged artists. The bright surreal paintings give the room a kind of bright and innocent playfulness. This is also a great place for people-watching. Boogaloos attracts a very interesting clientele.

—Tara Little

Café Chez Maman

Stuffy French restaurant? Au contraire!

$$$$

803 Cortland Ave., San Francisco 94110
(at Ellsworth St.)
Phone (415) 824-2674

CATEGORY	Low-key French neighborhood joint
HOURS	Sun-Thurs: 10 AM-10:30 PM
	Fri/ Sat: 10:30 AM-11 PM
GETTING THERE	Parking is okay, with street parking, metered and non-metered
PAYMENT	VISA ⬤ Cards
POPULAR DISH	Steamed mussels
UNIQUE DISH	Quesadillas made with French cheeses
DRINKS	In addition to sodas and iced tea the café has basic coffee and tea and a substantial wine list, including champagnes.
SEATING	The dining space is on the smaller side. Most of the tables are sized for two, but can be pushed together to accommodate larger parties.
AMBIENCE/CLIENTELE	Café Chez Maman challenges the old stereotype of the fussy French restaurant while indulging its clients with traditional French flavors and courtesy. European techno beats make it casual enough for jeans and tee-shirts, while candle light after dark and elegant presentation of all dishes set the stage for a classy, romantic evening. The owners have wisely kept the cafe's décor simple and understated, with retro prints of old ads for French wines and champagnes lining the walls. Copper table tops and polished wooden benches that run the length of the seating area create sleek, clean lines that keep this small, busy space from feeling cramped. The waitstaff are friendly and attentive. Many of the dishes are rich, especially the hamburger and the mushroom soup; all of them are delicious. The menu features some traditional fare such as the croque monsieur and the steamed mussels, as well as more unexpected items like gruyere quesadillas. Crepes, both for dinner and dessert, are also a specialty. In fact, the Nutella and banana crepe is the perfect combination of warmth, sweetness, and light, fluffy goodness.
EXTRAS/NOTES	The proprietor, a native of France, is charming and friendly. He offers customers a warm welcome; he has even been known to offer his coat to diners seated near the door.
OTHER ONES	• Potrero Hill: 1453 18th St., San Francisco 94107, (415) 824-7166

—Kathrine LaFleur

Café Ethiopian

Eat with your hands, without the guilt, at Café Ethiopian.

$$

878 Valencia St., San Francisco 94110
(between 20th St. and 19th St.)

Phone (415) 285-2729
www.ethiopianrestaurant.com/california

CATEGORY	Ethiopian
HOURS	Daily: 11 AM-10 PM
GETTING THERE	Metered parking is available on Valencia and the numbered cross streets, it is usually no problem to find a spot. It is midway between the BART stops at 16th and 24th and Mission.
PAYMENT	VISA
POPULAR DISH	The vegetarian and vegetarian/ meat sampler options provide the customer with a sampling of three traditional Ethiopian dishes to try. All served with *injera*, Ethiopian pancake bread, and absolutely no silverware.
UNIQUE DISH	Again, forks and knives are nowhere to be seen at Cafe Ethiopian, the diner picks up his foods (generally chunks of meat or vegetable in sauce) with bits of injera. Cafe Ethiopian is the only Ethiopian option in the area.
DRINKS	Beer and wine are both offered. For a traditional Ethiopian beverage, *tejj*, an Ethiopian honey wine, similar to mead.
SEATING	Seating is never a problem, there is one large room with tables and chairs, and you never have to wait.
AMBIENCE/CLIENTELE	Cafe Ethiopian has a varied client base, somewhat representative of the Valencia/Mission crowd- hip twenty-somethings. The décor is sparse and pleasant with some traditional decorations on the walls.

—*Ben Feldman*

Café Gratitude

(see p. 182)
California Vegan
2400 Harrison St. San Francisco

Cha Cha Cha

(see p. 50)
Hip Caribbean
2327 Mission St., San Francisco 94110,
Phone (415) 648-0504

"I have always been rather better treated in San Francisco
than I actually deserved."

—*Mark Twain*

El Farolito

Great dive to late night munchies.

$

2779 Mission St., San Francisco 94110
(at 24th St.)
Phone (415) 824-7877
www.elfarolitoinc.com

CATEGORY	One of the best taquerias in a neighborhood full of great taquerias
HOURS	Daily: 10 AM-1 AM
GETTING THERE	Street parking is not so easy in the Mission, and those few free spaces are metered. An alternative is to take BART, which stops right at Mission and 24th Sts.
PAYMENT	Cash only
POPULAR DISH	The super veggie burritos are humungous, tasty, and cheap. Be sure to ask for the "super burrito", as opposed to just the "burrito", so you won't miss out on the cheese, sour cream, and avocado. El Farolito serves real avocado wedges with your dish, not the mashed-up guacamole with the from-the-packet spices you find at most other taquerias. Don't pass up the salsa and condiment bar near the cash register either. While the condiment bar has several great salsas, as well as pickled jalapeños and carrots, the definite culinary highlight is the green avocado-chile salsa.
UNIQUE DISH	If you're looking for traditional, down-home taqueria fare, try tacos or burritos with one of the following classic fillings: *sesos* (beef brain), *lengua* (beef tongue), and *cabeza* (beef head meat). Of course, if that kind of authenticity isn't for you, you can always choose the carne asada (grilled steak), al pastor (marinated pork), *carnitas* (deep fried pork), chorizo (Mexican sausage), *pollo* (chicken), or vegetarian (whole pinto beans). All meat fillings are grilled at the time of your order and are not pre-cooked. Weekend-only specials include *menudo* and *birria*.
DRINKS	El Farolito serves an assortment of Mexican and American beers, *aguas frescas*, and both Mexican and American sodas.
SEATING	El Farolito is a mostly a take-out place, but there are a few tables – metal-and-plastic benches and particle board booths really – if you want to eat in. The décor is not a draw; good cheap food is.
AMBIENCE/CLIENTELE	El Farolito is popular with the locals and the late-night crowd. If you are into fine dining, look elsewhere. If you just want delicious, satisfying Mexican comfort food, get in line.
EXTRAS/NOTES	El Farolito has a jukebox filled with mariachi, banda, and Latin rock. If you're in this taqueria, or any other in the city, and you don't know what music to play, choose anything by the famous mariachi singer Vicente Fernandez. Vicente is sure to earn you a few instant friends amongst the locals.
OTHER ONES	• 4817 Mission St., San Francisco 94112, (415) 337-5500 • Mission: 2950 24th St., San Francisco 94110, (415) 641-0758

• 3646 E. 14th St., Oakland 94601,
(510) 533-9194
• 394 Grand Ave., South San Francisco 94080,
(650) 737-0138
• 565 Seabastapol Rd., Santa Rosa 95407,
(707) 526-7444

—*Go Reyes*

El Farolito
(see p. 74)
Taqueria
2950 24th St., San Francisco 94110
Phone (415) 641-0758

Emmy's Spaghetti Shack
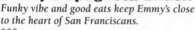
*Funky vibe and good eats keep Emmy's close
to the heart of San Franciscans.*
$$$
18 Virginia Ave., San Francisco, 94110
(at Mission St.)
Phone (415) 206-2086

CATEGORY	Hipster Italian
HOURS:	Sun-Thurs: 5:30 PM 11 PM
	Fri/Sat: 5:30 PM-Midnight
GETTING THERE	Metered street parking, but it is relatively accessible after hours. Also available by MUNI #14, 24, 26, J.
PAYMENT	Cash only, but in case you forget there is an ATM right across the street at the Safeway.
POPULAR DISH	As the name implies, this is the place to go for a spaghetti and meatball fix. The dish comes with three huge, juicy meatballs and a heaping, properly-sauced plate of spaghetti. But it is important to not get in a rut, since the other items don't disappoint. A cioppino-like fish stew with cod, fresh mussels and laced with anise is hearty and fulfilling and the orecchiette with gorgonzola, sun-dried tomatoes, pine nuts and garlic bread crumbs is a perfectly balanced and gratifying dish. Emmy's also makes a mean Caesar salad.
UNIQUE DISH	The Emmy's take on Bruschetta is assertive and bold. A Kalamata tapenade, tomato puttanesca and caper berries make a strong and flavorful topping but the melted fresh mozzarella on grilled crostini balances the dish.
DRINKS	A chalkboard displays a pretty small and basic list of wine, but surprisingly the bargain Chianti and Tempranillo are food-friendly and easy to drink. Emmy's offers a full bar, including a few house cocktails, and the official digestive of San Francisco, Fernet Branca. The beer list is adequate ranging from local microbrews like Prohibition Ale to 40 oz. of Mickey's.
SEATING	The shack is pretty small and seats about 50 at the most. There is almost always a wait, but there

is a little dive bar next door to keep you occupied while you pass the time.

AMBIENCE/CLIENTELE Emmy's is not the place for intimate conversation. The young, hipster crowd is obviously enjoying themselves and the music blasts anything from the Stones to Highway to Hell. Thursday, Friday and Saturday locals dig into their spaghetti to the groove of an in-house DJ.

EXTRAS/NOTES One of the quintessential San Francisco eateries. Really good food, eclectic group of people and reasonable prices. Kill your time when you wait at the bar next door. Chat it up with some of the friendliest waitresses on the block.

—*Andrea Wolf*

Cioppino:
A Peninsula Variation

Cioppino is a fish stew which was first developed in ancient Mediterranean times but which owes its current form to the way that it came to be made in the San Francisco Bay Area. Seafood has long been a staple of the area, and several Northern Italian restaurant owners found that they could use whatever fish and even other seafood that was available to create this ever-changing stew. They touted it as featuring the "fish of the day", but …

Cioppino may be most associated with the restaurants of North Beach (San Francisco's Little Italy) and the Fisherman's Wharf area, but the best places to get good cioppino actually exist outside of San Francisco proper. The peninsula is a good place to find cioppino; try **Sapore Italiano Restaurant** located at 1447 Burlingame Avenue in Burlingame. For a variation on the stew, try the lobstah seafood gazpacho served at the **Old Port Lobster Shack (see p. XXX)** in Redwood City (851 Veteran's Blvd.).

—*Kathryn Vercillo*

Lucca Ravioli Company
Tiny Little Italy in the Mission.
Since 1925
$$
1100 Valencia St., San Francisco 94110
(at 22nd St.)
Phone (415) 647-5581

CATEGORY Old school Italian
HOURS Mon-Sat: 9 AM-6 PM
GETTING THERE The 26 Valencia bus stops right out front.
PAYMENT VISA
POPULAR DISH Before walking into this corner storefront, stop by the window on Valencia St. to watch flour-covered workers shape and cut masses of ravioli beginning at 5 AM. Join the crowd clamoring after the meat-filled pasta pockets and take home some house-made marinara that has been simmering in the back kitchen for more than six hours.

Antipasti options abound within a pristine deli counter. Lucca also stocks pantry ingredients for traditional Italian cooking, such as pancetta, truffle oil, and squid ink.

UNIQUE DISH Sandwiches are made to order, but there's no menu. In-the-know regulars simply announce that they want a sandwich and the counter help takes care of the rest. Choose a soft or hard sour roll and any combination of meat, cheese, and marinated vegetables. For ease, request a vegetarian--fresh mozzarella, pesto, and sun-dried tomatoes—an ample sandwich on its own, but still with room for the addition of some sliced salami or prosciutto.

DRINKS Coolers on the back wall hold standard soda and bottled water offerings, as well as Italian sodas, teas and pre-chilled champagne for a special occasion. Well-stocked wine shelves fill up a large portion of the grocery section.

SEATING No seating is available on site, but grab some picnic fare and head west to Dolores Park.

AMBIENCE/CLIENTELE Take a number and join the crowd in this tiny space crammed with Italian specialty groceries and a large wine selection. The jovial counter staff in butcher's garb and old fashioned paper caps greets regulars with a smile and an inquiry about their families before taking any orders. Lucca is old-world, small-market shopping at its best. Kiddie customers receive bread sticks and tastes of salami while their parents chat about that night's dinner. When an order is complete, tabs are rung into an antique brass hand-crank cash register and parcels arrive on the counter wrapped in white paper.

EXTRAS/NOTES If the food isn't enough, Lucca also stocks t-shirts and other logo-emblazoned paraphernalia.

—*Majkin A. Klare*

Luna Park

Home-style American fare meets uptown sophistication.

$$$$

694 Valencia St., San Francisco 94110
(at 18th St.)
Phone (415) 553-8584 • Fax (415) 553-8660
www.lunaparksf.com

CATEGORY Trendy neighborhood restaurant with bookish sophistication

HOURS Mon-Thurs: 11:30 AM-2:30 PM; 5:30 PM-10:30 PM
Fri: 11:30 AM-2:30 PM; 5:30 PM-11:30 PM
Sat: 5:30 PM-11:30 PM
Sun: 11:30 AM-3 PM; 5:30 PM-10 PM

GETTING THERE: Street parking on this side of the Mission can be difficult. The closest garage (with bike parking!) is at 16th St. and Hoff. The easiest way to get to Luna Park is the BART, as it is three blocks from the16th St. Station. The 33 MUNI line also drops you off at the corner of 18th and Valencia.

PAYMENT VISA

POPULAR DISH Popular appetizers include the Hawaiian-style poke with crispy wonton chips, warm goat cheese fondue with grilled bread and granny smith apples, and mussels and fries. The dinner menu boasts hearty American fare, such as macaroni and cheese, steak and grilled chicken. Their pastas and salads are also very good. Save room for dessert, the best of which are the do-it-yourself ones such as make-your-own s'mores, and caramel apples that you can dip into miniature pots of caramel sauce and toasted almond.

UNIQUE DISH The pot of fire comes with high recommendations, a big plate of beef brisket, potatoes, carrots and leeks that come steaming to your table. The nicoise salad is a winner, a bright green salad with olives, a soft-boiled egg and a piece of seared rare tuna. The fontina stuffed ravioli is also very good, with braised spinach and truffle oil.

DRINKS The beer and wine list is extensive, with a selection of specialty cocktails. I recommend the mojitos, which are nicely tart and strong. There are also a variety of non-alcoholic drinks.

SEATING This spacious restaurant is great for big groups although be sure to make reservations ahead of time as it can get busy. Seating options include spacious booths, smaller private tables or dinner at the bar. Reserve the private booths weeks in advance for special occasions.

AMBIENCE/CLIENTELE I was originally drawn to Luna Park for the upscale American fare, such as make-your-own s'mores with homemade marshmallows, a great meatloaf and fresh salads. Two summers ago, they handed out crayons and paper to their patrons for a drawing contest, the winner receiving a free dinner. Back then, families often patronized the restaurant, but over the years Luna Park has developed a trendier edge. The bookish sophistication of the restaurant remains the same, but the clientele currently weighs more on urban working professionals. As much as patrons flock to Luna Park for the food, they also go for the ambiance. The dimly lit restaurant has the look of a handsome study, with dark walls, crimson curtains, mahogany furniture, and chandeliers. The menus come bound like old hardcover books and original artwork hangs on the wall.

EXTRAS/NOTES If you're going to bring your sweetheart, it's best to come to come on Sun-Weds, when it's a bit quieter.

—*Rui Bing Zheng*

Mariachi's

Lighter, healthier Burritos at Mariachi's.
$$
16 Valencia St., San Francisco 94103
(between 16th St. and 17th St.)
Phone (415) 621-4358

CATEGORY	Mexican, specializing in burritos
HOURS	Daily: 11 AM–11 PM
GETTING THERE	Metered street parking on Valencia, 16th, and 17th is available. The 16th and Mission BART stop is two blocks away (a two minute walk). The bus stops there as well.
PAYMENT	VISA
POPULAR DISH	The California veggie is delicious. All of the vegetarian burrito options are exceptionally fresh. Many of them have no cheese or sour cream, making them much lighter than other Mission District Burrito joints.
UNIQUE DISH	The burritos are like nothing else in the city, featuring grilled vegetables, mango salsas, and mushrooms in addition to the usual guacamole, rice, and beans. It's nice to be able to enjoy a burrito in the Mission without feeling like you need to lie down for a week afterwards.
DRINKS	Mariachi's offers a small selection of Mexican beers, as well as the usual options of soda, water and juice.
SEATING	It's always easy to find a spot to sit in Mariachi's. It is just one room, with only a few tables, but the turnover is quick enough that even on a weekend night you rarely have to wait for more than one or two minutes to sit down.
AMBIENCE/CLIENTELE	The clientele at Mariachi's is like the rest of the Mission District, a mix of hipsters and working class Latino families. At nights the bar traffic skews the clientele overwhelmingly toward the hipsters.
EXTRAS/NOTES	The perfect place to go when you want a break from the other fast Mexican options littered through the Mission District; the only one that is truly dissimilar to all of the others.

—Ben Feldman

R.I.P.
Radio Valencia

Of the many restaurant closings I've seen here, I think most of them are unfortunate, but that only a select few that I truly miss and Radio Valencia tops that list. To this day (it shut down in 2000) there are times when my wife and I will ask each other what we want to do for lunch or dinner and the answer will be "Radio Valencia", as if we still might be able to will it back into existence. It was a popular neighborhood café and art and music space on the corner of Valencia and 23rd in the Mission District. The place gained a level of notoriety in 1994 when a fire engine crashed through its front windows causing severe damage, but fortunately no injuries. After many months and benefits, and surely much luck, it re-opened. During this time, I moved nearby and after its

re-opening is when I started going pretty regularly. There wasn't anything about it I didn't like.

The décor included big Day of the Dead-style papier-mâché's, vintage album covers, and work by local artists, all cool and unique. The food was relatively basic, but very tasty. I'd recently become a vegetarian and had plenty to choose from among the salads and focaccia sandwiches as well as my favorites there, the chili and the nachos. Music was important element here. Each week featured a new play list with an eclectic mix ranging from indie rock to old blues and country to world music to anything else that seemed to fit. I would hardly know anything on the lists, but as with everything they did, it was not pretentious or snooty. A copy of the play list was at every table like a side menu. They featured live music on weekends, usually jazz or bluegrass. This was just a great place to hang out.

They also had one of the best cups of coffee around.

Sometime in 2000, I noticed the windows covered with newspaper and I feared the worst, but there were no signs and I hoped that they were merely remodeling. This happened at the peak of the dot-com boom and things were changing fast and often not for the better. Rents shot up all over town and a lot of good stuff got tossed aside. Eventually I found out that Radio Valencia would be no more, but whether it was another boom victim, I still don't know. That didn't keep me from holding that possibility against the Thai restaurant that took its place and only lasted for about a year. It is the current home of The Last Supper Club, a popular place that has been around for a few years now. I have eaten there a few times and I have mostly enjoyed it, but like many of the area's newer arrivals, it is slicker, more expensive, less vital to the neighborhood and simply not as much fun as what was there before.

—*Bill Richter*

Medjool

Hip and tasty Mediterranean restaurant,
complete with a brilliant sky terrace view.
$$$$

2522 Mission St., San Francisco 94110
(at 21st St.)
Phone (415) 550-9055 • Fax (415) 550-9005
www.medjoolsf.com

CATEGORY	Hip Mediterranean *tapas*
HOURS	Mon-Weds: 5 PM-10 PM
	Thurs-Sat: 5 PM-11 PM
	(Fri/Sat Drinks 'til 2 AM)
	Sky Terrace (October-April)
	Mon-Thurs: 5 PM-10 PM
	Fri: 5 PM-2 AM
	Sat: 2 PM-2 AM
	Sun: 2 PM-10 PM
GETTING THERE	Street parking can be tricky on Thursday, Friday, and Saturday nights. The best bet is to use the

parking garage on 21st and Bartlett. They also have valet parking.

PAYMENT VISA 💳 Cards

POPULAR DISH If you are a meat fan, the Lamb and Fig Tagine or the Harissa Crusted Hanger Steak over Sautéed Spinach. For veggie lovers, try the Artichoke a la Pancha with Romesco and Aioli Sauce, and the Grilled Vegetable B'stilla with Goat Cheese. And if seafood is a must have, the Seared Sea Scallops with Preserved Lemon Gremolata and the Sumac-Dusted Fried Calamari with Red Onions, Lemons and Aioli never fail.

UNIQUE DISH The diversity of Medjool's menu means that even astute foodies have a good chance trying a dish that hasn't passed their lips before. Try the Date Palm Sugar Crusted Quail over Pistachio Frissee Salad or the Zhoug Marinated Shrimp with Spicy Tomato Jam.

DRINKS The wine bar theme is "wines that kiss the Mediterranean"—covering eleven countries that touch the waters of the Med. The wine list for the restaurant is also comprehensive, with choices from California, Europe, Australia and New Zealand. California red are especially dominant. Bottles prices range from $22-$60+ With three bars, Medjool has no shortage of cocktails and beers to choose from.

SEATING The building itself is huge: the cavernous main dining room also houses a lounge and bar. The second level balcony has additional tables and another bar. Then there is the roof top terrace, with still more tables, yet another bar and the best view in the Mission. There are many options for laying claim to your own nook, and the diverse range of dishes can easily match your sustenance modus operandi.

AMBIENCE/CLIENTELE The scene is international hip, with a diverse, urban crowd and an upbeat atmosphere. If you are looking for a quiet corner for two, you may be able to find it in Medjool, but if you do, savor it: things will eventually get more rambunctious as the evening progresses. Patrons tend to be upscale, but artists in jeans and t-shirts mingle easily with Marc Jacobs and Diane von Furstenberg dressed professionals. You won't see families here, unless you stop by for lunch, when the odd toddler might cruise by. Because of the size, large parties frequent Medjool, so you are apt to see a group spruced up for a night out on the town.

EXTRAS/NOTES Local and guest DJs on Thursday, Friday and Saturday evenings from 10 PM–2 AM., both on the Sky Terrace and later in the evening in the main dining room. If you are sitting on the front patio, you can request a hookah stuffed with a light, aromatic tobacco.

—*Nicholas Walsh*

Osha Thai

(see p. 125)
Hipster Thai
819 Valencia St., San Francisco 94110
Phone (415) 826-7738

Panchita's Restaurant No. 2

Late night pupusa is for lovers.
$$

3091 16th St., San Francisco 94103
(at Valencia St.)
Phone (415) 431-4232

CATEGORY	Salvadorean and Mexican
HOURS	Mon-Fri 10 AM-11 PM
	Sat/Sun: 10 AM-3:30 AM
GETTING THERE	Street parking on this side of the Mission can be difficult. The closest garage (with bike parking!) is at 16th St. and Hoff. The easiest way to get to Panchita's is the BART, as it is one block north of 16th St. Station.
PAYMENT	VISA
POPULAR DISH	*Pupusas*—thick handmade corn tortillas stuffed with pork, beans or traditionally fresh cheese and *loroco*, a small edible flower. The pupusas come hot off the griddle, slightly crisped on the outside and served with shredded cabbage and salsa. At $2 a pupusa, they are hard to beat. Also delicious are their sweet plantains with cream.
UNIQUE DISH	The rich and aromatic soups at Panchita's No. 2 make it a standout among the Salvadorean restaurants in the Mission. Try the chicken soup, slow cooked with potatoes, carrots, zucchini and corn cobs. The beef soup is also good, with big chunks tender meat. All soups are served with tortillas, rice and *pico de gallo* (fresh salsa).
DRINKS	A limited selection of beer and wine is served at the restaurant, along with tea and coffee. Sodas and *agua frescas* (sweet, mainly fruit based drinks) such as tamarind and *horchata* are popular.
SEATING	Panchita's is spacious, with tables by the window for watching hipsters on bikes, locals with groceries, and drunk crowds from neighboring bars pass by.
AMBIENCE/CLIENTELE	Eating at Panchita's is casual and has the greasy spoon feel of an old diner. The restaurant is well lit, decorated with photos of El Salvador and can accommodate big groups. It's busiest on Friday and Saturday nights when hungry bar hoppers stream in for late night pupusas.
OTHER ONES	• Panchita's Restaurant No. 3: 3115 22nd St., San Francisco 94110, (415) 821-6660 (Panchita's No. 3 is an upscale version of the No. 2 restaurant, complete with attentive service and white table cloths. The menu remains affordable and is a good date option if you're on a budget.)

—*Rui Bing Zheng*

Cruising the Pupusa Corridor

Despite San Francisco's reputation as an expensive place, the city is home to a plethora of cheap-eats options. However, it can still be easy to fall into a burrito, pizza slice and sandwich kind of rut. If you haven't already, I recommend adding pupusas to your routine. For those unfamiliar with pupusas, here is the basic description, in haiku form:

> Fried to perfection
> Tortillas stuffed with goodness
> Salvadoran joy

Pupusas are readily available at a number of eateries throughout the Mission District and further south into the Excelsior District. The choices for fillings generally include pork, cheese, beans and loroco (an edible flower) or some combination of these items and you top it off with a cabbage salad called curtido. I tend to go with cheese and loroco. Fried dough with hot melted cheese: how can you go wrong?

Most restaurants serving pupusas have both El Salvadoran and Mexican food and you'll see Latino families ordering pupusas as a side dish. It is usually gringo types like me ordering them as a main dish and two pupusas do make a meal. A plate of two runs between $3 and $4 and with a beer and the tip, you'll be getting out for less than ten bucks. If you're really hungry, add a plate of fried plantains with beans and sour cream.

I've yet to find a bad pupusa and there are many, many surely satisfying places I haven't tried, but here are some excellent starting points:

Balompie Café – The bar area in front and the soccer-themed décor gives this restaurant a bit of a pub-like feel. They are also open for breakfast. (3349 18th St. at Capp. (415) 648-9199)

La Santaneca de la Mission – This is perhaps the most charming of this group. Keep their closing hours of 8 PM during the week and 9 PM on Friday, Saturday and Sunday in mind when heading over. No alcohol served. (2815 Mission St. at 24th St., (415) 285-2131)

Los Panchos – No such problems with the early hours here. Los Panchos stays open until 3 AM on weeknights and until 4 AM on Friday and Saturday nights. (3206 Mission St. at Valencia, (415) 285-1033)

El Zocalo – Just a few doors down from Los Panchos, El Zocalo also keeps the very late 4 AM hours. This is the first place I ate pupusas, brought here by real live Salvadorans many years ago, and it is still one of my favorites. (3230 Mission St. at Valencia, (415) 282-2572)

Los Guanacos – Excellent pupusas, a friendly staff that patiently suffers my Spanish, a year-round Christmas decoration and jukebox that plays at seemingly random intervals all help make this one of my favorites, and not just because I can walk here in minutes from my house. (4479 Mission at Excelsior, (415) 586-9907)

Reina's – Due to Los Guanacos, there are few other Salvadoran places in the Excelsior I've bothered to try and there are several around here. Reina's is one of the exceptions and a worthy choice. (5479 Mission at Guttenberg, (415) 585-7694)

—*Bill Richter*

Platanos
Nuevo Latino in the Mission's gourmet ghetto.
$$$$
598 Guerrero St., San Francisco 94110
(at 18th St.)
Phone (415) 252-9281
www.platanos-sf.com

CATEGORY	Upscale Latino eatery
HOURS	Sun-Thurs: 11 AM-10 PM Fri/Sat: 11 AM-11 PM
GETTING THERE	You can brave the Mission District's hellish parking waters or pay $8.00 for a valet. 16th St. BART stop is a brief walk away.
PAYMENT	VISA Cards
POPULAR FOOD	Being a life long eater of the namesake of this restaurant, I of course, had to try the plantains. The sweet plantains (*platanos maduros*) came with a lime sour cream, and while it was tasty, I've certainly had better in my mother's kitchen. A better choice was the twice-fried plantain chips that accompanied the tangy, delicious guacamole. My companion & I decided to try out the small plates rather than order entrées and were pleased with the quality of the pork pupusas.
UNQIUE FOOD	Platanos is located at the intersection of 18th & Guerrero, a section called the "gourmet ghetto" by locals given that across the street are San Francisco foodie favorites Tartine Bakery, Delfina Pizzeria, Delfina Restaurant, & Bi-Rite Market. Also, while the name of the restaurant may lead you to believe the food here is Caribbean influenced, most of the dishes are Central American.
DRINKS	Platanos has a full menu of libations ranging from an extensive beer selection to sugary house made cocktails (many surprisingly based on sake), to a beer margarita (which was surprisingly drinkable), to the ever-popular carafe of sangria.
SEATING	Medium-sized, with a variety of tables, would be great for couples and groups alike. However, I've seen this place on a weekend night and it can get crowded, so if you're looking to have an intimate dinner here, I would save it for a slower night like during the week or on a Sunday.
AMBIENCE/CLIENTELE	The best word to describe the scene at Platanos is tasteful – the lighting is tasteful, the Latin American art on the walls is beautiful and the ceiling is punctuated with majestic ceiling fans. It has high ceilings & one of the cleanest, most

pleasant smelling bathrooms I've ever used in a San Francisco restaurant. There are small two person tables & larger tables for groups. Most of the patrons are clean cut, good looking, but hip enough to eat in the Mission. Diners who seek to eat food with a Latin American beat but who can't stomach the usual divey-ness of Mission taquerias can't do better off than the grown up scene at Platanos. Underneath the sound of multiple lively conversations, Platanos plays Central American music. The food is good, but not great; it's telling when I spent most of the meal lusting after the breakfast menu posted on the wall rather than concentrating on the food that was in front of me.

EXTRAS/NOTES During their first year, one of the founders, Marvin Avilez, was sent to serve in the army in South America and they lost their head chef, Carlos. Nevertheless, Platanos has thrived, and the restaurant continues to be a popular fixture on the crowded Mission dining scene.

—Maria M. Diaz

Serrano's Pizza

Good, cheap, Italian.
$
3274 21st St., San Francisco 94110
(at Valencia)
Phone (415) 695 –1615
www.serranospizza.com

CATEGORY	Casual, guy's night out pizzeria.
HOURS	Sun–Thurs: 11 AM–Midnight
	Fri/Sat: 11 AM–1 AM
GETTING THERE	Street parking. Busy but you can always find a spot.
PAYMENT	VISA 〇〇 Cards
POPULAR DISH	The calzone is wonderful!
UNIQUE DISH	Pizza created fresh by the slice.
DRINKS	Sodas and bottled water
SEATING	Very small. Bring a group of ten to take over the restaurant.
AMBIENCE/CLIENTELE	As casual as it gets. Make this your stop for great eats at better prices after a full night of spending way too much on drinks.

—Tara Little

Ti Couz

Authentic Breton style crepes.
$$$
3108 16th St., San Francisco 94103
(at Valencia St.)
Phone (415) 252-7373

CATEGORY	Creperie
HOURS	Mon: 11 AM–11 PM
	Tues-Thurs: 5 PM–11 PM

Fri: 11 AM–11 PM
Sat/Sun: 10 AM–11 PM

GETTING THERE Parking is scarce as this is one of the busiest parts of The Mission. If close to BART: take it to 16th St. Mission, exit the station and head toward Valencia. Ample street maps (posted inside the BART station) will guide you! Ti Couz is between Valencia and Guerrero. If driving is a necessity, find parking on Guerrero.

PAYMENT VISA ●● ●● Cards

POPULAR DISH Both the Mushroom and Cheese crepe and the Amond Krampouz are unbelievably heavenly. Perfect for a cool night, and they are all cool nights.

UNIQUE DISH The Breton style buckwheat crepes. While there are plenty of the more commonly found type of Crepes in San Francisco, no one knows how to top them and fill them like Ti Couz. Try pairing the Chocolate Mousse with the Sweet Orange Crepe but be warned, this is enough for 4 people! Be prepared to break your stereotypes about French restaurants; Ti Couz is reasonably priced and not at all pretentious.

DRINKS The alcoholic ciders are cozy, memorable and best paired with dessert. Ciders stay true to the Breton tradition of Crepe and Cider pairing.

SEATING With W shaped, three room branching, seating of a large party is attainable, however the party will most likely be stretched thin over several small tables. This setting was obviously created more for intimate dining.

AMBIENCE/CLIENTELE Casually stylish. The background noise of mature crowds, French speaking patrons and every time, someone who has just been introduced to the Ti Couz Breton style crepe, and has fallen in love, fill the restaurant with a respectably satisfied hum. You will find a take your time atmosphere beneath the low ambient lighting that displays handsomely the marriage of dark metals and knocked-about wood. Low- key funky background harmony keeps the mood sleekly European.

EXTRAS/NOTES Did you know the Brenton-style crepe dates back to Brittany over 500 years ago? The shirts that the staff wears are for sale.

—*Tara Little*

Truly Mediterranean

The Mission's Middle Eastern destination.
$$
3109 16th St., San Francisco 94103
(at Valencia St.)
Phone (415) 252-7482 • Fax (415) 437-2222
www.trulymed.com

CATEGORY Neighborhood Middle Eastern hole-in-the-wall

HOURS Mon-Thurs: 11 AM-1 PM
Fri/Sat: 11 AM-Midnight
Sun: 11 AM-10 PM

GETTING THERE Parking is pretty bad here, especially at night.

Many Muni buses come through the area and the 16th and Mission BART station is one block to the east.

PAYMENT VISA [cards]

POPULAR DISH Falafel sandwiches and Shawerma sandwiches on lavash, not pita, are easily the most ordered items. They are hot, fresh, delicious, and bigger than your forearm. As a vegetarian, I can't personally recommend the Shawerma. Many meat-eaters will go with the Falafel and my meal of choice is the Falafel Deluxe (which includes eggplant & potato that the Falafel Regular does not) with hot sauce.

UNIQUE DISH Unless one is unfamiliar with Middle Eastern foods, there is not much here that I would call unique or unusual. They stick with the basics and do them extremely well. Besides the above-mentioned sandwiches, favorites like kabobs, hummus, *dolmas*, *baba ghannoush* and tabouleh salad are all also available.

DRINKS No alcohol, mainly soft drinks. For something a little different try the carrot juice or the garlic mint yogurt drink.

SEATING This is a very small place where customers stand in line to order. Seating consists of five stools at a narrow counter along one of the walls and a couple of tables with plastic chairs for six people outside.

AMBIENCE/CLIENTELE Come as you are. Being in the heart of the 16th and Valencia area of the Mission, this place sees a little bit of everything from longtime residents to neighborhood hipsters to the down-and-out to the weekend crowd hitting the bar scene. Watch the apparently endless supply of falafel burgers being prepared by the front window, listen to the Arabic music booming from the speakers and check out the numerous awards they've won from local newspapers' "Best Of" issues while you wait.

EXTRAS/NOTES With the paucity of seating, take-out is a good option here. Also, some of the neighboring bars don't mind people bringing in the food from here. Just ask around before breaking it out.

—*Bill Richter*

Zante Pizza and Indian Food
Where Indian food and pizza come together.
$$$
3489 Mission St., San Francisco 94110
(at Cortland St.)
Phone (415) 821-3949 • Fax (415) 821-3971
www.zantespizza.com

CATEGORY Pizza and Indian
HOURS Daily: 11 AM-3 PM; 5 PM-11 AM
GETTING THERE There is metered parking on Mission St. and un-metered up on Cortland. Parking is generally ok, though it can be a pain on weekend nights.
PAYMENT VISA [cards]

POPULAR DISH The Indian Pizza is hands down the most popular and the best dish here. Think of some of your favorite Indian foods along with Zante's "famous sauce" rather than tomato sauce, covered with bubbling mozzarella cheese, and you start to get the idea. Absolutely delicious. Little bits of cauliflower, eggplant, green onions and garlic are the bulk of the vegetarian toppings (for vegan, order this without the cheese) and meat eaters can opt for the version with lamb and Tandoori chicken.

UNIQUE DISH This is a case where what is unique is also what's best. The Indian food is good with some excellent dishes and the regular pizza is ok, but the Indian Pizza is the reason to check this place out.

DRINKS Beer and wine, including some imported beers in bottles and Bud and Michelob on tap and available in pitchers. Wines are of the more mass-produced variety, but at $9-12 for a bottle or carafe, the price is right.

SEATING This is fairly spacious dining room that can seat around 60 and is good for large groups. Tables can easily be moved together if necessary.

AMBIENCE/CLIENTELE After being in business for 20 years, this space retains a very casual neighborhood and perhaps divey feel. The Indian music and décor let you know that you are in an Indian restaurant that also serves pizza, rather than a pizza parlor that also serves Indian food. It is all pretty darned basic, but nobody is coming for the atmosphere.

EXTRAS/NOTES Free citywide delivery is available, but it's not for the impatient.

—Bill Richter

POTRERO HILL

Café Chez Maman
(see p. 72)
Low-key French
1453 18th St., San Francisco 94107
Phone (415) 824-7166

Chez Papa Bistrot
*French bistro with food and mood,
but not the snooty attitude.*
$$$
1401 18th St., San Francisco 94107
(at Missouri St.)
Phone (415) 255-0387
www.chezpapasf.com

CATEGORY Authentic French bistro
HOURS Sun–Thurs: 11:30 AM-3 PM; 5:30 to 10 PM

Fri: 11:30 AM-3 PM; 5:30 to 11 PM

Sat: 5:30 to 11 PM

GETTING THERE Street parking. Can be tricky on Monday, Friday and Saturday nights, but you can usually find a spot in the surrounding streets.

PAYMENT VISA MasterCard Cards

POPULAR DISH The classic Southern France dish of *moules* (mussels) is very popular, and they have two options: Mussels "Provencale" with garlic, shallots, cherry tomatoes, nicoise olives and pastis, and Mussels "Nicoise" with aioli, saffron, shallots and white wine. Use bread to soak up the savory juices, or order the *frites* (fries) and alternate between dipping in the aioli and the juices. For the indulgent, everyone raves about the roasted filet mignon with potato-parsnip gratin and a truffle foie gras sauce.

UNIQUE DISH Try the roasted black Mission figs with gorgonzola, crispy prosciutto, hazelnuts & pomegranate vinaigrette. The potent various flavors linger and actually seem to prosper more with each bite. For a second course, the halibut with baby greens, yellow squash, pea sprouts, and a cider-port sauce is plain yummy. The fish is very fresh and the cider-port sauce is sublime I would bottle and sell it if I bottled and sold sauces.

DRINKS The wine list is very strong, and has despite the culinary bias; there is a balance between French and Californian wines, with a few Australian, New Zealand and South African vintages sprinkled in as well. 25 are available by the glass and they also allow personal wine with a corkage fee. There is a tiny bar that serves cocktails. Bottled beer is available and they serve two on draft. To set the Gallic mood, try a classic Kir aperitif.

SEATING Cozy and small—seats 35 with space for an additional ten outside under heat lamps.

AMBIENCE/CLIENTELE The overarching theme is an honest joie de vivre. Most anything goes here, although the clientele probably tend to put more thought into their choice of personal fragrance and shoes than the average diner. The vibe is international, with most of the wait staff hailing from France. The owner's purported goal was to replicate the friendly local bistro from where he grew up in the South of France, and he has succeeded admirably. Scents of garlic, fennel and saffron pour out from the kitchen. The service is very professional, but not intimidating—you won't find snooty attitude of some Parisian waiters here—so don't hold back on asking the staff for recommendations.

EXTRAS/NOTES Due to its small size, it is a good idea to book in advance. You can book online at www. opentable.com. People from all over the city stop through and it is a magnet for the local French population. Feel free to drag out your high school French phrases. The sister restaurant, which is more of a tiny French diner, called

Chez Maman is three stores down on 18th. It serves up great burgers and the same fries found at Chez Papa. The owner also runs Baraka, La Suite, and Coleur.

—*Nicholas Walsh*

Eliza's

Fresh Chinese.
$$
1457 18th St., San Francisco 94107
(between Connecticut St. and Missouri St.)
Phone (415) 648-9999

CATEGORY	Low-key Chinese
HOURS	Mon-Fri: 11 AM-3 PM; 5 PM-9:30 PM
	Sat/Sun: 4:30 PM-9:30 PM
GETTING THERE	Street parking and easy muni/bus access
PAYMENT	VISA MasterCard Cards
POPULAR DISH	One of two locations and one of a group of Mandarin restaurants with a distinctively California twist, Eliza's has one of the best lunch specials in town. Less than seven bucks for a rich bowl of Hot and Sour soup, followed choices like Mango Beef, or Portabella Mushroom with Shrimp, brown rice and a cookie to boot. A great place for take-out, but be sure to ask for paper containers instead of styrofoam.
DRINKS	Beer and wine
SEATING	Plenty of seating for you and your friends
AMBIENCE/CLIENTELE	Clean and contemporary stylings
OTHER ONES	• Pacific Heights: 2877 California St., San Francisco 94115, (415) 621-4819

—*Kenya Lewis*

O'Neill's Irish Pub

(see p. 208)
Irish pub
747 Third St., San Francisco 94107
Phone (415) 777-1177

Hard Knox Café

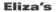

Soul-ish Food
$$
2526 3rd St., San Francisco 94107
(between 22nd St. and 23rd St.)
Phone (415) 648-3770
www.hardknoxcafe.com

CATEGORY	Low-key Southern food
HOURS	Mon-Sat: 11 AM-9 PM
	Sun: 11 AM-5 PM
PARKING	Street parking and easy bus access
PAYMENT	VISA MasterCard
POPULAR DISH	Next door to a boxing gym on 3rd St., Hard Knox is not what is known as a destination

restaurant. That is unless you have a craving for pretty authentic Southern-style soul food. No entrée over ten bucks and each includes heaping amounts of two side dishes of your choice: 3-piece fried chicken, with rice and corn; meatloaf with yams and black eyed peas; oxtails with mac n' cheese and biscuits. All come with two cornbread muffins. It ain't fancy, but it's pretty good.

UNIQUE DISH	Fried chicken is hard to find in SF
DRINKS	Beer, wine, and soda
SEATING	Small booths and counter
AMBIENCE/CLIENTELE	Laid back, definitely more of a soul food joint than "R"estaurant. It is frequented by locals of this eclectic neighborhood, which range from local musicians and artists to old-timers.
EXTRAS/NOTES	Laid back atmosphere and simple food makes it a great place for kids. Voted best fried chicken by SF Weekly in 2007.

—Kenya Lewis

Thee Parkside

Gourmet Dive, surprising bar food at Thee Parkside.

$$

1600 17th St., San Francisco 94107
(at Wisconsin St.)
Phone (415) 307-4996
www..theeparkside.com

CATEGORY	Hole in the wall bar with Thai
HOURS	Daily: 4 PM-Midnight
GETTING THERE	Free street parking everywhere
PAYMENT	Cash only, ATM on site
POPULAR DISH	Chef Ta-Wei Lin changes his menu every day, always serving bar food with a Thai twist (that sounds better than Thai food with a bar twist). Particularly good are his peanut noodles, which appear with some frequency on his rotating menus.
UNIQUE DISH	The food at Thee Parkside is unique in that it is unexpected. Looking around the grungy (which may be a euphemism for this self-described "dive") environs of Thee Parkside would cause you to expect reheated chicken nuggets and pretzels, rather than the Thai specials offered up.
DRINKS	Thee Parkside is principally a bar, and all manner of alcoholic beverages are sold, as well as some standard soda/juice/energy drink options.
SEATING	Lots of seating available, from bar stools and high two person tables to outdoor picnic style benches.
AMBIENCE/CLIENTELE	Thee Parkside has sort of a grungy hipsterish vibe, but, as the bar features live music several times a week, as well as a weekly "skate-night", the clientele can change drastically from one evening to another.
EXTRAS/NOTES	Ta-Wei's cooking is a bit of a secret. As Thee Parkside functions primarily as a bar, many of his

patrons are incidental, hungry bar-goers. Don't be dissuaded if you are the only one eating.

—*Ben Feldman*

SUNSET/INNER SUNSET

Café Gratitude

(see p. 182)
California Vegan
1336 9th Ave., San Francisco 94112
Phone

Gordo Taqueria

(see p. 44)
Taqueria
1239 9th Ave., San Francisco 94122,
Phone (415) 566-6011

"It's a mad city, inhabited by perfectly insane people whose women are of remarkable beauty"

—*Ibid. 1891*

Pluto's Fresh Food For a Hungry Universe

The future of fast and healthy dining at its finest
$$$
627 Irving St., San Francisco 94122
(between 7th Ave. and 8th Ave.)
Phone (415) 753-8863
www.plutosfreshfood.com

CATEGORY	High class Cafeteria
HOURS	Daily: 11 AM–10 PM
GETTING THERE	Street Parking is available, and for the city, it's pretty easy to find parking within the block. In terms of public transit, the N-Judah train, that travels all the way from the Cal Train station next to AT&T Ball Park, through downtown, and all the way out to Ocean Beach, stops right in front of Pluto's.
PAYMENT	VISA MasterCard
POPULAR DISH	The salads at Pluto's are unbelievable and arguably the best in the city, at least for anything in the same price range. What makes Pluto's salads so good, besides having the freshest ingredients around, is that they are completely unique to

whoever is ordering the salad. The reason each salad is so unique, is because of the vast options that patrons have to choose from. To start, choose from either a Caesar salad with croutons, or a "Farmer's Greens with choice of crunchy fixings", both of which can be ordered as a side salad (which is very well sized on its own) or as a main meal. For only $1 more you get to add perfectly cut bite size slices of grilled chicken or marinated flank steak. With the added protein and rich flavor, the meat is definitely recommended if you're looking to make your salad a full-fledged meal. If you're looking for an insane amount of meat – well more than any person needs in one meal – Pluto's does have the option to get extra meat on the salad for $1.75 more. With your choice of seven extra toppings for the salad and then your choice of dressing for the salad, if you know what you like, this most likely will be one of the best salads you've ever had. And, to top it off, fresh baked sourdough, or herb foccacia bread comes with the salad for only 25 cents more.

UNIQUE DISH The meats and poultry, either by themselves or as sandwiches, are very good, but adding a couple items from the veggies and spuds section of the menu really makes for an outstanding meal. If you really want an out of this world side dish, for only $2 each, try an order of "Saturn's Garlic Potato Rings" or try the "Orbital Onion Rings" with Spicy BBQ Dipping Sauce. I most recently had the Roasted Red Pepper "Smashed Spuds" with the Beef Sherry gravy and it was amazing. I had it with the chef recommended Tri-Tip steak, that combined very well, but I recommend getting gravy poured on the meat as well because it's outstandingly rich and delicious. Other meats offered include, grilled marinated flank steak, herb roasted Sonoma turkey, Aidells poultry sausage, and grilled herb chicken. For vegetarians, Pluto's offers a Grilled Eggplant Saucer and Roast Red Pepper Sandwich, as well as a Grilled Portabella Mushroom Sandwich.

DRINKS The drink selection has basically everything to be expected besides hard alcohol. Of course they have, coffees, teas, Iced teas, sodas, juices, milk, bottled beers etc., but on tap, not only do they have Fat Tire Amber Ale, Sierra Nevada Pale Ale, and Saison, they also serve Thomas Kemper Root Beer. And for those that don't know, root beer on tap is the best there is by far. In addition to all that, Pluto's also offers an assortment of Napa Valley wines.

SEATING Seating is well spread out in the oddly shaped dining area, but some tables in the middle of the room have to deal with a bit of in and out traffic as people come and go. In the dining area, there are six, half-booth-type, four person tables, about another six four-tops above that, three three-tops, and around twelve individual counter seats. The counter seats are all blue, retro-futuristic looking

stools that surround equally retro-futuristic looking, half-heart shaped counters, with plenty of space if you're trying to read a newspaper or book.

AMBIENCE/CLIENTELE Pluto's has a futuristic, space station from a TV show in the '60s, type look…sort of. It definitely has a cool look that seems to put a modern twist on a retro style. From the curvy, odd-shaped lighting fixture designs on the ceiling, to the shiny, stainless steel, open buffet style kitchen, to the multi-soft-colored walls, and the half-heart shaped counter seating, Pluto's has a look that makes you feel like you're on a different world. The contrasting, cool-toned colors blend well with the soft and relaxed lighting. One wall has names of fictional and non-fictional astronaut & outer-space characters like Neil Armstrong, Beldar Conehead, Sally Ride, Buzz Lightyear, John Glenn, Obi-Wan Kenobi, ET, Starman, The Borg, Mork, Hal 9000, and James Lovell, just to name some of the countless many. Without being distracting, the wall of names definitely adds to the vibe of Pluto's and if you're looking for somewhere to direct your eyes, besides the TV that usually has sports on, then the wall of names is a fun list to look at. With the interesting and fun look of Pluto's it's relaxing and fun to eat here time and time again. The cafeteria ordering style makes getting food incredibly fast and easy, and with fast turnover on the tables, finding a seat never seems to be a problem.

EXTRAS/NOTES Pluto's offers offsite catering for any order of at least $150 to turn any party or office occasion into a feast that will have everyone smiling. Their large catering menu includes breakfasts as well as virtually their entire regular menu and most things can be ordered per person. The buffalo wings, on the regular and catering menu, is an especially good catering item for large groups, but they also have some special items like Shish Kabobs. Even boxed meals can be prepared, but for boxed meals there is a minimum order of 10. Also, for desserts, a large assortment of treats are available including, Lemon Bars, Oatmeal Carmelites, and Chocolate-Dipped Biscotti to name a few.

OTHER ONES • Marina: 3258 Scott St., San Francisco 94123, (415) 775-8867
• Palo Alto: 482 University Ave., 94301, (650) 853-1556

—Ian J. Strider

Shangri-La

Your basic Chinese vegetarian, vegan and kosher eatery, oy vey!
$$
2026 Irving St., San Francisco 94122
(at 2nd St.)
Phone (415) 73102548

CATEGORY	Kosher vegetarian Chinese
HOURS	Daily: 11:30 AM-9 PM
	(Closed the 1st and 3rd Wednesdays every month)
GETTING THERE	Metered parking along Irving is your best bet, but watch your time, as this is a well-traveled meter maid territory. Carry quarters, the only coin accepted by San Francisco meters.
PAYMENT	VISA MasterCard
POPULAR DISH	The lunch special served in a bento box, frozen in time at a price of $4.50 and a choice of eight entrées, may be one of the best bargains in town. Try the spicy bean curd and the cashew gluten and vegetables. All served with soup, egg roll and jasmine tea.
UNIQUE DISH	The sweet and sour pork, substituting walnuts for the meat, is inspired and fooled my father in law from the Midwest, who also enjoyed its more sweet than sour taste. The shark fin soup, sans shark, is mystery on how it was prepared, with little help in explanation by the prototype surly middle-aged waiter, but just as good as any you would pay double for in Chinatown.
DRINKS	Stick to the beer
SEATING	A dozen tables pushed against the walls of this hallway type space. There is a large table almost always filled with large families from the neighborhood.
AMBIENCE/CLIENTELE	Appearing like any of the dozens of Asian eateries in the Sunset, with an unexciting storefront exterior and decorated in early 1970's style, including glass sheets to protect table cloths. Drop in's from the neighborhood looking for inexpensive food, dropouts from the neighboring Haight searching for good vegan fare and followers of Jewish dietary laws all converge on Shangri-La. Often simultaneously. Chinese and Jewish families often celebrate here.
EXTRAS/NOTES	They have in recent years taken down the Farrah Fawcett poster in the bathroom. Oh, and no MSG.

—*Bill Anderson*

WEST PORTAL

Fresca

(see p. 25)
Peruvian
24 West Portal Ave., San Francisco 94127
Phone (415) 759-8087

DOWNTOWN - CHINATOWN

Capital Restaurant

*Home-style meals at
Cantonese-American diner.*

$$

839 Clay St., San Francisco 94108
(between Stockton St. and Waverly Pl.)
Phone (415) 397-6269

CATEGORY	Chinese-American Diner
HOURS	Daily: 8 AM-9:30 PM
GETTING THERE:	Driving and street parking in neighborhood can be challenging as Chinatown is one of the densest areas in the city. Two garages are located by the restaurant; the first is Portsmouth Square Garage on Kearny and Washington Sts. and the second is located on Sacramento St. off of Powell. Many MUNI lines go through Chinatown, including the 1, 9, 15, 30, and 45 buses and the Powell Street cable car.
PAYMENT	Cash only
POPULAR DISH	Located on the corner of Chinatown's most iconic alley is Capital Restaurant, a family owned Chinese American diner. This neighborhood spot serves up large plates of comfort food, Cantonese-style. Lunchtime is busiest, as locals flock to the restaurants for the daily specials, ranging from chicken a la king to steamed chopped pork with salted egg. Lunch specials are "American" style with a complementary dish of vanilla ice cream and strawberry Jello or "Chinese" style with a cup of Capital's homemade soup. Show up early Tuesday for the restaurant's most popular lunch special- roast prime rib. Cooked rare and served with a small bowl of au jus, this tender cut of beef is one of the best (and affordable) in Chinatown.
UNIQUE DISH	Fried chicken isn't the most unique food in the world, but the way Capital prepares its spicy salt and pepper chicken is special. Wings and drumettes are deep-fried golden brown, rubbed with salt and white pepper, and tossed liberally with garlic, scallions and sliced jalapeno peppers. Capital has an array of tasty seafood dishes, such as their princess clams with bean vermicelli and whole steamed flounder. Their noodles are also very good, especially the beef chow fun with bean sprouts. If you are eating with a big group, try their set menus for easy ordering.
DRINKS	Black tea and coffee are the drinks of choice for most Capital patrons. Sodas and a limited selection of beer and wine are also available. A cold bottle of Tsingtao is a great accompaniment to dinner.
SEATING	Capital Restaurant can seat 40 people comfortably. The diner boasts a low counter for single patrons, a few round family style tables each equipped with a rotating lazy Susan at the

center of the restaurant, and smaller private tables along the wall.

AMBIENCE/CLIENTELE On the surface, Capital looks like many other casual eateries in the neighborhood, with its florescent lighting, scattered potted plants, standard wood furniture and specials in Chinese and English placards on the wall. The warm interaction between the wait staff and patrons mark it as different. Many of the locals who eat at Capital have been coming for years, some for decades. Younger patrons often talk of their fathers and grandfathers bringing them to the restaurant when they were kids. Indeed the mostly Asian-American clientele ranges in age, from teens lunching with their parents to grandmas and grandpas coming in from neighborhood shopping.

—Rui Bing Zheng

Fortune Cookie
A Staple of Downtown
San Francisco's Chinatown
Restaurants

The history of America, and in particular the history of the frontier, is a history which is dotted with both a mixture of good and bad experience. The excitement of developing a new way of life in a rugged land is marred by the fact that to do so required difficult labor in difficult times. To maintain the energy necessary to move through the bad and get to the good, people in the frontier days had to find simple pleasures where they could.

That is how the fortune cookie was born.

Much of the frontier building in the San Francisco came at the hands of Chinese laborer. Living in isolation camps, they did the best they could to retain some of their culture in the new world. One of the things which they left behind were the Moon Cakes which were used to celebrate special occasion in China. In an attempt to make their own Moon cakes, the laborers came up with the fortune cookie.

Today, the best place to get good fortune cookies in San Francisco is just outside of Downtown San Francisco in the restaurant of Chinatown. One of the most famous of the Chinatown restaurants is House of Nanking, located just outside of downtown at 919 Kearny Street. Right next door is Chef Jia's, a small hole-in-the-wall which offers delicious meals complimented by fortune cookies. Watch fortune cookies being made at the Golden Gate Fortune Cookie Factory located at 56 Ross Alley.

—Kathryn Vercillo

Golden Gate Bakery
Worth the wait.
$
1029 Grant Ave., San Francisco 94133
(at Pacific Ave.)
Phone (415) 781-2627

CATEGORY	Chinese bakery
HOURS	Daily: 8 AM-8 PM
	(Please keep in mind that around August the shop closes for about a month for vacation.)
GETTING THERE	Don't even think about it, unless you have a full day to invest in this or are in the neighborhood anyway. The 45 or 30 bus drops you off a block away. Get off at the Pacific Ave. and Stockton St. stop.
PAYMENT	Cash only
POPULAR DISH	The egg tarts, or dan tats, are by far the best in San Francisco, if not the country. At $1 a piece, they are the most expensive in town, but they're well worth it. With their flaky layers of crust surrounding a moist and delicate egg custard within, their opposing textures form a perfect combination, especially when eaten hot. If you are fortunate enough to eat one hot, you can practically slurp up the silky egg custard. This is a well-deserved, decadent snack. The other pastry that is worth waiting in line for is the *bo lo bow* or pineapple bun. Despite the name, it doesn't taste like pineapples. If pineapples tasted like this, they would be my favorite fruit. There is no filling, so it's all about the subtly sweet, crunchy, cracked topping on top of the soft round bun. This is a perfect light snack. The melon cakes are another pastry not to be missed. A slightly sweet melon paste with bits of crunchy melon is encased in a flaky layer, which is another great amalgamation of textures, and the flavor is unbelievably delicate.
UNIQUE DISH	All of the pastries are available at other bakeries, they're just not as delicious.
DRINKS	This shop serves only non-alcoholic beverages like coffee, tea and juices. Try their Vitasoy brand juice boxes in flavors like guava, mango and soy milk. They make great accompaniments to the delicate pastries.
SEATING	As long as I can remember for twenty years now, they have had several tables in the back. If you happen to get a seat you might catch some gossip from the local elderly folk (assuming you understand Chinese). On my most recent visit, however, the entire back section was closed off and only one table for two people was available, which really only acted as a resting place for those in line.
AMBIENCE/CLIENTELE	This is a highly casual place. If you wear anything more formal than a sweatshirt, you will get unabashed stares. This is not a "place to be seen" or a place to take a date you want to impress, unless they really like Chinese desserts. The atmosphere is, not surprisingly, that of a working, no nonsense bakery. On the shelves behind the

counter, pink boxes are piled high, red string to tie the boxes are hanging everywhere and paperwork is strewn aside. Basically, it's a mess, not unlike your closet when the in-laws come over unexpectedly. Atmosphere and ambience do not make a knee-weakening egg custard, and that's what you're here for. The clientele ranges from grandparents to yuppies to kids. The variety of pastries, whether you feel like something rich and calorific or light and delicate, will satisfy all of your snacking needs.

—*Michelle Berlanger*

Sam Wo's

No egg rolls for you!
$

813 Washington St., San Francisco 94108
(at Grant St.)
Phone (415) 982-0596

CATEGORY	Chinese
HOURS	Mon-Sat: 11 AM-3 AM Sun: 11:30 AM-9 PM
GETTING THERE	Good chance for parking spots at night on Grant St.
PAYMENT	Cash Only
POPULAR FOOD	Beef chow fun with broccoli, vegetable chow mein, won ton soup.
UNIQUE FOOD	Vegetarian egg rolls, stir-fried rice with crab bits, daily seafood specials (seasonal).
DRINKS	They just started serving tea and water. It used to be BYO everything. You still might be able to sneak in a bottle of your favorite beverage.
SEATING	Sitting in Sam Wo's is like sitting in an airplane. It's very narrow, but there are still two floors for seating.
AMBIENCE	Small tables and linoleum with harsh fluorescent lighting. This place is truly a dive; hence its "soup-nazi" style charm.
EXTRAS/NOTES	Sam Wo's was featured prominently when Conan O'Brien took his late night show to San Francisco; he did a segment every night for a week in which he poked fun at/paid homage to Sam Wo's "special" charm.

—*Alan Home*

Sweetheart Café

Best bubble tea in Chinatown!
$

909 Grant Ave., San Francisco, CA 94108
(at Washington)
Phone (415) 262-9989
www.sweetheartcafe.net

CATEGORY	Popular neighborhood tea and snack shop, specializing in boba, or tapioca pearl, drinks
HOURS	Mon: 11 AM-10 PM Tues-Thurs: 10 AM-10 PM

Fri: 11 AM–Midnight
Sat/Sun 10 AM–10 PM

GETTING THERE Driving and street parking in neighborhood can be challenging as Chinatown is one of the densest areas in the San Francisco. Portsmouth Square Garage on Kearny and Washington Sts. is the closest parking garage. An easier option is taking the BART to Montgomery station and walking to Grant Ave. It should be a 15-minute walk from the station. Many MUNI lines go by the café, including the 9, 15, 30, and 45 buses.

PAYMENT Cash only

POPULAR DISH The combo meals are very popular and affordable for a lunchtime or late afternoon snack. Six bucks buys a bag of the café's salty fried snacks and an icy black or green milk tea. The popcorn chicken is a local favorite, fried golden and dusted with salt and white pepper. Crispy chicken wings and calamari come in at close seconds, coming out of the kitchen piping hot and delicious with a milk tea. For dessert, try their shaved ice with condensed milk and fruit topping, their array of ice creams, and silken tofu pudding with sweet ginger sauce, made on site.

UNIQUE DISH Sweetheart Café has a line of traditional Chinese desserts that are as tasty as they are beneficial to your health. Items like double boiled egg and *harsmar* (a type of fungus) or double boiled egg with birds nest are slow cooked with rock sugar, which produces a light syrup.

DRINKS Sweetheart Café boasts an impressive list of over 140 drinks, from boba teas to fresh fruit smoothies, and sago drinks. The black milk boba tea is one of the best in Chinatown, full of tea flavor, perfectly sweetened, with a dash of milk. The tapioca pearls are a good consistency, being chewy and slightly sweet. Many of the drinks are made with slices of fruit such as mango, papaya and lychee. They also use fresh taro for their taro milk tea. Try the coconut milk and taro drink with sago for a creamy, vegan shake.

SEATING There's limited seating on the first floor, where customers watch Chinese pop star videos on the Café's flat screen TV while waiting for their drinks to be filled. Upstairs, there is seating for 20-30 in the form of square tables and benches. Large windows open out to busy Grant Ave. Grab a seat by the window on a sunny day for people watching, or bring a book to read before the after school rush.

AMBIENCE/CLIENTELE With its top-notch boba teas, variety of treats and casual atmosphere, Sweetheart Café is often the destination of choice for local kids and families, tourists, and anyone with a sweet tooth. During after school hours on weekdays (after 2 PM), teenagers from nearby schools flock to the Café in droves. Families, community members , and neighborhood people often frequent the Café. The sweetshop is a local favorite, but also catches the eye of tourists who walk by on colorful Grant Ave.

OTHER ONES • Berkeley: 2523 Durant Ave., 94704,
(510) 540-0707
• Berkeley: 2550 Durant Ave., 94704,
(510) 540-6136
• Oakland: 315 9th St., 94607, (510) 835-8136
• Milpitas: 372 Barber Ln., 95035,
(408) 428-0880

—Rui Bing Zheng

Dim Sum: A Heart's Delight

Ask any true San Franciscan to list the most important things in life, and they're bound to put "good food" at the top of the list. Food is such a part of our culture that we can't imagine a life that didn't involve regular discussions about where to get the best sushi or which taqueria grills, rather than steams, their tortillas. The culture of food is close to our hearts. It is fitting, then, that one of the cuisines San Francisco is most noted for is called Dim Sum or "a little bit of heart."

Dating back to the 10th century on Canton's famous Silk Road, Dim Sum originated in the "yum cha" (tea-drinking) establishments that catered to weary travelers and rural farmers. As the digestive qualities of tea became known, proprietors began to offer their customers selections of little snacks to go along with the invigorating brew, and the art of dim sum was born. Today there are more than 2,000 varieties of dim sum—from pillowy buns stuffed with tender barbecued pork to delicate dumpling wrappers filled with chunks of juicy shrimp to lettuce cups folded around spicy minced squab.

Traditionally served from first thing in the morning into the early afternoon, some believe the cuisine inspired the western concept of "brunch." And, really, what could be better on a lazy Sunday morning than a never-ending stream of tantalizing treats wheeled by your table where you can pick and choose among them with simple points and nods. There are usually no menus, and no need to decide what you'll have at the beginning of the meal. Simply sit back and wait for waiters to pass by with their varied offerings— the kitchen sends out new varieties every few minutes—and feel free to ask if you're unsure of what a particular dish is. At the end of the meal, your plates will be tallied to determine the amount of your bill.

Lingering in places with names like Good Luck Dim Sum, Dol Ho and Hang Ah its easy to become enthralled by the drama of these teahouses—the clatter of dumpling-laden trolleys trundling over linoleum floors, the exotic sounds of spoken Chinese, unusual treats glistening in threes and fours on little plates and nestled in tiny bamboo steamers. The scene is mesmerizing, but the spicy, meaty aromas will invariably rouse you from your trance at least long enough to point out your selections of steamed, baked, pan-fried, deep-fried savory and sweet delectables.

Finding good dim sum in San Francisco is hardly a challenge— from the financial district to Chinatown to the outer Richmond, the Sunset district and even SOMA, this city is virtually bursting with tasty dumplings. Your best bet for stumbling on a prime dim sum spot is simply to wander through Chinatown or down

Clement Street, where storefronts filled with eye-catching displays of the tasty treats—from lofty steamed buns stuffed with pork, vegetables or chicken to deep-fried delicacies like crab claws stuffed with shrimp—beckon on every block. Here are five of the best spots to try:

Ton Kiang

5821 Geary Blvd., San Francisco, (415) 752-4440, (415) 387-8273
This large, bustling restaurant in the outer Richmond district is widely considered to serve the very best dim sum in town. Near-perfect renditions of standards like barbecued pork buns and Siu Mai (pork dumplings) hold their own alongside well-loved house specialties like delicate Pea Tip and Shrimp Dumplings and juicy and addictive Foil-Wrapped Chicken. The prices are considerably higher here than at storefront counterparts, but the extra cost is justified by the superior ambience, service, cleanliness and, above all, quality.

Yank Sing

Since 1958, Yank Sing has established itself as a true San Francisco institution. Another on the spendy end of the spectrum, business people flock here from nearby offices for weekday lunches, and on weekends the elegant dining room fills up with tourists and locals alike. Once you've scored a seat and are happily devouring an impressive variety of dishes you won't wonder why. Don't miss their famous minced squab, Peking duck and custard tarts. Woo Gok (deep-fried, pork-filled taro dumplings) are crisp, flavorful and not at all greasy, putting all others to shame. The Har Gao (shrimp dumplings) are some of the best you'll find—plump, briny, sweet shrimp wrapped in a disarmingly tender rice noodle wrapper. (One Rincon Center, 101 Spear St., San Francisco, (415) 957.9300 or 49 Stevenson St., San Francisco, (415) 541-4949)

Good Luck Dim Sum

This bustling storefront bakery makes up in taste what it lacks in ambience. Designed for mostly take-out business, the narrow space is barely big enough to contain the hordes of mostly Chinese customers who knowingly call orders across the counter to crabby ladies briskly packing assorted delicacies into pink pastry boxes. If you can't wait until you get home to dive into your dumplings, there are several tables in the back. Prices here are unbelievably cheap (ranging from $1 for three-piece servings of many items to a high of $1.70 for a lotus leaf filled with pork). These aren't the most delicate dumplings you'll ever savor, but you'll definitely get good bang for your buck here. Try the Fun Kor (steamed rice paper-wrapped dumplings filled with pork, water chestnuts, and peanuts) or crispy steamed-then-pan-fried Turnip Cake. (736 Clement St., San Francisco, (415) 386-3388)

Hang Ah Tea House

Opened in 1920, this Chinatown standard claims to be the oldest Chinese restaurant in the city. To find it, climb the steep half block up Sacramento from Grant toward Stockton and duck into the alley next to the playground. Dingy, dark and a bit greasy all over, this is an unlikely place to discover unforgettable culinary delights. But alas, one bite into one of their airy buns filled with succulent, sweet, salty and tender barbecued pork and you'll forget all about the low ceilinged, slightly sticky decor. Despite the fact that this

spot has been "discovered" by tourists in recent years, the quality remains high and the prices low. (1 Hang Ah Alley (near Stockton and Sacramento), San Francisco, (415) 982-5686)

Dol Ho
This true hole-in-the-wall with a reassuringly mostly Chinese clientele churns out a wide variety of tasty dim sum at extremely reasonable prices. The dumplings are meaty and fresh, even if the service can be a bit unfriendly. Try the Chive and Shrimp Dumplings—tender, sweet shrimp punctuated by brightly flavored chives inside a delicate rice noodle wrapper. Where many other superb dumpling houses have been overrun by swarms of tourists, Dol Ho somehow manages to maintain an aura of existing in the "real" Chinatown. (808 Pacific Ave., San Francisco, (415) 392-2828)

—*Robin Donovan*

DOWNTOWN – UNION SQUARE/FINANCIAL DISTRICT

Ananda Fuara
Vegetarian Restaurant
Aiming to satisfy your nourishment and your spiritual needs.
$$$
1298 Market St., San Francisco 94102
(at Hayes St.)
Phone (415) 621-1994
www.anandafuara.com

CATEGORY	Vegetarian restaurant
HOURS:	Mon/Tues: 8 AM-8 PM
	Weds: 8 AM-3 PM
	Thurs-Sat: 8 AM-8 PM
	(Sunday Brunch 10 AM-2 PM, once a month)
GETTING THERE	Metered parking, very difficult at times. The Civic Center BART and Muni train station is one block up Market.
PAYMENT	Cash only
POPULAR DISH	Neatloaf, a vegetarian meatloaf, is the most popular item on an extensive menu. Whether served between slices of organic bread along with a salad or along side mashed potatoes and mushroom gravy, this is always a satisfying choice. A cup of dal (Indian-spiced lentils) soup goes very well with either option.
UNIQUE DISH	If you haven't tried much in the way of faux-meat dishes, much of the menu will be new and different. In addition to the Neatloaf, the best thing about coming here is the range of selections and diversity of the menu with so much of it done well. Despite the relative ease of being vegetarian in San Francisco, few restaurants offer so many options be it sandwiches, wraps, meatloaf, nachos

or samosas, and at such reasonable prices. Many of the selections are, or can be made, vegan.

DRINKS No alcohol is served. There are many choices for coffee, tea, iced-tea, soda, juice and yogurt drinks.

SEATING Seating consists of about 10-12 tables for four and an equivalent number of tables for two.

AMBIENCE/CLIENTELE This is an oasis of calm and serenity in an otherwise bustling and sometimes not-so-pleasant corner of Civic Center. The name Ananda Fuara, meaning "Fountain of Delight", was bestowed by spiritual teacher Sri Chinmoy, of whom the owners and employees are followers. Photos of Sri Chinmoy with dignitaries such as Mother Teresa, Pope John Paul II and Nelson Mandela are among the décor on the pale blue walls and one of his videos plays unobtrusively toward the back. Male servers all wear blue polo shirts with white pants and the female servers all wear saris and are a humble and tranquil presence. The more cynical may find this all a bit cult-like, but no worries, no one is trying to convert you.

EXTRAS/NOTES For those so interested, books, videos and CDs by Sri Chinmoy are available. Also, the hours can be variable so call ahead to make sure they'll be open.
—*Bill Richter*

Citizen Cupcake

Bakery and bar affords sweets, treats and cocktails high atop Market St.
$$$
2 Stockton St., 3rd Floor of the Virgin Records, San Francisco 94108 (at Market St.)
Phone (415) 339-1565 • Fax (415) 339-1566
www.citizencupcake.com • www.citizencake.blogspot.com

CATEGORY Bakery café specializing in cupcakes

HOURS Sun-Thurs: 11 AM-9 PM
Fri/Sat: 10 AM-10 PM

GETTING THERE Parking is nearly impossible on busy Market St. and the Financial District, so plan to take on of the many MUNI Bus lines (for example: the 5, 21, 6)

PAYMENT VISA MasterCard Cards

POPULAR DISH Citizen Cupcake specializes in – what else – cupcakes and desserts. Try one the Joe Cool Cupcake, with a "chocolate infusion" and mint frosting, a pineapple upside-down cupcake or the Signature Chococupcake, a chocolate chiffon cupcake filled with vanilla cream topped with a chocolate ganache glaze.

UNIQUE DISH If you need something more substantial before indulging in a bit of sugary froth, try a tuna or ham sandwich (not available Monday) or a panini, including a cheddar and gruyere grilled cheese sandwich on dry Jack bread, or a roasted mushroom and olive tapenade with "a hint of truffle," arugula and Fontina on sourdough bread. Soups include potato leek, butternut squash and sweet corn. Other offerings include a savory

bread pudding with ham and cheese, tamales and local greens salad. Other cupcake offerings include the Persian Love cupcake, a chiffon cake with a rose buttercream filling, saffron punch, rose confectioner's glaze, pistachios and candied rose petals, or the Candy Bar #1 Cupcake, a devil's food cupcake filled with caramel and covered with peanut butter frosting and salted Spanish peanuts.

DRINKS Features Illy espresso and coffee, Peaberry's tea, a range of non-alcoholic beverages including sparkling water, lemonade, sodas and juice. Beer, wine and sake cocktails are also popular.

SEATING Seats about 30, but many patrons take their treats to go.

AMBIENCE/CLIENTELE Citizen Cupcake is on the third floor of the Virgin Store, which means you have to go through the store to reach the café. While you can relax with a cup of coffee and a cupcake while looking out over Market St., the waitstaff is cheerful and strives to make your experience a pleasant one and almost makes you forget that you're in a shop above a megastore.

EXTRAS/NOTES Citizen Cupcake is the offshoot of restaurant Citizen Cake, self-described as the "pastry chef's restaurant." The café clearly prides itself on its superior and special cupcakes, as well as its interesting sandwich and soup selections. But while it's a great place to grab lunch or a sweet treat, it's not necessarily a place to linger long since it's hard to forget you're not in a small Montmatre hideaway; the sights and sounds of the Virgin store eventually encroach on the peace and quiet. Your best bet? Secure a window seat away from the entrance, or grab a few delicious bites to go. Want to hear live music? Check their blog for event listings.

OTHER ONES • Hayes Valley: Citizen Cake, 399 Grove St., San Francisco 94102, (415) 861-2228

—*Nicole Spiridakis*

City View Restaurant

Fancy dimsum for fancy people.

$$

62 Commercial St., San Francisco 94111
(Kearny)
Phone (888) 234-7316
www.cityviewrestaurant.reachlocal.com

CATEGORY Upscale dim sum

HOURS Mon-Fri: 11 AM-2:30 PM
Sat/Sun: 10 AM-2:30 PM

GETTING THERE The best way to get to City View Restaurant is to take the BART to Montgomery station and walk down Kearny St., making a right onto Commercial St. It should be a 10-minute walk from the station. Many MUNI lines also go by the Restaurant including the 1, 9, 15 buses. For

drivers, Portsmouth Square Garage on Kearny and Washington Sts. is conveniently located a block away.

PAYMENT VISA ◯ ▭ Cards ▱

POPULAR DISH City View boasts many popular dishes, from the steamed hagow dumpling filled with fresh shrimp and ginger to the Buddha roll, a delicate item made of bamboo shoots, carrots and shitake and wood ear mushrooms wrapped in crispy tofu skin. All of their steamed items are good and taste like they just came out of the kitchen. Try their tiny buns filled with barbeque pork or their rice noodle dishes. The size of their dim sum is smaller than at other restaurants but City View's presentation is held to a high standard. My friend and I recently ordered a seafood dumpling that was fashioned into the shape of a flower and dotted with bright green peas and carrot. While the presentation was impressive, the flavor of the food was often was muted. Additionally, the dumpling skin was too thick in some of the dishes. In exceptional dim sum, especially in seafood ones such as hagow, the dumpling wrapper should be very thin, almost transparent. For dessert, the mango pudding is outstanding, silken, perfectly sweetened, and creamy with a splash of milk on top.

UNIQUE DISH One dish that surprised me was the *shumai*, the steamed pork dumpling. These little treats are made of minced pork, shrimp, shitake mushrooms and are topped with bright orange crab roe. City View's version is topped with grated carrot, which lends a sweet and refreshing flavor to the dish. Also exceptional was the sesame chicken. Fried with dried chili peppers and tossed in a sweet sauce, this dish hit all the right sweet, salty, tart, and spicy notes.

DRINKS Tea is the drink of choice for dim sum and City View carries a wide array of loose-leaf teas, including oolong, jasmine green, pu-erh, chrysanthemum and more. The also have a soda and limited alcohol selection.

SEATING City View seats up to 120 people, with its round banquet tables to smaller, private ones. All tables are covered with white table clothes.

AMBIENCE/CLIENTELE The restaurant has a clean contemporary design and is decorated with well-kept plants, mirrors, and a large scenic painting of China's mountains. City View is well lighted, as sunlight pours in from the storefront's wide windows. Chandeliers also provide extra light. The background instrument is classical, stringed instruments.

The clientele is a mix of Chinese-Americans and their friends and the business people from the nearby Financial District. City View is a popular destination for power lunches on weekdays, whereas the restaurant fills up with families going out for tea and brunch on the weekends.

EXTRAS/NOTES Business crowd. So, business attire is probably best.

—*Rui Bing Zheng*

Dotties True Blue Café

The best brunch in the city is the
not-so-best part of the city.
$$$
522 Jones St., San Francisco 94102
(at O'Farrell St.)
Phone (415) 885-2767

CATEGORY	Affordable organic café
HOURS	Mon: 7:30 AM–3 PM.
	Weds-Sun: 7:30 AM–3 PM
GETTING THERE	Walk, bike, cab, or bus. 38 Geary is one block away. Street parking is a nightmare.
PAYMENT	VISA ⬤ ▬ Cards
POPULAR DISH	It's really hard to go wrong here, the entire menu is outstanding; a variety of creative egg dishes, sweet pancakes and French-toasts made with love and care and only the best ingredients. The andouille sausage scramble is a house favorite, mushrooms and cheese and eggs cooked just the right consistency. The pancakes are a rich and decadent splurge. There are lots of menu options, so deciding can be challenging. Don't forget to look at the specials board, where some of the best dishes live. The baked goods are fresh made daily; the baker comes in at 4 AM to get the oven going. We had a cinnamon roll appetizer and it was hands down, the best one I've ever tasted. Every entrée comes with a side of their famous cornbread, again, the best I've ever had.
UNIQUE DISH	The food is the best. It will knock your socks off. But to get to it, there are two extremes you will have to bear. First, there is a minimum of an hour-long wait. Seriously, it's no joke, if you come here you will wait. Unless you are a single diner, in which case you might get into the counter sooner.
DRINKS	Coffee, tea, fresh juice and delicious smoothies and Mimosas.
SEATING	The restaurant is small with only a handful of tables and a counter.
AMBIENCE/CLIENTELE	The room is always packed and the décor has a retro old-San Francisco vibe. Homey and cute, with an open-air kitchen so you can see Kurt (the owner) cooking up a storm.
EXTRAS/NOTES	Kurt the owner is always behind the counter cooking up a storm. A sweet guy with genuine care for the food and your dining experience, say hello and be sure to strike up a great conversation with him.

—*Lily Amirpour*

Fuzio Universal Pasta

(see p. 65)
Hip pasta spot
1 Embarcadero Center., San Francisco 94111
Phone (415) 392-7995

Henry's Hunan

(see p. 124)
Chinese
674 Sacramento St., 94111
Phone (415) 788-2234

Java House

*You might have more fun here
than at the game.*
Since 1912
$$
Pier 40, San Francisco 94107
(at Townsend St.)
Phone (415) 495-7260
www.javahousesf.com

CATEGORY	Historic American diner
HOURS	Mon-Fri: 6 AM-5 PM
	Sat/Sun: 7 AM-5 PM
GETTING THERE	There are many parking lots in the area because of its proximity to the Giant's Stadium. However, the N Judah Muni line also passes right by this spot, which is preferable since walking along the Embarcadero is always pleasant.
PAYMENT	Cash only. ATM on site.
POPULAR DISH	This is my favorite hot dog in the city—you can even get a double dog. The hamburgers are also great and you can never go wrong with the short stack of pancakes, which are offered all day long.
UNIQUE DISH	This is a popular spot on game days and the schedule can sometimes shift accordingly. The outdoor seating next to the marina is a relaxing way to spend the lunch hour in the summer.
DRINKS	They have some beer in bottles, the typical sodas but also good coffee (as it's name should suggest).
SEATING	There are two indoor rooms to sit, but this is for the winter time. In the summer everyone is outdoors at the tables enjoying the view of the bay and the marina and the stadium. Groups come here for lunch as the tables can easily accommodate different numbers.
AMBIENCE/CLIENTELE	This is definitely a low-key place but full of character. The building has been there since 1912 as one of the owners, Phillip Papadopoulos, made me aware by pointing out the large I-beams that carried it boldly through the 1989 earthquake. The Greek Papadopoulos family has been running the joint for 35 years and it certainly has a fun, easy-going atmosphere as they joke with you and ask after a regular's family or business.
EXTRAS/NOTES	The last time I was in for lunch, I was on my own and was invited to join the owner, Phillip, and two regulars at their table. If you check out their website with cartoons by Bob Nelson and pictures with former Mayor Willie Brown you'll begin to see why I left with a smile that lasted the rest of the day.

—Caitlin Cameron

Love's Café
Lighten up the loin baby.
$$
1101 Polk St., San Francisco 94109
(at Post)
Phone (415) 441-7755 • Fax (415) 441-4577

CATEGORY	California café
HOURS	Mon-Sat: 9 AM-6 PM
GETTING THERE	There is metered street parking around that neighborhood, but if you aren't around, there is the 19 muni line that runs down polk all the way from the Fisherman's Wharf area to the South of Market area.
PAYMENT	VISA MasterCard Cards
POPULAR DISH	Alright so the highlight of this place is the extensive baked potato options at your disposal. Me, I do breakfast burrito's and this is the place for a great one. Egg, potato, cheese, sausage, mushrooms, avocado (personal combination provided by myself) c'mon are you kidding me that sounds awesome. You have choices of many other ingredients to customize your personal burrito. If it was a long night, this is my hangover craving.
UNIQUE DISH	Different selection of baked potatoes available or customize your own. The teriyaki chicken looked interesting, but I haven't veered from the breakfast burrito just quite yet.
DRINKS	Fresh squeezed juices and smoothies available with other sodas and bottled/can juices.
SEATING	Medium seating with both downstairs and upstairs options. I prefer the relaxing upstairs loft style.
AMBIENCE/CLIENTELE	It never really has been that busy anytime I have gone. The neighborhood isn't too well trafficked. Literally no wait for your beautiful burrito.
EXTRAS/NOTES	I'm telling ya people if you are any fan of breakfast burritos at all, this is your place. At the meager prices from $5 for the basic and tipping the scales at $9-10 for more things that could actually fit in the burrito, you wont be left hungry for the rest of the day. It's big enough to eat half at a time, oh yes, satisfaction is still obtained.

—Don Saliano

O'Neil's Irish Pub
(see p. 208)
Irish pub
747 Third St., San Francisco 94107
Phone (415) 777-1177

Osha Thai
(see p. 125)
Hipster Thai
4 Embarcadero Ctr., San Francisco 94111
Phone (415) 788-6742

Sellers Market

Fresh local ingredients are
worth a couple extra bucks.

$$$

388 Market St., San Francisco 94111
(at Fremont St.)
Phone (415) 956-3825 • Fax (415) 956-0237
www.sellersmarkets.com

CATEGORY	Organic California Cuisine
HOURS	Mon-Fri: 7:30 AM-3 PM (breakfast available 'til 11 AM)
GETTING THERE	If you can find a parking space on the street during the day in the Financial District, I give you all the credit in the world! Public transit is freaking everywhere, so that is the way to go.
PAYMENT	VISA
POPULAR DISH	My personal favorite is the classic Margherita pizza—one-person sized, but enough to keep you comfortably full for a few hours. The over-toasted sandwiches are some of the most commonly ordered items. Their macaroni and cheese has a bit of a cult following as well; it's so rich, I couldn't even finish my whole serving.
UNIQUE DISH	When you have local and organic ingredients at your disposal, you tend to get creative. Each of the dishes here is unique in its own way, though feel free to ask for something added or removed— everything is made fresh, so adjustments are not a problem.
DRINKS	You can't find alcohol here (why would you be drinking during the day anyway!?), but just about everything else is available: bottled water, tap water, sodas, coffee, tea, hot chocolate, lemonade, iced tea, fresh juice.
SEATING	As with most Financial District locations, seats are limited. If it is a nice day, sitting outside is an option, thanks to the five tables they set out there. A few tables line the Pine St. side of the eatery, but most seating inside is in the form of "bar style" seating—raised, longer tables with raised, moveable chairs.
AMBIENCE/CLIENTELE	The interior is comfortable, yet gives me a slight feeling of being temporary: 50% farm, 50% modern sleek. An open kitchen allows you to see your food made, which a number of folks enjoy. You'll find mostly business folks, of course, but tourists and folks enjoying a day off mosey in as well.
OTHER ONES	• SoMa: 595 Market St., San Francisco 94108, (415) 227-9850

—Victoria Everman

Turtle Tower Restaurant

The best pho in town.

$

631 Larkin St., San Francisco 94109
(at Eddy St.)
Phone (415) 409-3333

CATEGORY	No frills pho
HOURS	Daily: 8:30 AM-7:30 PM
GETTING THERE	Metered street parking only
PAYMENT	Cash only
POPULAR DISH	You cannot get more authentic than the Pho here. The broth is clear and tasty, the noodles perfectly slippery, and the meat is fresh. Both the beef and chicken are excellent choices. It is served with a side of lime and jalapeno slices to spice it up.
UNIQUE DISH	What is unusual about this place is that the Pho is actually good! Besides the Pho, they offer a really good *nem cuon*, egg rolls served with lettuce leaves, vermicelli noodles, and *nuoc mam*. You take a lettuce leaf put in a piece of egg roll and a little bit of vermicelli noodles, wrap it up, and dip into the *nuoc mam*. Also, they serve a good beef stew served with a French baguette.
DRINKS	Soda, soy bean milk, tea, lemonade, juice, and Vietnamese coffee.
SEATING	There are two dining rooms, one in the front of house and one in the back. Both are moderately sized, with round and square tables. During busy times, it is cafeteria style where they may seat different parties at the same table.
AMBIENCE/CLIENTELE	The atmosphere here is definitely simple and casual. The restaurant is usually busy, bustling with Asians or people who work nearby at the Civic Center. Be careful not to run into the hard at work servers and bussers who are endlessly carrying steaming hot bowls of pho and quickly cleaning the tables for the next group of people.
EXTRAS/NOTES	Slanted Door chef/owner Charles Phan mentioned in an interview that this is one of his favorite places to eat Pho.
OTHER ONES	• Outer Richmond: 5716 Geary Blvd., San Francisco 94121, (415) 221-9890

—Thy Pham

DOWNTOWN - NOB HILL

Bar Crudo
Some like it raw.
$$$$
603 Bush St., San Francisco 94108
(between Burritt St. and Stockton St.)
Phone (415) 956-0396
www.barcrudo.com

CATEGORY	Raw food
HOURS	Sun-Thurs: 6 PM-10:30 PM
	Fri/Sat: 6 PM-11 PM
GETTING THERE	Street parking in this neighborhood can be difficult – your best bet is make a beeline for one of the many garages downtown, saving time and headache trying to park. Several Muni lines run through the Nob Hill area, so non-car owners

should have no problem making their way to Bar Crudo.

PAYMENT VISA MasterCard Cards

POPULAR DISH Start with a selection of oysters (SF's own Hog Island is usually well-represented) and move on to the crudo menu. Tender cubes of Artic char laced with horseradish and topped with black tobiko and scallops with orange whet your appetite for more. If you're still hungry after your raw courses and craving hot vittles, make your way to seafood chowder laced with smoky bits of bacon, ample hunks of fish and potato in a thick creamy broth, prepared daily from a house recipe.

UNIQUE DISH Keep in mind the menu focuses primarily on raw seafood - there are only three hot dishes on the entire menu. A gamut of geographical influences flavors the plates at Crudo, hints of daikon, piquillo peppers, ginger and lemongrass pipe up throughout your meal.

DRINKS Choose from a slew of tasty Belgian ales to pair with lightly dressed raw dishes or kick your bill up a few notches and splurge on a bottle of wine. A short but well-rounded wine list has several choice picks for red, white and sparkling options—no specialty cocktails or hard booze are served at all.

SEATING Two tiny zinc bar counters seat five people each in the downstairs area-- perfect for solo diners or sociable couples, and a small dining loft upstairs is slightly more secluded, seating roughly twenty patrons at a time. A large chandelier and fresh-cut roses soften otherwise streamlined surroundings; reservations for more than two are a must, but spots fill up fast. Perseverance is your friend when trying to snag a spot at Bar Crudo—occasionally just popping in to check for an empty seat downstairs proves rewarding with an immediate seating.

AMBIENCE/CLIENTELE Best for a light meal or a social date, Crudo's crowd are typically leisurely diners, willing to wait for each made-to-order course. Dinner tends to run on the expensive end so you won't find too many young, hipster diners here. A mature crowd that relishes in paced, artisan dining (and can afford it) frequents this spot, although you will see the occasional gourmand on a budget, out to sample the wares.

EXTRAS/NOTES Owned by twin brothers Tim and Mike (formerly of Yabbie's Coastal Kitchen & Cafe Maritime) Selvera, hot dishes on a four-burner stove tucked away downstairs.

—*Jenna Wortham*

The Big 4 in the Huntington Hotel

Relax in a railroad tycoon's lounge.
Since 1950
$$$

1075 California St., San Francisco 94108
(at Taylor St.)
Phone (415) 474-5400 • Fax (415) 474-6227
www.huntingtonhotel.com

CATEGORY	Hotel restaurant and lounge, very upscale
HOURS	Daily: 11 AM–Midnight
GETTING THERE	Valet parking is available at the main entrance, or--if on foot--ride a cable car to the top of Nob Hill.
PAYMENT	VISA ⬤⬤ Cards
POPULAR DISH	Though the restaurant is known for its wild game selections, the bar menu is both lighter and more approachable. Soups, salads, and sandwiches all easily make a meal. Local organic field greens, fat crab cakes, and a traditional burger are top choices.
UNIQUE DISH	Strapped for cash? Snack on the roasted spiced almonds delivered with the cocktails.
DRINKS	The full bar features high end and local liquors and the classy bartenders mix traditional cocktails to perfection. A mostly California wine list is peppered with a few European selections, all offered by the glass.
SEATING	The lounge is comprised of several small tables and a small bar. The space fills up after 6 PM.
AMBIENCE/CLIENTELE	Located in one of the more exclusive downtown boutique hotels, the Big 4 attracts older local Nob Hill ladies an gentlemen in furs and finery. The reserved staff seems to appreciate the occasional younger guest, perhaps because of their rarity. Cozy up on a hunter green leather banquette, or hold court at a cut glass table in a leather armchair. The small bar is edged with a brass rail and even the bar stools feel luxurious. Dining in the lounge is an educational experience—the dark wood paneled walls feature Californian memorabilia that recalls the early days of the railroad. It is easy to imagine historical business meetings taking place here over cigars and cocktails as the pianist plays favorites from an era gone by.
EXTRAS/NOTES	The name of the restaurant and lounge celebrates the four most prominent railroad tycoons of the 19th century: C.P. Huntington, Charles Crocker, Leland Stanford, and Mark Hopkins. Each lived nearby in the Palatial mansions of Nob Hill.

—Majkin A. Klare

Nob Hill Cafe

The Nob Hill Café is a cozy bistro offering familiar Northern Italian cuisine.

$$$$
1152 Taylor St., San Francisco 94108
(between Sacramento St. and Clay St.)
Phone (415) 776-6500
www.nobhillcafe.com

CATEGORY	Low-key, traditional Italian
HOURS:	Daily: 11 AM–3 PM; 5 PM–10 PM (Sat/Sun brunch: 11 AM–3 PM)
GETTING THERE	Parking is difficult in Nob Hill, so the Café offers valet parking. It's located one block away from the restaurant, at the corner of Washington and Taylor streets. The Grace Cathedral parking garage is also available.
PAYMENT	VISA
POPULAR DISH	The homemade Gnocchi Bolognese, made with ground beef, Italian sausage, and pomodoro, is popular at Nob Hill Cafe.
UNIQUE DISH	The range of toppings available for pizzas, including five different types of cheese, make each one unique.
DRINKS	The broad wine list includes many different varietals, mostly red. Sparkling and white wines also make an appearance, along with Italian and American beers.
SEATING	A great place for couples, Nob Hill Café is very warm and cozy. It's in an unlikely location, which adds to its charm, and perfect for intimate occasions. Not recommended for big groups.
AMBIENCE/CLIENTELE	Located amongst some of San Francisco's nicest hotels, Nob Hill Café is a little more upscale than the average restaurant. There isn't an official dress code, but business casual is probably most appropriate.
EXTRAS/NOTES	Because reservations are not taken, sometimes the wait can be a bit long. There are a few tables outside, where patrons can wait to be seated, and the staff will usually offer to bring a glass of wine to enjoy while you wait.

—*Katie Klochan*

Nook Café

Wine and free wi-fi: a darling combo.

$$$
1500 Hyde St., San Francisco 94109
(at Jackson)
Phone (415) 447-4100 • Fax (415) 447-4124
www.cafenook.com

CATEGORY	Coffeehouse
HOURS	Mon-Thurs: 7 AM-10:30 PM
	Fri: 7 AM-11 PM
	Sat: 8 AM-11 PM
	Sun: 8 AM-10:30 PM
GETTING THERE:	You can try and find street parking, but it might involve going up and down the steep hills in

the area. Public transportation, as with most SF places, is a good bet. Around here, you have the Powell-Hyde cable car running right past the front door, and the 1, 12, 19, and 27 buses within a couple of blocks.

PAYMENT

POPULAR DISH If you aren't in the mood for a salad but still want something light, choose one of the "small plates" – a tasty mix of veggies, a spread, carbs and protein will satisfy but not weight you down (a good thing considering the hills).

UNIQUE DISH Looking to try something new? Ask for the daily special, listed on a small chalkboard to the left of the counter. Need a sugar kick? Try one of their uber tasty vegan or organic desserts: fruit pies, chocolate cake, carrot cake, brownies, and more.

DRINKS Coffee-style drinks are popular during the day, as well as juice, water, and tea. For later hours, drop in for their unique wine bar, variety of beers, as well as soju and sake cocktails.

SEATING On sunny days, try to stake out a little table out front. Otherwise there are less than 15 tables inside. Though small (as the name suggests), most folks have no problem with sharing their extra seat or table space with fellow customers.

AMBIENCE/CLIENTELE Most folks that come here already live in the neighborhood. This is their little, dependable place to come, get a good bite to eat, and work on their laptop at the same time. Despite this, there is not a sense of being rushed for time here. Relaxed, enjoyable, cozy, and staffed with friendly and helpful folks, this is a great place to take a break if you are roaming around or need a break from life.

EXTRAS/NOTES Check out the happy hour 5 PM-7 PM everyday: all cocktails $4, Happy Hour wine $2.50, PBR beer $1.50

—Victoria Everman

Osha Thai
(see p. 125)
Hipster Thai
696 Geary St., San Francisco 94102
Phone (415) 673-2368

Shalimar
Excellent Indian and Pakistani food in the Tandoorloin.
$
1409 Polk St., San Francisco, 94109
(at California St.)
Phone (415) 776-4642
www.shalimarsf.com

CATEGORY Hole-in-the-wall Indian
HOURS Daily: Noon-3 PM; 5 PM-11:30 PM

GETTING THERE Metered parking can be difficult in the evenings.

PAYMENT VISA MasterCard

POPULAR DISH I highly recommend the Chicken Tikka Masala, the ground beef kabab, the curries, the Kabli Chana (chickpeas cooked in butter), and the Daal Masala (lentils stewed with cumin and coriander). Make sure to order a side of naan and Shalimar's own basmati rice. Beware all dishes are made SPICY!

UNIQUE DISH The Brain Masala is for the adventurous. Try the Mango Lassi (mango smoothie made out of yogurt) to cool down your tongue after the meal.

DRINKS No alcohol is served, but I have seen people bring their own bottle of beer. Sodas, Chai tea, Mango Lassi and water.

SEATING Around twelve tables inside and outside, another six tables.

AMBIENCE/CLIENTELE The atmosphere is completely no frills. Shalimar is a true city joint filled with a diverse clientele. Once you step off the urine stained streets and into Shalimar, your senses are overwhelmed with the spicy smells of curry, coriander, cumin, and other exotic spices.

EXTRAS/NOTES According to my Indian friends who are very picky about food, they mention that Shalimar is the best and most authentic Indian restaurant in the city.

OTHER ONES • Civic Center/Tenderloin: 532 Jones St., San Francisco 94102, (415) 928-0333

—Thy Pham

Tommy's Joynt

Like a beerhaus only with better food.
Since 1947
$$
1101 Geary Blvd., San Francisco 94109
(at Van Ness Ave.)
Phone (415) 775-4216 • Fax (415) 775-3322
www.tommysjoynt.com

CATEGORY Cafeteria-style Hofbrau restaurant

HOUR Daily: 11 AM-1:45 AM
(bar opens at 10 AM)

GETTING THERE Parking at Cathedral Hill Hotel. $1.25 for one hour with validation. Also accessible by two major bus lines 47 and 49 that runs along Van Ness Ave. or 38 that runs along Geary Blvd.

PAYMENT Cash only

POPULAR DISH Impossible to say the best. Amongst the winners are Corned Beef, Turkey Dinner and BBQ Brisket. Every day of the week there's a new special.

UNIQUE DISH Baked Beans with homemade hickory sauce or the Beer and Bean soup are both special to Tommy's. But the horseradish sauce and complimentary pickles are enough for me.

DRINKS Full bar, wine, cider, cocktails and soda. But the beer selection is the most appealing. The list alone covers an entire wall.

SEATING Four long picnic style tables at the entrance. Eight

four-person tables towards the rear. Ten more tables upstairs. Always room to sit.

AMBIENCE/CLIENTELE It's a lively, casual hangout. Mostly composed of regulars and beer connoisseurs, but when the occasional tourist stumbles upon it they make sure to return. Many diners are even on a first name basis with the chef, who slices your meat right in front of you. The glow of the meat station is the centerpiece as you walk in. Most people hardly notice the unique décor because they are mesmerized by the overwhelming aromas behind the glass.

EXTRAS/NOTES Among the regulars are locals, tourists, students, and people who work nearby. Anyone who appreciates good food at a good price will like Tommy's. Lots of regulars, they usually hangout at the bar and tell "back in the day stories". Historical beer signs and nostalgia scattered everywhere. T-shirts, cap and tank tops for sale. The TV is always showing sports, but most people don't bother looking up from their plates.

—*Fabrice Beaulieu*

DOWNTOWN – CIVIC CENTER/TENDERLOIN

A La Turca

The Tenderloin's Turkish haven.
$$$$
869 Geary St., San Francisco 94109
(at Larkin St.)
Phone (415) 345-1011 • Fax (415) 614-9961
www.alaturcasf.com

CATEGORY Neighborhood Turkish with Mediterranean food

HOURS Sun-Thurs: 11 AM-10 PM
Fri/Sat: 11 AM-11 PM

GETTING THERE Parking is difficult. The Civic Center BART and Muni Stations are about seven blocks away if you don't mind walking through the Tenderloin, which is not considered one of San Francisco's finer areas.

PAYMENT

POPULAR DISH The appetizer combo platter (vegetarian and for two) including tangy stuffed grape leaves, savory *baba ghanouj* and several other tasty samplings is a great place to start. *Pides* (more on these below) and the falafel sandwich with lavash bread are also scrumptious. For the meat-eaters, the kebobs, especially the beytil kebob (ground lamb) and the chicken shish kebob, are highly praised.

UNIQUE DISH Unique at least to my experiences is the *pide*. Consider *pides* a Mediterranean-style calzone with flatbread as the shell and no tomato sauce. They are stuffed with veggies and cheese, usually

mozzarella and feta, or meat and cheese and oven-baked. This is a taste-treat and I tend to go back and forth between the spinach and cheese and the fresh tomatoes and cheese. They are also a great deal with the vegetable pides under $7 and the meat pides about a buck more.

DRINKS They have a modest selection of bottle beers and house wines. The beer choices include Efes Pilsen, a crisp Turkish lager. Turkish coffee is available if you are in need of a pick-me-up.

SEATING About fifteen tables for one to four that can be put together for larger groups line the wall and fill the space between that and the kitchen along the other side. Groups larger than eight to ten are probably pushing it.

AMBIENCE/CLIENTELE Bright, with Middle Eastern music and a flat-screen TV perpetually tuned to Turkish television, A La Turca serves a clientele made up of a growing Turkish population and locals out for the night at one of the area's bars, clubs or movie theaters. When it opened in 2002, the look was basically that of a cafeteria or sit-down deli, but they have worked on the décor adding colorful tablecloths and other touches to liven its look.

—*Bill Richter*

Original Joe's

(see p. 273)
Landmark
144 Taylor St. San Francisco 94102
Phone (415) 775-4877

Shalimar

(see p. 115)
Indian
532 Jones St., San Francisco 94102
Phone (415) 928-0333

DOWNTOWN – SOMA

7 Mission Restaurant

Vietnamese in SOMA? You bet!
$$
150 7th St., San Francisco 94103
(between Mission St. and Howard St.)
Phone (415) 861-3298 • Fax (415) 863-6987

CATEGORY Low key neighborhood Vietnamese
HOURS Mon-Sat: 10 AM-9 PM
GETTING THERE 7 Mission Restaurant is nearest to the Civic Center BART/Muni Station. However, if you

need parking, 7th St. is metered until 6 PM but there are often open spots. Natoma, Minna and other side streets have unmetered parking with open spots as well. There is also a paid lot across the street.

PAYMENT VISA ⬤

POPULAR DISH My favorite is the BBQ pork/fried egg roll vermicelli bowl. Another popular dish is the pho, which this restaurant has cleverly figured out how to package to-go. Once when they had run out of my favorite fried egg rolls they gave me a freshly rolled egg roll in rice paper with basil.

UNIQUE DISH Usually people go to the Sunset or Mission Districts for Vietnamese, but I find that the quality and authenticity of this food is comparable and cheaper than those other places.

DRINKS Typical of neighborhood Asian restaurants, they have an urn of green tea at the ready and also a stock of Vietnamese and Thai iced coffee and tea. There is also the option of soy milk, grass jelly drinks, and more exotic fruit juices. They also have a couple of beers handy.

SEATING The front room is lined with booths and has a few tables. Lunchtime can have a little wait but at dinnertime there are a few families and a few open tables.

AMBIENCE/CLIENTELE Lunchtime has a typical office/worker lunch crowd whereas the dinner hours are more locals, mostly Asian families. Most people are regulars as the hotel guests in the neighborhood usually choose to dine in trendier areas.

EXTRAS/NOTES They have a big screen TV that is tuned to sports channel. This adds to the "neighborly" character of the place, as there are usually a couple of guys hanging out watching a game. Everyone is friendly and accommodating—they always offer me tea and a seat as I wait for my take out.

—*Caitlin Cameron*

Asia SF

Tantalizing food meets gender illusionist show.

$$$

201 9th St., San Francisco 94103
(at Howard St.)
Phone (415) 255-ASIA • Fax (415) 255-8887
www.asiasf.com

CATEGORY Pan-Asian

HOURS Mon-Weds: 6:30 PM-10 PM
Thurs: 6 PM-10 PM
Fri: 5:30 PM-10 PM
Sat: 5 PM-10 PM
Sun: 6 PM-10 PM
(Club open 6 PM-2 AM)

GETTING THERE Street parking, metered, parking tends to be easy to find.

PAYMENT	
POPULAR DISH	The Ahi burger is famous! The chicken Satay. Orange lamb, and Ribs are sure winners.
DRINKS	The drink menu is quite varied, featuring drinks from the dancers as well as classic favorites, such as the Cosmo. The Victoria's lemon drop is a must try!
SEATING	Perfect dining for gathering with friends or out of town guests. They are very accommodating for large parties, and this is a prime spot for bachelorette parties. Intimate seating about bar also provides perfect views of the girl's dance shows.
EXTRAS/NOTES	The staff is warm and inviting and makes tremendous efforts to make your night special.

—*Ronda Priestner*

It's an odd thing, but anyone who disappears is said to be seen in San Francisco. It must be a delightful city and possess all the attractions of the next world."

—*Oscar Wilde*

Brainwash
The detergent bar is not for eating.
$$
1122 Folsom St., San Francisco 94103
(between 7th St. and 8th St.)
Phone (415) 861-FOOD • Fax (415) 255-0307
www.brainwash.com

CATEGORY	Hip Laundromat/California coffee shop (no, really)
HOURS	Mon-Thurs: 7 AM-11 PM
	Fri/Sat: 7 AM-Midnight
	Sun: 8 AM-11 PM
PARKING	The major streets in this area are metered until 6 PM. This place is three blocks from the Civic Center BART/Muni Station and also nearby some side streets such as Natoma and Minna that have un-metered parking. Just make sure if you are bringing laundry or dry cleaning that you can carry it.
PAYMENT	ATM onsite
POPULAR DISH	They have a good hamburger but also great vegetarian/healthy options. I like the Teriyaki Tofu Stir-fry. Basically, I've never tried anything here that I didn't enjoy.
UNIQUE DISH	Well, they do have a soap and detergent bar, but that part's not for eating. Other than the ingenious combination of laundromat and cafe, they also have all-day breakfast options here, which is always nice on those days when you really just want pancakes.
DRINKS	They have limited beers on tap and a few wine options. The coffee is great.
SEATING	There are two and four-top tables and benches nicely decorated with laundry-related ads and

motifs. Though it is a popular place, I always manage to find a seat. The outdoor seating, though directly on Howard St., is nicely shaded by trees and good for when you want to bring your dog or enjoy the nice weather days.

AMBIENCE/CLIENTELE There is a mix of the work crowd at lunch, laptop toting hipsters, bedraggled weekend loungers waiting for their laundry, couples reading their Sunday paper and having coffee, singles getting out for live music or comedy act in the evenings. When there isn't live music the staff put on their own iPod mixes.

EXTRAS/NOTES The most unique thing about this set-up is the conjoined cafe and laundromat. It's a logical combination and works really well as it is always a populated and lively place. Brainwash manages to attract a variety of people because there are so many reasons to come here, between the laundromat and dry-cleaning, the live performances, the nice space with local artists, the outdoor seating, the internet connection and the good food it is an overall winner and awesome neighborhood cafe to have nearby.

—*Caitlin Cameron*

The Story of San Francisco Sourdough

Everyone knows 1849 as the year San Francisco was swarmed by young men in raucous pursuit of the "gold in them thar hills," but another valuable resource "discovered" here that year put San Francisco on the culinary map. "Lactobacillus San Francisco" may not sound like a precious commodity, but it is one of the essential secret ingredients in San Francisco's world-famous sourdough bread. And, in fact, the story of the original San Francisco sourdough is intricately tied to the tale of the 49ers.

Using bread "starters"—an ancient method of making bread with a fermented mixture of flour, water, and yeast—was common practice in the 19th century. Miners purchased such starters in San Francisco and carried them on their treasure-seeking journeys to the Sierra foothills, where they baked loaves with a unique, sour tang. Their sourdough bread was so much a part of the culture that seasoned prospectors came to be known as "sourdoughs"—having long fermented in the mines.

Meanwhile, back in San Francisco, an enterprising French baker named Isidore Boudin was drawing crowds with the delicious aromas wafting from his ovens. Just down the hill from Boudin's tiny old-world bakery on Dupont Street (now Grant Avenue), the "Barbary Coast" was a bawdy bedlam where fortunes were won and lost, vices indulged, appetites fed. Most of all, it was a place where a weary miner could find a decent meal, a bottle of hooch, a high-stakes card game, and any number of naughty diversions and creature comforts. The city teemed with speculators, gamblers, mavericks, and adventurers of all sorts—many of whom flocked to Boudin's for his exquisite bread. When Boudin ingeniously began pairing the original concept of a sourdough starter that had

proved so popular with the miners with the artistry of his native country's baking traditions, he struck culinary gold—a golden loaf, crispy-chewy on the outside, airy and light on the inside, with that distinctive sour tang. Soon everyone from pan handlers to the city's elite were lining up each morning for a fresh-baked loaf of his sourdough bread—the same famous San Francisco Sourdough Bread that we know and love today.

What the miners and Boudin had stumbled upon was a group of wild microorganisms, which thrive only here in the Bay Area's unique climate and work together in a feat of culinary science to produce this distinctive bread. While most breads are leavened using a single genetic strain of commercial yeast—trading flavor for consistency and predictability—sourdough relies on these wild microorganisms for leavening as well as flavor. Using a bowl of flour and water as bait, the baker makes a starter by capturing yeasts and bacteria (including lactobacillus sanfrancisco) from the air, the mixing bowl itself, even the baker's hands. Feeding on the flour, these microorganisms begin to multiply. The yeasts give off carbon dioxide, which makes the dough rise, while the bacteria produce lactic acid and acetic acid (vinegar), which contribute the sour flavor. Once the dough is made, a bit of it is folded back into the unused portion of the starter, providing sustenance for the ever-growing colony of wee wildies, which is henceforth known as "the mother." Fed a regular diet of flour and water, this mother strain continues to multiply, creating new "babies" every day, producing descendents indefinitely. In fact, the Boudin Bakery still uses the same "mother" strain that was created by Isidore more than 150 years ago!

While sourdough breads have been made throughout the world—as long ago and far away as Egypt while the pyramids were being built—San Francisco's sourdough is widely regarded as the best in the world. Soon after 1849, several other bakeries sprung up in the Bay Area—including Parisian in San Francisco and Toscana and Colombo in Oakland—that, like Boudin, built their reputations on superb sourdough bread. Today, all four of these bakeries are still in operation—Parisian, Toscana and Colombo under the parent company San Francisco French Bread Company, and Boudin—which claims to be the oldest business in San Francisco—as a thriving chain of bakery/cafés found throughout California and elsewhere. Many exquisite newer bakeries, too, make wonderful sourdough that is sold in gourmet shops and supermarkets and served in fine restaurants throughout the city and beyond.

The San Francisco French Bread Company (includes the former Parisian, Toscano, and Colombo)
Available in most Bay Area supermarkets—and even at the airport—under the Parisian label. Or order online at www.sourdoughbread.com

Boudin
101 California St # 4, San Francisco, 94104 (415) 362-3330
Plus 13 other locations throughout San Francisco and the Bay Area. Check their website for other locations: www.boudinbakery.com

Arizmendi
1331 Ninth Ave. (near Irving), San Francisco 94122 (415) 566-3117
www.arizmendibakery.org

Noe Valley Bakery & Bread Co.
4073 24th St., San Francisco 94114 (415) 550-1405

Acme Bread Company
1601 San Pablo Ave., Berkeley 94702 (510) 524-1327

Semifreddi's
372 Colusa Ave., Kensington, 94707 (510) 596-9935

—*Robin Donovan*

Hennessey's Wines & Specialty Foods

It's a deli, no, it's a wine shop, no, it's Hennessey's.
$$$
545 Second St., San Francisco 94107
(between Harrison St. and Brannan St.)
Phone (415) 348-1432 • Fax (415) 777-9004
www.gourmetwines.com

CATEGORY	Gourmet deli and sandwich shop
HOURS	Mon-Fri: 7 AM-8 PM
	Sat: 10 AM-7 PM
GETTING THERE	Most parking around here is now metered with the occasional unmetered side street. The Giant's stadium is nearby, so there are plenty of big paid parking lots around, too. For pedestrians, there is a N Judah Muni stop right in front of the ballpark, which is two blocks down from Hennessey's.
PAYMENT	VISA MC
POPULAR DISH	Most people come for a sandwich at lunch. Try the chicken salad on rye with some Swiss. Everything in the deli case is housemade daily. Usually, I will get one of the two, daily housemade soups (daily soup selection posted on the website), some bread and a gourmet cheese.
UNIQUE DISH	A combination deli, grocery, and wine bar, which also sells cigars. Hennessey's has fresh bread, gourmet cheeses, fruit, chocolate, juices, soups, and a well chosen selection of wines.
DRINKS	This is the first place I stop to grab a bottle of wine because I know most everything they have will be good. The website has a large focus on wine and wine recommendations. There is also a monthly wine club.
SEATING	Most people use Hennessey's as a deli - ordering their food and then heading back to the office. There is limited seating (4-5 tables) on the back patio with space heaters and shade umbrellas.
AMBIENCE/CLIENTELE	This is a small place where the same people keep coming over and over for their lunch. Sometimes

you have to shuffle through people waiting for their sandwiches to get to what you want, but seeing so many people reassures you that you're eating good stuff.

EXTRAS/NOTES A nice thing to do in the afternoon is to have a flight of wine and the daily cheese and fruit board all chosen by the proprietor. The only place to sit in Hennessey's is outdoors on a patio - so make sure the weather is nice. Once a friend and I were doing just that when the owner offered us some game tickets he couldn't use. They really appreciate their customers.

—*Caitlin Cameron*

Henry's Hunan

Would you like that hot, hotter or hottest?
$$
1016 Bryant St., San Francisco 94103
(between 8th St. and 9th St.)
Phone (415) 861-5808

CATEGORY Neighborhood Hunan-style Chinese

HOURS Mon-Sat: 11:30 AM-9 PM

PARKING Most streets are metered until 6 PM, some side streets are unmetered. A little far from BART/Muni Civic Center Station - but if you're willing to walk it's about 10 minutes.

PAYMENT VISA

POPULAR DISH Some of the standouts are Diana's Meat Pie, the Hot and Sour soup (great for clearing out the sinuses), the dumplings, the string beans with shrimp, and Henry's Special.

UNIQUE DISH The first to serve hot-Hunan style Chinese food in the US. As I understand it, all locations of Henry's are very good about making things to order. You can specify modifications and spiciness or change something to vegetarian without much trouble at all. Even better, at this location, if you become a regular the headwaiter, Jeff, remembers your favorites for you.

DRINKS Typical pot of green tea is usually sufficient but the also have the usual suspects when it comes to Asian beer.

SEATING Seating at this location is ample. Typical two and four top tables throughout the large room painted red and white.

AMBIENCE/CLIENTELE This is a pretty bare bones place (as opposed to the Natoma location). The walls are cheerfully painted red and white, but there are no pictures. The only things on the wall are reviews and publicity for the restaurant. Many people stop in just to pick up their take-out order, but there are always a few diners around making small talk with the waiter, Jeff, or watching sports. Lunchtime is the more crowded hour (usually a wait).

EXTRAS/NOTES The thing that stands out, for me with Henry's, is the freshness of the food. I notice every time I have the string beans and shrimp, for example,

that everything tastes fresher to me than any other Chinese restaurant I've been to. The thing to keep in mind is that the portions are big, so if you go alone, you are essentially buying tomorrow's meal as well.

OTHER ONES • Financial District: 674 Sacramento St., 94111, (415) 788-2234
• The Embarcadero: 924 Sansome , San Francisco 94101
• SoMa: 110 Natoma St., San Francisco 94105, (415) 546-4999

—Caitlin Cameron

Izzy's Brooklyn Bagels

(see p. 217)
Jewish deli/bagelri/pizzeria
151 Townsend St., San Francisco 94107
Phone (415) 543-0900

Osha Thai

It might be too pretty to eat.
$$$
149 Second St., San Francisco 94105
(between Mission St. and Howard St.)
Phone (415) 278-9991 • Fax (415) 278-9992
www.oshathai.com

CATEGORY	Hipster Thai
HOURS	Mon-Sat: 11 AM-11 PM Sun: 4:30 PM-11 PM
GETTING THERE	There is a parking lot on Natoma St. but the restaurant is very close to the Financial District and also the Montgomery BART/Muni Station.
PAYMENT	VISA
POPULAR DISH	I like to test the quality of a Thai restaurant by its Pad Thai. Osha makes one of the better Pad Thais around but each dish is more exciting than the next here. There is a good mix of traditional Thai and the occasional fusion flair.
UNIQUE DISH	The mango and sticky rice with coconut milk is gorgeous. One dining companion remarked that Thai restaurants always seem to be the most artistic and innovative when it comes to presentation. Osha is no exception.
DRINKS	Everyone goes for Thai Iced Tea, but they also have a great wine list and the usual suspects when it comes to Asian beers.
SEATING	The space is huge and seating ample with a surprising variety. There are large tables with benches and back cushions, and there are many two and four tops. It suits any size group.
AMBIENCE/CLIENTELE	The decor is beautiful with a mix of traditional Thai sculpture and motifs combined with details such as metallic tiles and dramatic lighting. Lunchtime is the typical office crowd and usually packed—they only accept lunch reservations for

groups bigger than five. Dinner is a very eclectic crowd with birthday parties, dates, and small groups. It is always lively but not alienating to the lone diner (as I have been on occasion).

EXTRAS/NOTES There is a definite trendy vibe here as it is just across the street from 111 Minna (a hip gallery and club).

OTHER ONES • Nob Hill: 696 Geary St., San Francisco 94102, (415) 673-2368
• The Mission: 819 Valencia St., San Francisco 94110, (415) 826-7738
• Financial District: 4 Embarcadero Ctr., San Francisco 94111, (415) 788-6742

—Caitlin Cameron

Roy's

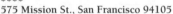

Haute Hawaiian hospitality without the long flight & tourists.
$$$$
575 Mission St., San Francisco 94105
(at 2nd St.)
Phone (415) 777-0277
www.roysrestaurant.com

CATEGORY Pan-Asian and Hawaiian

HOURS Mon-Fri: 11:30 AM-2 PM; 5:30 PM-9 PM
Sat/Sun: 5 PM-10 PM

GETTING THERE Valet parking is available on weekends until about 8:30 PM. There is usually street parking in front of the restaurant on Mission free of charge in the evening or anyone of the many public garages that are available on 2nd or Mission St.

PAYMENT VISA mastercard Cards

POPULAR DISH Yellow Fin Ahi Poketini with Wasabi Aioli, Avocado and Tobiko Caviar. This tasty delight comes served in a decadent martini glass with two freshly fried chips for dipping out the bed of tomato salsa. The ahi is always superbly fresh and the spicy/cool pairing of the dish is sure to delight.

UNIQUE DISH The tofu version of the poketini will definitely keep vegetarians in good spirits at the carnivore driven venue . It has all the delicious flavors of the yellow fin poketini, sans meat.

DRINKS Roy's offers a full bar with a wide selection of wines. A must try: Roy's signature Hawaiian Martini. By soaking SKYY vodka, Malibu coconut rum and fresh cut pineapple together for over three days this heavenly concoction, with no juice, tastes as sweet and smooth as a frothy pineapple smoothie.

SEATING Great for couples and groups. Tables can be arranged to accommodate large groups. There is an upstairs loft specially designed for large engagements that offers more privacy and a great overlook of the entire restaurant. This venue is quite spacious for San Francisco dining and the upper floor helps to give an open and airy feel.

AMBIENCE/CLIENTELE Do you miss Hawaii? Have you never been but always wanted to go? Who ever you are, Roy's

is definitely a tiny piece of Hawaii here on the
mainland. You will find traditional and Pan-
Asian fusion dishes here with unique flavors and
unsurpassed freshness. Everything is prepared
and presented with such immense attention to
detail that you will feel like an honored guest
every time you visit. Although it can be tough
to get a table in the restaurant, the full menu
is always served at the bar and you will be
delighted with a unique experience of friendly,
engaging bartenders and managers. Most people
come dressed in at least business casual, but
all are welcome. The feeling of Ohana is spread
throughout this venue and the warmth of Hawaii
can be felt no matter how foggy The City gets.

EXTRAS/NOTES Every May 1st, Roy's takes a Hawaiian holiday
and celebrates Lei Day. This holiday, which began
in Hawaii in 1928, is celebrated with a special
prix fixe menu, live Hawaiian music and fresh leis
flown in from Maui for all of Roy's guests.

—*Mary Poffenroth*

Schnitzelhaus

Schnitzelhaus. Gezhundheit!

$$$$

294 9th St., San Francisco 94103
(between Folsom St. and Howard St.)
Phone (415) 864-4038
www.schnitzel-haus.net

CATEGORY	Low-key German
HOURS	Tues-Thurs: 5 PM-10 PM
	Fri: 11:30 AM-10 PM
	Sat/Sun: 5 PM-10 PM
GETTING THERE	This place is about three blocks from the Civic Center BART/Muni station. Parking is relatively easy to find on the street (free after 6 PM) with some unmetered streets nearby, too.
PAYMENT	VISA
POPULAR DISH	There is a good selection of schnitzels as the name of the restaurant would suggest. Go for a schnitzel with a sauce, such as the Jagerschnitzel. Another of my favorites is the beef rolls, which are seasonal vegetables stuffed into thin beef rolls and covered with sauce. Most dishes come with potatoes and red cabbage sauerkraut. Go for the soup. It's garlic, potato, and excellent. Apple strudel is especially good.
UNIQUE DISH	German restaurants are less common than Asian places and burger joints, so the novelty of going to a German restaurant is part of why Schnitzelhaus is unique in the first place. All the food is authentic German or Austrian as the owners are originally from the German/Austrian border. Venison and rabbit are both on the regular menu. However, there is an impressive vegetarian section of the menu for those who are there for the atmosphere and not the heavy cholesterol.

DRINKS Beer, beer, and more beer. There is an ample (though not exhaustive) German and Austrian beer list with sizes ranging from .3-litres up to 1-litre.

SEATING In true German Beer Hall style, the wood-paneled room is lined with padded benches and large wooden tables that are moved around to accommodate different sizes. If your party is small and the restaurant is crowded, do expect to be seated at a table with others.

AMBIENCE/CLIENTELE Schnitzelhaus can be a little hard to spot—sausaged in between a cafe and an x-rated cake shop, the dark wood paneling and unassuming signage don't stand out. But once you're inside it's nice and cozy and . . . German. The dining room is covered in wood paneling and has a little bar to the back. The two owners are the servers and they are very charming, making sure to come by the table to chat a little bit - but you're on their schedule. This is a place to go with a group. The tables are large for communal seating and large groups and the portions of food are huge.

EXTRAS/NOTES Unfortunately, they are only open for lunch on Fridays. The rest of the week it is dinner only. Be prepared to be there for a while. You are never rushed here and neither are the other customers.

—*Caitlin Cameron*

Tres Agaves

Not one, not two, but Tres Agaves.
$$$$
130 Townsend St., San Francisco 94107
(at 2nd St.)
Phone (415) 227-0500 • Fax (415) 227-0535
www.tresagaves.com

CATEGORY Stylish restaurant and tequila lounge

HOURS Mon-Weds: 11:30 AM-3 PM; 5 PM-10 PM
Thurs/Fri: 11:30 AM-3 PM; 5 PM-11 PM
Sat: 10:30 AM-11 PM
Sun: 10:30 AM-10 PM

GETTING THERE Parking can be OK earlier in the evening, but gets harder the later it gets. During baseball season, count on taking a cab or using public transit.

PAYMENT VISA MasterCard

POPULAR DISH Since the Chile Rellenos are the only meatless entrée, it is a darned good thing that they are among the best ones I've ever had. Poblano chiles filled with cheese, corn, zucchini and mushrooms, they are often noted by non-vegetarians as well. The Pollo al Pastor (spit-roasted half-chicken) and Tacos al Pastor are among the meat-eater favorites.

UNIQUE DISH Featuring upscale traditional Mexican cooking, primarily of the Jalisco region, this will be a new experience for those accustomed to having their Mexican food wrapped in a large tortilla and/or slathered with salsa and cheese (although there is usually nothing wrong with that). The tasty sides

including rice, beans and cabbage salad are served family-style with all entrees, making for easy sharing.

DRINKS Tequila is the featured item here with dozens of choices available. With flight samples, you can learn the differences between highland and lowland varieties. There is something for everyone from the merely curious to the budding tequila snob. The margaritas are excellent, but at prices ranging from $24 to $68 per pitcher, you can run up a big tab fast.

SEATING This is spacious and has a variety of seating. Three booths mark each end with around twenty tables for one to four people (or more when put together) and two large picnic-style tables that can seat ten to twelve in between. There is also a sizeable bar area. Two private dining rooms can be rented for private events, one of which seats up to 125.

AMBIENCE/CLIENTELE This is your basic Mexican rancho meets South of Market warehouse chic with high ceilings, country-style tables and an open kitchen enabling you to watch the skewered chickens roast over flames. It is well designed, but casual and filled with an animated, positive energy as large groups, SOMA scenesters, the post-work Financial District crowd and during baseball season, the pre- and post-Giants' game crowd, all come together.

EXTRAS/NOTES Among the partners in this venture is Sammy Hagar, but don't worry, you won't be subjected to his music while you are there.

—*Bill Richter*

Tu Lan

Vietnamese diamond amidst the rough of a filthy downtown street.

$$

8 6th St., San Francisco, 94103
(at Market St.)
Phone (415) 626-0927

CATEGORY Hole-in-the-wall Pho and BBQ

HOURS Mon–Sat: 11 AM-9 PM

GETTING THERE Being right off of Market St., any interested patron of Tu Lan can arrive to the location on a plethora of Muni Buses and trains, or East Bay residents can take the BART train to just one long block away from 6th St. (get off at either Powell or Civic Center Bart Stations). If driving, parking is available on the street, but be mindful of the neighborhood.

PAYMENT Cash only

POPULAR DISH The greatest thing about Tu Lan is there's a different dish at every table because everything is delicious. In my opinion the best dish is the combination noodle bowl with Pork Kabob and Imperial Roll. A hefty amount of cold rice noodles sit on top of a bed of speared cucumber and sprouts. Crumbled Peanuts sit above the noodles with tender and savory Barbecue Pork Kabob and 2 large, bite-size-

cut imperial rolls spilling over the top of the big dinner bowl. Pouring the light and sweet imperial sauce with carrots all over everything and utilizing the Siracha and Hoisin provided on the table, turns this dish into the most perfect Vietnamese noodle dish I could ever ask for.

UNIQUE DISH The Spicy Beef Noodle soup sits atop a great selection of pho selections at Tu Lan. Thin slices of onions and beef surround a large bowl of noodles in a spicy and hearty broth. All Pho is served with a garnish of sprouts, lemon/lime wedges, and cilantro. I highly recommend using the garnish in your soup and try mixing it differently in each small individual bowl you serve yourself. For an extra impressive flavor add some of the Hoisin condiment provided on the table. If you don't like spicy, try any of the other noodle soup options because they're all great. My other personal favorites would be the chicken, but as I said before, everything on this menu is impressively tasty.

DRINKS The drink menu is somewhat limited, but incredibly inexpensive. Although no cocktails are served – or any hard drinks or wine – they do provide local and imported (Vietnamese) beer for around $2. A local favorite on the drinks menu would be the Vietnamese coffee, which is quite strong and authentically Vietnamese.

SEATING The seating is cozy and simple. There are about sixteen tables downstairs and about another six upstairs. Also, the diner seating probably seats another ten. With a relatively fast turnaround, it's rare to have to wait for seating at Tu Lan.

AMBIENCE/CLIENTELE Tu Lan is a very fast-paced, no frills Vietnamese Diner. The walls are simple with some cultural art, and some Vietnamese beer advertisements, but otherwise, the environment is rather simple and crammed together. With the open kitchen right behind the diner seating, Aromas of Vietnamese spices from every dish permeate the restaurant, stimulating taste buds and inspiring me to over-order and over-eat because there's just too much good food. Every type of clientele seems to arrive for dine-in or take-out from the shabby, bearded toothless types, to the middle aged, snobby, executive, Yuppie types, and everything in between. The diversity of patrons creates a melting pot almost as inspiring as the Beef noodle soup. The loud and snappy waitstaff are all business, and do their jobs very well.

EXTRAS/NOTES If a homeless person directs you into a parking spot, don't be alarmed, they are simply trying to get a couple dollars from you without having to wash a windshield. Use your discretion as to whether you decide to provide them with any monetary compensation for pointing you to a spot you could've found on your own. They've been around for so long that there's a picture of Julia Childs on the menu and she looks really young.

—*Ian J. Strider*

NORTH BAY/ WINE COUNTRY

NAPA

Bistro Don Giovanni

*Cavernous yet cozy Napa staple delights
locals and tourist alike.*
$$$$
4110 Howard Ln., Napa 94558
(at Highway 29)
Phone (707) 224-3300
www.bistrodongiovanni.com

CATEGORY	Italian bistro for locals and tourists
HOURS	Sun-Thurs: 11:30 AM–10 PM
	Fri/Sat: 11:30 AM–11 PM
GETTING THERE	A large parking lot, never a problem
PAYMENT	VISA MasterCard Cards
POPULAR DISH	The double cut pork chop grilled to perfection with olive oil mashed potatoes
UNIQUE DISH	*Pollpette de Agnell*—milk braised lamb meatballs, with artichokes, fennel and Tuscan mint. Try the whole roast fish of the day.
DRINKS	Full bar, great wine list (the wait staff is very wine savvy and offers great suggestions at any price level). There are mixed drinks too, but, really, you're in Napa. How could you not get wine?
SEATING	Very large dining room, especially for Napa. Cavernous yet cozy with room for 100. Beautiful patio, with room for up to 45
AMBIENCE/CLIENTELE	The heavy wooden door opens to a crush of humanity, then you smell aroma the combination of garlic and the wood-burning oven. A place where local Napa-ites mingle with the limo-riding tourists for a friendly and fun dining experience. Start with a glass while you wait for your table, then enjoy professional service and hearty Tuscan fare.
EXTRAS/NOTES	The management runs the restaurant as if it's a family house party and you are the guest of honor. Reservations are strongly recommended, and you still may have to wait, but the fun bar makes the time pass quickly and the outside patio is a great place to wait, wine glass in hand.

—*Bill Anderson*

Kelly's No Bad Day Café

*No pretensions, no hummers,
and no bad days*
$$$$
976 Pearl St., Napa 94559
(at Main St.)
Phone (707) 258-9666

CATEGORY	American café
HOURS	Mon-Thurs: 5 PM-9 PM
	Fri/Sat: 5 PM-10 PM

GETTING THERE There is parking on the street only and a movie theatre nearby so it can get kind of crowded. So, if you have to walk a block or two, who cares? It's Napa! There are worse places to stroll…

POPULAR DISH The Thai Spinach Salad is a local's favorite with tender baby spinach, nuts and "secret" salad dressing. Everyone wants the recipe, but Kelley ain't talkin'. It's as addictive as her personality. Also, the burger is phenomenal and her specials are inspired by the seasons and change nightly so be sure and check with the chef. Mostly, she offers down home, good cookin' with roasted chicken, freshly whipped mashed potatoes and perfectly seasoned green beans. Her Ribeye is also delicious, accompanied by her rich Polenta and veggies of her choice. The Chef Salad, as mundane as they can be, is incredible. It is huge and every ingredient is the best there is to offer: juicy chicken breast, Neuske's bacon, local blue cheese, etc. It is outstanding and great to share.

UNIQUE DISH Chef Kelley Novak spent some time in Thailand and that influence adds a light dusting of Thai essence to her cooking without overwhelming it to the degree of a pseudo-Thai place.

DRINKS Wine is the preferred drink but I've been known to cleanse my palate with a Negro Modelo beer or an ice-cold Corona. This is part of Kelley's I-wish-I-were-in-Mexico-right-now-instead-of-cooking-for-you-clowns influence. But, while she's here, it's our gain and Mexico's loss. She has a passion for her food: a la Soup Nazi. Also, if you are ordering wine, share with the Chef (she loves Chardonnay).

SEATING There are about 20 tables in the dining room and 6-8 barstools at the hotly coveted bar counter. Only here can you truly receive the brunt of the chef's frustrations and humor so arrive early for those seats. Large parties can be accommodated in the dining room with advance notice.

AMBIANCE/CLIENTELE It's Tommy Bahama meets Jimmy Buffet with a lot of lively, kitschy trinkets and not-so-understated political adornments. There are palm trees painted on the windows and the brightly colored walls are adorned with plastic parrots and Dia de los Muertos (Day of the Dead) artwork. At one visit, a life size George Bush cut-out welcomed you at the door, complete with blacked out teeth. If you happened to miss the neon Hummer with a slash through it in the front window, you can't help but notice the toy-size version with a chef's cleaver stuck in the roof, dangling over the bar counter which overlooks the open kitchen. And, if you were too entranced by the numerous sets of George Bush playing cards, punching puppet nuns, plastic peeing toys, odd salt and pepper shakers (a few in adult positions) or the bamboo bar, complete with thatched roof that sits patiently in the corner, waiting for summer, then heed the warning on the menu: No Hummers allowed! Aside from all the distraction,

Kelley Novak is one of the best cooks in Napa, never mind a creative Chef and savvy business owner. Since bathrooms are always an item of discussion when reviewing a restaurant, they are equally as busy and entertaining. Everything from jokes, to songs lyrics to quotes from Tom Robbins, makes you think and smile as you do your otherwise necessary duty. They are always clean and well decorated. Back in the restaurant, there is an occasional acoustic guitar player who is very talented. Also, she has been known to hire a DJ on occasion but that is kinda between the locals. You can become one, if you play your cards right. Heed the warning on the back wall of the kitchen: "The Chef is Always Right". Call ahead to find out if they have music that evening. The dishes can sometimes take a while to come out of kitchen, but that is only because she is executing every dish herself and hurling insults and teasing regulars at the same time. Be patient, it's absolutely worth it.

EXTRAS/NOTES One night, a particularly dense couple parked their gleaming Hummer right in front of Kelley's No Bad Days Café and came tripping on in for dinner. Somehow, they missed all the warning signs. The staff noticed them, but feared Kelley's reaction and decided not to tell her. Well, she happened to see the aforementioned monstrosity, parked irreverently right out front, walked to the front door, turned on her heel and said, in a G-rated version, "Whose Hummer is this?". Well, the unassuming couple raised their hands. Kelley was bemused to learn that they had already ordered and were through their first course. So, she decided to let them stay and enjoy the rest of their meal. However, she did get the last laugh when she served their beautifully executed dinner, not on a traditional plate, but the back of a license plate that read: HUMRH8R (Hummer hater). That's our Kelley.

—*Kelly McFarlane*

Eleven of Our Favorite Songs About the Bay Area (In No Particular Order)

"Palo Alto" by Radiohead
"Journey to the End of the East Bay" by Rancid
"We Built this City on Rock and Roll" by Starship
"San Francisco Blues" by Peggy Lee
"I Left My Heart in San Francisco" by Frank Sinatra
"San Francisco (Be Sure to Wear Flowers in Your Hair)" by The Mamas and the Papas
"Fake Tales of San Francisco" by Arctic Monkeys
"California Uber Alles" by The Dead Kennedys
"Dear Mama" by Tupac Shakur
"Sitting on the Dock of the Bay" by Otis Redding
"Yay Area" by EB-40

SANTA ROSA/HEALDSBURG

Flavor

No more bland dining in Santa
Rosa thanks to Flavor.
$$$
96 Old Courthouse Sqr., Santa Rosa 95404
(at Fourth St.)
Phone (707) 573-9600

CATEGORY	California cuisine with Wine Country flair
HOURS	Mon: 11 AM-10 PM
	Tues-Thurs: 6:30 AM-10 PM
	Fri/Sat: 6:30 AM-11 PM
GETTING THERE	Metered street parking usually full, but there's a parking garage next to the restaurant (enter at Fifth St.)
PAYMENT	VISA ⬤ Cards
POPULAR DISH	Crab Cake topped with crunchy fried shoe string yams with a drizzle of basil aioli; Harvest Salad (huge!) with fruit, toasted nuts, feta cheese; fresh pasta dishes such as butternut ravioli in a toasted sage butter and an autumnal risotto with chicken, mushrooms, spinach and garlic.
UNIQUE DISH	There is nothing remarkably unique about the entrées; however, many of the dishes are offered in a small and large size so you have the option of ordering two or three small dishes or one large plate
DRINKS	A little of everything; good wine list, lemonade, sodas, and beer
SEATING	It is a huge restaurant, with tables for two and four that can be easily arranged to seat more. Seats in the front of the restaurant by the fireplace are the most prized.
AMBIENCE/CLIENTELE	Santa Rosa has its share of overpriced restaurants and chain eateries, but nary anything in between. Flavor fills that void. It seems to cater to everyone; you'll see couples toasting by the fireplace and loud families just a couple of tables away. But it works. The main dining room is huge, yet the warm yellow walls, wine country paintings, and distinctive bar provide a comfortable atmosphere. And though there are tons of tables, this is a joint that fills up by 6:30 PM.
EXTRAS/NOTES	If you're bringing little ones, they offer organic PB&J sandwiches and homemade Mac and Cheese. Kids will eat and parents won't have to worry about what they're eating.

—*Melinda Wright*

El Farolito

(see p. 74)
Taqueria
565 Seabastapol Rd., Santa Rosa 95407
Phone (707) 526-7444

Grateful Bagel

(see p. 154)
Bagelry **1015 4ᵗʰ St., Santa Rosa 95404**

Zin Restaurant
Wine Country comfort food.
$$$$
344 Center St., Healdsburg 95488
(at North St.)
Phone (707) 473-0946
www.zinrestaurant.com

CATEGORY	California comfort food
HOURS	Mon-Fri: 11:30 AM-2 PM; 5:30 PM-9 PM Sat/Sun: 5:30 PM-9 PM
GETTING THERE	Street parking, easy enough, but can become more difficult during the peak of tourist season.
PAYMENT	VISA
POPULAR DISH	Applewood Smoked Pork Chop with Andouille Sausage and Corn Bread Stuffing. Even though the portions are ample here at Zin, you can never get enough of that stuffing. They also do a remarkably tender braised short rib. The nightly blue plate specials are worth careful consideration too—who knew you could order meatloaf in the wine county? The Brownie Sundae with Kona Ice Cream will garner envious glares from those nearby who settled on a more "adult" dessert.
UNIQUE DISH	Mexican Beer-Batter Green Beans for a starter. All dishes have ingredients that make them compatible with a good bottle of Zinfandel so if you aren't an oenophile you can look like you know what you are doing.
DRINKS	Zin—of course. Great variety of Sonoma County wines from the Russian River, Dry Creek and Alexander Valleys. Over half of the wine list features Zinfandel, but you can find other red and even some whites here too.
SEATING	Roomy, with booths lining the sides of the restaurants and tables in between.
AMBIENCE/CLIENTELE	This place is loved by the locals, and exemplifies that casual-yet-urban "Wine Country style" where the food (and drink) is more important than the scene. Open kitchen, small yet convivial bar add to the ambience. You can dress up if it's a date night, but this is tourist country, so prepare to see a lot of khakis.

—*Melinda Wright*

PETALUMA

Dempsey's

Hometown American brewery goes organic.
$$$$
50 E. Washington St., Petaluma 94952
(at Petaluma Blvd. North)
Phone (707) 765-9694
www.dempseys.com

CATEGORY American diner and brewery

HOURS Daily: 11:30 AM-9:00 PM

GETTING THERE Dempsey's Restaurant & Brewery is located in historic downtown Petaluma about one mile west of 101, in the Golden Eagle Shopping Center. Parking is plentiful in the shopping center, but by far the best way to arrive at Dempsey's is to include a stop there while wandering around downtown and along Petaluma's River Walk. From Petaluma Boulevard North (the main drag), take the alleyway where Western Avenue crosses the Boulevard and cross the Petaluma River on the walking bridge that links Dempsey's to historic downtown.

PAYMENT

POPULAR DISH The best choices are always on the Specials Menu, which changes daily. The selections are consistently creative, blending the freshest locally grown ingredients with various ethnic influences (Mexican, Cuban, Thai) on the specials menu and then offering tried and true favorites on the regular menu, such as pork chops or roasted half-chicken. Or, if you're just looking for a snack to have with your brew, try the decadent Plate of Thin Fried Onion Rings with Chipotle Ketchup.

UNIQUE DISH I was hooked on Dempsey's from my first visit when they offered stuffed zucchini blossoms on the specials menu—a dish I enjoyed many years ago in Italy, but had never seen on a menu in the US. Dempsey's owners run a small organic farm that supplies the restaurant with its perfect produce, which never fails to please the locals who are big on organics.

DRINKS Dempseys award-winning brews are definitely the drink of choice here. Be sure to sample the Ugly Dog Stout, named in honor of the Word's Ugliest Dog Contest. The annual event hosted by the Sonoma Marin Fair for the past eighteen years became known around the world when Sam, the ambassador of ugly dogs everywhere and so ugly he was often mistaken for a burn victim, reigned three years in a row until he died in 2006. See photos of Sam on his owner's blog at: http://samugliestdog.typepad.com/

SEATING Dempsey's is laid out in an "L" shape with booths along one side and plentiful tables along the other, which can be arranged to accommodate large or small groups of diners. Dining is also

available at the casual but elegant bar and a special bar menu is always available which is perfect for the solo diner, sports fans, or after work crowd. Plentiful outdoor seating is set up in fair weather so that patrons can enjoy the Petaluma River with their meal.

AMBIENCE/CLIENTELE Dempsey's is a great place to go for almost any occasion: the ambience is distinctly casual, yet you wouldn't feel out of place if you went dressed for a party. Part of what makes it truly special is the staff, many of whom have worked there for many years and are very knowledgeable about the local wines and Dempsey's special home brews. They will gladly make recommendations on the best food to go with them, and I highly recommend placing your dining fate in their able hands! The clientele is mostly local and you will see families with children, workers just off a shift, professionals hosting out-of-town guests and the occasional lucky tourist who happens to stumble upon this gem of a dining experience.

EXTRAS/NOTES Dempsey's is definitely as kid-friendly just as Petaluma is a distinctly family-friendly town. High chairs are available, as is a diaper-changing station in the restroom. Wait staff have been seen diving for Binkies under the tables and even rinsing them for dining parents of young children and there is an ever-present line of strollers parked at the front door. What is perhaps best about dining at Dempsey's with children is that it is almost always noisy, and so if your little one melts down, no one will even notice!

—LeAnn Joy Adam

Sea Modern Thai

Mummies not Zombies: a lesson in Thai and Petaluma poultry.
$$$$
500 Petaluma Blvd. South, Petaluma 94952
(at G St.)
Phone (707) 766-6633

CATEGORY Neighborhood Thai
HOURS Tues-Fri: 11:30 AM-9 PM
Sat: Noon-9 PM
Sun: 5 PM-9 PM
GETTING THERE Sea is located on Petaluma Boulevard South and easy street parking is available on the Boulevard or G Street. The restaurant can be overlooked, as it is just a couple of blocks outside the main part of historic downtown Petaluma, but for a unique, fun and exquisite Thai dining experience, Sea is not to be missed.
PAYMENT VISA Cards
POPULAR DISH I love the Sea Golden Halibut, slowly grilled with fresh minced red chilies and basil, incorporated with Merlot, milk, onion, red bell pepper and zucchini. However, my personal favorite is the

Drunken Man Noodles, stir-fried wide noodles, with egg, bell pepper, fresh chili, onion, tomato and soy sauce. According to Chef Tony, this dish is extremely spicy as it is served in Thailand and you can really only take the heat if you are good and drunk, hence the name. Sea's version is actually very mild for the uninitiated, though you can ask for varying degrees of spicy if that is to your liking.

UNIQUE DISH The ubiquitous Petaluma Mummy Chicken, marinated chicken breast and bacon strip wrapped in a banana leaf like a mummy and deep-fried. Served with sweet sauce and cucumber salad. For dessert: pan-roasted pineapple with coconut ice cream. Need I say more?

DRINKS Sea serves the best Thai iced tea I have personally ever tasted. There is a selection of local Sonoma wines, in particular, the handcrafted Pinot noir and Chardonnay from local Keller Estate. These and other fine California wines are also incorporated into Chef Tony's sauces.

SEATING Sea offers mostly small tables, but a larger table can easily be accommodated upon request. Every effort is made to accommodate young children and high chairs are available, but I would not recommend going in with a stroller, as the spaces between tables are narrow and Sea Thai is often crowded after 7 pm, even on weeknights.

AMBIENCE/CLIENTELE Sea has an informal and graceful feeling with its warm colors, candle light and décor that features religious artifacts from Thailand. The open kitchen and welcoming atmosphere gives one the feeling of visiting a friend's home rather than a restaurant. From the outside Sea Thai is like a fishbowl with tall windows along the front that give the outsider a view into the pleasant inside. Because of this, my first impression was that a family with small children might feel like bulls in a china shop, but my experience has been quite the contrary. I dined at Sea Thai with my infant daughter and the staff was exceptionally accommodating, and seemed genuinely happy to make us feel comfortable. Pia occasionally entertained my daughter while I concentrated on my Drunken Man Noodles and Mummy Chicken. There is also a robust take-out clientele.

EXTRAS/NOTES Ever since I first tried Chef Tony's Mummy Chicken, I have wondered if there is a connection to the local (and true) legend of the zombie chickens. In Petaluma, where chickens and eggs have been an agricultural staple for a century, the legend goes that zombie chickens have been seen staggering out of the compost heap at egg farms like the living dead. This is not a very appetizing thought and there is actually no connection between the two, but when I asked Chef Tony about it, we both got a good laugh out of the idea. He supports local farmers and wineries, but they can keep the zombie chickens.

—LeAnn Joy Adam

The Tea Room Café

*Quintessential Petaluma
community life.*

$$

316 Western Ave, Petaluma 94952
(at Howard St.)
Phone (707) 765-0199 • Fax (707) 765-0179

CATEGORY	Low-key bakery café
HOURS	Tues-Fri: 7:30 AM-4 PM
	Sat: 8 AM-2 PM
	Sun: 9 AM-2 PM
GETTING THERE	Four blocks off the main drag (Petaluma Blvd North) on Western Avenue, parking is easy at the Tea Room Café unless it's Sunday Mass time at St. Vincent's across the street. Parking right in front is free but limited to 2 hours from 8 AM -6 PM (except Sundays and Holidays), or free and unlimited ½ a block up Western on the other side of Howard Street.
PAYMENT	Cash Only
POPULAR DISH	Quite simply the best breakfast in Petaluma offering hearty dishes like Veggie Hash (with potato, leek, carrot and zucchini) and Buckwheat pancakes, or more gentle options such as homemade granola with seasonal fruit or organic yogurt. The breakfast favorites, according to owner Molly Best, are the Heavenly Pancakes (made with a sour cream base) and the home-made scones.
UNIQUE DISH	You simply cannot resist the enormous, fluffy and alluring coconut cupcakes, displayed for your pleasure and temptation right at the counter where you order your tea. Just try to walk away—I challenge you.
DRINKS	The Tea Room Café's specialty is tea: herbal, black, green, oolong or white, or you can try a café au lait European style in an enormous bowl. Wine and beer are also served, including local made-in-Petaluma Lagunitas beer, a "battle-tested brewery capable of making great beer out of goat's milk, brambles, and asphalt on the surface of the Moon, if need be." (Check it out www.lagunitas.com).
SEATING	Mostly small tables, including two choice tables right by the sunny windows. Go in between the breakfast and lunch rushes if you plan to hang out for a while and read the paper or watch the neighborhood life going by outside.
AMBIENCE/CLIENTELE	As you walk in the front door, the first thing you see is a quirky life-size model of a cow on a platform above the serving area. Strange as this sounds, the locals don't seem to mind and the Tea Room is almost always filled with neighbors, their friends and family. It's a great place to strike up a conversation with someone over their baby, dog, book or the scrumptious-looking thing they are eating. Small and chic, I'll often take some paperwork and my infant daughter, order a large pot of tea and sit all morning in a sunny window and pretend to work. It's heaven. The Tea Room serves breakfast and lunch (or coffee/tea and a snack) only.
EXTRAS/NOTES	I often see my neighbors out on a walk with

their kids and dogs sitting at the outdoor tables,
enjoying a steaming bowl of café au lait.

—LeAnn Joy Adam

NOVATO

Star Restaurant
*Down-home comfort food; everything
IHOP wishes it was.*
$$$
700 Novato Blvd., Novato 94947
(at Tamalpais Ave.)
Phone (415) 897-1970

CATEGORY	Large neighborhood '50s-type diner with expanded menu.
HOURS	Daily: 6 AM-10 PM
GETTING THERE	De Long exit off 101. Plenty of free parking on premises.
PAYMENT	VISA ●● Carte ●●
POPULAR DISH	Any breakfast, especially waffles. Huge eclectic menu of chicken-fried steak, liver and onions, a dozen salads, 41 sandwiches, Italian, Middle Eastern, you name it.
UNIQUE DISH	Fattoush salad (chicken, romaine, onion, calametto olives, peta, feta with mint vinaigrette dressing…the management is Middle-Eastern).
DRINKS	Full bar service
SEATING	Large, seats nearly 100, lots of leatherette booths.
AMBIENCE/CLIENTELE	Locals, families, blue collar, savvy area business people, served by gum-chewing, friendly, wise-guy, waitresses wearing tiaras. A welcome throwback to the '50s.
EXTRAS/NOTES	With waitresses like these, it's no wonder this place has been here over twenty years; they will make you feel like you're visiting your sister's home for dinner. Simply a terrific lofalutin' place especially for breakfast or lunch. Star Restaurant = star value.

—Saul Isler

FAIRFAX/SAN RAFAEL/SAN ANSELMO

Bangkok Thai Express
*The biggest variety of delectable
Thai cuisine this side of Asia.*
$$$
857 Fourth St., San Rafael 94903
(at Cijos St.)
Phone (415) 453-3350
www.BangkokThaiExpress.com

CATEGORY	Thai
HOURS	Mon-Thurs: 11 AM-3 PM; 5 PM-9:30 PM Fri: 11 AM-3 PM; 5 PM-10 PM Sat: Noon-4 PM
GETTING THERE	Plenty of street parking on 4th Street, 3rd Street, and in the two metered lots south of it.
PAYMENT	VISA mastercard Cards DISCVR
POPULAR DISH	My favorite dish in any Thai restaurant is usually Pad Thai. Here, they offer Pad Prik King — Chicken, Pork and Beef sautéed with crispy green beans and red bell peppers in a spicy sauce; and Pad Prik King—prawns sautéed with crispy green beans and red bell peppers. Other popular dishes are the Stir-Fried Asparagus and Crispy Basil Chicken.
UNIQUE DISH	It's tough to pick one unique dish but the Grilled Chicken Salad with Mango Salsa that I had was extremely tasty. The Railroad Track Veggies with Tofu sounded tempting, as did any of the curry dishes: Red Curry with Prawns, Chicken and Pineapple; Yellow Curry with Chicken or Prawns; or Green Curry with Chicken, Pork, Prawns, or Seafood.
DRINKS	Beer, wine, fresh fruit smoothies, Thai iced tea and coffee, baby coconut drink, Asian juices, soft drinks, hot coffee, and Thai hot tea are all on the menu.
SEATING	Seats about 50. Great place for large groups. But you can get a cozy table for two, too.
AMBIENCE/CLIENTELE	This is a casual neighborhood place, like most of the eateries that line Fourth Street in San Rafael. I saw folks wearing everything from T-shirts and shorts (me) to dress shirts and slacks (the 9-to-5 working class).
EXTRAS/NOTES	Bangkok Thai Express has been a local staple for Thai food for years in downtown San Rafael. Its web site only shows its two sister restaurants in the East Bay but I believe the menu is the same in all three.
OTHER ONES	• Berkeley: 1459 University Ave., Berkeley 94702, (510) 848-6483 • Emeryville: 5959 Shellmound St., Emeryville 94608, (510) 601-1038

—Gil Zeimer

Barney's Gourmet Hamburger

(see p. 160)
Hamburger joint
1020 Court St., San Rafael 94901
Phone (415) 454-4594

Café Gratitude

(see p. 154)
California Vegan
2200 4th St., San Rafael 94901

Casa Mañana

*The love child of Alice in Wonderland
and Diego Rivera, with pupusas.*
$$

120 Bolinas Rd., Fairfax 94930
(at Elsie Ln.)
Phone (415) 258-4520

CATEGORY Mexican/Salvadoran

HOURS Daily: 11 AM–8 PM (varies)

GETTING THERE Lot attached to restaurant, plenty of free street parking

PAYMENT VISA

POPULAR DISH Burritos named after Hispanic icons such as the Frida, Diego Rivera, Che, and Chewbacca (Chewbacca is Hispanic? File that under Who Knew?) are filled to the edges with perfectly-seasoned chicken, carnitas or shredded pork, among others. But what really sets this restaurant apart from its sombrero-birthday contemporaries are the platters: here, the enchiladas stuffed with your choice of meat or fried plantains and drenched with a rich, spicy mole sauce; grilled eggplant and tofu blanketed with homemade ranchera sauce; tamales cooked in plantain leaves; all served with rice and your choice of the best-seasoned black or refried beans ever. Period.

UNIQUE DISH Don't leave without trying a pupusa: a thick fried cornmeal pancake stuffed with Monterey jack, black beans, and/or chipotles. Served with a little sour cream, it's, well it's crack.

DRINKS Aguas and soft drinks, but no beer or wine. However, the laid-back staff is happy to let you bring your own cervezas or bottle of vino. If your visit is spur-of-the-moment and you forgot your Rothschild, 7 11 is just up the street; you can pick some up there.

SEATING Inside there are two tables that seat two and five barstools along the perimeter counter. On the porch outside are four tables and chairs. Many people get their food to go and take it to the Redwood Grove Park across the street.

AMBIENCE/CLIENTELE Ever seen a Mexican wrestler action figure? You can here. The interior of Casa Manana is like a little cigar box shrine. Azure blue walls are a backdrop to Our Lady of Guadalupe art, Cervantes and Gabriel Garcia Marquez quotes, woodblock prints. Suspended from the ceiling, antique Mexican marionettes rub shoulders with Virgin Mary paper lamps. Below John Coltrane's "A Love Supreme" album cover, a boom box blares Latin tunes. Try as you might not to gobble your crispy warm chips, between the jam-packed walls and the homemade salsas, you'll be at the bottom of the bowl in no time. And as the sign on the wall admonishes, "Absolutely, always, without a doubt even on Sunday even "just a few" extra chips $1".

OTHER ONES • San Rafael: 711 D St., San Rafael, (415) 456-7345

—Judy Zimola

Hanna's

Italian meets Mediterranean.
A match made in food heaven.
$$$$
1700 Fourth St., San Rafael 94903
(at G St.)
Phone (415) 457-6252
www.hannasrestaurant.com

CATEGORY	Low-key gourmet Italian
HOURS	Tues-Sun: 5 PM-10 PM
GETTING THERE	There is lots of on-street parking. Unless there is a special event going on downtown, parking is usually a breeze. Bicycles would be a lovely way to get there, and a great way to work off your pasta on the way home.
PAYMENT	VISA
POPULAR DISH	The Italian Pot Roast is fantastic! A great blend of wine and spice. The rich flavor makes you feel like you're sitting in your grandma's kitchen in Naples.
UNIQUE DISH	If you're thinking you want pasta, but you also may want a little *babaganoush* to start, you're in the right place.
DRINKS	A great place for wine. They have a nice selection for any meal.
SEATING	This is a small place, just a couple handfuls of small tables, which makes it oh so cozy.
AMBIENCE/CLIENTELE	This dimly lit, romantic place is all about locals. Countless patrons stroll up to the bar to greet the owner and staff, like they've known each other forever.
EXTRAS/NOTES	Clever interior. Lots of photos of famous people on the wall, most with autographs! The staff is always friendly and you usually get to see the same, helpful faces.

—*David Christopher Dubin*

Clam Chowder Bread Bowls for Everyone

San Francisco is known worldwide for its delicious clam chowder bread bowls, and most people know that the Fisherman's Wharf area is the place to go to get them, but where specifically should you go to get the best tasting bowl for your buck? Well, that depends on the type of clam chowder and the type of dining experience that you're looking for. Whether you want to enjoy this treat within an upscale dining atmosphere offering views of the bay or amongst street performers down at the corner, there is a place for you.

For those who are looking to get a traditional sourdough bread bowl with a bit of tourist information on the side, **Boudin's Bakery** is the place to go. Boudin's is known historically for being the first maker of the famous bread bowls which are now central to San Francisco's culinary culture. Their unique style of bread bowl is made from a fusion of French baking styles with traditional sourdough starter. It was developed in the middle of the nineteenth century and remains as tasty today as it was

reputed to be then. The Boudin Bread Factory is located right near Fisherman's Wharf.

Insiders know that there are two ways to get a bread bowl at Boudin's. Most travelers find themselves enjoying the sit-down restaurant on the second floor of the bread factory. On crowded days, a wait at this spot will include free admission tickets to the bread museum also housed there. The museum provides interesting historical information about San Francisco, excellent bread tasting opportunities and a view of Alcatraz sitting in the bay.

However, locals know that if a clam chowder bread bowl is all the food your heart desires, it makes more sense to pay the $3 museum admission tour, take the tour and forego the restaurant. That's because the sit-down version of the clam chowder bread bowl costs nearly $14. This doesn't mean that you have to miss out on tasting that famous sourdough. Located downstairs in the same building is a Boudin's Bakery-Café which offers the very same clam chowder in a bread bowl for less than half the sit-down price.

As far as picking up an inexpensive bread bowl goes, the most well-known spot is Pier 39. Travelers can stop at any number of little stands to get their clam chowder to go, sitting down on curbs or benches with their food to watch the street performers and caricature artists sell their skills. Alternatively, they can take the bowl with them over to where the sea lions are barking and enjoying the San Francisco waters. However, if you want more than just the experience of Pier 39, if what you're really looking for is the best clam chowder bread bowl in the city, there's a specific Pier 39 place to go get that bowl;

Chowders.
Chowders sits among the bustling walkways of the Pier 39 shopping center. This sit-down diner-style restaurant is easy on the pocketbook. Even better than that, it offers two different types of clam chowder; the traditional white chowder and the less-traditional red chowder. Red clam chowder is often only found on the East Coast but San Francisco visitors will find that this special treat is done up right out here in the West.

For those people who aren't looking for a sit-down dining spot, the other Pier 39 vendors are suitable but there's a better option just down the street. At Pier 41, right along Taylor Street, visitors can find a row of vendors lined up to sell seafood straight out of carts on the streets. There's not a bad batch in the bunch and the average cost is less than $5 for a bowl.

Of course, some people find that the bustling tourist activity of the pier areas is just a bit too over-stimulating for them. For those people who are looking to enjoy a more relaxed atmosphere while still getting a great bowl of clam chowder, the place to go is **Rogue's**. This brewery, located in the famous North Beach neighborhood is off-the-beaten path enough that the ambience is relaxed. And the clam chowder is some of the best in the city. The slightly thinned broth is complimented with flavorful chunks of bacon to offer a unique twist to the normal taste of clam chowder.

This chowder isn't served in a bread bowl, but it's complimented perfectly with the Hazelnut Ale Bread made with the brewery's own brew.

Whether you are the type of traveler who wears a fanny pack and carries a map or the kind who desperately wants to avoid being labeled a tourist, there is a place in San Francisco where you can go to enjoy the city's most delicious treat.

—*Kathryn Vercillo*

Lotus Cuisine of India
Northern India Cuisine—from vegan and vegetarian to fish and meat.
No passport required.
$$$
854 Fourth St., San Rafael 94903
(at Tamalpais Ave.)
Phone (415) 456-5808 • Fax (415) 456-5874
www.lotusrestaurant.com

CATEGORY	Northern Indian
HOURS	Mon-Sat: 11:30 AM-2:30 PM; 5 PM-9:30 PM Sun: 5 PM-9 PM
GETTING THERE	Plenty of on-street parking in meters along 4th Street, 5th Street, Lincoln, Tamalpais and neighboring streets.
PAYMENT	VISA
POPULAR DISH	My friend Jatin, a vegetarian and native of India, guided me through the menu on my two most recent visits. The Northern Indian cuisine is a bit spicier than Southern Indian fare. The chicken tikka masala, the naans (breads), curries (vegetarian, vegan, seafood, chicken and lamb), and Tandoori Specialties offer something for everyone.
UNIQUE DISH	Though there are four other Indian restaurants within a few square blocks of Lotus, I prefer the Lotus and Thali Specials of tantalizing and exotic combinations. Also, the Mushroom Mattar (Green Peas with Mushrooms Vegan dish) is not usually served in Indian restaurants in the US.
DRINKS	Beer, wine, mango lassi (homemade yogurt drink with mango), Indian teas, coffee, sodas and juices are available—all at reasonable prices.
SEATING	This restaurant offers a small room in the front with space for about 24 diners and a larger room in the back that can accommodate about 60 more.
AMBIENCE/CLIENTELE	The ambience is very much like India, with very courteous, very attentive service, a casual mood, and a music system providing Indian Fusion music (a blend of new age with Indian classical). When the roof is open, the room is light and airy. When it's closed, it's still a very comfortable, casual atmosphere.
EXTRAS/NOTES	Lotus has remained a bellwether for courteous service, outstanding variety and delicious

Northern Indian cuisine for over 20 years. Be sure to try their brunch buffet.

—*Gil Zeimer*

M&Gs

You just missed Gidget and Moondoggie.
Since 1962
$$

2017 Sir Francis Drake Blvd., Fairfax 94930
(at Claus Dr.)
Phone (415) 454-0655

CATEGORY	Burger shack
HOURS	Mon Sat: 11 AM– 9 PM Sun: Noon-8 PM
GETTING THERE	Lot attached to restaurant, plenty of free street parking
PAYMENT	Cash Only
POPULAR DISH	Hot dogs, hamburgers, chili, even garden burgers and salads come to you quickly in a paper boat with red checks, just as it should. Everything is cooked to order, so you get it hot and fresh. Burgers are all a quarter pound and done how you want it, with an array of artery-clogging options such as cheese, bacon, chili, or (if you're watching your waist) sautéed onions. The fish and chips are three crisp, lightly battered filets of cod served on a heap of golden crinkle fries with a Dijon mustard-mayo side. Remember tuna melts? They have those, too. Stack an onion ring on it as you eat and feel like you're 16 again.
UNIQUE DISH	You have a choice of regular hormone-fueled beef, Prather organic beef, or even a free-range organic buffalo burger. Cheese choices run from cheddar to the blue cheese or fontina, for the gourmands. Chalkboards display specials, such as Cajun sausage sandwiches and clam chowder. Shakes and malts are triple-thick and come in a range of flavors from plain (but rich) vanilla to butterscotch or coffee.
DRINKS	Famous shakes and malts in three sizes, the usual soft drinks.
SEATING	Tables inside and barstools along the front window can seat up to 24 people. Outside seats 24 as well.
AMBIENCE/CLIENTELE	Do-it-yourselfers, Harley riders passing by on their way to the coast, teenagers, and little leaguers crowd keep this little throwback in time perpetually busy. Plaques displaying pictures of winning softball teams jostle for space with old Pepsi signs on the wood-paneled walls. You could take your order home, but the outdoor patio with its oak barrel tables and wrought iron chairs is a fun place to relax and watch the cars go by. When your double cheeseburger with bacon comes (because that's what you'll order), blow the paper off your straw at your companion, then for the complete experience, dunk your crinkle fry in your shake.

| EXTRAS/NOTES | Started in 1962, this is the oldest burger place in Marin County. Owner Mark Escobar worked his way up from burger flipper to owner. |
| OTHER ONES | • Larkspur: 989 Magnolia Ave., Larkspur |

—Judy Zimola

Mambo's Café

A touch of the Caribbean in downtown San Rafael.
$$$
903 Lincoln Ave., San Rafael 94901
(at 3rd St.)
Phone (415) 453-1155

CATEGORY	Eclectic Cuban/Puerto Rican
HOURS	Sun-Thurs: 11 AM– 9 PM
	Fri/Sat: 11 AM-10 PM
GETTING THERE	Easy street parking
PAYMENT	VISA MasterCard Cards
POPULAR DISH	Appetizers are best. *Relenos de papas* (stuffed potatoes), ham croquettes, coconut shrimp.
UNIQUE DISH	Paella Valenciana for two. Spectacular combination of rice, a "myriad of seafood," chicken, onions, green peppers, tomato, olive oil, peas, chorizo, pimientos. Requires 45 minutes prep.
DRINKS	Beer and wine
SEATING	36 seats
AMBIENCE/CLIENTELE	Casual. Brightly lit. Dazzling neon coconut palms in middle of room lend festive atmosphere. Salsa music enhances Caribbean ambience.
EXTRAS/NOTES	New to neighborhood. Cuban/Puerto Rican restaurants on each side but this is the best of the three.

—Saul Isler

Maria Manso World Cuisine

She's got the whole world in her Cuban chef's hands.
$$$$
1613 4th St., San Rafael 94903
(between. F St. and G St.)
Phone (415) 453-7877 • Fax (415) 453-2869
www.mariamanso.com

CATEGORY	World cuisine
HOURS	Tues: 5 PM-9:30 PM
	Weds/Thurs: 11:30 AM-2:30 PM; 5 PM-9:30 PM
	Fri/Sat: 11:30 AM-2:30 PM; 9 PM-2 AM
GETTING THERE	Plenty of street parking in meters along 4th Street, 5th Street, F, G and adjacent neighborhood streets.
PAYMENT	VISA MasterCard Cards
POPULAR DISH	If you're a carnivore, this is your idea of meat heaven. Three of us ordered the Grilled Cowboy Steak and it was a huge hunk of burning, burning love, with 14 oz. of prime rib on the bone, accompanied by crispy yucca, baby bok choy and a reduced shitake mushroom merlot sauce.

UNIQUE DISH	The Maui Dumplings were exquisite, pungent and delish – pulled pork with Maui sweet and sour sauce and a grilled pineapple salsa.
DRINKS	The mojitos were perfectly blended and cooling. Huge wine and beer list, full bar, interesting list of cocktails, from Soju Martinis to Fizzes to blended drinks like Margaritas and Mudslides.
SEATING	This restaurant offers a medium room in the front with space for about 30 diners and a smaller deck in the back that can accommodate about 16-20 more.
AMBIENCE/CLIENTELE	The ambience is a blend of a hip nightclub with a trendy multi-cultural restaurant. On Friday and Saturdays, with more patrons, it can get pretty loud but it's still casually Marin.
EXTRAS/NOTES	This is a superb restaurant and an eclectic culinary experience. Maria's mom is Cuban. Her dad is Italian. Her menu is a United Nations tour of the Mediterranean, Latin American, Asia, the Middle East and beyond—in an elegantly casual setting, with warm, professional service at remarkably reasonable prices. It's best to call ahead for reservations.

—*Gil Zeimer*

Phyllis' Giant Burgers

The quintessential greasy spoon burger joint. Best burgs in Marin.
$$
2202 4th St., San Rafael 94901
(at Crescent)
Phone (415) 456-0866
www.phyllisgiantburgers.com

CATEGORY	Diner-style hamburger joint
HOURS	Daily: 11 AM-9 PM
GETTING THERE	Central San Rafael exit off 101 then east on 4th
PAYMENT	Cash Only
POPULAR DISH	Any burger. Great fries and O-rings. That's about it. Burgers are hand-made with that "fjords and peninsulas periphery look. These burgers drip and that ain't all bad.
DRINKS	Beer and soft drinks
SEATING	About eight counter stools plus a dozen chairs plus an outdoor patio.
AMBIENCE/CLIENTELE	Ain't nothin' here but the burgers.

—*Saul Isler*

Royal Frankfurter

Flay me with a footlong if these dogs ain't the best in the North Bay.
Since 1972
$
811 4th St., San Rafael 94901
(at Lincoln Ave.)
Phone (415) 456-5485

CATEGORY	Hot dog stand
HOURS	Daily: 11 AM-4 PM
GETTING THERE	101 to Central San Rafael exit, left on 4th
PAYMENT	Cash Only
POPULAR DISH	Any dog
UNIQUE DISH	Not an everyday dog, does that surprise you? It's the bockwurst, a fat, succulent German weenie. Crunchy buns are a plus.
DRINKS	Sodas and beer
SEATING	The place is just ten feet wide, a sort of bricked-over alley
AMBIENCE/CLIENTELE	People come here from miles around. The Grateful Dead's Jerry Garcia loved the place.
EXTRAS/NOTES	Opened in 1972 by Calvin and Grace Wong who've done the dogs daily for 34 years…with a smile. What cost 45 cents in '72 now runs $2.75-$4.35.

—*Saul Iser*

Sol Food

*Casual Puerto Rican cuisine
served in a broom closet-like setting.*
$$
732 4th St., San Rafael 94901
(at Lincoln St.)
Phone (415) 451-4765
www.solfoodrestaurant.com

CATEGORY	Puerto Rican
HOURS	Mon-Fri: 6:30 AM-10 PM
	Sat/Sun: 8 AM-10 PM
GETTING THERE	Lot which shares space with dry cleaners limits parking to fifteen minutes. If you are lucky to find metered parking you find a bargain at 65 cents an hour.
PAYMENT	VISA MasterCard
POPULAR DISH	The *Camarones Criollos* with seven large prawns sautéed in onions and garlic in a light tomato sauce served with heaping portions of rice and salad a quarter avocado and two pieces of *tostones* or *maduros* has just the right amount of garlic and the size of the portion may warrant a siesta after you eat. Also flat pressed sandwiches with natural pork, roasted chicken, Spanish chorizo or roasted peppers all made to order; so big, a bargain at $7.25
UNIQUE DISH	With all combinations or a la cart you can choose between the *tostones con mojo*, green plantains, fried, smashed then fried again in garlic and olive oil or *maduros*, a sweet fried plantain patty.
DRINKS	No booze, but plenty of American soft drinks as well as Puerto Rican coconut and molasses sodas in a self-service tub of ice.
SEATING	Inside there are seven chairs crowded next to two wood planks that serve as a bar. Outside is room for ten at the counters and four more at two small tables at the sidewalk. Also available, a wooden bench, a short brick wall and the hood of your car.
AMBIENCE/CLIENTELE	Friendly and casual service by a staff of six, crammed into a mini-van sized kitchen that

resembled the Tokyo subway at rush hour. The diverse clientele is a mix of business people at lunch or an early meal, Marin soccer moms and folks wandering over from the neighboring tattoo parlor. All are here to brave the crummy parking, crammed tables for a truly unique dining experience.

EXTRAS/NOTES An altogether it's-all-about-the-food experience. No frills, just exquisitely executed lunches and dinners that never disappoint.

—Bill Anderson

Sushi to Dai For

A stainless steel fishbowl,
breeding grounds for flavor.
$$$$
869 Fourth St., San Rafael 94901
(between Lootens Pl. and Cijos St.)
Phone (415) 721-0392

CATEGORY	Hip Japanese sushi
HOURS	Mon-Thurs: 11:30 AM-2:30 PM; 5 PM-10 PM
	Fri/Sat: 5 PM-11 PM
	Sun: 5 PM-10 PM
GETTING THERE	On-street parking is your best bet. Being downtown, parking is never quite easy, but also not impossible.
PAYMENT	VISA
POPULAR DISH	The very tasty, and mouth tingling Volcano Roll is a must in any sushi order.
UNIQUE DISH	The Harley Davidson Roll is fantastic. Don't you just love deep fried sushi? If you're in the mood for flavor, here it is.
DRINKS	Wine and beer are served for sure. Pair a scrumptious bottle of sake with your 'under the sea' meal for the true sushi experience.
SEATING	Small place, mostly small tables scattered throughout, plus the sushi bar.
AMBIENCE/CLIENTELE	Marin sushi lovers frequent this hotspot. From old to young, they come in droves to this modern, dark and metallic little place, to taste the sushi goodness.

—David Christopher Dubin

Avatar's Punjabi Burritos

Mexican done Punjabi-style.
$$
15 Madrona Ave., Mill Valley 94941
(at Throckmorton Ave.)
Phone (415) 381-8293

CATEGORY	Indian burritos

HOURS	Mon-Sat: 11 AM-8 PM
GETTING THERE	Fairly easy metered parking
PAYMENT	Cash Only
POPULAR DISH	Some of the most smokin' fusion burritos on the planet. These so-called burritos are really more akin to Indian food: a paratha Indian flatbread wrap filled with garbanzo beans, potatoes, basmati rice, chutney, carrot pickle, nonfat yogurt, and tamarind sauce.
UNIQUE DISH	You can add a number of fillings to this basic burrito from the regular menu, or chose one from the day's specials. On my last visit, the specials included fresh mustard greens with spinach, tofu, and chicken, a blackened ahi sea bass with pumpkin, blackened Niman Ranch beef with vegetables, and fresh rock crab meat with pumpkin and veggies.
DRINKS	The mango lassi and chai tea are everything they should be, but try the rose lassi for something out of the ordinary. Made with rose water, it tastes slightly like perfume. No alcohol.
SEATING	Seating is at a minimum in this postage stamp-sized restaurant, with two tables inside and three outside in good weather.
AMBIENCE/CLIENTELE	It's fun to people-watch here, with Mill Valley's mix of hippies, artists, and trophy wives. After filling up at Avatar's Punjabi Burritos, be sure to check out Sweetwater, the legendary bar and performance place across the way.
EXTRAS/NOTES	The owner's wife is an amazing hostess. Not only does Avatar's wife look like a goddess (after just one look at her stunning green eyes, a photographer friend of mine insisted on a photo session), but she is also damn nice.
OTHER ONES	Avatar's Punjabi Burritos is actually the off-shoot of Avatar's Indian fusion restaurant in Sausalito, which is also definitely worth a visit. If you go to Avatar's in Sausalito, try the pumpkin curry enchiladas. Yum.

—Karen Kramer

Half Day Café

*Bright, breezy and boisterous,
and the food is good too.*
$$$
848 College Ave., Kentfield 94904
(at Stadium Way)
Phone (415) 459-0291

CATEGORY	Hip California bakery café
HOURS	Mon-Fri: 7 AM-2:30 PM
	Sat/Sun: 8 AM-2:30 PM
GETTING THERE	Free parking lot, and some on-street parking is available. Parking could be a battle during those busy weekend breakfast rushes.
PAYMENT	VISA MasterCard
POPULAR DISH	Blubes. Fluffy blueberry pancakes. In a word, fantastic.

UNIQUE DISH	They have these interesting, sweet little fried balls of dough. Rich and decadent, but oh so worth the sin.
DRINKS	Coffee and the café usual
SEATING	Large and open. Many tables and booths. Large group, they'll push some tables together for ya.
AMBIENCE/CLIENTELE	Local Marin residents frequent this popular spot. A great place to take an out-of-town visitor. It's a bright and airy place, beautifully draped on the outside with lattice and ivy.
EXTRAS/NOTES	FUNEMNX? S, VFMNX. OK, MNX" written on the backs of the staff t-shirts. A hint, it has something to do with ham and eggs. Guessing the meaning is a good conversation starter, or if dining alone, a good way to pass the time.

—David Christopher Dubin

M&Gs

(see p. 147)
Burger shack
989 Magnolia Ave., Larkspur

SAUSALITO

Arawan Thai Restaurant

When you're in a hurry for curry.
$$$
47 Caledonia St., Sausalito 94965
(at Johnson St.)
Phone (415) 332-0882 • Fax (415) 332-8207
www.arawan.com

CATEGORIES	Low-key neighborhood Thai
HOURS	Mon-Fri: 11:30 AM-3 PM; 4 PM-10 PM
	Sat-Sun: 4:30 PM-10 PM
GETTING THERE	Street is fairly easy near the restaurant, which is a plus in Sausalito, where parking is often difficult. It is also fun to bike to the restaurant.
PAYMENT	VISA ⬤ Cards
POPULAR DISH	The curries always get rave reviews here. I personally love the red curry.
UNIQUE DISH	Try the specials and delicious seafood dishes. The food at Arawan is simply good, honest Thai cuisine.
DRINKS	No alcoholic drinks currently until Arawan again obtains a liquor license. When it does, go for a Thai beer. In the meantime, chill with some Thai tea.
SEATING	While it is popular, it usually doesn't take too long to get a seat at Arawan. Last time I visited for dinner, we were seated right away at a cute little corner table.

AMBIENCE/CLIENTELE The first time I went to Arawan, a friend of mine
in Sausalito who has lived there for years took
me, calling the restaurant "a local secret." On a
side street, parallel but far enough removed from
the downtown drag, very few people except for
locals ever find this place. It has a quiet, cozy
atmosphere during dinner and can be lively at
lunch.

—*Karen Kramer*

Caffe Trieste

(see p. 8)
Italian Coffeehouse
1000 Bridgeway St., Sausalito 94965
Phone (415) 332-7660

SEBASTAPOL

Grateful Bagel

*All your bagel dreams
will come true.*
$
300 S. Main St., Sebastopol, 95472
(at Hwy. 116)
Phone (707) 829-5220

CATEGORY Bagelry
HOURS Mon-Fri: 6 AM 5 PM
Sat/Sun: 7 AM-3 PM
GETTING THERE In the heart of downtown, walking distance from
all the public lots. The do have a mini parking lot
of their own in the rear.
PAYMENT VISA ⬤ Cards
POPULAR DISH Go with something classic, like an onion,
garlic, blueberry, or seeded bagel, pasted and
spread with one of many exciting cream cheese
concoctions. Lox and cream cheese, garlic cream
cheese, berry cream cheese etc., Try hearty egg
sandwiches made with your favorite bagel and
overflowing with yummy additions like melted
cheddar or Swiss and onions. Another standout
is their HUGE pizza bagels. They don't need
much dressing up, especially the yummy pesto
pizza.
UNIQUE DISH Trev's Herban Myth is such a clever sandwich.
Local Willie bird turkey slices and chopped herb
cream cheese are perfect together. And if you like
odd bagels, try the one covered in rock salt, or
the pumpkin bagel that is just like eating pie.
DRINKS They have a cooler, stocked with cold drinks like
Vitamin Water, Odwalla, and Martinelli apple
juices. They also have full service espresso with
Taylor Maid Farms fair trade beans.

SEATING One table with two chairs inside seems like not enough. Outside there is a picnic bench.

AMBIENCE/CLIENTELE Because the Grateful Bagel is perfect for "togo" you will find many merchants and busy working people scooting in and out all day long. But if you have time to spare and hangout, their outdoor giant chess set with squares painted on the concrete in front ought to entertain.

OTHER ONES • Santa Rosa: Grateful Bagel Cafe des Croisants 1015 4th St., Santa Rosa 95404

—*Brookelyn Morris*

Papas and Pollo

Burritos filled with everything but the kitchen sink.
$$

915 Gravenstein Hwy. So. (Hwy 116), Sebastopol 95472
(at Hutchins Ave.)
Phone (707) 829-9037

CATEGORY North Coast style Mexican

HOURS Hours vary from the actual times posted, generally open for lunch and dinner on "surfer time"

GETTING THERE Easy parking in their lot and on the street

PAYMENT VISA

POPULAR DISH Burritos are your best bet. Each one is as big as your head. Their chicken is signature, mesquite grilled with juicy bits and charred edges. Try it in the "Funky Chicken", the "Papas and Pollo", or the "Chicken on a Hot Tin Roof". But don't skip the tofu. Braised in brewers yeast and tamari, its flavor is huge. It is well showcased in the "Tofu Temptation".

UNIQUE DISH "Papas" – enormous baked potatoes are roasted and split down the middle. The centers are packed with your choice of chicken, tofu or fish. Piles of fresh salad, often grown on the Papas farm, cover the entire thing.

DRINKS Colas, Mexican fruit sodas and an ever-rotating tap of local microbrews like Bear Republic, Lagunitas and Booneville.

SEATING Two rooms of seating. Main dining room is large with metal patio furniture and brick benches and feels like outside. There is additional seating in a small room to the side and an outdoor patio in front.

AMBIENCE/CLIENTELE The thatched roof and swinging doors bring the outside in. This place is a melting pot of hippies, yuppies, bohemians and celebrities. The cutest women bare their surf brown bellies, while the men trade travel and adventure stories.

—*Brookelynn Morris*

Wild Flour Bread
Destination bread.

$

140 Bohemian Hwy., Sebastapol 95472
(at Bodega Hwy.)
Phone (707) 874-2938
www.wildflourbread.com

CATEGORY	California bakery
HOURS	Mon: 8:30 AM-6 PM
	Fri-Sun: 8:30 AM-6 PM
GETTING THERE	Free parking lot
PAYMENT	VISA ⬤
POPULAR DISH	Anything coming out of Wild Flour's wood-burning brick oven is manna from heaven—manna in the form of freshly baked, hand-kneaded bread. Another way to describe Wild Flour's bread is high art. Any way you slice it, this bread is damn delicious. You can sample each of their breads, which may include treats like cheese Fougasse bread, or the Egyptian bread with pear, fig and candied ginger. Wild Flour bakes up to 900 loaves daily. They usually have 10 to 12 kinds of bread every day.
UNIQUE DISH	Also try their sticky buns, scones, and other baked goods. It's great to buy some of their delicious baked goods and eat it at the communal table. Or take it on a hike with you in nearby Sebastopol or Bodega Bay.
DRINKS	Coffee/tea, non-alcoholic drinks.
SEATING	Large communal table, looking out on the surrounding countryside. Be sure to check out the bakery's beautiful garden.
AMBIENCE/CLIENTELE	Everyone comes from far and wide to experience this bread.
EXTRAS/NOTES	Wild Flour has some great literary magazines to leaf through while enjoying the best thing you've ever tasted.

—Karen Kramer

EAST BAY/ OAKLAND

Bake Sale Betty

*Brings the N back in
Neighborhood.*

$$

5098 Telegraph Ave., Oakland 94618
(between 51ˢᵗ St. and Telegraph Ave.)
Phone (510) 985-1213 • Fax (510) 985-1213
www.bakesalebetty.com

ATEGORY	Bakery and nouveau American/American bistro
HOURS	Mon: 8 AM-8 PM
	Tue-Sat: 7 AM-7 PM
	Sun: 8 am-8 PM
GETTING THERE	Walking or sauntering are the best modes of transport, although there is ample metered parking right in front and a parking lot across the street. Fairly close to Rockridge and MacArthur BART, bus lines too. Bike friendly.
PAYMENT	*VISA*
POPULAR DISH	The scones, lamingtons, fried chicken sandwich, and chocolate chip cookies with nuts.
UNIQUE DISH	The Fried Chicken Sandwich: crispy chicken breast served on generous French bread with the signature jalapeño, red onion and cabbage coleslaw.
DRINKS	Coffee, sodas, juices, water
SEATING	Cute miniature black wooden stools inside and out accommodate small amounts of breakfast and lunch regulars.
AMBIENCE/CLIENTELE	Bake Sale Betty takes all kinds, which is why this place brings the 'N' back to Neighborhood. One is immediately greeted by the signature vase of yellow roses, and then Bake Sale Betty and her blue wig. Fresh flowers and blue hair? What's not to like? Anyone can feel welcome here. Allison Barakat founded Bakesale Betty in 2002 after cooking for three years at the Chez Panisse Café. She brings her Aussie accent to Oaktown, winning over locals. Where else can one get great pastries and be called 'love'? Try the lamingtons, the scones, and the sandwiches. Then sit down and watch; you're bound to see someone you know.
EXTRAS/NOTES	Bake Sale Betty adds charm, warmth, atmosphere and awesome baked goods to the Temescal neighborhood. On a recent visit I ran into three friends and saw a bunch of the local firemen. We all go there for the same thing: great food and wonderful service. This place has become a beacon for the area. A must on the list for places to visit in Oakland's budding gourmet ghetto.
OTHER ONES	• Bake Sale Betty sells at the Walnut Creek and Temescal Farmers' Markets.

—Natasha Ravnik

Your Black Muslim Bakery

Though they're all called "Your Black Muslim Bakery," if you're not a **Black Muslim**, it's hard to feel immediately comfortable in one of the many such bakeries scattered around Berkeley and

Oakland. However, like most new experiences, it's worth getting over the initial awkwardness. Not only do these bakeries make the best damn veggie burger EVER, but they're just plain interesting places to visit. So how did this network of **Black Muslim** bakeries crop up here? Well, in the early '60s Dr. Yusef Bey, who grew up in Oakland (his family moved here from Greenville, TX when he was five), embraced Islam and decided that the principles detailed in "How to Eat to Live," an Islamic dietary code, were important for all humans, but especially for the Black community. The gist of the code is this: Eat fresh foods, once a day; stay away from complicated things, sweets, too much starch, and, in general "eat to live and not to die." So, with the help of his father, a veteran cook, Dr. Bey created a line of natural ingredient products and opened "Your Bakery" in the late '60s, which was later renamed "Your Black Muslim Bakery" by the Most Honorable Elijah Muhammad. Now, decades later, there are half a dozen of these bakeries throughout Berkeley, Oakland, and Emeryville, and even a "Your Black Muslim Bakery" cart in the Oakland airport selling their famous honey buns. Dr. Bey is the host of a popular weekly TV show called "True Solutions," and the business has been incorporated and has its own website,www.bmb.com. The bakeries have also been very important to the **Black Muslim** community in Oakland, as they not only employ and service the members of the community, but are the site of several weekly business and self-empowerment meetings and religious services. As Dr. Bey, CEO of Your Black Muslim Bakery, Inc., puts it, "Not only does Your Black Muslim Bakery, Inc. produce the best food for human consumption, but for the past 30 years it has made a statement for Freedom, Justice, and Equality. We are a living example that Blacks can be producers and manufacturers of our needs, as well as consumers."

History, religion, and intentions aside, these bakeries boast reasonable, delicious, and extremely healthy food. In addition to the aforementioned veggie burgers and honey buns, I recommend the bean soup, the bean pies, and anything with carob in it. I've never tried anything bad here, though, so feel free to be adventurous. For first-timers, the first **Your Black Muslim Bakery** is the outlet to hit; located at 5832 San Pablo Ave., it's the largest outpost, the site of most of the aforementioned meetings and services, and the main bakery. If you're vacationing in the Bay Area and missed the bakeries, the airport outlet is a great place to grab a snack on the way to your flight. Otherwise, there are bakeries on 17th St. in downtown Oakland, University Ave. in Berkeley, and at the Oakland Coliseum.

—*Amy Westervelt*

Bangkok Thai Express

(see p. 141)
Thai
5959 Shellmound St., Emeryville 94608
Phone (510) 601-1038

Barney's Gourmet Hamburger

A bonanza of gourmet burgers to satisfy everyone—even vegetarians.

$$$

5819 College Ave., Oakland 94618
(Oak Grove Ave.)
Phone (510) 601-0144
www.barneyshamburgers.com

ATEGORY	Hamburger joint
HOURS	Mon-Thurs: 11 AM-9:30 PM Fri/Sat: 11 AM-10 PM Sun: 11 AM-9 PM
GETTING THERE	The restaurant is three blocks north of the Rockridge BART station. Metered street parking is available along College Ave. During the day, limited free parking is available on nearby side streets.
PAYMENT	VISA MasterCard Cards
POPULAR DISH	It'll take you at least five minutes to pick the perfect hamburger off Barney's bewilderingly big menu. Try one with all the gourmet fixin's— maybe the "Milano Burger" with roasted eggplant and pesto sauce, or the fiery Cajun blackened burger. All of the chicken and turkey burgers are served in a rainbow variety of styles, too, from "Popeye" with sautéed spinach and feta cheese to "Maui Wowie" with teriyaki glaze and sliced pineapple. Don't skip the spicy curly fries, which come with a house-made ranch dressing.
UNIQUE DISH	Though it's famed as a red-blooded burger joint, vegetarian-friendly Barney's has an enormous selection of garden and tofu burgers, fresh salads and party-sized baskets of batter-fried vegetables showered with parmesan cheese.
DRINKS	No one should come to Barney's without trying a thick milkshake—the javalicious Turkish coffee flavor is especially addictive. There are specialty Thomas Kemper sodas, as well as a short list of California wines and domestic and imported beers.
SEATING	Barney's eatery is spacious enough to accommodate even huge groups. The crowd ebbs and flows throughout the day, from rambunctious groups of college students to families with toddlers in tow, all showing up for a tasty bite. When it's sunny, escape to the refreshing outdoor back patio.
AMBIENCE/CLIENTELE	The warm wooden environs of Barney's define California casual. It's the kind of favorite neighborhood eatery where you can show up at almost any hour hunger strikes. The wait staff is quick to deliver heaping plates of famous burgers straight to your table. You'll be salivating over the comfort-food smells as soon as you walk in the door, too.
OTHER ONES	• Oakland: 4162 Piedmont Ave., Oakland 94611, (510) 655-7180 • Marina/Cow Hollow: 3344 Steiner St., San Francisco 94123, (415) 563-0307 • Noe Valley: 138 24th St., San Francisco, 94113, (415) 282-7770

• Berkeley: 1600 Shattuck Ave., Berkeley 94709,
(510) 849-2827
• Berkeley: 1591 Solano Ave., Berkeley ,94707
(510) 526-8185
• Berkeley: 5819 College Ave,, Berkeley 94618,
(510) 601-0444
• San Rafael: 1020 Court St., 94901,
(415) 454-4594

—*Sara Benson*

Cactus Taquería

*Tacos, burritos y mas—all with
a Californian twist.*
$$$
5642 College Ave., Oakland 94618
(at Keith Ave.)
Phone (510) 658-6180 • Fax (510) 658-6181
www.cactustaqueria.com

CATEGORY	Mod-Mexican with sustainably ranched meat
HOURS	Mon-Sat: 11 AM-10 PM
	Sun: 11 AM-9 PM
GETTING THERE	The restaurant is catty-corner from the Rockridge BART station. Metered street parking is available along College Ave. During the day, limited free parking is available on nearby side streets.
PAYMENT	VISA
POPULAR DISH	The do-it-yourself burrito menu presents enough possibilities for a hundred meals, with a rainbow of mole and chile sauces, plus multiple types of beans, rice, salsa and tortillas—go wild! The crispy tostadas and tacos are the real deal. So are the handmade corn tamales filled with sautéed shrimp, chile chicken, grilled vegetables or cheese.
UNIQUE DISH	Don't miss sampling the entire contents of the fresh salsa bar, anything from pineapple salsa to devilishly hot chile. Also look out for special holiday tamales, like turkey mole. Cactus chips are an unusual side dish, served year-round.
DRINKS	There's a cornucopia of concoctions to slake your thirst, from Mexican soda pop and beer stocked in a self-serve refrigerator to draft beers, housemade aguas frescas and spicy hot chocolate dispensed by the staff.
SEATING	There are over two dozen tables of varying sizes in a sunny split-level dining area, plus counter stools handy for solo diners.
AMBIENCE/CLIENTELE	Much more than a street corner taco truck could ever dream of being, this snappy spot is packed full of moms, students, retail workers and anyone else who finds themselves hungry for economical, surprisingly healthy Cal-Mexican fast food in the hip Rockridge neighborhood. A come-as-you-are ambience infuses the wide-open seating areas, which can accommodate even the largest, most boisterous groups and offer fresh-faced furnishings done up in earthy, natural tones. Food definitely takes center stage

here, though, with spicy aromas issuing from a modern kitchen.

EXTRAS/NOTES The restaurant prides itself on not using lard, but olive and vegetable oils to prepare its food, which means that the beans are OK for vegetarians, unlike at many other Mexican restaurants.

OTHER ONES • Berkeley: 1881 Solano Ave., Berkeley 94706, (510) 528-1881

—*Sara Benson*

"But oh, San Francisco! It is and has everything—you wouldn't think that such a place as San Francisco could exist. The lobsters, clams, crabs. Oh, Cat, what food for you. And all the people are open and friendly."

—*Dylan Thomas*

Caffe Trieste

(see p. 8)
Italian coffeehouse
2500 San Pablo Ave., Berkeley 94702
Phone (510) 548-5198

El Farolito

(see p. 74)
Taqueria
3646 E. 14ᵗʰ St., Oakland 94601
Phone (510) 533-9194

I.B Hoagies

Best garlic fries on the West Coast.
$$
400 21ˢᵗ St., Oakland, 94612
(at Franklin St.)
Phone (510) 893-3944

CATEGORY Greasy spoon grill
HOURS Mon-Fri: 7:30 AM-4 PM
(breakfast 'til 10:30)
GETTING THERE Metered parking is hard to come by. You'll have more luck with a pay by the hour lot, or walking up Franklin from the Downtown Oakland BART station (a quick four block walk).
PAYMENT VISA MasterCard
POPULAR DISH The best garlic fries on the West Coast are

available here. Fresh garlic and parsley are heaped onto fresh, piping hot fries, and are a wonderful accompaniment to any sandwich. All of the grilled sandwiches are excellent, with fresh ingredients grilled to order in a fashion traditional to East Coast hoagies and cheese steaks. The bacon cheese steak has a fan club that consists of businessmen and locals alike. The breakfast crowd here is fast paced, and the pancakes are something to write home about.

UNIQUE DISH Most delis in downtown Oakland have a Rueben on their menu, but this is the only place I've been to that really does it right. The sauerkraut is fresh and crisp, and the cheese and meat are always heated through to a point of poetic fusion.

DRINKS There are no alcoholic beverages on site, but you have a wide selection of bottled and canned drinks in a cold case, and fountain sodas to quench your thirst. Coffee and tea are also available.

SEATING There are a number of cafeteria-style tables available, and there's room for about 30 people to sit and eat. You can pretty much arrange the tables to accommodate any size of group, but it's definitely something you're going to be doing yourself.

AMBIENCE/CLIENTELE This is a self-serve, order at the counter kind of place. It's small enough for you to be able to smell all the things that are coming off the grill, but you can feel comfortable bringing a half a dozen of your friends or co-workers. Waiting in line to place your order will put you next to businessmen and panhandlers alike, but that's just a sign of how good the food truly is. This is a place you can come on your lunch break or on a Tuesday when playing hooky, and consistently get one of the most comforting hot sandwiches you've ever had. It'll leave you with an experience that will nurture a craving you'll only be able to quench at I.B.'s.

EXTRAS/NOTES If you want to catch up on the latest, the TV in the corner is usually on mute.

OTHER ONES • Oakland: 601 San Pablo Ave., Oakland 94612, (510) 839-5018
• Berkeley: 2513 Durant Ave., Berkeley 94704, (510) 841-1681

—*Michele Ewing*

Khana Peena
New wave comfort food.
$$$$
5316 College Ave., Oakland 94618
(at Bryant Ave.)
Phone (510) 658-2300
www.gokhanapeena.com

CATEGORY Hipster Indian
HOURS Sun-Thurs: 11:30 AM-3 PM; 5 PM-9:30 PM
Fri/Sat: 11:30 AM-3 PM; 5 PM-10 PM

GETTING THERE	There is metered parking and street parking in the area. Very accessible via BART (Rockridge BART station) and on several bus lines. Walk and bike friendly. Tricycles accepted.
PAYMENT	VISA MasterCard
POPULAR DISH	For starters, I recommend the Vegetable Samosas. The *Moong Dahl* (lentil soup) at $4 is a steal. A popular house special is the Chicken Tikka Masala—chicken pieces baked in a clay oven cooked in a creamy sauce. Very rich, very delicious. Khana Peena has a wide variety of lamb, vegetable, chicken and seafood entrées. Tandoori dishes as well. For breads, the Garlic and Potato Mint Naan are a good investment and complement many dishes well. This is the place to go to feed a hungry soul.
UNIQUE DISH	Khana Peena sets itself apart as the only Indian restaurant in Rockridge and one of exceptional quality.
DRINKS	Full bar with a swanky bartender. Take a gander at the frescoes which surround the skylight—saucy views of sultry positions which could give the most demure diner after dinner ideas. Khana Peena even has its own line of beer, brewed by a local brewery. I love their chaiwarm, spicy, yummy.
SEATING	The best part about Khana Peena's Rockridge location is the outside patio seating. Comfortable padded concrete benches line the street-side patio. Heat lamps and canvas keep out the cold of winter and air is fresh in summer. Bring guests to the corner seat near the fountain on a full moon night—not a better seat to eat under the stars.
AMBIENCE/CLIENTELE	Despite the chic re-do of this once local mini-mart, Khana Peena on College Avenue welcomes all kinds: romantic dinners for two, roommates after work, family dinners, and the usual get-a-drink-to-celebrate-you kind of crowd.
EXTRAS/NOTES	Khana Peena is the family business of the Aggarwals of Northern India. It is a welcome spice to the neighborhood. I call this "New Wave Comfort Food" because when I feel low, I seek naan over noodles. In a yogic life, one should splurge on good food. Khana Peena's cuisine, atmosphere and surroundings lift my spirits and my taste buds.
OTHER ONES	• Berkeley: 1889 Solano Ave., Berkeley 94707, (510) 528-2519
	• Berkeley: 2136 Oxford St., Berkeley 94704, (510) 849-0149

—Natasha Ravnik

Ohgane

Barbeque, ban chan, and service! Oh my!
$$$$
3915 Broadway, Oakland 94611
(between Broadway and 40th)
Phone (510) 594-8300 • Fax (510) 594-8304

CATEGORY	Korean BBQ

HOURS	Daily: 11 AM-Midnight
GETTING THERE	Free parking lot and some street parking right by the restaurant.
PAYMENT	VISA ●●● ■■ Cards
POPULAR DISH	The D-I-Y barbeque is always popular. I'd highly recommend the broiled short ribs marinated in Ohgane's special sauce—a complimentary stew (usually bean paste) comes out with two orders of the barbeque. Another favorite is the *dol sot bi bim bab*, a mouth-watering mixture of rice, vegetables and meat topped with an egg in a sizzling stone bowl. All the traditional Korean dishes can be found here, including the delicious assortment of *ban chan,* those obligatory side dishes Korean restaurants are known for.
UNIQUE DISH	Try a piece of *gal bi* (hot short rib) over some cold buckwheat noodles—it's a unique, mind-blowing combo of opposite temperatures. At Ohgane, you can order half portions of the buckwheat noodles, which is great as a side order with the Palace Gal Bi. The bubbling casseroles are also fun to share—a two serving minimum so bring a friend, or two.
DRINKS	Like every other Korean restaurant, Ohgane serves soju and some Korean lagers, which go great with the barbeque! Ohgane, however, also serves some wines, but I'd stick with the soju and beer. Another interesting drink is actually the dessert, a sweetened rice punch called *shik kae,* that comes free at the end of the meal. (If you become enamored with the rice punch, you can buy some at the Korean grocery store down on Telegraph Avenue.)
SEATING	There is plenty of seating! Rows and rows of tables, which makes Ohgane a great place for parties and random get-togethers with friends. There are also smaller tables for more private dining.
AMBIENCE/CLIENTELE	Clean, bright, with a nice touch of Korean décor (the walls are murals of Korean pastoral scenes and traditional life), this restaurant is all about convenience and class, or at least as much as a Korean restaurant can afford in Oakland. The scene is usually families going out for dinner, or college groups celebrating a birthday. Friday nights can be especially busy, with people barbequing it up with some soju to end a hard week's worth of work or studying. Regardless of the group, everyone is boisterous, busy stuffing their faces and having a great time.
EXTRAS/NOTES	It may not have belly dancers, but if you enjoy cooking your own food and think of eating as an art, Ohgane is a great place for a dining experience. You can create various taste combinations with the ban chan, and nothing beats grilling your own meat to crispy, delicious perfection, and then wrapping it in a leafy bundle of rice and bean paste to then place lovingly in your mouth. Heaven! Also, this place has a pretty attentive staff, and if that's not enough, there are "Happy Call" buttons at each table in case you

don't see anyone nearby to get you more of that free ban chan!

OTHER ONES • San Leandro: 1292 Davis St., San Leandro 94577

—*Shioun Kim*

Ole's Waffle Shop
Low carb diet? Fagetaboudit!
Since 1927
$$
1507 Park St., Alameda 94501
(at Santa Clara Ave.)
Phone (510) 522-8108 • Fax (510) 522-3517

CATEGORY	Waffle house
HOURS	Mon-Fri: 5:30 AM-8 PM
	Sat: 6 AM-8:30 PM
	Sun: 6 AM-8 PM
GETTING THERE	There is plenty of parking either on Park Street or any of the side streets in the area.
PAYMENT	
POPULAR DISH	Breakfast! Ole's claim to fame is the waffle; that delightful round wafer delivered straight from heaven. But it would be a mistake to forsake the pancakes, my personal favorite. Those cakes are so soft and fluffy, they inspire gluttony.
UNIQUE DISH	Ole's stayed true to its 1927 roots. It's a neighborhood favorite and evokes images of grandma and apple pie.
DRINKS	The most popular drink is the coffee, to wash down your breakfast.
SEATING	There are over 20 tables, booths and counter seats—collectively.
AMBIENCE/CLIENTELE	The clientele is of the over 50 crowd. They ain't buying Dr. Atkin's diet, mkay! Occasionally, you will see young families or couples enjoying a hearty American meal.
EXTRAS/NOTES	Careful on weekends because there is a line out the door for breakfast. At the same time Park Street is so cute, in that small Mid-Western town sort of way, it's nice to hang out in a wholesome environment while waiting for eats.

—*Chenda Ngak*

Pasta Pomodoro
High class Italian at middle
class prices.
$$$
5500 College Ave., Oakland 94618
(at Lawton Ave.)
Phone (510) 923-0900 • Fax (510) 923-9380
www.pastapomodoro.com

CATEGORY	Neighborhood Italian
HOURS	Mon-Sun: 10 AM-11 PM
GETTING THERE	The best way to get here is on BART. Exit at Rockridge and walk up College Avenue toward

Broadway for a couple of blocks. There is parking on the street, but this is a popular neighborhood so you may have to troll around on side streets.

PAYMENT VISA ⬤

POPULAR DISH The *polenta farcita* appetizer is amazing. It consists of polenta topped with spinach, fontina cheese and butter fried sage. But it is rich; between this and all the foccacia and dipping oil they bring to the table, you may fill up before the entrée.

UNIQUE DISH I am a connoisseur of pasta primavera, and the linguine primavera is very good here, as is the Gemelli (a type of pasta) with smoked and grilled chicken, sun dried tomatoes, mushrooms and cream.

DRINKS They serve, beer, wine, sodas.

SEATING The big draw here are the outdoor tables—15 of them. Indoors, there are 22 tables.

AMBIENCE/CLIENTELE You'd be comfortable here wearing anything from hiking boots and cargo shorts to an Indian-print skirt and sandals. The strong smell of garlic and herb assaults you even as you stroll past. The place is often crowded in the evenings, but not to worry. There are lots of tables and the wait is nonexistent or short. The atmosphere is classy and Spartan; tiny red lampshades hanging from long black cords are the only lighting here. The kitchen area is open in the middle of the room, so one can see all the food being prepared.

EXTRAS/NOTES There are paper placements and crayons provided for the kiddies to use. Some of the Bay Area locations of this restaurant (Pleasant Hill and North Beach) have live jazz every week.

OTHER ONES • Around fifty other locations in California and Arizona. Check their website for a complete listing.

—Laura Wiley

Middle East Meets West

Describe a restaurant as "fusion" and hard-core foodies are apt to yawn. The term, first coined in America two decades ago to describe the influences of Asian cooking techniques and ingredients on Western cuisine, has become so ubiquitous that Wolfgang Puck, once considered a ground-breaking chef, now hawks his Thai chicken pizzas from the grocery store freezer.

In all fairness, fusion is one of the most important culinary innovations of the last fifty years, but it has become so prevalent that we often fail to notice it. Customers routinely order wasabi mashed potatoes, ahi tuna tacos or salmon with sautéed bok choy and don't even bat an eye. Wanderlust is no longer confined to Japan and China, or even Asia; influences from India, Mexico and Morocco appear with equal frequency, and equal flair.

In the Bay Area, a handful of chefs are reinventing Middle Eastern cooking. Drawing on staples like hummus and baklava that have already worked their way into the American pantry, they add unfamiliar spices like sumac, a tart seasoning ground from the

purplish-red sumac berry, or za'atar, an earthy herb akin to thyme. Mix that with California's emphasis on organic foodstuff, and the resulting meals give you a reason to ditch the falafel at the door.

Medjool traces the old spice trade routes through Southern Europe, North Africa and the Middle East. There's plenty of room for cocktails on the mezzanine or rooftop terrace with its far-reaching city views. When it's time for dinner, take a seat in the warehouse-like dining room and choose from small plates like fried calamari, made over with a dusting of sumac and aioli. Be sure to order the couscous with your choice of dates, olives or preserved lemons – you'll want something soothing to munch on between bites of the fiery chicken in almond- pomegranate sauce. Lightly charred shrimp are accompanied by a cinnamon-infused tomato jam, and who can pass up razor-thin frites with parsley and lemon? A moderately priced wine from Greece or Spain complements the food nicely. (2522 Mission Street, (415) 550.9055)

Saha means "good health" in Arabic, and the wide variety of vegetarian dishes and reliance on hormone-free meats fulfill its inherent promise. Low-hanging lamps look like they might be hiding genies, and the walls are hung with stark photos of Yemen, reminders of chef Mohamed Aboghanem's homeland, but the real art is on the plate. Grab a hunk of bread to sop up fouel, an addictive dip of fava beans and roasted peppers. Traditional Yemeni pairings of sweet and savory shine in the grilled prawns served atop a puddle of cool mint, rosewater and cilantro pesto, or the signature ravioli stuffed with shitake mushrooms and napped with a spicy mix of mango, mint and cream. Scoop up lahem sougar, succulent hunks of grass-fed lamb sautéed in pine nuts and sumac, with warm pitas. You can order a series of small plates, or go for entrees like the lamb and prune tagine, a thick stew named for the clay pot it's served in. (1075 Sutter St., 415.345.9547)

YaYa Cuisine first opened in 1988, wowing critics and developing a cult following. Though the Mesopotamian restaurant's latest incarnation has preserved its original name and the sweeping murals of ancient Babylon, chef Yahya Salih now focuses on "Nomad style" dishes inspired by the Bedouin tribes. Traditionally, these Iraqi nomads built their meals bite by bite from communal platters of rice, meat and vegetables, but at YaYa Cuisine "Nomad style" entrées come three to a plate. Order the Ancient Nomad for a meat trifecta: Mosul Kebe, a cracked wheat and beef shell stuffed with tender lamb, almonds and spices in a smoky eggplant and pepper sauce; Kubet Basra, turmeric-spiced rice balls filled with succulent duck breast, cloves, cinnamon, and pine nuts; and Kubet Baghdad, a bulgur shell surrounding beef, dates, rice and cardamom. Each entrée comes with salata, a mix of shredded lettuce, tomatoes and radishes in a sweet-tart pomegranate dressing. Traditional entrées like whole grilled fish and chicken kebabs are available too. For dessert, order the kenafa and a coffee. While you devour the nest of crisp phyllo dough and mild cheese drizzled with date syrup and pistachios, the chef will come out and tell your fortune from the coffee grounds. (2424 Van Ness Ave., (415) 440-0455)

Zatar beckons from the outside with twinkling lights, shimmering curtains and ancient-looking candelabras. Inside husband and wife owners Kelly and Waiel Majid create fare they've dubbed "eclectic Mediterranean." It crosses borders from Europe to Waiel's native Iraq with a strong emphasis on cooking seasonally, locally and organically. The Majid's organic garden supplies fresh herbs, vegetables and fruits, and even the wines reflect this philosophy: most are from small producers and some are crafted from organic or bio-dynamically grown grapes. Meals start with bread and za'atar, the restaurant's namesake, a saucy blend of thyme, sesame seeds, sumac, sea salt and olive oil. Crostini with eggplant and chevre or tomato and haloumi cheese change often, and juicy chicken kebabs boast a free-range Sonoma County provenance. The local Niman Ranch lamb is raised humanely and sustainably without the use of antibiotics or growth hormones; whether tucked into dolmas or served as a fork-tender shank with black-eyed peas, it's as good as it is good for you. Homemade cardamom and date ice cream runs out quickly so get there early. (Note: Cash only.) (1981 Shattuck Ave., Berkeley, 510.841.1981

—*Catherine Nash*

Soi 4 Bangkok Eatery

It's not just another average
neighborhood Thai kitchen.
$$$$
5421 College Ave., Oakland 94618
(at Kales Ave.)
Phone (510) 655-0889
www.soifour.com

CATEGORY	Mod Thai
HOURS	Mon-Fri: 11:30 AM-2:30 PM; 5:30 PM-10 PM
	Sat: 5:30 PM-10 PM
GETTING THERE	The restaurant is a four-block walk south of Rockridge BART station. Metered street parking is available along College Ave. During the day, limited free parking is available on nearby side streets.
PAYMENT	
POPULAR DISH	You could easily fill up on appetizers here, from the blue crab rolls with anise plum sauce to nine types of grilled skewers, including chicken, pork and lamb satay. A full menu of Thai classics includes a rainbow of savory curries, tempting Bangkok-style street snacks and a few Isaan dishes from northeastern Thailand.
UNIQUE DISH	Though it's definitely not an Asian fusion restaurant, Soi 4 takes creative leaps with its menu. Atypical ingredients like okra, Indian roti, Australian lamp chops and honey-roasted duck may surprise veteran fans of Thai cooking. Super-fresh seafood dishes are made with Japanese scallops, New Zealand mussels, Atlantic salmon and Alaskan halibut.
DRINKS	There's a full bar and a select list of beer and wine from the Pacific Coast, Europe, South

America, Australia and New Zealand, as well as Japanese sake. Thai iced coffee, iced tea and coconut and palm juices are all freshly made.

SEATING Ultra-high ceilings make the restaurant feel roomy, even when every table is packed—expect to be jostling elbows with other patrons. There are two dozen tables on the crowded ground floor backed by a small bar, while more await upstairs on the floating balcony level, which can be sectioned off for parties and private events.

AMBIENCE/CLIENTELE While many hole-in-the-wall Asian restaurants ignore their interior design, Soi 4 successfully creates a sleek modern atmosphere with meditative earth tones, live plants and naked light bulbs hanging from heavenly high ceilings. The casual scene is laidback, with families, office workers and groups of friends at lunch and dating couples at dinner, when the lights are seductively dimmed. Whenever you visit, you'll be tantalized by the aromas of complex Thai combinations of spices wafting over from nearby tables.

—*Sara Benson*

Tamarindo Antojeria

Minimalist Mexican delicacies in sleek setting.
$$$$
468 8th St, Oakland 94607
(between Washington St. and Broadway Ave.)
Phone (510) 444-1944
www.tamarindoantojeria.com

CATEGORY Hip Mexican restaurant

HOURS Tues-Thurs: 11 AM-9:30 PM
Fri: 11 AM-10 PM
Sat: 10 AM-10 PM

GETTING THERE Street parking (easy at night; okay during business hours). Four blocks from 12th St. BART

PAYMENT VISA ⬤ Cards

POPULAR DISH *Guacamole con Totopos* (avocado, tomatoes, onions, lime, cilantro and chips); tortas for a beyond filling lunch; and the perfect side of black beans.

UNIQUE DISH Sopecitos surtido: a trio of dainty corn masa patties, with three different toppings, including chorizo and potato carnitas rajas.

DRINKS A nice list of red, white and dessert wines. Great house sangria.

SEATING Small tables, couple-style, and not too many of them. One larger table for parties.

AMBIENCE/CLIENTELE Low key, but elegant ambience at night, where the sleeker side of Oakland shows its face. Speeds up for lunch with the work crowd around Broadway. A great date restaurant.

EXTRAS/NOTES One of the classier spots in Downtown Oakland, Tamarindo made a splash debut a little over

a year ago and has been winning awards ever since. Because of its emphasis on small plates, it can be more affordable than some of the other examples of Mexican haute-cuise popping up around town.

—*Sarah Ann Wells and Victor Goldgel*

Yet Nal Zza Zang

Black bean noodle—Korea's fast food.
$$

4390 Telegraph Ave., Suite B, Oakland 94609
(between 44th and Telegraph Ave.)
Phone (510) 652-3900

CATEGORY	Low-key Korean and noodle house
HOURS	Daily: 11 AM-10 PM
GETTING THERE	There is limited parking in front of the restaurant, but street parking (meter) is available nearby.
PAYMENT	VISA ●●● ■ Cards
POPULAR DISH	People come here for the *zza zang myun* (sweetened black bean noodles) and whatever they like best with it, be it dumplings or the Korean style hot-and-sour pork or beef. Also very popular is *jahm bbong* (spicy seafood noodle soup) and *goh chu jab chae* (vermicelli noodles with jalapeño). If you can't decide between the *zza zang myun* or *jjahm bbong,* you can actually order both in half portions on a divided bowl-plate. There's no "ban chan" (side dishes) here, instead, you'll get a little plate of pickled yellow radish and chopped onion to dip in the black bean sauce that comes with it.
UNIQUE DISH	A growing trend that can be found here is the spicy *zza zang myun,* which contains minced jalapeñojalapeños for that extra kick. Another twist on a traditional favorite is the white *jjahm bbong,* where the soup base isn't the usual chili-red color but a clearish white, as it's been made with jalapeñojalapeños in a seafood stock. Same heat, but no rings of chili oil around the mouth.
DRINKS	Soda, Korean alcoholic drinks such as soju and beer are available.
SEATING	There are only a few seats, but the food is served quickly and eaten often in a rush so you won't have to wait too long.
AMBIENCE/CLIENTELE	The atmosphere is very low-key, and there is often only one host/waiter who will both seat and serve you. It's just understood that you come here to order, eat and leave quickly, although on Sundays, you will probably see some people lingering as they've just come back from church. There are no pretenses here... just good, fast food.
EXTRAS/NOTES	There's a cyber café in the same plaza (as well as a full menu Korean restaurant, sushi bar and hair salon). There really isn't too much to look at inside, but then again, you'll probably be focusing on slurping up your noodles and if by chance

you're with your bf/gf, you can chuckle at the
ring of black bean sauce around his or her mouth
(you'll probably have one too.)

OTHER ONES • Hayward: 22532 Foothill Blvd. Hayward 94541
—Shioun Kim

Yo Ho Restaurant
*Take advantage of 'dim sum
price wars' in Chinatown.*
$$
337 8th St., Oakland 94607
(between Webster and Harrison)
Phone (510) 268-0233 • Fax (510) 268-0206

CATEGORY Hole in the wall dim sum

HOURS Daily: 9 AM-2:30 PM; 5 PM-9:30 PM

GETTING THERE There is metered parking on the streets but this is
Chinatown so it's hard to find a space. There is a
pay lot on Franklin St, just after 9th Street, which
is only $1.25/hour and well worth it. Or take
BART to the 12th Street or Lake Merritt stations
and walk the few blocks.

PAYMENT VISA MasterCard

POPULAR DISH This place is all about the staples: Sui mai? Check.
Har Gow? Got it. Pork buns, shrimp in tofu skin,
rice noodle rolls, sesame seed balls, turnip cakes,
sticky rice in lotus leaves, egg custard tarts the dim
sum carts keep coming and you'll keep choosing.
If you want something besides the typical dim
sum fare, have one of the "Chef's Specials" like
plates of eggplant or fried tofu. If you're craving
something that you don't see, just ask. You can
always order a plate of steaming Chinese broccoli
to counteract all the fried you're consuming. This
place is seriously no-frills and is consistent and
delicious. Go with a bunch of friends so you can
order a huge variety and try a little of everything.
You'll walk out full, having paid next to nothing.

UNIQUE DISH Again, it's just the staples. Some may find the
steamed chicken feet intimidating.

DRINKS Tea comes automatically. You'll need to ask for
if you want water, sodas, Tsingtao beer or a soya
bean drink.

SEATING One big room contains lots of tables for both
large and small parties. If it's busy, you'll end up
sharing one of the large tables with strangers,
battling over the lazy-susan.

AMBIENCE/CLIENTELE Filled with people who live and/or work in the
area—mostly groups of older Chinese folks
getting together for their lunch. The "decor"
consists mostly of tile floors and promotional
red Tsingtao lanterns hanging from the ceiling.
Bustling with people filtering in and out and wait
staff pushing carts, it can get crowded during
the lunch hour and you may have to wait a few
minutes for a table.

—Rana Freedman

Zachary's

*Towering slices of 'za from
a zany Chicago-style kitchen.*

$$$

5801 College Ave., Oakland 94618
(at Oak Grove Ave.)
Phone (510) 655-6385
www.zacharys.com

CATEGORY	Famous Chicago-style pizza
HOURS	Sun-Thurs: 11 AM-10 PM
	Fri/Sat: 11 AM-10:30 PM
GETTING THERE:	The restaurant is three blocks north of Rockridge BART station. Metered street parking is available along College Ave. During the day, limited free parking is available on nearby side streets.
PAYMENT	Cash only
POPULAR DISH	It's true—Zachary's Chicago-style stuffed pizzas are the real deal. The original Oakland restaurant was started by Chi-town expats Zach Zakowski and Barbara Gabel more than two decades ago. Its cult-like following today is all thanks to the unique deep-dish pies that the ovens keep cranking out. The cooks start with a garden's worth of fresh ingredients sealed between two layers of pizza dough, topped with a chunky tomato sauce and then baked until the crust golden brown. The spinach-and-mushroom combination is the most popular, though you can also design your own perfect pie by picking and choosing among a score of a la carte ingredients.
UNIQUE DISH	Half-baked pizzas are available to take home, if you just don't have time to wait in line.
DRINKS	Like any classic pizzeria, pitchers of soda pop are seen standing on almost every table. Adult patrons skip the wine list, which isn't exciting, in favor of tall glasses of beer.
SEATING	Don't expect much elbowroom here—seating is always at a premium. Whether you come for lunch or dinner, expect to have to queue. In fact, Zachary's is so popular that patrons can order their pizzas while they're still waiting in line, so that by the time they sit down, it's almost ready to eat.
AMBIENCE/CLIENTELE	Casual Zachary's is a madhouse, with lines usually out the door, wait staff moving at warp speed, and tables of hungry diners eyeing the kitchen to see whose deep-dish pizza is due up next. The walls are plastered with fun, funky graphic art and memorabilia to keep you amused while you wait. But you'd better bring friends with you, too, to pass the time. After all, baking the perfect pizza takes some time!
EXTRAS/NOTES	The local restaurant chain, which is so famous it even has its own entry in Wikipedia.org, is now employee-owned.
OTHER ONES	• 1853 Solano Ave., Berkeley 94707, (510) 525-5950
	• San Ramon: 3110 Crow Canyon Pl., San Ramon 94583, (925) 244-1222

—Sara Benson

Asian Pearl

A whirlwind tour of Chinese cuisine.
$$$$
3288 Pierce St. #A-118, Richmond 94804
(between Washington and Central)
Phone (510) 526-6800 • Fax (510) 526-6801

CATEGORY	Trendy Chinese
HOURS	Mon-Thurs: 11 AM-10 PM
	Fri: 11 AM-11 PM
	Sat: 10 AM-11 PM
	Sun: 10 AM-10 PM
GETTING THERE	The restaurant is located in the Pacific East Mall. Parking is available in the lot outside the mall. It can be difficult on weekends, so park on the street if you can't find any parking in the lot.
PAYMENT	VISA [cards]
POPULAR DISH	This is a good place to go for afternoon dim sum, as it's not too greasy. The smaller main courses, such as the Shanghai Style Crab Meat Dumplings and the North China Onion pancakes, are innovative and make great starters. Make sure to try some "China Delights," "Hong Kong Flavors," "Zhong Shan Style Specialties," and "Shun De Style Specialties." You'll be blown away by the choices, including Deep-Fried Dungeon Crab, Pork Spare Ribs with Bitter Melon in Clay Pot, Pan Seared Salted Fish, and Stewed Eel in Abalone Sauce.
UNIQUE DISH	The menu has a very extensive selection of specialties from all over China, so there's bound to be a dish that pleases your palette. They even come with color photos so you can identify any unfamiliar dishes you come across. For those looking for gringo-friendly fare, there are some "American Flavors" like lemon chicken, Mongolian beef and sweet & sour pork with pineapple. It's also got some scrumptious desserts like glutinous rice dumplings in almond soup, egg custard tart with bird's nest, and red dates pudding.
DRINKS	Serves red wine, the standard sodas, and tea.
SEATING	Has lots of small and large tables available. Some tables are in semi-private areas.
AMBIENCE/CLIENTELE	The ambience is fairly relaxed and a bit upscale but not snobbish. It's best to come with groups, especially families. The clientele are mostly Chinese, with some occasional non-Asian customers.
OTHER ONES	• Fremont: 43635 Boscell Rd., Fremont 94538

—Valerie Ng

Macau Café

A culinary fusion of Chinese and Portuguese flavors.

$$

3288 Pierce St. #C-136, Richmond 94804
(between Washington Ave. and Central Ave.)
Phone (510) 559-7888 • Fax (510) 559-8883

CATEGORY	Macau and Chinese cuisine
HOURS	Mon-Fri: 11 AM-11 PM
	Sat/Sun: 10 AM-11 PM
GETTING THERE	The restaurant is located in the Pacific East Mall. Free parking lot in front and behind the mall. It can be difficult to park on weekends, so park on the street if you can't park in the lot.
PAYMENT	VISA
POPULAR DISH	Portuguese-influenced dishes, such as Seafood & Cheese Baked Pasta in White Sauce and Baked Chicken with Spaghetti/Rice are popular, as are "Culinary Innovation" dishes like Deep Fried Prawn with Pineapple and Deep Fried Pork Loin with Honey Flavor, which seem to be the favorites. But if you're looking for traditional Chinese (Cantonese) dishes, though, there are also noodle soups, chow fun, chow mein, Hainan chicken, rice porridge and other standard Chinese restaurant fare. The dinner specials (for 2-6 people) during the week are a pretty good deal.
UNIQUE DISH	This restaurant features food from the former Portuguese colony of Macau, located in the southern tip of China near Hong Kong. Thus, most of its specialties involve a lot of Western influences, especially Portuguese, hence its pasta dishes with cheese sauce.
DRINKS	No alcohol is served. Most of its drinks are Asian-style: coffee, lemon tea, coke with lemon, Ovaltine, an almond drink, Hong Kong style milk tea, milk tea with coffee, an iced red bean drink, a longan ice drink, and assorted fruit iced drinks.
SEATING	There is plenty of seating, mostly at smaller tables and booths, as well as a few bigger tables.
AMBIENCE/CLIENTELE	Fairly quiet ambience. It brings in mostly families and anyone looking for an inexpensive meal before or after mall shopping.
OTHER ONES	• Sacramento: 4406 Del Rio Rd., Sacramento 95822

—Valerie Ng

Sawaddee Thai Restaurant

A leafy oasis across the street from Wendy's

$$$

12200 San Pablo Ave., Richmond 94805
(between MacDonald Ave. and Barrett Ave.)
Phone (510) 232-5542

CATEGORY	Low-key Thai

HOURS	Daily: 11:30 AM-9:30 PM
GETTING THERE	Easy street parking, no meters. Approximately 3/4 mile from El Cerrito Del Norte BART, right on the 72/72M/72R bus lines.
PAYMENT	VISA ⬤
POPULAR DISH	The spring rolls are amazing: crispy but not greasy, and the dipping sauce is perfect. My favorite is the Pad Eggplant, and the *Larb Ped* (sliced, roasted duck) is also quite good.
UNIQUE DISH	Daily unique specials, some I've never seen at other Thai restaurants.
DRINKS	Wine and beer, That iced coffee and tea, regular coffee and tea, orange juice, soda.
SEATING	Lots of seating; one half of the building is devoted to traditional cushions and low tables, with the other half "normal" Western-style tables.
AMBIENCE/CLIENTELE	Lots of plants, a fish tank, the room is decorated with lots of Thai carvings and cloth hangings, and lots of wood. Feels very calm and serene, and a welcome escape from the San Pablo Ave. madness. Clientele is a low-key neighborhood crowd, mostly residents of the immediate area, some student types. The music is quiet but modern, and the staff is very laid-back. Though the service can be slow, it's the kind of place you don't mind lingering in.
EXTRAS/NOTES	A great place for a date—low key, friendly, not too loud, interesting dishes to use as conversation starters, bubbling fish tanks to calm you down, and a BART station nearby for a quick getaway (or, alternatively, a supermarket across the street if you want to continue the date back at your pad.)

—*Melissa Kirk*

Tevino's of El Cerrito

Cadillacs & neon in the fast food jungle.
$$$
11795 San Pablo Ave., El Cerrito 94530
(at Wall Ave.)
Phone (510) 234-7462

CATEGORY	Low-key Mexican
HOURS	Mon: 11 AM-9:30 PM
	Weds-Sun: 11 AM-9:30 PM
GETTING THERE	Free parking in lot out front, plus ample street parking. Right across the street from El Cerrito Del Norte BART, right on the 72/72M/72R and 7 bus lines.
PAYMENT	VISA ⬤ ⬤ Cards ⬤
POPULAR DISH	Fajitas and Entomatadas—enough to keep you in leftovers for the next week! The sopes are great, too.
UNIQUE DISH	Lots of fancy meat: steak picado, pechugas asadas, carne tampiqueña, steak a la mexicana.
DRINKS	A selection of specialty cocktails, margaritas, sangria, domestic and imported beer, house wine, soda, juice, coffee, Naranjada, tea, milk. The regular margaritas are just OK, but for $2 more, try the Cadillac Margaritas- they're dee-lish!

SEATING	Large room with lots of booths and tables.
AMBIENCE/CLIENTELE	From the outside, the building looks like it was built in the 50's as a steak-n-rib joint. But once inside, it's all terracotta tiles, heavy wooden carved tables topped with colorful inlaid tile, lots of plants, and colorful decorations. The clientele is locals and families. There's a banquet room available for large parties.
EXTRAS/NOTES	In an area full of Mexican, South American, and Central American restaurants, this is the "nice" one. This is the place to bring your family or friends from out of town, or to celebrate grandpa's 90th birthday.

—*Melissa Kirk*

WALNUT CREEK/CONCORD

Bangkok Kitchen
*A friendly place to sample the
cuisine and hospitality of Thailand.*
$$$
1980 Galindo St. Concord 94520
(at Willow Pass)
Phone (925) 680-4421, Fax (925) 680-4421
www.BangkokKitchen.net

CATEGORY	Authentic home-style Thai
HOURS	Mon-Thurs: 11 AM-3 PM; 5 PM-9:30 PM
	Fri. 11 AM-3 PM; 5 PM to 10 PM
	Sat: Noon-3 PM
	Sun: 4:30 PM-9:30 PM
GETTING THERE	There is plenty of free parking in a nearby garage.
PAYMENT	VISA mastercard
POPULAR DISH	The Curries here come in Mild to Hot and Wild! No matter which one you choose, they are well flavored and generously portioned.
UNIQUE DISH	Seafood Kra Prow is a mixed seafood dish with sweet basil, bamboo shoots, and chili. This must have dish is a great accompaniment to any of the other entrés. Be sure to check out the specials board, as they will not always point it out to you. Specials are often the best offering of the day, and sure winners.
DRINKS	Thai Iced Tea and Thai Coffee are authentically presented and delicious. If you prefer something a little harder, Bangkok Kitchen also has a full bar menu. A family favorite is the Coconut Juice over ice with bits of young coconut meat.
SEATING	The seating is roomy and a great place to bring the whole family or a group of friends.
AMBIENCE/CLIENTELE	The moment you walk in you are greeted by a warm smile. The ambiance is friendly, like being home again (or, in some cases, better!)
EXTRAS/NOTES	Food is served family style. The portions are

generous without being over the top. Lunch specials vary and include rice plates appropriate for one person. For about $25 you can enjoy a feast fit for a king!

—*Ana Cabrera*

Hot Dog Palace

Cheap eats and some of the best dogs in the bay!

$$

1990 Grant St., Concord 94520
(at Willow Pass Rd.)
Phone (925) 676-8723

CATEGORY	The best hot dog joint in the East Bay!
HOURS:	Daily: 10:30 AM-8 PM
GETTING THERE	Plenty of free parking both on the street and in the adjacent parking structure. Only a few blocks away from the Concord Bart station.
PAYMENT	
POPULAR DISH	The Concord Dog is an all beef dog with all the fixings. The buns are soft and fresh.
UNIQUE DISH	Don't like the crunch, get a skinless dog. There are also burgers, fries, and other finger lickin' foods for your enjoyment. If you like it hot, try the Hot Link, it will set your taste buds on fire! This is good, simple food for very little money.
DRINKS	Beer, shakes, and of course…sodas.
SEATING	Hot Dog Palace is a large hole in the wall. There are a few tables inside with some patio seating. It is on the corner of Todos Santos Park, so you can take your order to go and have a tasty meal in the park. There are picnic tables and plenty of shaded grass to enjoy your delicious dogs.
AMBIENCE/CLIENTELE	Flip flops welcome in this very casual family oriented Hot Dog heaven.
EXTRAS/NOTES	The Hot Dog Palace is a favorite spot for the families of Concord. It sits on the corner of the downtown Todos Santos Park. This park is home to many seasonal festivals and the farmers Market. Food is served fast by a friendly and attentive staff. No frills good food at a great price.

—*Ana Cabrera*

Three Seasons

(see p. 220)
Vietnamese
1525 N. Main Street, Walnut Creek 94596
Phone (925) 934-4831

Tin's Tea House Lounge

Authentic Chinese dim sum in the heart of suburbia!
$$$

1829 Mt Diablo Blvd., Walnut Creek 94596
(at S. California Blvd.)
Phone (925) 287-8288

CATEGORY	Authentic Chinese dim sum
HOURS	Mon-Fri: 1 AM-3 PM; 5 PM-10 PM Sat/Sun: 10 AM-3 PM; 5 PM-10 PM
GETTING THERE	Parking is a bit of a nightmare as the free parking lot is tiny and usually full. There is plenty of metered street parking. It is also only a few blocks from Walnut Creek Bart.
PAYMENT	VISA Cards
POPULAR DISH	How can one choose from the hundreds of dishes? No visit is complete without the warm baked custard buns. They are only available on the weekends, while supplies last. Be sure to ask for them as they are not on the menu.
UNIQUE DISH	If you have never experienced Dim Sum, you are missing out on the joy of having tasty little morsels brought right to your table. The steamer trays are always hot and fresh. Tame favorites like Siu Mai and Haw Gaw are available along with more exotic fare like the White Chicken Feet and Steamed Tripe.
DRINKS	Tin's is at its heart a Tea House. They offer a wide variety of teas and herbal teas for your enjoyment. They even have many rare medicinal teas. Teas can also be purchased by the pound to enjoy at home. Tin's offers a full bar, and there are even kids cups for the little ones.
SEATING	Don't let long lines and big crowds fool you. Tin's is spacious and a great place for private events. Even with the biggest crowds, the wait is never very long.
AMBIENCE/CLIENTELE	When you walk through the front door, you are immediately transported out of Walnut Creek and into what feels like the city's Chinatown. The ambiance is casual and laid back. Guests are often dressed in casual wear, though the occasional party will bring in a group dressed to the nines. Whatever goes at Tin's; you are surrounded by the aroma of food all around. (Not such a great thing if you are pregnant and feeling a little woozy!) It is a noisy place, as diners ask the wait staff to reveal what is under each little covered dish. The staff is very good with children. Not a place to go for a quiet romantic dinner!
EXTRAS/NOTES	People who have not experienced Dim Sum in an authentic setting may mistake the staff for being a little stand offish, and maybe even a little rude. They are not. The management and waiters all speak English, but often, the Dim Sum Ladies do not. (Or speak limited English) This is not a place to go to get pampered or kissed up to. This is a joint you go to for a lot of delightful Dim Sum at a reasonable price.

—Ana Cabrera

Va de Vi

Sample a bit of the good life.

$$$$

1511 Mt Diablo Blvd., Walnut Creek 94596

(at S. Main St.)

Phone (925) 979-0100

www.va-de-vi-bistro.com

CATEGORY	International small plates and wine bar.
HOURS:	Sun-Weds: 11:30 AM-2:30 PM; 5 PM-9 PM Thurs-Sat: 11:30 AM-2:30 PM; 5 PM-10 PM
GETTING THERE	There is plenty of free parking in one of the many parking garages only a few blocks away.
PAYMENT	VISA
POPULAR DISH	Always ask for the seasonal special. It changes often, but you can never go wrong. The seafood is impeccably fresh at Va de Vi and should not be missed.
UNIQUE DISH	Shrimp-Avocado Lumpia reflects the Asian influence on the menu. The fusion of Western and international flavors is executed flawlessly.
DRINKS	It's about the wine after all. There are many wines available by the glass, or you can purchase wine tasting flights. Either way, Va de Vi makes it easy to taste a large sampling of the menu.
SEATING	This spacious bistro keeps a small and cozy feel as it is often packed with happy patrons. Reservations are recommended for weekend dinner. Va de Vi always accepts walk ins, but the wait can be long. The plus is that it is located steps away from Broadway Shopping Center, so you will have plenty to keep you busy while you wait.
AMBIENCE/CLIENTELE	Va de Vi is a little high brow but still friendly. Come dressed to impress. Casual by day, and dressed for a night out on the town for dinner.
EXTRAS/NOTE	Va de Vi is a little pricey since you typically need to order many plates to be "full". The plates are smaller than an entrée, but bigger than *tapas*. Definitely worth the splurge to enjoy a full menu sampling. However, if you want a slice of the good life on a smaller budget, come in for a snack. Simply order just one or two selections and enjoy a glass of wine. You will get to taste the good life without breaking the bank.

—*Ana Cabrera*

The Popsicle

An East Bay Food

San Francisco is widely known as being a place where it never gets very hot outside but the surrounding Bay Area doesn't always have the luxury of the foggy chill in the air that the city itself has. Maybe it's not so surprising, then, that the favorite of all warm weather snacks, the Popsicle, was first invented in the Bay Area. What is surprising, though, is that it was invented by an eleven-year-old boy.

In 1905, Frank Epperson put his summer boredom to good use. He began making flavored drinks in his home using combinations of water, soda powder and different natural and artificial flavors. His curiosity spread and he left some of his new concoctions outside during a cold Bay Area night. As children will do, he had abandoned the project without removing the stirring stick he'd been using, and thus was born the first popsicle. Epperson called it an Epsicle at the time and worked on perfecting its form. He patented it in 1923, but eventually sold all of the rights to it.

Today, the popsicle can be bought at convenience stores all over, but there are variations of the popsicle which can only be found in the East Bay restaurants where Epperson (a native of Oakland) first developed his treat. For example, try the plum wine sorbet at Angelfish Japanese Restaurant in Alameda (883 Island Dr., #C-2) which is just like a wine popsicle without the stick. Or get a more traditional type of Popsicle from the Colusa Market, located at 406 Colusa Avenue in Kensington. This organic food market sells fruit juice popsicle which can be enjoyed by people of all ages.

—Kathryn Vercillo

BERKELEY

Brazil Fresh Squeeze Café

Tri-tip with a side of samba.
$
2161 University Ave., Berkeley 94704
(between Shattuck Ave. and Oxford St.)
Phone (510) 845-8011

CATEGORY	Hip neighborhood sandwich shop
HOURS	Mon-Sat: 11 AM-8:30 PM
	Sun: 11 AM-7 PM
GETTING THERE	Located near a major intersection in downtown Berkeley, parking can be a bit of a challenge. There is a parking lot just behind the restaurant (which is really more of a sidewalk shack), but it is for a neighboring store and your car will probably be towed if it sits there for more than a minute. I would suggest walking or riding a bike if you have that luxury.
AYMENT	Cash Only
POPULAR DISH	Chef Pedro's Special is the king of all tri-tip sandwiches. Layers of juicy meat are topped with pineapple and grilled onions, then smothered with cheese and rich garlic-cilantro sauce. Most days Pedro himself will greet you on the sidewalk with a smile and a sample. Both are hard to resist!
UNIQUE DISH	Sandwiches are all made with homemade, fresh-baked bread that is light and airy with a perfect crispy shell. Given its location on a commercial

sidewalk and its food stand structure, you wouldn't expect the luxury of artisan bread. It's a pleasant surprise and elevates the entire eating experience. Also, for a place specializing in tri-tip, the veggie plates and sandwiches are quite delicious. They feature the same killer sauce as the meat varieties, only substitute grilled vegetables for tri-tip or chicken.

DRINKS Pair a refreshing mango smoothie with your sandwich or plate. Also try the acai smoothie for something a little different but equally complementary to your lunch or dinner.

SEATING There is a funky little seating area on the side of the stand. It is walled-in with transparent tarps and very colorfully decorated. The space is very small, but maintains a certain charm with its abundance of fake plants, green carpet, and giant pictures of Rio de Janeiro.

AMBIENCE/CLIENTELE Everything from the blaring samba music to the bright and colorful paint give this little sandwich stand enough character to keep people coming back. Its close proximity to the UC Berkeley campus draws a lot of students, especially during the lunch hour. It's a true Berkeley establishment, with its flavorful ethnic fare and selection of National Geographic magazines to flip through while waiting for food to come out.

EXTRAS/NOTES If you've never been to Brazil, a visit to this place will make you want to go home and book a trip. If you have been, it'll make you nostalgic for your time there and anxious to go back.

—*Emilee Schumer*

Café Gratitude

Refreshing take on live food and celebration of aliveness.
$$$
1730 Shattuck Ave., Berkeley 94709
(between Virginia and Francisco)
Phone (415) 824-4652
www.withthecurrent.com/cafe.html

CATEGORY California vegan

HOURS Mon-Sun: 10 AM-10 PM

GETTING THERE Street parking can be difficult; arriving by bike, bus or walking best.

PAYMENT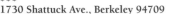

POPULAR DISH Pizzas are unique—crust is a buckwheat and sunflower seed sourdough flatbread, topped with a house made sauce, sliced tomatoes, cashew ricotta, micro greens with a sprinkle of brazil nut parmesan.

UNIQUE DISH Hardcore vegan and raw food restaurant, but very innovative and tasty. Even if you're not a vegan, you'll still be impressed by the extensive menu and be amazed by how fun vegan food can be.

DRINKS All beverages are organic. Smoothies, milkshakes, nut milks, teas, coffee, juices, wine, beer,

SEATING	cocktails. All juices pressed from hydraulic juice press. Shakes and juices made from an interesting mix of organic and natural ingredients.
SEATING	Family-style seating. Individuals or smaller parties may be seated next to other parties but everyone keeps his or her own space.
AMBIENCE/CLIENTELE	Draws a diverse crowd—students, middle-aged, retirees, etc.
EXTRAS/NOTES	Very casual, somewhat noisy ambience. The entire wait staff sings for anyone celebrating his or her birthday. Lots of organic foods, drinks, books, dishware for sale at front of restaurant.
OTHER ONES	• Mission: San Francisco: 2400 Harrison St. San Francisco 94110 • Inner Sunset: San Francisco: 1336 9ᵗʰ Ave., San Francisco 94112 • San Rafael: 2200 4ᵗʰ St., San Rafael 94901

—Valerie Ng

Café la Mediterranee

Savory pastries in a romantic setting.
$$
2936 College Ave., Berkeley 94705
(at Ashby)
Phone (510) 540-7773
www.cafelamed.com

CATEGORY	Hip Mediterranean
HOURS	Mon-Fri: 10 AM-10 PM Sat: 10 AM-11 PM Sun: 10 AM-9 PM
GETTING THERE	Parking is fairly easy in the Elmwood district. There is ample street parking. If you feel like walking, you can always take BART to the Rockridge stop, and walk towards Berkeley until you get here.
PAYMENT	VISA ⬤ Cards
POPULAR DISH	My favorite is the Vegetarian Middle Eastern Plate. It is a combo of spanikopita, cheese karni, levant sandwich and dolma. My husband likes the regular Middle Eastern plate because it comes with Chicken Cilicia (a phillo pastry with shredded chicken) as well as chicken in pomegranate sauce.
UNIQUE DISH	The chicken pomegranate is pretty unique here, tangy and savory. The soups here are aromatic and tasty.
DRINKS	They serve beer, wine and aperitifs like port, Spanish sherry, and champagne cocktail.
SEATING	There are 25 indoor tables and 13 outdoor tables.
AMBIENCE/CLIENTELE	This is a very dark and romantic spot—perfect for outdoor dining. White lights make for a festive atmosphere, and potted ferns and other plants give exotic life to the gold and red tiled mosaics that line the wall. This is where the hipsters eat and work, and piercings, tattoos and black clothing are all about. The man at the bar has long hair, green glasses, a cowboy hat and tattoos up and down his

arms like a Mediterranean Axel Rose. The leitmotif here is food as decoration—and shelves of tahini sauce, pita bread and Amato olive oil line the walls on the way to the back. There is exotic music playing that is unobtrusive enough so that you can still carry on a conversation without listening to those of the people at the next table.

EXTRAS/NOTES' There is usually a wait here on weekends, so be prepared. I am a bit of a bathroom connoisseur, and this place has a good bathroom that satisfies my requirements by being clean, and having soft, recessed lighting, all punctuated by a vase of freshly-cut flowers.

OTHER ONES • Pacific Heights: 2210 Fillmore St., San Francisco 94115, (415) 921-2956

—*Laura Wiley*

Cha-Am Thai Restaurant

The famous Thai tree house.
$$
1543 Shatttuck Ave., Berkeley 94709
(at Vine St.)
Phone (510) 848-9664

CATEGORY Thai

HOURS Mon-Thurs: 11:30 AM-3 PM; 5 PM-9:30 PM
Fri/Sat: 11:30 AM-3 PM; 5 PM-10 PM
Sun: 11:30 AM-3 PM

GETTING THERE Street parking

PAYMENT VISA Cards

POPULAR DISH Everything you'd hope for from a Thai restaurant. Great curries and pad thai.

UNIQUE DISH Try the tofu stir-fry or the sour mushroom soup. In fact, whatever entrée you choose, make sure you try one of the soups. They just might be the cure for the cold day blues. Be sure to try the coconut or green tea ice cream for dessert. Hey, it's never too cold for ice cream.

DRINKS Sodas, Thai iced tea, and water. Lots of water.

SEATING A great intimate setting. Sit in the funky greenhouse-like alcove upstairs and relax with a date. It almost feels like your own private tree house.

AMBIANCE/CLIENTELE Finally, a place that reaches the prefect balance of food and ambiance. The vive here is amazing (it feels like a tree house!). They serve water in metal cups and rice in little silver bowls! No pressure, but you might want to swap out of those sweat pants if you're coming here. No one will guffaw, but a lot of couples come here on dates.

—*Louis Pine*

The Cheeseboard Pizza Collective

The landmark cheesy collective.
Since 1967
$$

1512 Shattuck Ave., Berkeley 94701
(at Vine St.)
Phone (510) 549-3055
www.cheeseboardcollective.com

CATEGORY	Pizza joint
HOURS	Mon-Fri: 11:30 AM-2 PM; 4:30 PM-7 PM
	Sat: noon-3 PM; 4:30 PM-7 PM
GETTING THERE	Street parking
PAYMENT	Cash Only
POPULAR DISH	The pizza changes daily. It's always good and always meat-free. Don't expect to get your greasy New York pepperoni here. But whatever you get it's going to be good. Call ahead or check out their website.
UNIQUE DISH	Every day's pizza is unique here. It's all the better when they come up with consistently creative pizzas with fresh ingredients and plentiful cheese.
SEATING	Not much seating. Grab one of the coveted tables out front or take it home with you. Be careful though, you might finish it before you get anywhere near your home.
AMBIANCE/CLIENTELE	The Cheeseboard is a collective. That means it's run by twelve owner-operators. No bosses. No managers. Walk in here and you can tell, it makes for happier pizza people. It also means hours can be variable, so try not to show up at the last minute.
EXTRAS/NOTES	The Cheeseboard Collective was established in 1967 by Elizabeth and Sahag Avedesian. It used to be housed where the Juice Bar Collective is. Their history reads something like a history of progressivism in the Bay Area. Check it out on their website and watch history unfold. Check out the jazz trio that plays here. They're really good.
OTHER ONES	• The Cheeseboard Collective

—Louis Pine

Gelato Milano

Watch out Milan—you've got competition.
$

2170 Shattuck Ave,. Berkeley 94704
(at Center St)
Phone (510) 649-1888
www.gelatomilano.com

CATEGORY	Italian gelato
HOURS	Mon-Thurs: Noon-11 PM
	Fri-Sat: Noon-Midnight
	Sun: Noon-11 PM
GETTING THERE	Parking can be tricky depending on the time/ day, given that it's right smack in the middle of downtown. There is lots of metered street parking in the vicinity. I would suggest hitting a side

street first. It is also conveniently located directly in front of the main entrance to the Downtown Berkeley BART station.

PAYMENT Cash Only

POPULAR DISH Silky and rich, all flavors are obviously made with only real ingredients, some imported directly from Italy. Decadent *Ciocolatto* tastes like pure cocoa. Pistachio is delicate yet nutty. Lemon *sorbetto* is tart and refreshing. Coconut is full of fresh coconut shavings, straight out of the shell.

UNIQUE DISH Flavors can range from spicy chocolate to blood orange and are frighteningly accurate. Other unique selections include *Zuppa Inglese*, a rum-flavored tiramisu minus the coffee, and Candied Chestnut. *Sorbetto* is the real conversation piece— it's richer and creamier than most ice cream, yet miraculously dairy-free, tempting both vegans and non-vegans alike.

DRINKS Water and a limited selection of soda

SEATING A handful of simple metal tables and chairs are squeezed in the back of the tiny shop. There is also a small table in the front window where customers can sit and watch people shuffle in and out of the Downtown Berkeley BART station.

AMBIENCE/CLIENTELE The colorful 24-flavor glass case is literally the focal point of the tiny shop, given that the rest of it is empty and white. Walls are stark and offer a dramatic contrast to the bright decorative bins of gelato, which clearly supply all the visual spectacle needed. The clientele is varied and seems to include all of Berkeley's Italian population.

EXTRAS/NOTES The owner, Curtis Chin, is friendly and proud of his gelato. On any given night, he will happily chat with you about the ingredients brought over from Italy or let you sample his latest favorite flavor. He's not afraid to declare his gelato superior to all other American gelato, and guess what: he's right.

—*Emilee Schumer*

Lanesplitter Pub and Pizza

Tasty grub and grog at hoppin' Berkeley hang-out.
$$
2033 San Pablo Ave,. Berkeley 94702
Phone (510) 845-1652
www.lanesplitterpizza.com

CATEGORY Hip pizzeria and pub

HOURS Mon-Weds: 11:30 AM-1 AM
Thurs-Sat: 11:30 AM-1:30 AM
Sun: 11:30 AM-1 AM

GETTING THERE Parking isn't too bad. Both San Pablo and neighboring cross-streets have metered street parking. I used to ride my bike and park it in a nearby bike rack.

PAYMENT

POPULAR DISH The pizzas here are fantastic – fresh ingredients,

lots of cheese, and sauce with just the right volume of spice. While you can create your own combination of toppings, the menu offers a number of tasty options, most featuring hearty servings of veggies. My favorite is the "Heartstopper", which comes loaded with all things delicious: gorgonzola cheese, spinach, bacon, and lots of roasted garlic. You may not get that goodnight kiss, but trust me, it's a worthwhile trade.

UNIQUE DISH Yes, Lanesplitter is a pizza joint, but there are some tasty alternatives to pizza on the menu. Try a hearty piece of the Roasted Eggplant Bake. It's full of roasted garlic, spinach, and of course, eggplant. The garden salad is also tasty and satisfying and comes in three different sizes. Pair a plate with a side of the Garlic Bread Stixs with bleu cheese and red sauce for a light but satisfying meal. Also noteworthy is the homemade vegan cheese, "Notta Ricotta". A vegan-friendly pizza joint? Brilliant!

DRINKS Nothing goes better with pizza than beer, and this place has one of the best beer selections in the Bay Area. Each night they feature a variety of microbrews, and the best part is that the lineup is constantly changing so there's always something new to sip. Favorites range from Bear Republic's Racer 5 to Death and Taxes from Moonlight Brewing Company. Of course, there are sodas, juices, tea and coffee available for those not in the mood for a frosty brew (although I don't know how that could happen).

SEATING The restaurant is narrow and not too deep, meaning there isn't a lot of space for tables. My favorite places to sit are either at the bar, which is made out of an old bowling lane, or outside on the back patio. The patio has great heat lamps as well as a charming garden setting, so it's perfect regardless of the temperature.

AMBIENCE/CLIENTELE Despite the giant motorcycle in the entryway, Lanesplitter seems more hipster than biker. The atmosphere is very relaxed, thanks in part to dim lighting and the fact that tattooed bartenders keep customers happy, well-fed, and full of good beer. The crowd is young but not overwhelmingly collegiate, despite Berkeley's large student population. You could sum up the place and the crowd in one word: cool.

EXTRAS/NOTES Don't miss the giant chalkboard behind the bar where pub-goers can buy a beer for their favorite friend. The bartender will record the transaction so that when the lucky friend comes in, he or she can claim the pre-paid pint. Genius!

OTHER ONES • Oakland: 4799 Telegraph Ave., Oakland 94609, (510) 653-5350
• Albany: 1051 San Pablo Ave. (for takeout), Albany 94706, (510) 527-8375

—Emilee Schumer

Saul's Restaurant and Delicatessen

Two cities and several continents in one restaurant.

$$$

1475 Shattuck Ave., Berkeley 94709
(at Vine St.)
Phone (510) 848-DELI • (510) 848-8366
www.saulsdeli.com

CATEGORY	Kosher deli
HOURS	Mon-Thurs: 8 AM-9 PM
	Fri/Sat: 8 AM-9:30 PM
	Sun: 8 AM-9 PM
GETTING THERE	Metered parking is available but can be difficult. Getting there by walking, AC Transit, BART or bicycle is best.
PAYMENT	*VISA* ⬤ ⬤ *Cards* ⬤
POPULAR DISH	Sandwiches are very popular. They're all served with thick stacks of fresh thinly sliced meat between slices of Acme bread. A jar of deli-style mustard sits on every table. Latkes, knishes, falafel, and other Jewish specialties are also very popular. Orders come with a complimentary homemade pickle. There's also a fine deli counter with an assortment of deli meats, cookies, baklava, hummus, rice pudding, tapioca pudding, knishes, chocolate layer cakes, hummus, and other scrumptious goodies.
UNIQUE DISH	This restaurant incorporates influences from New York City, Berkeley, Greece, Spain, Turkey and the Middle East. Thus, you can find specialties from all of these regions on the menu. Breakfast is served until 2 PM on weekdays and 3 PM on weekends.
DRINKS	Beer, wine and cocktails available, as well as the usual hot and cold beverages, including an Arnold Palmer (lemonade & iced tea) and Kedemshki (lemonade, grape juice & spritzer)
SEATING	There is plenty of table and booth seating, as well as at the counter by the deli counter.
AMBIENCE/CLIENTELE	Moderately quiet and relaxed ambience. It draws a diverse crowd, including families, students, retirees and heavily tattooed punk-rocker types.

—*Valerie Ng*

Martini
Crossing the Bay Bridge Bond Style

The martini is perhaps one of the most famous drinks in the world, with numerous references to it in literature and film, the most well-known of which, of course, is James Bond's "shaken, not stirred" line. There is some argument as to where specifically the martini was first invented, but every single story leads back to somewhere in the Bay Area circa the end of the nineteenth century.

Many say that the drink was named after Martinez, California, a city in the upper East Bay where the drink may have originated. It is believed that saloon owner Julio Richelieu created the drink in 1870. However, the drink seems to crop up a lot in different

histories of the area at the time, including within the city of San Francisco itself. It is known that by 1887, recipes for the Martinez were being printed in drink books and shortly thereafter, the popular drink's name was shortened to martini.

The Bay Area knows how to drink, and there aren't too many places where you are going to get a bad martini, but if you want to enjoy your martini with some good food, there are a few extra-special places to try. Despite the fact that the martini was likely invented either in the East Bay or in the city proper, some of the best options for getting martinis and good food are located in the North Bay. To enjoy a view of the city and a good martini at the same time, head to the bar at the Sausalito Alta Mira Hotel at 125 Bulkley Avenue in Sausalito. For a real treat, try the Martini House at 1245 Spring Street in Helena, California where you can sample different mushrooms, complete a full organic meal and enjoy an extensive martini menu.

— *Kathryn Vercillo*

Tacubaya

Electric Enchiladas &
Gourmet Guacamole.
$$
1788 4th St,. Berkeley 94710
(between Virginia St. and Hearst Ave.)
Phone (510) 525-5160 • Fax (510) 525-5160

CATEGORY	Gourmet Mexican
HOURS	Mon: 10 AM-9 PM
	Tues: 10 AM-4 PM
	Weds-Fri: 10 AM-9 PM
	Sat/Sun: 9 AM-9 PM
GETTING THERE	Metered parking lot and street parking nearby, but expect to work up an appetite
PAYMENT	
POPULAR DISH	Enchiladas, with shredded Niman Ranch beef and cheese, rolled in a homemade tortilla and topped with tangy guajillo-tomatillo sauce and crema will warm up an ordinary day like the blazing Mexico sunshine.
UNIQUE DISH	If there's no time in your busy schedule for a Oaxacan vacation, then order the Chile Relleno—a battered and fried poblano chile stuffed with cheese, summer squash, and onions, served in a tomatillo salsa with crema and cilantro and a side of home-made tortillas, then sit back and pretend you're sitting in the Zocalo of a quaint Mexican town.
DRINKS	Beer and wine, along with Mexican sodas and thirst-quenching Agua Frescas
SEATING	Choose from long, wooden, communal-style tables, cozy two-tops, a seat at the counter, or enjoy a panoramic people-watching opportunity outside on the shared patio.
AMBIENCE/CLIENTELE	From 4th Street fashionistas to struggling Cal students, you'll see a wide swath of humanity

enjoying a hearty meal here side by side. Feast your eyes upon walls the color of a Mexico City sunset, sip from your Watermelon Agua Fresca and take in some of the best gourmet Mexican food the East Bay has to offer.

EXTRAS/NOTES This anything but typical taqueria is the fast-food answer to Oakland's infamous, Dona Tomas Restaurant, opened by Thomas Schnetz and Donna Savitsky, who've just had their regional Mexican recipes memorialized in their cookbook, Dona Tomas, published by Ten Speed Press, 2006.

OTHER ONES • Oakland: Dona Tomas, 5004 Telegraph Ave., Oakland 94609, (510) 450-4522

—Mimi Novak

Thai Buddhist Temple Wat Mongkolratanaram a.k.a. Thai Brunch

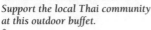

Support the local Thai community at this outdoor buffet.

$

1911 Russell St., Berkeley 94703
(at Martin Luther King Jr.)
Phone (510) 849-3419

CATEGORY Thai brunch

HOURS Sun: 9 AM-2 PM

GETTING THERE Free street parking. One block from Ashby BART

PAYMENT Cash Only

POPULAR DISH Cruise the cases, get in line, step up, and tell the server what you'd like. Main dishes include pad thai, yellow or red curry, spicy green beans, eggplant or squash stir-fry—all in either a vegetarian or meat option. Some dishes can be very spicy, so make sure you get a Thai Iced Tea to wash it down. The noodle soup (much like Pho) is great for colder or damp days. The papaya salad is prepared right in front of you and there is also a wide variety of rolls to choose from. The sticky rice with mango (served with a side of custard) is almost everyone's favorite and the fried chicken is much loved as well.

UNIQUE DISH *Khanom krog* are little medallion-shaped, coconut and green onion cakes that are simply divine. You can order it in combo with *khanom babin* (sweet taro fritters). There are also a wide variety of unique Thai desserts that you'd be hard pressed to find anywhere else.

DRINKS Thai Iced Tea and coffee are the real treats. You can specify if you'd like them with "more tea" or "more milk". There are also sodas and water. All drinks are one token. You can bring you own drinks as well.

SEATING Long plastic tables and folding chairs are set up in the courtyard—some under canopies for relief from the sun or rain—and fit the 200 or so folks who are eating at a time. The tables are communal so be prepared to sit with others.

If you want to eat away from the crowds, there are grassy spots next door in front of the library.

AMBIENCE/CLIENTELE Packed with people from all walks of life—young and old, hipsters and hippies, college students and professors, monks and locals—all coming to enjoy the heaping plates of home-cooked Thai food. The event can get very crowded, often with long lines for the food, people trying to slide their way through the hordes to get back to their table. You'll get jostled, it can feel like chaos and be overwhelming, but this is a true community event. Many meet up with friends (or bump into those they haven't seen in a while) and eating with a bunch of people is ideal as you can sample a huge variety of the offerings since the portions often feed two. You can't get more Berkeley than this. Definitely a "must" experience.

EXTRAS/NOTES "Thai Brunch" benefits the Thai Buddhist Temple and Cultural Center and happens rain or shine. No money is exchanged around the food. When arriving, buy tokens in the back-left hand corner; buy more than you think you'll need, as you can always exchange them back for dollars if you don't use them. Dishes cost between 3-6 tokens each, drinks are 1 token each. You can get a combo of 1, 2, or 3 main dishes for 4, 5, or 6 tokens. Don't give the server the tokens directly; put them in the containers on top of the glass case. You can get your food "to go" if you're feeling agoraphobic just make sure you tell the server before ordering. The food is only cooked in the morning, then served all day, so get there early if you want it warm and to avoid the crowds. Did I say get there early? Sometimes the food runs out by 12:30 pm. On Buddhist or Thai holidays there can be music and dancing or monks performing rituals. Afterwards, hit up the flea market at the Ashby BART station.

—*Rana Freedman*

SAN RAMON

Zachary's
(see p. 173)
Chicago-style pizzeria
3110 Crow Canyon Pl., San Ramon 94583
Phone (925) 244-1222

DUBLIN

Fuzio Universal Pasta

(see p. 65)
Hip pasta spot
4930 Dublin Blvd., Dublin
Phone (925) 833-7124

FREMONT/UNION CITY

Asian Pearl

(see p. 174)
Trendy Chinese
43635 Boscell Rd., Fremont 94538

Pho Pasteur

Beef, it's what's pho dinner.
$$
31860 Alvarado Blvd., Union City 94587
(at Dyer St.)
Phone (510) 441-7130 • Fax (510) 555-7130

CATEGORY	Neighborhood Vietnamese noodle house
HOURS	Mon-Sun: 9 AM-9 PM
GETTING THERE	This noodle house is in the 'burbs so there's no need to worry about parking. Pho Pasteur is located in a local shopping plaza right next to an intersection with three gas stations. So drive and get gas after your meal if need be.
PAYMENT	Cash Only
POPULAR DISH	Some people paint by numbers; here, we order by numbers. The popular favorite for those with a big appetite is #1 (Special Pho Large). If I can't decide what I want, I go for #4 which is basically a smaller version of #1. If you want to keep it simple, order #17. The rice plates and vermicelli bowls are good too…but then again, it's not called "Rice Plate Pasteur" or "Vermicelli Bowl Pasteur" now is it?
UNIQUE DISH	Simply put, the Pho. What's unique about this place is that they serve what they know. So rather than expand into other types of Vietnamese cuisine, they offer over 30 variations of noodle soups, eighteen of which are of the beef pho variety. I don't order pho at places that offer less than a handful.
DRINKS	I usually keep it simple and go for the Vietnamese Ice Coffee with Condensed Milk but they've been expanding their drink menu a lot. Plum and lemon sodas, rainbow layered drinks and desserts just to name a few.

SEATING	Picture one room filled with about 25 tables each topped off with your typical Vietnamese self-serve utensils and condiments. Tables can be put together for larger groups or you can sit solo at a table for two.
AMBIENCE/CLIENTELE	This noodle shop is notorious for its speed; it's as if they know what I'm going to order. The last time I went there, our food was on our table in under 5 minutes. This place is for people who want non-pretentious, real, no-need-to-impress-because-everyone-knows-it's already-good kinda meal. You know what they say, "you are what you eat."
EXTRAS/NOTES	It's kid friendly because it can get pretty loud. Also, I can hear about three different languages from various tables at any given time so everything just turns to white noise.
OTHER ONES	• Pho Pateur II: 1779 Decoto Rd., Union City 94587, (510) 489-2949 (larger, brighter, and slightly more expensive)

—Bonnie Yeung

Salang Pass

An Afghani splash of yogurt
& dash of spice.
$$$
37462 Fremont Blvd., Fremont 94536
(between Central Ave. and Peralta Blvd.)
Phone (510) 795-9200 • Fax (510) 795-9009
www.salangpass.com

CATEGORY	Afghani and Middle Eastern
HOURS	Mon-Thurs: 11:30 AM-10 PM Fri/Sat: 11:30 AM-10:30 PM Sun: Noon-10 PM
GETTING THERE	Street parking on Freemont Boulevard is to find. There's also an easy to miss parking lot behind restaurant (spots are always available).
PAYMENT	VISA
POPULAR DISH	Kabob skewers (lamb, beef, chicken) are a consistent hit with new and frequent customers. The entrée is typically served with salad, a basket of Afghani *Naan* (bread), basmati rice and a grilled tomato. The meat is charbroiled to perfection and the fiery taste of the grill doesn't leave your tongue. Another favorite is either the *Aushak* (Afghani style ravioli) or *Mantoo* (Afghani style dumplings), which are both topped with bits of seasoned ground beef and a light but creamy yogurt sauce. Get one of these latter dishes with a kabob entrée and you're set with two very complementary tastes.
UNIQUE DISH	An unusual dish is the *Firni* (dessert) which consists of Afghani pudding prepared with milk, rosewater, cardamom, sliced almonds and topped with pistachios. It is a burst of flavor from start to finish. Hopefully you prefer some, if not all of these ingredients because not a single one is masked beneath the other.

DRINKS Aside from the normal drinks (coffee, tea, soda), there is an unfamiliar item on the menu: *Dogh* (yogurt drink mixed with cucumber and dry mint leaves). For those who prefer the unique taste, the drink veers towards the sour side and you can actually slurp in thin slices of cucumber through your straw.

SEATING Upon entering, the right side of the restaurant creates a modern and casual feel with mahogany wooden tables and chairs. This side is seemingly larger with a wall that is painted with tranquil colors of an outdoor landscape. Contrastingly, the adjacent side of the restaurant creates a more traditional feel, as if you were entering into another world. It is embellished with rich colored curtains flowing across the ceiling, traditional artifacts and a raised floor with low tables where you can rest against cushioned seating and patterned pillows to comfortably enjoy your meal.

AMBIENCE/CLIENTELE Because of the differences in décor, the modern side is suitable for a casual lunch meal and the traditional side is no less than perfect for a romantic date. The enclosed space, dim lighting and deep colors provide a feeling of warmth and intimacy. The weekdays are filled with local worker bees and the nights are taken up mostly by couples, small groups of friends and some families.

EXTRAS/NOTES Don't be fooled by the somber outside and emptiness of surrounding restaurants; the restaurant is always filled with people in adoration of the authentic food and environment.

—Shannon Lee

Going Native in the Bay

Who wants to walk down the street or go into a restaurant or bar and immediately get labeled a tourist? All self-respecting travelers eschew the scarlet T, trying like mad to blend in with the local population wherever they are. Of course, if you're a 6'4" blond guy in Tokyo, you're screwed. But the San Francisco Bay Area has one of the most diverse populations on the planet. Anybody can fit in here! But not everybody does. Here are a few hints that will keep us locals from knowing immediately that you're from Topeka, or worse, from L.A.

Getting Dressed:

- In San Francisco, always wear long pants. No local ever wears shorts in the City. Also, it's cold and foggy all summer long.
- In the Silicon Valley, dress exclusively in local-company logowear. Ebay, Google, and Apple are hip. Defunct companies like @Home, Webvan, and Seibel are even hipper. (But never wear Microsoft!)
- Dress down. This isn't Manhattan—the latest runway fashions will make you look like a freak in the Bay Area. Jeans and a t-shirt are fine in all but the fanciest restaurants.

At the Beach:
- Wear jeans, a sweatshirt, and a hat. This isn't Hawaii. This isn't even L.A. The average temperature on a Bay Area beach in July is 65 degrees.
- Bring a self-help book to read. Even better if it's business related. "Who Moved My Cheese" or "Seven Habits of Highly Effective People" are perfect Bay Area beach reading.
- If it's sunny, slather on the SPF 50 sunscreen. Bay Area denizens care far more about skin cancer than they do the perfect tan.
- If it's overcast and misty, slather on the SPF 50 anyhow. San Francisco beaches are the home of the infamous "cloud burn."

On the Road:
- Never say "the" before any freeway number. Once you're north of Ventura, it is no longer "the 101." It is just 101, and we're proud of it!
- Do not stop at the foot of a freeway onramp. Ever. For any reason.
- If you see someone with a local license plate trying to parallel park, get out of the way. We don't have to learn to do that to get a driver's license here.

Around the Bay
- The City of San Francisco is always "the City." It is not "San Francisco" and it is never, ever "Frisco" to a native.
- The area from Daly City to San Jose is always "the Peninsula."

Drinking Coffee
- Avoid the big-name chains. Pick a tiny local coffee house instead.
- Bring a laptop computer. Be sure to ask if there's free wireless Internet.
- Get snotty about the coffee itself. If you're visiting Berkeley, order a fair-trade organic soy latte.

In a Restaurant
- Make your dinner reservations online. (Hey, if the café's got free wireless, you might as well!)
- Go local and organic. In the Bay Area, "Con-Agra" is synonymous for "disgusting-hormone-ridden-overprocessed-cancer-causing-preservative-filled inedible evil." Many menus proudly proclaim their local, organic ingredients. Bonus local-points for starting an argument with the server over the relative merits of shipped organic vs. local semi-conventionally grown.
- Care about the lives of fish. Order only wild-caught salmon and sustainably farmed tilapia. Never order the swordfish or the Chilean sea bass. Nod knowingly when the Monterey Bay Seafood Watch program comes up in conversation.
- Know your California wines, or learn to fake it. Wine snobbery has become an integral part of Bay Area culture. The good news—serious wine-lovers are not ashamed to consult the sommelier in a fine restaurant, and take her recommendations.

—Liz Scott

Yuri Japanese Restaurant

Locals-only Tokyo style sushi bar in downtown Fremont.

$$$

3810 Mowry Ave., Fremont 94538
(at Fremont Blvd.)
Phone (510) 795-6701

CATEGORY	Low-key Japanese sushi
HOURS	Mon-Sat: 11 AM-2 PM; 5 PM-10 PM
GETTING THERE	Lots of free parking in front of restaurant
PAYMENT	VISA MasterCard
POPULAR DISH	#2 Special Spicy Tuna Roll—Spicy ahi tuna inside and an extra layer of ahi on the outside. For an extra layer of texture and contrasting flavor ask the chef to add avocado to the roll.
UNIQUE DISH	Garbage Roll: Tuna, Crab, Eel, Tobiko, Cream Cheese, Shrimp Tempura & Vegetable
DRINKS	Large premium Sake selection, beer & wine (plum & grape). Complimentary fresh brewed green tea served upon request, coffee, and sodas
SEATING	Thirteen tables and eight bar chairs. Overall restaurant is small, but can be modified to accommodate a large group with advanced notice. Great for couples because of the peaceful atmosphere and for those single diners, the sushi bar is a wonderful place to make new friends or relax and watch the game.
AMBIENCE/CLIENTELE	This is a relaxing local dive. Nothing flashy, nothing fancy—just fresh, well prepared and expertly presented Japanese fare. For a more private and intimate experience sit in one of the pine booths or if you're looking for a little more interaction the sushi bar is definitely the place to be. At the bar you will be delighted with the opportunity to explore all of your sushi and sake fantasies with the charming sushi chefs and some of the more lively regulars. Traditional Japanese harmonies play softly in the background and there is a flat screen TV in the sushi bar for sports and other entertainment. Dress is always very casual and there is never a wait. Come hungry for some phenomenal sushi and you will not leave disappointed.
EXTRAS/NOTES	Although the restaurant has been open since 1986, it has changed ownership many times. The newest owner took over in February 2006 and has made some much needed improvements such as expanding the sake collection and adding a flat screen TV for entertainment. So if you haven't tried Yuri's in a while come back and see what's new!

—Mary Poffenroth

HAYWARD

Yet Nal Zza Zang

(see p. 171)
Korean noodle house
22532 Foothill Blvd., Hayward 94541

SAN LEANDRO

Bangkok Thai Express

(see p. 141)
Thai
1459 University Ave., Berkeley 94702
Phone (510) 848-6483

Ohgane

(see p. 164)
Korean BBQ
1292 Davis St., San Leandro 94577

Zachary's

(see p. 173)
Chicago-style pizzeria
1853 Solano Ave., Berkeley 94707
Phone (510) 525-5950

ALBANY

Café Raj

Casual dining for the
sophisticated palate.
$$
1158 Solano Ave., Albany 94706
(between Stannage Ave. and Cornell Ave.)
Phone (510) 524-5667 • Fax (510) 527-5797

CATEGORY	Northern Indian and Pakistani
HOURS	Mon-Thurs: 11:30 AM-10:30 PM
	Fri/Sat: 11:30 AM-11 PM
	Sun: 5 PM-11 PM
GETTING THERE	Parking is on the street and can be a pain at times. Alternatively you could walk 15 minutes from El Cerrito Plaza Bart or catch the AC transit line #43.

PAYMENT	VISA ⬤ ATM on site
POPULAR DISH	The Chicken Tikka Masala is a real crowd pleaser. The chicken is tandoori grilled and served in a tomato, ginger, garlic, curry sauce with slivered almonds. I also recommend the Channa Masala. Whole chickpeas in a nice tomato cilantro sauce. The cilantro just gives a perfect hint of green and it's a great veggie option.
UNIQUE DISH	The Keema Mater: spiced ground beef and peas. It sounds simple, and it is. That's part of the beauty. It's aromatic, flavorful and saucy. Try it with the cheese naan. You won't regret it.
DRINKS	The more unusual beverages are: *Nimboo Pani* (Lemon and rose water beverage), Lassi: (yogurt beverage) in your choice of Mango, Rose, Banana, Cumin, Plain, Plain Sweet and Plain Salty. They also serve a selection of juice, soda, sparkling water, Orangina, coffee, tea and real Indian Chai. They have a good selection of wine and beer as well.
SEATING	The dining room is of moderate size and fills up quickly even on a weekday evening. However I have never waited more than 15 minutes for a table.
AMBIENCE/CLIENTELE	This is a neighborhood place if I've ever seen one. Everyone and their uncle goes there. It's clean, simple and unpretentious. I recommend it as a casual date place and a great spot to bring your close friends and family.
EXTRAS/NOTES	If you stand in front of the Albany post office (corner of Cornell Ave. and Solano Ave.) anywhere between 10 AM and 11:30 AM and take a couple sniffs with your nose you will experience the intoxicating scent wafting over from Cafe Raj. More than once this was enough to convince my appetite that nothing but curry would do. Cafe Raj is family owned and it shows. The atmosphere is always welcoming and the clientele are varied and neighborly. The food is delicious, consistent and won't hurt your wallet.

—*Anne Goffin*

Lanesplitter Pub and Pizza

(see p. 186)
Pizzeria and pub
1051 San Pablo Ave., Albany 94706
Phone (510) 527-8375

Nizza la Bella

France meets Italy on San Pablo Ave.
$$$$
825 San Pablo Ave., Albany 94706
(at Solano Ave.)
Phone (510) 526-2552
www.nizzalabella.com

CATEGORY Artisan pizzeria and French bistro

HOURS Mon-Thurs: 5 PM-9:30 PM
Fri/Sat: 5 PM-10:30 PM
Sun: 5 PM-9:30 PM

GETTING THERE Parking is available on San Pablo Ave. or in the parking lot two doors down. Alternatively you could walk 15 minutes from El Cerrito Plaza Bart or catch the AC transit line #43 to Solano Ave. at San Pablo Ave. and walk half a block to get there.

PAYMENT VISA MasterCard

POPULAR DISH The pizzas at Nizza la Bella are made in the fashion of legendary Pizzaiolos Gennaro Lombardi and Anthony Pero of New York City just after the turn of the century. No wonder these guys were legendary. The crust is fantastic, crispy and soft at the same time. The wood fired pizza oven maintains 800 degrees Fahrenheit as the crust becomes bubbly and ever so lightly charred. A handful of pizzas grace the menu. The toppings are well selected and an additional pizza is offered on the seasonal menu. Also try the classic Steak-Frites, Moules Feu De Bois or Bouillabaisse (French fish stew),

UNIQUE DISH A very unusual dish called La Socca is on the menu here. It is a specialty on the streets of Nice and is rarely seen elsewhere. A crepe like batter is made with chickpeas and is cooked in the wood fired pizza oven. Truly a regional specialty.

DRINKS Nizza la Bella has a full bar. They offer a very nice wine list, a variety of beers and a selection of regional, classic and imaginative cocktails. I recommend the Nigroni or the French Martini witch is made like a Mojito but with Creme De Casis.

AMBIENCE/CLIENTELE The light is low and the mood intimate. From the bar to the wooden booths the colors are rich and provincial. You feel as if you are in a classy southern French bistro. Nizza is both a local spot and a destination restaurant. I once saw a man bring his own ergonomic chair to dinner there and greet the bartender with a familiar smile.

EXTRAS/NOTES Nizza la Bella (Nice the Beautiful) is an upscale restaurant but correctly priced. You can share a pizza or go all out, whichever you choose. It has adopted the California standard of dressing up while wearing jeans. Do it up date style or stroll in with jeans and sneakers. Whatever you or your dining partners are wearing, your palate will not be unimpressed. Top notch ingredients and skillful, artisan care make this place a spot to remember.

—*Anne Goffin*

Sam's Log Cabin

Organic eggs and Lincoln logs.
Since 1930
$$$

945 San Pablo Ave., Albany 94706
(between Solano Ave. and Marin Ave.)
Phone (510) 558-0494

CATEGORY Low-key California café

HOURS Tues-Fri: 7 AM-2 PM
Sat/Sun: 8 AM-2 PM

GETTING THERE Parking is available on San Pablo Ave. or you could park in the Town Center parking lot across the street. Alternatively you could walk 15 minutes from El Cerrito Plaza Bart or catch the AC transit line #43 to Solano Avenue and San Pablo Avenue and walk half a block to the cabin. It's small so don't blink or you'll miss it.

PAYMENT VISA

POPULAR DISH Everyone loves the home made, fresh baked muffins, scones and coffee cake.

UNIQUE DISH The Schooner: two griddlecakes topped with two of Judy's organic eggs. You can add "ores" (Hobbs bacon) at extra cost.

DRINKS All the regular breakfast beverages are available including fresh squeezed O.J. and grapefruit juice. The coffee isn't top notch so I usually opt for a latte.

SEATING Sam's is a little place with about a dozen small tables. On sunny weekends they open up their little patio out back for a few extra seats.

AMBIENCE/CLIENTELE Sam's Log Cabin has a unique old timer/home made vibe. I'd call it campy but it's more than that. The décor is rustic, vintage lumberjack with a large collection of antique egg beaters hanging from the peak in the roof. There's also a vitrine of collectible log cabin maple syrup tins below the register. They are down at my nephew's eye level and he made sure I didn't miss them. Sam's is a neighborhood joint with lots of regulars. There are newspapers to read and interesting conversations to overhear.

EXTRAS/NOTES Sam's was built in 1930 from a Sears log cabin kit. The place has changed hands a few times over the years but has been a restaurant of some kind at every stage. I am reminded of the children's book "The Little House" because it's apparent that modern Albany sprouted up around this little cabin. It's nice to visit a funky bit of history like Sam's.

—*Anne Goffin*

PENINSULA

SOUTH SAN FRANCISCO

Hungry Hunter Steakhouse

*Old-school lounge with local flavor
and a fab bartender named Chuck.*

$$

180 S. Airport Blvd., South San Francisco 90480
Phone (650) 873-5131
www.paragonsteak.com

CATEGORY	Upscale steakhouse
GETTING THERE	There is a free lot with easy access from both directions.
PAYMENT	VISA ⬤ 💳 Cards 💳
POPULAR DISH	Okay, so the ones not in the know would say the Prime Rib. Granted it is an excellent prime rib. Don't pass it up! But, trust me, try the Cajun Lamb Chops. This is a hidden secret at this place since it is an off the menu item. The lamb chops are coated and grilled with Cajun spice and served hot on a bed of cabbage and ranch dressing. Since this dish is low on carbs it is a fantastic choice for any diet and palate. The small set can have these as an entrée but many order a few and use them as an appetizer. The choice, of course, is yours.
UNIQUE DISH	For those of you on the no-carb diet, this dish will seriously tempt you…and you will be deliciously rewarded if you cheat. Hungry Hunter's Calamari Fritti is lightly breaded and fried with red peppers and sweet onions then drizzled with ancho-chile mayonnaise. To make it a bit healthier for you, just remove the batter from the calamari and you will be good to go. Oh, and don't forget to ask for extra ancho-chile mayonnaise on the side.
DRINKS	My favorite part of Hungry Hunters is the lounge. With weathered wood ceiling planks, low-set converted lanterns on the walls, stained glass windows and a wood grained bar, you are looking at a good time regardless of the company. But, I have been in there alone and the bartender, Chuck, will keep you entertained with stories of horses, home and Texas. Since I just moved here from Texas, I felt right at home. And, there are a few regulars that will jump in and start talking, so don't be afraid to go it alone! I have also been there on a date and had a good time (thank God for the good food and drinks), so, okay, I didn't make it to the second date, but who's counting right? A girlfriend of mine and I went as well and we enjoyed ourselves. There were a lot of single guys but not a lot of single women so we got most of the attention. Their beer and wine list is good as well as the cocktails. You name it and Chuck will make it happen if he can.

SEATING The seating here is ample and, since they have a second floor, it is perfect for company gatherings or parties. I asked my fav bartender about corporate gatherings and he says they have all the equipment you need to make it a great place for presentations and the like.

AMBIANCE/CLIENTELE I have met a few of the wait staff and everyone was very friendly. You get to know the staff pretty quickly when you go in and it makes it nice to be greeted in a familiar tone when you walk in. This place could go either way...you want to hang out with your friends in the lounge, have at it. The TVs, the drinks, the booths and the tables lend themselves to any mood you want to set. If you want to go for a more private, intimate affair, head to the main restaurant and enjoy a private table for two. The wine list will loosen you up and get the romantic juices flowing.

EXTRAS/NOTES The chain was established in 1967 in San Diego and now has 25 steakhouse and specialty restaurants in Arizona, California, Indiana, Michigan, North Carolina, Ohio, Utah and Virginia. Each restaurant reflects different styles, flavors and budgets.

—*Amber Bagwell*

DALY CITY/BRISBANE

7 Mile House
Don't judge this book by its cover; historically great fare.
Since 1853
$$$$
2800 Bayshore Blvd., Brisbane 94005
(at Geneva Ave.)
Phone (415) 467-2343
www.historic7milehouse.com

CATEGORY Bar & grill with Filipino food

HOURS Mon-Thurs: 11:30 AM-9 PM (bar open 'til 10 PM)
Fri/Sat. 11:30 AM-11 PM (bar open 'til 2 AM)
(open Sundays when the 49ers are playing... check their site)

GETTING THERE The good news is, the 7 Mile House is easy to find; just a few blocks south of the Cow Palace. The bad news is, it takes some effort to get there (but well worth it). It's at the confluence of Brisbane, San Francisco and Daly City but Sam Trans #121 or 292 gets you closest. The parking lot out front has not changed much since the 1850s...basically a dirt lot, but in fairness, it's easy and free.

PAYMENT VISA Cards

POPULAR DISH They call it the 'Famous 7 Mile Burger' I call

it the 'oh my God don't walk … run and bring your friends, wear old clothes, dig in and get sloppy, heaven on earth burger.' Yes, it's that good!

UNIQUE DISH Vanessa Villacarlos, a lovely Filipina, owns and manages this unassuming eatery and it's lucky for us because she lends her countries traditional dishes to the menu. Who doesn't get a craving for Lumpia or Pork Adobo … both perfectly prepared and very fresh. Not in the mood, then try the Blue Point Oysters on the half shell. Dang…I'm drooling over my keyboard again.

DRINKS You name it, they got it. More than one missionary has enjoyed a liquid lunch in the building's 153-year history.

SEATING Comfortably seats about 50 patrons including the ability to belly up to the bar.

AMBIENCE/CLIENTELE You can't appreciate this place without giving it a little context. Originally, the 7 Mile House was a stopping point for stagecoaches on their way to and from San Francisco. It's the only "mile house" still in its original location, which happens to be seven miles from the Embarcadero. About the only thing that has changed in all those years are the owners. It has a raucous saloon look on the outside but the inside is warm and friendly with heaps of character. Regulars have an air of 'look what I have discovered!' about them while newbies sheepishly wander in but are quickly made to feel comfortable.

EXTRAS/NOTES Be adventurous and check out this historic sports bar and grill. The food and drinks are great, the history is interesting, and they have enough variety in the entertainment department to make this place a great stop any time. It has served travelers since the 1850s, played a part in the early gang wars of San Francisco and was one of the few joints around during prohibition licensed to sell whiskey; it has a long and colorful legacy, which continues, hopefully for a long time to come. If you're in the mood to sing (or hear someone else sing) Wednesdays are Karaoke night, and there is live Jazz Jam on Thursdays and R&B/Soul night on Fridays.

—*James T. Wigdel*

Barracuda Japanese Restaurant

(see p. 62)

Peruvian and Japanese sushi fusion

127 H Serramonte Blvd., Daly City 94015

Bangkok Kitchen

(see p. 177)
Semi-casual Thai
201 Southgate Ave., Daly City 94015
Phone (650) 755-8749

(see p. 177)

SAN BRUNO/BURLINGAME

Barracuda Japanese Restaurant

(see p. 62)
Peruvian and Japanese sushi fusion
347 Primrose Rd., Burlingame 94010
Phone (650) 548-0300

(see p. 62)

Don Pico's Original Mexican Bistro

*Festive Mexican eatery just
minutes south of the SF border.*
$$$$
461 El Camino Real, San Bruno 94066
(at Jenevein Ave.)
Phone (650) 589-1163

CATEGORY Family-style Mexican restaurant

HOURS Tues-Sat: 11 AM-9 PM

GETTING THERE A small lot is available and street parking is not difficult.

PAYMENT

POPULAR DISH On the vegetarian side, I heartily recommend the chile rellenos and the cheese enchiladas. Both the red and green enchilada sauces add flavor without overwhelming everything else. In the meat and seafood categories, I hear and read good things about the *carnitas* and the *mariscada*, a seafood stew. Portions are quite large but should still be preceded with an order of their guacamole.

UNIQUE DISH Beyond the traditional basics, Don Pico's offers a generous selection of seafood entrées and out of the ordinary specials such as Mexican jambalaya. Look for variations on the standards including the (optional) use of goat cheese in a couple of dishes and other modern California cuisine touches. Hence, the word "Bistro" in the restaurant's name.

DRINKS Beer, wine and margaritas. However, they do not have a full bar and wine is used in the margaritas rather than tequila. They taste pretty good, but don't count on getting hammered off of them.

SEATING Nine booths line the walls, most are for two to four people, but two others can accommodate ten to twelve. There are also several tables for two to four that can be put together for additional guests plus four seats at a small bar.

AMBIENCE/CLIENTELE Don Pico's is a good cure for a bad day. This is the traditional family-style restaurant more typically found in Southern California and seen much less up here. It is casual, cheerful, welcoming and even a bit classy with oil paintings and portraits, sombreros and colorful festival posters adorning the walls and large wrought iron and glass chandeliers above. The service can be surprisingly fast, but you don't feel like they are trying to rush you out. The karaoke-like live music is not ideal, but neither is it distracting.

—Bill Richter

King Yuan Restaurant

A tasty treat on trendy Burlingame Ave.

$$$

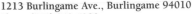

1213 Burlingame Ave., Burlingame 94010

Phone (650) 343-5130

www.eatkingyuan.com

CATEGORY Mandarin and Szechwan Chinese

HOURS Mon-Thurs: 11 AM-3 PM; 4 PM-9:30 PM
Fri-Sun: 11 AM-9:30 PM

GETTING THERE Since it is located on the trendy, ever-popular (no matter what time of day) Burlingame Avenue, it can be hard to park. Either take a pocket full of quarters and be prepared to drive around a bit or just head to the parking lot behind Sephora and grab a spot there.

PAYMENT VISA ⬤ Cards

POPULAR DISH Mongolian Chicken, which is on the spicy side. I also adore the Kung Pao Chicken, Garlic Chicken and the Mongolian Beef…all served on the spicy side.

UNIQUE DISH Rumor has it, the crab and cheese dumplings are can't-miss items. They also put a different twist on rice soup by giving it a little sizzle. Check it out and you will know what I mean.

DRINKS A few wines to choose from and the usual assortment of teas, coffees and beverages.

SEATING For such a small place, they do a good job of assuring that there's always a spot for you. They also offer special events and catering. All their food is offered to go, so if you find yourself a chair or two short, don't be afraid to take it home.

AMBIENCE/CLIENTELE The space is pretty small but they do their best with it. There is a cubed glass partition when you walk in, a couple of chandeliers and a mirrored wall on one side. Because of its location on B-game Ave., you get a lot of locals and the occasional tourist. After you dine, be sure to head out to the Ave. and visit some shops. It is definitely worth it.

EXTRAS/NOTES This placed used to be called King Yen but when the Wang family bought it about 15 years ago they changed it to King Yuan.

—Amber Bagwell

Steelhead Brewery Company

Dining with a view.
$$
33 California Dr., Burlingame 94010
(at Peninsula Ave.)
Phone (650) 344-6050
www.steelheadbrewery.com/burlingame.htm

CATEGORY	Brewery
HOURS	Sun-Mon: 11:30 AM-9:30 PM Tues-Thurs: 11:30 AM-10 PM Fri/Sat: 11:30 AM-11 PM
GETTING THERE	Because of its great location, parking can sometimes be a chore. It is metered so bring your pocket change and some extra time to scout a location.
PAYMENT	VISA
POPULAR DISH	To start with, the Calamari Fritti is a definite favorite. Follow that with a Station Starter salad and then dive into either the Woodfired Stuffed Pork or the Southwestern Scallops and Prawns. Either way, you will be pleasantly pleased.
UNIQUE DISH	Try the Fiery Jambalaya, a "hot, hot" combination of chicken, shrimp, andouille sausage, Cajun spices and vegetables tossed with steamed Basmati rice. It is the first I have seen at any of the places I have dined in so far and I am dying to try it out.
DRINKS	The sampler, a taste all their fine micro-brew beers currently on tap…need I say more? But, Chris, one of my favorite bartenders, will hook you up with whatever you are in the mood for.
SEATING	The seating is quite spacious and plentiful in the restaurant area. There is also an outdoor beer garden (seating is limited here so get there early to grab a seat) and there is bar seating in the billiards area which also holds 6 billiards tables.
AMBIENCE/CLIENTELE	Depending on what area you are in, the ambience runs from mellow to party…either way you are bound to enjoy your experience.
OTHER ONES	• Check their Web site for info on their Eugene, Oregon and Irvine, California locations.

—*Amber Bagwell*

SAN MATEO/FOSTER CITY

Kaimuki Grill

Japanese comfort food.
$$$
104 S. El Camino Real, San Mateo 94401
(at Second Ave.)
Phone (650) 548-9320

CATEGORY	Low-key Japanese sushi, soup and noodle house
HOURS	Mon-Fri: 11:30 AM-2 PM; 5:30 PM-10 PM Sat: 5 PM-10 PM Sun: 5 PM-9 PM

207

GETTING THERE There is metered parking on El Camino, in front of the restaurant. Parking is much easier here than across the street, which is in the thick of busy downtown San Mateo.

PAYMENT VISA ⬤ ⬤

POPULAR DISH Kaimuki Grill is where you'll find me most nights, warming up on hot tea in earthenware cups in the winter, cold sake or Japanese beer in the summer. A friend of mine who is a sushi snob admits that this little place has "very, very good sushi." Try the spicy tuna roll, which is extremely spicy (I always ask them to make it less spicy, and then it's perfect for my palate). The mushrooms stuffed with ground beef are delicious.

UNIQUE DISH The tuna *poki* is very popular. Expect well-prepared sushi and sashimi. The *yaki udon* is delicious: stir fried udon noodles with vegetables and chicken, served with miso soup. The udon and ramen soup portions are huge and relatively inexpensive.

DRINKS Green tea, Japanese beers, plum wine, sake

SEATING There is a sushi bar and a decent number of four-top tables for such a small place.

AMBIENCE/CLIENTELE This is a neighborhood *yakitori-ya*, a place that specializes in skewered grilled meats, much like you'd find in Japan. The waitresses and sushi chefs are kind and welcoming.

—*Karen Kramer*

O'Neill's Irish Pub

A great place for a pint and live music.

$$$

34 S. B St., San Mateo 94401
(at Primrose Rd.)
Phone (650) 347-1544
www.tisoneills.com

CATEGORY Irish pub

HOURS Daily: Noon–2 AM

GETTING THERE There is metered parking along the street in front of the restaurant; public lots are also in the area.

PAYMENT VISA ⬤ ⬤ Carte

POPULAR DISH O'Neill's doesn't actually serve food, but just ask for a menu book, which includes menus from several nearby restaurants (including burgers, Japanese, Indian, Chinese). You can call in the food order yourself, or the staff will do it for you; either way, the restaurant then brings the food right to your table at O'Neill's. So you can just sit back and enjoy your Guinness.

DRINKS Full bar

SEATING The front of the room is where you'll find the bar and bar tables. In the back are half a dozen or so tables. Things don't get too loud in here, until the live music starts (in which case, you can't hold a conversation very well in the back).

AMBIENCE/CLIENTELE This lively spot draws in a good mix of locals (some just stepping off CalTrain) and after-work people. The service is super-friendly and, to add to the fun vibe, there's always something going on here. Check the web site for nightly events.

EXTRAS/NOTES O'Neill's offers free Wi-Fi to customers, so it's okay (albeit slightly geeky) to open up your laptop in this bar. There's something going on pretty much every night at O'Neil's. Monday is live music and Monday Night Football; Tuesday is Irish set dancing; Wednesday is pub quiz night; Thursday live music and martinis; and on Friday and Saturday they have more live music.

OTHER ONES • Potrero Hill: 747 Third St., San Francisco 94107, (415) 777-1177

—*Anh-Minh Le*

Saigon City

Authentic Vietnamese cuisine.
$$$
418 East 3rd Ave., San Mateo 94401
(at S. Railroad Ave.)
Phone (650) 340-8878

CATEGORY Neighborhood Vietnamese

HOURS Daily: 11 AM–9:30 PM

GETTING THERE The metered parking directly in front of the place is 24 minutes (why not 30?), turns out, with super-fast service I actually had a few minutes to spare!

PAYMENT VISA [cards]

POPULAR DISH The Chicken Rice Noodle soup is to die for. Made fresh, you have rice noodles, torn chicken, cabbage and green onions. Served on the side you have bean sprouts, jalapeños and mint. Put it all together and you have one killer dish! You have a choice of a medium bowl or a large and unless you are super hungry, go with the medium. You also have a wide variety of vegetarian options, so if you like to stay away from the dead; you have quite a few options.

UNIQUE DISH If you are looking for unique, this isn't the place for you. You have your traditional Vietnamese fare at this place and it will make you happy. So order up! I have heard the crepes are good, but I haven't tried them yet….

DRINKS The most unusual for most will be the Vietnamese Coffee served with ice and condensed milk; it is pretty sweet though so you might want to save this for supper time. You can also choose from a Soy Bean Drink, Thai's Iced Tea, Plum Soda, Jasmine Tea and your regular array of soft drinks and lemonade. The best though is to order a carafe of their wine. House wine is all you get so it isn't anything fancy but the price is hard to pass up. At $1.95 a glass, you have no idea what you are drinking but it gets the job done.

SEATING You have limited seating in this neighborhood place so watch out if you come during peak

lunch/dinner hours. I usually go for lunch and I
make it 11:30 AM so I beat the rush.

AMBIENCE/CLIENTELE This is a no-frills place and you won't be reading
about it in the society pages, but it is a local
favorite of the Asian and local set and the food
sells the place so get your chopsticks ready. This
place is situated very close to the movies, so if
you are looking for dinner and a movie, definitely
check this place out. It will cost you more for
popcorn and a drink than it will for dinner and a
glass of wine.

EXTRAS/NOTES To go also available.

—Amber Bagwell

Shabu Shabu

Cook-It-Yourself: Japanese fondue.
$$$
145 E. Third Ave., San Mateo 94401
(between S. Ellsworth Ave and N. San Mateo Dr.)
Phone (650) 548-2483
www.shabuway.com

CATEGORY Japanese shabu-shabu
HOURS Tues-Fri: 11:30 AM-10 PM
Sat: Noon-10 PM
Sun: Noon-9 PM
GETTING THERE Metered parking both on street and in public
parking lots.
PAYMENT *VISA MasterCard Cards*
POPULAR DISH *Shabu shabu* is a beef fondue, which is a
traditional Japanese cuisine made out of thinly
sliced pieces of beef. Each table has a cooking
area in the center where you immerse your food
in hot broth. It's fun to go to this restaurant with
a group of friends or someone you've been dating
a while, but I wouldn't recommend this place
for a first date unless you don't mind smelling
like cooked beef afterward (the broth tends to
splatter). I suppose that cooking your own food at
the table could be a good conversation starter on
a first date, though.
UNIQUE DISH The beef *shabu shabu* comes with vegetable, rice
and *udon*. The menu is more extensive than just
the traditional thinly sliced beef. You can also
cook your own shrimp potstickers or veggies
(broccoli, asparagus and pumpkin).
DRINKS Order from the sake list or try a Japanese beer,
soft drink, or tea.
SEATING There is counter seating and several tables.
AMBIENCE/CLIENTELE This is generally a young, hip crowd and it can be
pretty lively with everyone cooking at their tables.
EXTRAS/NOTES Take out available.
OTHER ONES • Mountain View: 180 Castro St., Mountain View,
94041, (650) 961-8880

—Karen Kramer

SAN CARLOS/BELMONT

CreoLa, A New Orleans Bistro

Southern comfort.
$$$$
344 El Camino Real, San Carlos 94070
(at Holly St.)
Phone (650) 654-0882
www.creolabistro.com

CATEGORY	Upscale Creole/Southern
HOURS	Mon/Tues: 5:30 PM–9:30 PM
	Weds-Fri: 11:30 AM–2 PM; 5:30 PM–10 PM
	Sat: 5:30 PM–10 PM
GETTING THERE	Parking is usually easy. CreoLa has a small free lot, but on busy nights or on the weekend, parking can be difficult. There is limited street parking on El Camino Real.
PAYMENT	VISA
POPULAR DISH	No offense to mom, but CreoLa's Maple Cured Pork Chop is the best pork chop I have ever had. The cut is also the thickest I have ever seen, standing at two inches high, glistening in its own juices. The meat is moist, which I didn't know was even possible in a pork chop, and has the perfect texture with a hint of maple flavor. The pork industry should thank CreoLa for putting me and possibly countless others back on pork.
UNIQUE DISH	The Cajun Feast, which includes lightly breaded alligator and jambalaya of duck, chicken, and Andouille sausage is not as scary or insurmountable as it sounds. The alligator tastes like a cross between fish and chicken, not unlike frog. This dish is surprisingly light and is a great way to try something both unique and classic.
DRINKS	They serve wine and the standard choices of sodas.
SEATING	In the rear corner, there is a long cushioned bench on the inside of a rectangular table with chairs on the outside, which is ideal for groups of up to ten. The elegant accent pillows on the bench are a nice touch and add to the sophistication of the place.
AMBIENCE/CLIENTELE	This compact one story space is like a bungalow, which creates an intimate setting accentuated with soft lighting and candles. It is like a neighborhood eatery that's gone upscale, but it's not too intimidating. Eating there is like going to your well-to-do uncle's home where you are careful not to knock over any vases, but feel comfortable enough to put your feet up on the coffee table when you're watching TV. The clientele appears mostly to be middle-aged middle class suburbanites. You probably won't be turned away if you are wearing flip-flops, but it would be out of place. I wouldn't have been surprised if a Southern belle in full regalia walked through the door to be wined and dined on these

classic Southern dishes with a hint of California sophistication. The flavors are complex, yet light and fresh. With healthy sized portions, the presentation is clean and simple.

EXTRAS/NOTES According to the website, Bud Deslatte opened restaurants in New Orleans, Atlanta and San Diego, but they have been sold to employees.

—*Michelle Berlanger*

El Charrito
Comida perfecta.
$
1100 Holly St., San Carlos 94070
(at El Camino Real)
Phone (650) 654-1400

CATEGORY Mexican

HOURS Mon–Sat: 8 AM–10 PM
Sun: 9 AM–9 PM

GETTING THERE There is a small parking lot that tends to fill up often and is difficult to turn around in. Please do not panic if you start feeling like Austin Powers with his golf cart stuck in the hallway. Another option that is not much easier is street parking further up Holly Street in the residential area or on El Camino Real.

PAYMENT VISA ⬤

POPULAR DISH The soft shell tacos are ridiculously inexpensive at $1.25 a piece. Though they are tiny, they are authentic and delicious and it won't break the bank if you order 2 or 10. The wet burrito smothered in tomato sauce and topped with cheese is another good choice, particularly if you have been fasting because it is the size of a small pillow.

UNIQUE DISH If you are feeling adventurous, the *birria de chivo* or goat soup is for you. The soup is thin with a good helping of goat meat, which tastes similar to lamb. It comes with wedges of lime and chopped onions and cilantro that enhance the flavors of the soup. It smells and tastes homemade and simple, but nevertheless, is delicious.

DRINKS This restaurant serves both beer and non-alcoholic beverages, including Jarritos, a Mexican soda, and American sodas.

SEATING The dilemma with taco trucks, the trucks that serve delicious Mexican food, is that seating is either in a derelict parking lot or non-existent. The solution to this serious problem is El Charrito, which has plenty of tables (inside) with seating for 2 to 6 people. In addition to a second room of tables, there is a tiny patio for seating. It overlooks El Camino Real so don't count on a quiet meal outside.

AMBIENCE/CLIENTELE This is a casual place. It's located at a busy intersection and draws in lots of different people, ranging from skater punks to construction workers. The food is fragrant and you should resist the urge to order whatever

is cooking because there is a lot on the menu. You have choices of meat for your burrito or tacos, ranging from (boring) chicken to *cabeza* (beef head - interesting) to *lengua* (beef tongue - exciting). If the cowboy lassoing on the outside sign doesn't set the mood for you, then maybe the mirrors cut in the shape of horses inside will do it for you. Not only does El Charrito serve authentic food, but it also is educational. Maps of Mexico showing the locations of cervezerias or breweries are taped near several tables for a quick geography lesson.

—Michelle Berlanger

MENLO PARK/ATHERTON

Bistro Vida

Can't make it to Paris?
Head to Bistro Vida.
$$$$
641 Santa Cruz Ave., Menlo Park 94025
(at Doyle St.)
Phone (650) 462-1686

CATEGORY	French cuisine with California twist
HOURS	Tues-Sun: 11:30 AM-2 PM; 5:30 PM-10 PM (Sat/Sun brunch 9:30 AM-3 PM
GETTING THERE	There is metered parking along the street in front of the restaurant, plus a large public lot behind the restaurant.
PAYMENT	VISA
POPULAR DISH	Start with a Caesar salad. Then, take yourself back to your favorite Parisian bistro by ordering up one of the French favorites—such as *Daube de Boeuf au Vin Rouge* (beef stew) or *Coq au Vin*. The *frites* are excellent, so be sure to get a side of them if they don't come with your dish.
DRINKS	Full bar
SEATING	Although the long dining room is a good size, the space still manages to feel intimate and cozy. The space is filled with booths and tables, as well as a bar by the entrance.
AMBIENCE/CLIENTELE	With its high ceilings, deep burgundy walls that are lined with mirrors, and warm wood paneling, this place instantly makes you feel at home. The large chandeliers cast a beautiful amber hue on the space. The restaurant appeals to a range of people – from families and young couples to business associates and solo diners. And, thankfully, the service is better than most Parisian bistros.

—Anh-Minh Le

Carpaccio

Cheaper than a flight to Roma.
$$$$

1120 Crane St., Menlo Park 94025
(at Santa Cruz Ave.)
Phone (650) 322-1211
www.carpaccios.com

CATEGORY	Upscale Italian
HOURS	Mon-Thurs: 11:30 AM-2 PM; 5 PM-9:30 PM
	Fri: 11:30 AM-2 PM; 5 PM-10 PM
	Sat: 5 PM-10 PM
	Sat: 5 PM-8:30 PM
GETTING THERE	Plentiful (and appreciated) Menlo Park public parking.
PAYMENT	VISA
POPULAR DISH	Try the *melanzana al forno* (baked eggplant with spinach, cheese, and pomodoro). Of course, they have all of your favorite pasta dishes, pizza and classic antipastas.
UNIQUE DISH	If you like your Italian by the sea, try any of their seafood dishes. The *petrale piccasta* (sole sautéed with lemon and capers) has a perfect delicate taste. For dessert, try their fantastic tiramisu.
DRINKS	Highly respectable wine list and incredibly helpful wait staff. When you're done with your meal try one of their lattes. With the tiramisu, it just might be one of the best ways to end any meal.
SEATING	Long room divided into several sections means there's plenty of room and plenty of quiet in which to enjoy your meal. Grab a seat by the window at lunchtime for great people watching.
AMBIANCE/CLIENTELE	Perhaps, a slightly more mature crowd here than a lot of the hipper foodie places in the Bay, but some of the best authentic Italian food in the area. At the same time, it's far from chichi. The staff is extraordinarily friendly. Dim lighting and gorgeous décor make this a great place to take your honey to for a glass of wine and a great meal. Great for larger parties too.
EXTRAS/NOTES	For most, this should be a fantastic once-in-a-while treat. Nearly every dish and nearly every glass of wine is superb, so come here when you have something to celebrate.

—*Louis Pine*

REDWOOD CITY

Bangkok Bay

*Say "Bangkok Bay" fast 5
times. It's that good.*
$$$

825 El Camino Real, Redwood City 94063
(at Broadway St.)
Phone (650) 365-5369 • Fax (650) 365-5391
www.bangkokbay.com

CATEGORY	Gourmet Thai
HOURS	Mon-Thurs: 11 AM-3 PM; 5 PM-9:30 PM
	Fri: 11 AM-3 PM; 5 PM-10 PM
	Sat: 5 PM-10 PM
	Sun: 5 PM-9 PM
GETTING THERE	No parking lot, but there is metered street parking. You can usually get away with parking in the lot behind the restaurant as long as it's after normal business hours.
PAYMENT	VISA [cards]
POPULAR DISH	I don't know where to start! When a large group of my friends come here we practically order the entire menu (or so it feels that way). A few highlights of the items that keep us coming back are: *Meang Kum*, Fried Calamari, Duck Curry, Salmon *Panang*, and Spicy Basil Chicken. For dessert (and I rarely order dessert at other places but I *always* have some here) try the (fried flatbread topped with sweet condensed milk), mango with sweet sticky rice, and deep-fried ice-cream.
UNIQUE DISH	Their spicy basil chicken is actually made with ground chicken—a true sign of authenticity.
DRINKS	Thai iced tea and Thai iced coffee are usually what we get. They serve alcohol on their menu also.
SEATING	The restaurant is long and rectangular with room for larger parties if you put some tables together. Majority of the tables are midsized for smaller groups.
AMBIENCE/CLIENTELE	In general, the restaurant feels really calm and peaceful. The lighting is a dim, which goes with the volume. The family that runs the restaurant is warm and welcomes their guests with huge smiles. Traditional Thai décor is strategically placed throughout the venue. I've mostly seen families and smaller groups dining here. It's a more intimate setting. Though, don't let that discourage you from checking it out in a larger group!
EXTRAS/NOTES	Four sisters and their families run the restaurant. Rumor has it that you can spot a family member on the road based on their license plates showing their Bangkok Bay pride. You know how places like In 'n Out have secret items not listed on their menu? Here, I dare you to ask them to make your entrée selection "Thai spicy". You can also buy gift certificates.

—Bonnie Yeung

Mexquite

Tequila. Good company. Great food.
$$

2616 Broadway St., Redwood City 94063
Phone (650) 369-7482 • Fax (650) 568-1609

CATEGORY	Mexican
HOURS	Sun-Thurs: 11 AM-10 PM
	Fri/Sat: 11 AM -Midnight
GETTING THERE	Parking isn't much of an issue but it is metered so bring along some pocket change. If you can't find parking on the street in front, don't panic. Swing

around to the back and you have quite a few options there.

PAYMENT VISA mastercard Cards

POPULAR DISH The fajitas of course! I always order combo fajitas with chicken and beef and both are cooked to perfection. They are uniquely served in a black clay pot with your usual variety of grilled onions, bell peppers and jalapeños. Qué aproveche!

DRINKS Margaritas! The staple of every Mexican food place is its margaritas! You can tell right off the bat if the joint is any good just by taking a sip! By the time I was done with my one and only top shelf margarita, I was ready to jump on the little planter next to my outdoor table and yell "Ole!" at the top of my lungs! Okay, okay, I am exaggerating, but I kid you not, the margarita was great!

SEATING I always sit outside since the outside area is dog friendly. But the inside looks relaxed with a nice and spacious seating.

AMBIENCE/CLIENTELE Good atmosphere all around. During the day, casual is good, at night, you could definitely go for something more fun.

EXTRAS/NOTES Next to the tequila (pronounced: To-Kill-Ya) and the food, the outdoor dining is my favorite hotspot I live alone with my two dogs and I often find myself craving Mexican food and no one to call for a last minute munch. So, I load up the pooches and head to Mexquite. Their outdoor dining is dog friendly and there is plenty of seating for you and your canine friends. The clientele are friendly and are used to the occasional pooch so all is well. I enjoy people watching so, when the weather is nice, outdoor seating will hit the spot.

—Amber Bagwell

PALO ALTO

Empire Tap Room

Tap it like the English with SV VPs.
$$$$
651 Emerson St., Palo Alto 94301
(at Forrest Ave.)
Phone (650) 321-3030

CATEGORY British-inspired pub and brewery

HOURS Mon-Fri: 11:00 AM-9:30 PM (bar closes 11 PM)
Sat/Sun 11:30 AM -9:30 PM (bar closes 11 PM)

GETTING THERE Street parking or any of the nearby Palo Alto municipal lots.

PAYMENT VISA mastercard Cards

POPULAR DISH For a place that's best known for its brews, the food here is surprisingly good. Try the burgers or the salads.

UNIQUE DISH If it's a special occasion (or if you're just there with someone special) try their oysters.

DRINKS	Beer's the thing. A solid selection of microbrews with seasonal specials. If you are for something a little stronger, they have a respectable top shelf. They also have all of your favorite cocktails.
SEATING	One of the better patios in Palo Alto. Of course, if you're an indoors kid there's plenty of room for you around the bar. They can accommodate large groups well, but if you come alone you'll feel more than welcome at the Continental-style bar.
AMBIANCE/CLIENTELE	On a weekend night expect a slightly quieter crowd than the nearby Palo Alto hotspots. It's a great place to start your evening with your friends. The patio and the relatively low-key atmosphere make it romantic enough to bring your sweetheart, too. During the daytime you can expect the ladies-that-lunch set.
EXTRAS/NOTES	Like many places in Palo Alto, the Taproom can weigh on your wallet. Nearly everything on the menu is great, but if you want to save some money it's best to come for a pint, and enjoy some appetizers and atmosphere.

—Louis Pine

Izzy's Brooklyn Bagels

An amalgam of the neighborhood in a bagel hole.
$

477 S. California Ave., Palo Alto 94306
(at El Camino Real)
Phone (650) 329-0700 • Fax (650) 329-0799
www.izzysbrooklynbagels.com

CATEGORY	Jewish deli/bagelry/pizzeria
HOURS	Mon-Fri: 6 AM-4 PM
	Sat: 7 AM-2 PM
	Sun: 7 AM-3 PM
GETTING THERE	You can always find a spot in any of the public lots behind California Ave., but you will have to try harder during peak lunch hour. The spots in the lots by Sherman Ave. are best for compact cars or for those who like the thrill of almost shaving the paint off the car on the next spot (and are thin enough to get out afterwards.) There is a Caltrain station three blocks down at the north end of California Ave. The Marguerite shuttle has two routes with stops nearby (C, RP). VTA lines 88, 22, 522 all leave you within a block or two.
PAYMENT	VISA
POPULAR DISH	From onion to chocolate chip, jalapeño to rye-pumpernickel, bagels are the main theme. Take them solo or take your time to decide among the many options to smear them with cream cheese: classic, low-fat, non-fat, lox, strawberry, blueberry, walnut-raisin, sun-dried tomato and basil, roasted red pepper, olives, cucumber and scallion, Dijon garlic if you must… You can also fill them up with something a bit more substantial like egg salad, whitefish salad, tuna, herring, or if you want to splurge, go for the sliced lox. (See notes)

UNIQUE DISH	Izzy's is a strictly kosher establishment serving afewdelicaciesfromtheJewishcuisine:noodlekugels,knishesor bourekas,rugelach,BlackandWhitecookies,babka,malva,andevena veggie version of chopped liver.
DRINKS	Self-serve your own soft drink, hot tea and coffee. There's also a small automatic espresso machine.
SEATING	Izzy's is small but wide enough to accommodate two rows of two-person tables. There are ten tables inside and three outside that share a single umbrella.
AMBIENCE/CLIENTELE	Izzy's is small enough to be cozy, dark enough to stay subdued, and messy enough to feel homey. (There's even a reminder to tidy up a bit by the coffee thermos, just like you'd hear it at home.) Small round tables with marble tops and a single wrought iron leg row along two long walls. The chairs have a deceiving metallic look that matches the style of the tables but are –thankfully for everyone's bottom,made of warmer and softer plastic. One wall is covered with mirrors, the other with a collection of black and white and faded-color photographs composing a collage of Brooklyn nostalgia; the bridge, Babe Ruth, the Seinfeld cast. Peeking by the side of the shelves of bagels next to the counter one can see the trays full of bagels, breads, and pastries going in and out of the oven, their sweet smells seeping out into the dining room. Izzy's is everyone's place, a mellow spot to relax on your own or in quiet conversation with a friend.
EXTRAS/NOTES	Izzy's is not the place to go if you're in the mood for some meaty stuff, their kosher denomination means no meat is allowed in the premises.
OTHER ONES	• SoMa: 151 Townsend St., San Francisco 94107, (415) 543-0900

—Maria Richardson

Miyake

Miyake offers good sushi, strobe lights and Sake Bombs.
$$$
40 University Ave., Palo Alto 94301
(at High St.)
Phone (650) 323-9449 • Fax (650) 323.4436
www.miyake-usa.com

CATEGORY	Hip Japanese
HOURS	Daily: 11:30 AM-10 PM
GETTING THERE	There's metered parking in the front of the restaurant and several free lots within a couple of blocks' radius.
PAYMENT	VISA MasterCard Cards
POPULAR DISH	The house specialties are named after well-known local places and businesses. There's the Apple Roll (tuna, crab stick, avocado, cucumber); IBM Roll (unagi, crab stick, avocado, cucumber); HP Roll (white tuna, crab stick, avocado, cucumber); and Stanford Roll (crab, asparagus, tomato) – to name just a few. If you're not in the mood for sushi,

order up a bowl of udon or donburi. The tempura is also delicious.

UNIQUE DISH Sure, you could stick with the familiar California Roll, or expand your sushi horizons and try the Hawaiian Roll (avocado, tuna, cucumber, pineapple).

DRINKS Sake, Japanese beers, sodas and hot tea are available. For the true Miyake experience, order a Sake Bomb (a shot of sake dropped in a glass of beer).

SEATING The dining room is one big room with lots of tables and more than a dozen seats at the sushi bar. Things can get loud here, especially on the weekends, so it's not ideal for a cozy, romantic date.

AMBIENCE/CLIENTELE The food here is good, but what may be an even bigger draw is the ambiance. Miyake's may be the most stimulating Japanese restaurant outside of Tokyo. The techno beats, fog machine and disco lights are only part of the fun. The real crowd-pleaser: when a Sake Bomb is ordered, the lights are dimmed and the patron gets up on his/her chair to down the drink—cheered on by the entire restaurant. The waiters have even been known to join in.

OTHER ONES • 10650 S. De Anza Blvd., Cupertino 95104, (408) 253-2668

—Anh-Minh Le

Nola

Soulful meals served straight-up from the bayou, with a twist.

$$$$

535 Ramona St., Palo Alto 94301
(at University Ave.)
Phone (650) 328-2722 • Fax (650) 328-3726
www.nolas.com

CATEGORY Cajun restaurant and meat market

HOURS Mon-Thurs: 11:30 AM-10 PM
Fri: 11:30 AM-11 PM
Sat: 5:30 PM-11 PM
Sun: 5:30 PM-9 PM

GETTING THERE Limited free parking is available in public city parking lots and garages nearby. Metered street parking in front of the restaurant is usually taken.

PAYMENT VISA ⬤ ⬤Cards ⬤

POPULAR DISH People standing in line outside are already salivating just after glancing at Nola's menu of Cajun, Creole and Southern fare, with a few Southwestern dishes thrown in for variety. If you're craving N'awlins classics, the spicy jambalaya, shellfish étouffée, seafood gumbo and blackened fish dishes and fried chicken don't disappoint. Plates are so enormous that if you're not looking to loosen your belt a notch or two, you might want to stick with just a humble po-boy sandwich and housemade Creole fries.

UNIQUE DISH Everything that's not truly authentic N'awlins cuisine can be classified as haute comfort food, from the cornbread-stuffed pork chop with sour cream smashed potatoes to the bourbon-glazed flank steak to the drunken "Uncle Jack's Pain Go Bye Bye Rootbeer Float" with specialty root beer, vanilla bean ice cream and vanilla-infused rum.

DRINKS Giant glasses signal that cocktails are more than a sideshow here: top-shelf margaritas, mojitos splashed with flavored rums and whimsical signature drinks like the "Pink Panty Dropper" and "Gator Juice." A half dozen microbrews are on tap and a decent wine list hails from California and Oregon.

SEATING Nola's restaurant sprawls inside a triple-decker N'awlins-style courtyard. There's a maze of seven different dining areas tucked away at the back of the property. Request a balcony table upstairs, where you can gawk at all the action. Couples get cozy in quieter side nooks. More spacious sections can be cordoned off for private events.

AMBIENCE/CLIENTELE With its joyful Mardi Gras ambience, Nola's is a perfect place for all sorts of gatherings. Going on a blind date? Looking for a place to kick up your heels at a birthday party? Throwing together a girls' night out? No problem: Nola's fun, funky environs plastered with outsider art and splashed with bold hues will jump-start any evening out. Hoppin' Southern tunes keep the place even more lively, while a spicy mix of Cajun and Creole aromas heating up the kitchen is offset by a tall menu of cooling elixirs.

EXTRAS/NOTES By the entrance, the ground-level bar is packed with sociable singles. Thanks to Nola's killer drinks menu, it's a happening place to while away any wait you may have to endure for a table on busy weekend nights.

—Sara Benson

Paxti's Pizza

(see p. 30)
Casual, Chicago-style pizza
441 Emerson St., Palo Alto 94301
Phone (650) 473-9999

Three Seasons

A downtown destination for contemporary Vietnamese cuisine.
$$$
518 Bryant St., Palo Alto 94301
(at University Ave.)
Phone (650) 838-0353 • Fax (650) 838-0380
www.threeseasonsrestaurant.com
CATEGORY Vietnamese

HOURS	Mon-Thurs: 11:30 AM-2 PM; 5:30 PM-11 PM
	Fri: 11:30 AM-2 PM; 5:30 PM-11 PM
	Sat: 5:30 PM-11 PM
	Sun: 5:30 PM-10 PM
GETTING THERE	There's metered parking in the front of the restaurant and several free lots within a couple of blocks' radius.
PAYMENT	VISA MasterCard Cards
POPULAR DISH	There's a big selection of spring rolls and satays. You can't go wrong with the traditional Vietnamese roll (which features shrimp and pork). If you like lamb, try the Malaysian lamb kebab. Just be sure to save room for dessert: the fried bananas are some of the best around.
UNIQUE DISH	For desserts, the banana desserts are the way to go (fried bananas or the banana spring rolls).
DRINKS	Full bar. Go for one of the specialty cocktails, like the lychee martini.
SEATING	There are two dining spaces—upstairs and downstairs. While this place can get loud during peak times, the upstairs won't be quite as hectic (as the bar is downstairs). The space is set up well to accommodate intimate parties of two, as well as larger groups.
AMBIENCE/CLIENTELE	Although the restaurant's interior is stylish, you can easily fit in here wearing casual attire – or post-work slightly nicer clothes. Despite the noise level, the place still feels relaxing. Maybe it's the soft music, the tropical plants, or the large Asian murals.
OTHER ONES	• Marina/Cow Hollow: 3317 Steiner St., San Francisco 94123, (415) 567-9989
	• Walnut Creek: 1525 N. Main Street, Walnut Creek 94596, (925) 934-4831

—Anh-Minh Le

WOODSIDE

Alice's Restaurant
*Home style meets motorcycle riders
meets California Redwoods.
Since the 1950's*
$$$
17288 Skyline Blvd., Woodside 94062
(at Hwy. 84)
Phone (650) 851-0303
www.alicesrestaurant.com

CATEGORY	American bistro/Biker restaurant
HOURS	Mon-Fri: 8:30 AM-9 PM
	Sat/Sun: 8 AM-9 PM
GETTING THERE	Parking is free in their huge lot—very conductive to motorcycle parking. Additional parking lot available across the street for overflow.
PAYMENT	VISA MasterCard
POPULAR DISH	Burgers are the thing here, but there's something for virtually anyone. Breakfast is served until 2 PM and offers the range, from classic biscuits and

gravy to heart healthy oatmeal. For those whose appetite borders somewhere in between, a variety of eggs/omelets, pancakes, waffles, French toast and breakfast burritos are available. The lunch menu covers ever-classic creature comforts to include the tuna melt, BLT, hot pastrami and Swiss on rye, and grilled ham and cheese. Soup, chili, salads, and deep fried sides are available for the less hearty diner. The dinner menu offers a wider variation of the lunch menu with appetizers to include vegetarian and chicken quesadillas, bruschetta and nachos with chicken. Additional dinner choices include Caesar salad with choice of chicken or prawns, Philly cheese steak and BBQ chicken & avocado sandwiches and crispy tacos served with rice & beans.

UNIQUE DISH Fried calamari served over French fries

DRINKS Alice's Restaurant offers a standard variety of soft drinks as well as sparkling and bottled water, coffee, tea, iced tea, lemonade, Nantucket Nectars and other juices. Great wine list showcases top local wineries primarily featuring wineries of the Santa Cruz Mountains and Central Coast. Bonny Doon, Storrs and Thomas Forgarty, to name just a few. All wines are available by the glass and bottle. Offering more than a dozen and a half imported and domestic bottled beers, Alice's features a selection of beers on tap to include, Mountain Amber ale, Skylonda Blonde ale and & Lager Diabla. All from Devil's Canyon a local brewing company from Belmont, CA.

SEATING Alice's Restaurant offers indoor, covered patio and outside seating. If you go on a weekend afternoon be prepared to share your picnic table with fellow Alice devotees. When you arrive, you will be greeted with a friendly smile and told to sit at any (open) table. Should it be standing room only, most folks will invite you to share their table provided they have room. I'm not sure if it's the scenic peaceful drive prior to arriving or the mountain air, but one tends to get a bit folksy to strangers when dining at Alice's. When you arrive at Alice's you are family and so anyone sitting next to you (be they in your party or someone you just met) is kin. It's hard to say just exactly how many Alice's can accommodate (and when you go you will understand why.) but the covered patio seats about 35, the main dining area about 20 and the deck seating at least 40. For larger groups, please call in advance to discuss seating options.

AMBIENCE/CLIENTELE While the clientele may range from starving artists to CEOs, it would be hard to pick out who's who in this casual setting where most patrons are donning shorts, a T-shirt or blue jeans and some sort of leather ensemble. If you ride a bike (motorcycle or other) in the Bay Area and have never been to Alice's Restaurant, you cannot officially say you "ride" or call yourself a biker. But rest assured being inducted to biker

status is as easy as ordering a burger & fries or eggs with a side of hash browns. Alice's offers a wide variety of burgers to suit the palate as well as the style of the Harley, BMW, Kawasaki, Yamaha and Moto Guzzi owner to name just a few. The indoor seating is quite rustic with counter stools and booths that are wrapped in cow hide, which lend themselves to an indestructible and timeless style. The action has a tendency to be on the front deck where one can dine in the open air at a picnic table while watching the eclectic diversity of motorized metal arrive and depart with unmatched flash, fashion and a flare for dare.

EXTRAS/NOTES This history dates back to the early 1900s when the building was constructed to serve as a general store called The Four Corners, which supported the logging industry. The building was then turned into a restaurant in the 1950's and sometime in the 1960's bought by Alice Taylor who named the restaurant after herself. Already, a world famous stop for motorcyclists, hikers, locals and tourists Alice's Restaurant was bought in the 1970's has been family owned and operated ever since. Alice's website has a link to BARF (Bay Area Riders' Forum) a site that has information for upcoming events in the area for motorcycle riders. Alice's insignia baseball caps and T-shirts (short sleeve & long sleeve) are available for purchase for $15-$22. Be sure to check out the live music, every Thursday 7-9 PM.

—*Jackie Kortz*

Buck's

Valley classic for cyclists and bikers.
$$
3062 Woodside Rd., Woodside 94062
(at Whiskey Hill Rd.)
Phone (650) 851-8010
www.buckswoodisde.com

CATEGORY British Pub and brewery

HOURS Mon-Thurs: 7 AM-9 PM
Fri: 7 AM-10 PM
Sat: 8 AM-10 PM
Sun: 8 AM-9 PM

GETTING THERE Medium sized lot, or park elsewhere in the neighborhood. If you're really in you'll ride your bike, though.

PAYMENT VISA MasterCard Cards

POPULAR DISH Like their catch phrase goes, flapjacks and Tom Foolery. Get great, big breakfasts here. Try the buttermilk pancakes with real maple syrup. Or if you're the picky sort, make your own omelet.

UNIQUE DISH Try their coffeecake, really. There are a lot of places that talk about theirs, but this stuff is not to be trifled with. For those of you who don't eat anything with a face, try their garden burger (it comes with great tahini and fruit salad).

DRINKS Beer, wine, coffee, and juices

SEATING Plenty of room for you and your friends, though patience is suggested during weekend brunch rushes.

AMBIANCE/CLIENTELE If you're looking for the real low-down on the tech industry, put down *Red Herring* and come over here. This is where all the VCs (that's Venture Capitalists, bub) come for post-cycling breakfasts. But even if you aren't cooking up the next big thing or wearing biker shorts and funny shoes, you'll get great service here. If you're a space cadet, there's tons of funky stuff to stare at on the wall. Be sure to wave 'hello' to the Moose.

—*Louis Pine*

Village Pub

American-inspired food in a cozy atmosphere.

$$$$

2967 Woodside Rd.. Woodside 94062
(at Whiskey Hill Rd.)
Phone (650) 851-9888 • Fax (650) 851-6827
www.thevillagepub.net

CATEGORY Pub, lounge, and California cuisine

HOURS Mon-Fri: 11:30 AM-2:30 PM; 5 PM-10 PM
Sat/Sun: 5 PM-10 PM

GETTING THERE Large public lot behind the restaurant.

PAYMENT VISA Cards

POPULAR DISH Start with the crispy sweetbreads or the charcuterie assortment. If they're offering the heirloom tomato and mozzarella salad as a special, get it. The dish is prepared table-side—complete with the server tearing up fresh basil leaves on the spot, and the cheese is flown in that morning from Italy. Be sure to end the evening with a chocolate soufflé (save room and time for that dessert!). Tip: If you're running low on cash, you can still dine well here! Order the Pub Burger ($11, including delicious fries); it's not on the main dinner menu, but it's always available.

DRINKS Full bar

SEATING Although the dining area is just one big room, it's not raucous or too loud, so you can feel free to take a date here, or come with a group of business associates.

AMBIANCE/CLIENTELE Being one of the most sophisticated restaurants in the Peninsula, the Village Pub attracts everyone from couples celebrating a special occasion to a group of ladies out for the evening to work colleagues who want a good meal in a nice environment. Although people have been known to hang out in the bar in jeans and even riding boots (this is Woodside after all), business casual is the recommended way to go.

—*Anh-Minh Le*

SOUTH
BAY AREA

Amber India

Amber is the color of my love.

$$$

2290 W. El Camino Real #9, Mountain View 94040
(at Ortega Ave.)
Phone (650) 968-7511 • Fax (650) 968-1820
www.amber-india.com/MtnView/home.htm

CATEGORY	Northern Indian
HOURS	Daily: 11:30 AM-2:30 PM; 5 PM-10 PM
GETTING THERE	Large mini-mall parking lot
PAYMENT	*VISA* *Mastercard*
POPULAR DISH	Amber India specializes in tandoori dishes (the shrimp is a personal favorite). Their list of *naan* is excellent. Try the assorted basket or just skip to the Frontier *naan*.
UNIQUE DISH	Like most Indian places, Amber India offers some great options for those who don't eat anything that have a face. Try the *dal bukhara* (slow cooked lentils in a tomatoes sauce) or any of their lentil dishes. The *samosas* are light and delicious and their *riata* (cucumber yogurt sauce) is great. If you eat meat, try the Frontier kebab (lamb marinated in yogurt and ginger).
DRINKS	Lasi, Indian beer, cocktails, soda, and tea
SEATING	Two rooms, each with ample seating. The smaller of the two is probably better for couples and those that want a little more privacy. The spacious larger room is great for groups. Be sure to call ahead if you are going to bring your entourage.
AMBIANCE/CLIENTELE	Another great spot to overhear some great tech talk. Expect to see a lot of very local engineer types at lunch. Families and couples in the evening. Great ambiance and outstanding service. You would never guess it from the mini-mall façade, but Amber India is colorful, friendly, and surprisingly upscale. Dark woods, mellow lighting, statues, and artwork. Of course, all of this said, the real star is the food.
EXTRAS/NOTES	If you want to have all the same great food and save a few greenbacks, try their lunch buffet. Most of the dishes from the dinner menu are served in gorgeous brass. Great for take out.
OTHER ONES	• Santana Row: 377 Santana Row Suite 1140, San Jose 95128, (408) 248-5400 • Mountain View: Café Mountain View: 600 W. El Camino Real, Mountain View 94040, (650) 968-1751

—*Louis Pine*

Cascal

Tapas and mojitos al fresco.
$$$$
400 Castro St., Mountain View 94041
(at California St.)
Phone (650) 940-9500
www.cascalrestaurant.com

CATEGORY	Old world Spanish meets new world Latin/Cuban cuisine.
HOURS	Sun-Thurs: 11:30 AM–10 PM Fri/Sat: 11:30 AM–11 PM
GETTING THERE	Parking is very ample on the street and always free in the evening.
PAYMENT	VISA ⬤ ▦ Cards
POPULAR DISH	Black Bean Soup with a shot of sherry: whether it is a crisp winter evening or a hot summer lunch, this soup's creamy smooth texture is only made better by the sharp bite from the layer of sherry.
UNIQUE DISH	Hearts of Palm Salad—a zesty blend of oranges, red onion, hearts of palm and a light but creamy citrus dressing make this salad a sinful but good-for-you pleasure.
DRINKS	Full bar that specializes in mojitos, multiple sangrias, and caipirinhas. Great Happy Hour deals too. Mon-Fri 3:30 PM–6:30 PM. Half price mojitos, sangria, house margaritas and caipirinhas with $3 well and draft beers.
SEATING	Nearly sixty tables make this place a Mecca for large groups. The best seats in the house are out on the heated patio which provides views of the bustling restaurant through the restaurants large glass windows and of the lively Castro strip.
AMBIENCE/CLIENTELE	Take the short flight to a land of warmth and soul, even if it is raining outside, by coming to Cascal. The entire restaurant is draped in deep red and mahogany, which only serves to compliment the richness of the food. Exotic tapas easily stand alone or pair seamlessly with one another to create a unique dining experience every time you come. Come on Friday or Saturday night to get the full fusion flavor with addictive live Latin music. Everyone is welcome here and three-inch stilettos sit happily next to flip-flops throughout this expansive venue.
EXTRAS/NOTES	The James Robinson Group plays most Saturday nights and is tremendously infectious. Deep, soulful world beats only serve to further complement the rich aromatic flavors of the food. Live music 'til around midnight on Friday and Saturday.

—Mary Poffenroth

Monster Sushi
Sushi rolls as big as your head (or close).
$$$
2595 California St., #C, Mountain View 94040
(at San Antonio Ave.)
Phone (650) 947-9985

CATEGORY	Japanese sushi and sports bar
HOURS	Daily: 11:30 AM-9:30 PM
GETTING THERE	There's a small lot, which Monster Sushi shares with another establishment, but parking usually isn't a problem.
PAYMENT	VISA (cards)
POPULAR DISH	My three favorite rolls: Caterpillar Roll (crab and *unagi* topped with avocado), Dynamite Roll (Battered and deep-fried spicy fish), and Spider Roll (Deep-fried soft shell crab and vegetables with *tobiko*)
UNIQUE DISH	Two rolls I haven't seen any where else: Mountain View Roll (soft shell crab and wild carrot with *unagi* and tobiko) and Yummy Yummy Roll (shrimp tempura, *unagi* spicy tuna, *tobiko,* macadamia nut)
DRINKS	Sodas, beer, sake, tea
SEATING	Bar style seating around the sushi bar as well as two-seater and four-seater tables spread throughout the restaurant. Can be cramped for large groups, so I suggest ordering takeout.
AMBIENCE/CLIENTELE	Large TV screens in the corners, but the staff is pleasant, greeting you at the door with "Irasshaimase" (Japanese for "Welcome") This is a casual dining experience and the restaurant is notably small, but the sushi will blow you away (and so will the size of it). One roll's enough for me!
EXTRAS/NOTES	I've heard that if it's your birthday Monster Sushi will give you a sushi cake (a large plate of sushi).

—*Michelle Rogers*

Shabu Shabu
(see p. 210)
Japanese shabu shabu
180 Castro St., Mountain View, 94041
Phone (650) 961-8880

SUNNYVALE

Ariake

(see p. 256)
Japanese sushi
759 E. El Camino Real, Sunnyvale 94087
Phone (408) 245-8383

Dishdash

Warmth, comfort, and
good food in Sunnyvale.

$$$$

190 South Murphy St., Sunnyvale 94086
(at Washington)
Phone (408) 774-1889 • Fax (408) 774-1896
www.dishdash.com

CATEGORY	Middle Eastern
HOURS	Mon-Thurs: 11 AM-2:30 PM; 5 PM-9:30 PM
	Fri: 11 AM-2:30 PM; 5 PM-10 PM
	Sat: 5 PM-10 PM
GETTING THERE	Located in downtown Sunnyvale on historic Murphy Avenue, Dishdash is easily accessible by freeways and the Cal Train Sunnyvale station is located just a block away. Parking is fairly easy as you can park on the street, in the lot behind the restaurant or in the large parking lot located across Washington Avenue.
PAYMENT	
POPULAR DISH	You can't go wrong with any of the kabobs at Dishdash whether they are beef or lamb. All the food is great.
UNIQUE DISH	The lamb and vegetarian dishes are all delightful giving your lunch party vegetarians lots of options.
DRINKS	Beer, wine. BYOB, with a $10 corkage fee.
SEATING	Dishdash has a variety of seating arrangements available, from small tables to larger ones. Because they are a very popular lunch destination, they also take over the business located next door to seat all the hungry lunch goers.
AMBIENCE/CLIENTELE	Lunchgoers at Dishdash tend to be trendy, local workers. Most of the eaters are in the middle to late 30s.
EXTRAS/NOTES	On Sunday, Dishdash closes for private events. Ask them about catering yours.

—*Maeve Naughton*

Faultline
Brewing Company

The Faultline experience is faultless,
not your ordinary pub grub.

$$$$

1235 Oakmead Parkway, Sunnyvale 94086
(at Lakeway Dr.)
Phone (408) 736-2739 • Fax (408) 736-2752
www.faultlinebrewing.com

CATEGORY	American bistro and brewery
HOURS	Mon-Tues: 11:30 AM-2 PM; 5 PM-9:30 PM
	Weds-Fri: 11:30 AM-2:30 PM; 5 PM-9:30 PM
	(bar menu 3:15-9:30 PM)
GETTING THERE	FBC parking lot that has a tendency to get packed at dinner. Neighboring business lots can handle the overflow.
PAYMENT	
POPULAR DISH	Three cheese ravioli (with roasted butternut

squash, fried sage, pecans, blue cheese, onions and a balsamic brown butter.) Caesar salad, made with hearts of romaine with creamy garlic dressing, sun dried tomatoes and shaved parmesan—available with warm grilled chicken.

UNIQUE DISH Blackened salmon hush puppies with jicama orange salad and andoullie cream. Bar menu provides an upscale selection and variety. My favorites are the Mediterranean mini falafels (served with cucumber yogurt, pomegranate and red pepper sauces) and the chicken and wild mushroom crepes (savory crepes rolled with roasted chicken, wild mushrooms, goat cheese, fresh peas and onions topped with a sun dried tomato aoli). Depending on my level of appetite, at lunch I go for the Caesar salad or the three cheese ravioli. The salad is crisp and delicious with a creamy garlic dressing with the addition of sun dried tomatoes that give this classic favorite a little kick. Warm grilled chicken can be added to provide a heartier salad for the protein conscious. The ravioli is superb. These cheesy little pillows melt in your mouth and provide an abundance of textures and flavors that marry well. For the hungriest appetite at dinner, it is hard for the carnivorous customer to pass up the Bloody Mary NY steak served with twice baked horseradish and bacon potato, green beans almandine with a smoked tomato and blue cheese sauce. The grilled swordfish provides a lighter meal and is served with an herb potato cake, shrimp and avocado gazpacho sauce and tomato concasse with chervil.

DRINKS FBC offers five standard varieties all brewed on site (hefenweizen, pale ale, stout, bitter and IPA) which reflect a range of colors and flavors and rotate a series of specialty beers which are offered during the appropriate season. The IPA (Indian Pale Ale) is known to be the best in the Silicon Valley. The IPA is dry and crisp and lighter in color than the pale ale and has a strong hop aroma. (You can check out what is on tap in advance by visiting their website.) The staff is knowledgeable of the beers on tap and can always recommend a beer suited to your taste. SEATING Seating capacity is close to 300, an excellent place for large groups.

AMBIENCE/CLIENTELE It's a toss up as to what is busier at Faultline Brewing Company (FBC), lunch or dinner. Located in the heart of Silicon Valley this place always packs the business crowd for lunch, dinner and happy hour as well. In fact, it is often referred as "Building F" for there are many business located within walking distance of FBC. The restaurant is spacious, with an open airy feeling with its high ceilings and tri level seating that don white linen table cloths. The large windows in the back of the restaurant provide a great view of the outside patio and pond. The bar area always seems busy no matter what the time of day, and provides the option of table or counter bar seating.

EXTRAS/NOTES Because of its location and mainly catering to the

business crowd, FBC is not open to the public on weekends. However this is an excellent place on weekends to hold a private party, wedding reception or other large events complete with banquet packages and event coordinator. Gift cards can be purchased online and FBC is currently in the works of creating an online merchandise store. Mini kegs are available to purchase, advanced ordering is required. FBC offers a cigar list. Reservations are recommended, especially if you are on a schedule.

—*Jackie Kortz*

Kal's BAR-B-Q

Mmmmm, BBQ!
Since 1968
$$$
425 N. Mathilda Ave., Sunnyvale 94086
(between Maude Ave. and Indio Way)
Phone (408) 739-5271

CATEGORY	BBQ
HOURS	Mon-Fri: 6 AM-9 PM Sat: 6:30 AM-2:30 PM
GETTING THERE	Parking in the Kal's parking lot is limited to only a few cars. However, there is a large parking lot located behind the restaurant but your best bet is to try to find street parking.
PAYMENT	VISA ⬤
POPULAR DISH	Can't go wrong with the 50, 40. That's a cheeseburger with fries.
UNIQUE DISH	Most lunch goers tend to get the hamburger, cheeseburger or steak sandwich.
DRINKS	Beer, soda, water
SEATING	Because Kal's is such a popular place for local tech workers, seating can get a bit tight if you don't show up before noon. There are a few smaller tables but in general the tables are large and seat multiple people from multiple lunch groups. Chances are high that you'll be sitting next to someone you don't know at all unless of course you're able to grab one of the few picnic tables on the patio.
AMBIENCE/CLIENTELE	This is a male local tech worker lunch hangout. Women are allowed, but they are certainly out numbered.
EXTRAS/NOTES	Most local workers know of Kal's or else people have noticed the great BBQ smell while driving on Mathilda. Lunches are made to order in front of you (yes, they cook the food while you watch, if you want) and you dress up your burger or sandwich with the condiment counter located in the middle of the small restaurant. This is also one of the few Bay Area barbeque joints that also serves breakfast. No matter when you're there, you won't be the only one.

—*Maeve Naughton*

Udupi Palace
Hearty comfort food from South India.
$$

976 E. El Camino Real, Sunnyvale 94087
(between Wolfe Rd. and Lawrence Expressway)
Phone (408) 830-9600 • Fax (408) 530-9653
www.udupipalaceca.com

CATEGORY	South Indian Vegetarian
HOURS	Mon-Thurs: 11:30 AM-10 PM
	Fri/Sat: 11:30 AM-11 PM
	Sun: 11:30 AM-10:30 PM
GETTING THERE	There is a parking area around the restaurant with a few spots in front and more on the side and back. They usually are busier than their parking can handle so you'll have to find street parking. A large sign at the entrance warns patrons not to park in the lots of contiguous businesses and apartment buildings as people do get towed. VTA line 22 stops about a block south on El Camino Real.
PAYMENT	VISA MasterCard
POPULAR DISH	At Udupi Palace they're the masters of *dosa*. This Indian version of a savory crepe (thinner and larger than its French counterpart) is made from a rice-based batter and served folded into a long flat tube. There are seventeen different dosa dishes in their menu, all delicious, making it hard to single out one as a favorite. You can eat them on their own, just the plain crepe without filling, good for dipping in the *sambar* and coconut chutney, or filled with spiced potatoes and onions in the classic *masala dosa*. The food is generally quite spicy and a bit hot. For a stronger rush, give the spicy vegetable masala dosa a try.
UNIQUE DISH	Indians come here to enjoy many variations of homey dishes like Uthappam and Vada. The special pav bhaji is a thick concoction of mashed potatoes and peas cooked in a crushed tomato puree served with bread (soft dinner rolls drenched in butter and toasted on the pan). It comes accompanied by fresh onions, tomatoes, cilantro, and sliced jalapeños. Very yummy and filling, it is misplaced in the appetizers section since it makes a meal in and of itself.
DRINKS	Sodas and Indian specialty drinks (lassi, Madras coffee, Masala tea, falooda, badam milk)
SEATING	At this Silicon Valley venue the scales of taste are heavily tipped to the side of the food. To the other side is the dining room, dull and worn-out, a seemingly bare space with four columns in the middle that, if you notice them at all, scarcely manage to separate the inner rectangle that they delineate from the rest of the room. It has capacity for about a hundred people seated around small square tables with black marble tops that are pulled together to achieve the required size for each party. Remember to bring your legs covered in the summer, or you'll stick to the vinyl on the chairs!

AMBIENCE/CLIENTELE Udupi Palace is a little piece of India in the middle of Sunnyvale, and not just because of the menu. Saris are common and sandals popular. This is where Indian geeks from the nearby businesses come to eat lunch during the week and where Indian families come to dine on the weekends. Bustling waiters rush between the tables and sometimes, on busy nights when the line forms out the door, forget about your order. The crowd, relaxed and friendly, is made up of a lively mix of people of all ages, from the babies to the grandparents. Their voices mingle into a loud buzz that manages to muffle the music playing from the speakers above. The food, the noise, and the people combine together to make some feel at home, some as if they just traveled all the way across the world.

EXTRAS/NOTES Not recommended if your favorite dish from an Indian restaurant is a westernized version of chicken tikka. For lunch you can eat a la carte or go to the buffet that is available until 3 PM.

OTHER ONES • Newark: 5988 Newpark Mall Rd., Newark 94560, (510) 794-8400
• Berkeley: 1901 University Ave., Berkley 94704, (510) 843-6600
• Check their website for locations in LA, Seattle, New York, and beyond.

—Maria Richardson

MILPITAS

Dakao

(see p. 259)
Vietnamese sandwich
72 S. Abel St., Milpitas 95035
Phone (408) 946-3668

Flames Coffeshop and Bakery

(see p. 264)
Diner
1191 Calaveras Blvd., Milpitas 95035
Phone (408) 262-2005

233

Andy's BBQ

Aka "The he man meat eaters club."
Since 1965
$$$$
2367 El Camino Real, Santa Clara 95050
(at San Tomas)
Phone (408) 249-8158 • Fax (408) 247-8940
www.andysbbq.com

CATEGORY	Family BBQ
HOURS	Mon-Thurs: 11 AM-9 PM
	Fri/Sat: 3 PM-10 PM
	Sun: 3 PM-9 PM
GETTING THERE	Andy's has a free parking lot with about a dozen and a half spaces with neighboring lots right next door.
PAYMENT	VISA ⬤ Cards
POPULAR DISH	They specialize in baby back ribs and homemade peach cobbler with vanilla ice cream. Still, I'd recommend going at lunch as the menu has more of a variety, serving a selection of burgers and chicken sandwiches that are not on the dinner menu. If you dine in the evening, it's best to order the platters that are served with garlic bread, salad and choice of French fries, baked beans or baked potato with butter, sour cream and/or cheese sauce. Should you forgo the platter route and order a la carte (side orders) you will only shave off about $3 from your bill and miss out on a delectable cheese sauce that oozes like lava from a volcano of baked potato. Portions are hearty so cleaning your plate is a rarity but, no worries here, most entrées will serve up nicely for breakfast the next day with a couple of eggs. The baby back ribs tend to be the best seller, flavorful pork and nicely trimmed packed with a zesty sauce. The smoke pork shoulder is yummy and tender with the sauce served on the side allowing you to zest to your pleasure. Dessert is limited, offering peach cobbler with vanilla ice cream, primarily because this award winning dessert is in a class by itself.
UNIQUE DISH	Nothing, they just serve BBQ—so don't expect to get a vegan entrée here.
DRINKS	Full service bar with a big screen TV and tables for the avid sports fan diner
SEATING	While the majority of tables are booth seating, Andy's has a few tables that when combined can accommodate larger parties. Total occupancy is 110.
AMBIENCE/CLIENTELE	Andy's atmosphere is casual with the wait staff sporting black pants and a black Andy's BBQ T-shirt. The décor is simple and a bit retro with a 70's diner flare with walls decorated in light wood paneling and a collection of framed photos of BBQ events, cook offs and other affairs

that Andy's has hosted and catered. This is a carnivorous family restaurant with minimal fan fare as all their efforts go into the oak wood smoke 'que and signature sauce. Andy's offers on site catering, bringing the 'que to you, which makes any event a visual and aromatic treat. While the friendly service is fast, the cooking methods are not. It's the slow cooking, up to eighteen hours that makes Andy's a cut above the rest.

EXTRAS/NOTES In 1965, Andy Unzen opened a small bar on Campbell Ave. in the city of Campbell, California.Shortly thereafter, a chef with a little barbeque experience offered to open the vacant kitchen, which was located in the back of Andy's bar. Andy agreed—with the intent of never getting involved in the restaurant operations. About 6 months later, when the chef decided to move on, Andy found himself operating a barbeque restaurant...with no experience whatsoever. Andy went behind the grill, teaching himself how to cook barbeque using real oak wood and the finer cuts of beef, pork, and chicken. Word immediately began to spread and soon the South Bay found itself traveling to Campbell for the best barbeque around. After expanding the business to include BBQ catering as well as the marketing of Andy's famous BBQ sauce, Andy Jr. has passed the torch of good cooking to Andy's longtime cook Ken Smith. Ken vows to continue the tradition using everything he's learned since he started working at Andy's in 1976 at the age of 16. T-shirts ($15) and baseball caps ($10) are available for purchase as well as Andy's bottled BBQ sauce ($3.95) in Original Recipe of Spicy

—Jackie Kortz

Dumpling and Noodle

Guess what they serve here.
$$$
3212 El Camino Real, Santa Clara 95051
(at Calabazas Blvd.)
Phone (408) 615-7705

CATEGORY	Casual Korean noodle house
HOURS	Daily: 11 AM-10 PM
GETTING THERE	Free parking lot
PAYMENT	VISA ⬤ Cards ⬤
POPULAR DISH	The beef bone broth with noodles and dumplings is a savory bowl of comfort. The dumplings are plain by themselves, but delicious with the restaurant's hot sauce that's at every table. The level of soup in your bowl never really seems to go down, no matter how long you drink it.
UNIQUE DISH	If your stomach can handle it, the spongy, steamed meat dumplings are delicious and filling.

It's not something often found at usual Korean restaurants.

DRINKS Tea, soda

SEATING Bright, clean, cozy restaurant with roughly 10 tables.

AMBIENCE/CLIENTELE Everyone can come to this casual noodle house. If you're not Korean, the hospitable waitress will mix the dumpling dipping sauce for you. If you're lucky, at times it feels like you've gone to visit your new Korean auntie. Expect to spend a while sipping your soup even after several trips to the bathroom. It's that good.

EXTRAS/NOTES Dumplings usually come in servings of six, but a party of four can sometimes get two extra dumplings for free so that everyone gets an even number of dumplings.

—Megan Kung

Pedro's Restaurant and Cantina

Great food served missionary style.
$$$
3935 Freedom Circle, Santa Clara 95054
Phone (408) 496-6777 • Fax (408) 496-6597
www.pedrosrestaurants.com

CATEGORY Mexican restaurant and bar

HOURS Mon-Thurs: 11 AM-10 PM
Fri: 11 AM-11 PM
Sat/Sun: 11 AM-10 PM

PARKING Located just off Highway 101 at the Great America Parkway exit, Internet maps might tell you to take a right on Mission College Blvd, followed by another right on Freedom Circle, but locals know that taking the first right at the oft-overlooked Hichborn Drive from Great America cuts out over a half mile of needless driving to get here. There is plenty of free parking at the restaurant and at any of the nearby office building parking lots. You could walk from the VTA Light Rail stop on Tasman Drive (about a mile away), but I'm not too sure I'd want to hoof it back that far after a large meal.

PAYMENT VISA

POPULAR DISH Assuming you don't fill up on the endless supply of chips and salsa, you'll want to try the enchiladas. The Enchilada Chipotle (sautéed chicken topped with a mild sauce of chipotle chiles, pineapple juice, and brown sugar) and the Enchilada Jalisco (pork carnitas smothered in their secret, signature "ranchero sauce") are both served with Spanish rice and black beans, and are tasty yet relatively inexpensive choices for lunch. If enchiladas are not your thing, the Chile Colorado with its tender chunks of beef in a creamy sauce of *colorado chiles* (what else?!) is a popular alternative.

DRINKS The cantina serves up a variety of beers, wines,

and spirits, but is best known for its inexpensive yet generous margaritas, available in classic lime or other more trendy fruit flavors. While the grub served at the bar during Happy Hour (4-7 PM weekdays) is not quite the same the regular menu, there are scarce few places where you can start off the weekend right—get a little blotto on fast-flowing margaritas and fill up on pretty good (and free!) food, all for about ten bucks.

SEATING Seating, thanks to the quite large capacity, is almost always fast, no matter the size of your party. The quality of service can be hit or miss during busy times and, since it is the only reasonably priced restaurant within walking distance of several high-tech, high-rise office buildings, it is often extremely busy.

AMBIENCE/CLIENTELE Pedro's elegant, Mission-style architecture among its boring, sky-rise neighbors is one of its appeals. The interior features a circular, fully enclosed, courtyard-like setting, complete with a miniature staircase leading up to rooms unknown, and a wooden gazebo overlooking a fountain. Smaller tables for two abound in these charming surroundings, perfect for a romantic evening date, or a relaxed Sunday brunch. Other areas of the restaurant appear much hardier with heavier, wooden, drinking-hall-style tables, ideal for large office lunches, a perfect place to go with the guys to lunch. I had my wedding rehearsal dinner here, and all the guests thought it an ideal location with terrific food.

OTHER ONES • Los Gatos: 316 North Santa Cruz Ave., Los Gatos 95030, (408) 354-7570

—Richard D. LeCour

SGD Tofu House

The bubbling hot spot for religious tofu conversions.
$$$
3450 #105 El Camino Real, Santa Clara 95051
(between Pomeroy Ave. and Flora Vista Ave.)
Phone (408) 261-3030

CATEGORY Korean family restaurant
HOURS Mon-Sat: 11 AM-9:30 PM
GETTING THERE Free parking lot
PAYMENT VISA ⬤

POPULAR DISH The combination tofu soup with beef and seafood is a good choice for both soon dubu newbies and veterans. Clams add a nice sweetness to this spicy surf and turf. Be sure to crack an egg into your bowl when it arrives to help calm the fiery soup. You could also order it mild or not even spicy, but seriously, why? They also have excellent bibimbob, a rice dish with meat and vegetables served in a hot stone bowl to crisp up the rice on the edges.

UNIQUE DISH The mushroom soon dubu with white, oyster and enoki mushrooms is hearty and almost meaty,

providing a flavorful option for vegetarians.

DRINKS Tea and soda

SEATING It's hard to judge the number of tables from the constant combining and separating of tables for large Korean families. However, the restaurant is big enough so that you and your friends never have to wait too long.

AMBIENCE/CLIENTELE A fun, cozy family place with children's drawings covering the walls and windows. About half the drawings are inexplicably on Google stationary. Munch on the free side dishes of kimchi, bean sprouts and pickles while awaiting your order, or the delicious smell of soon dubu will drive you crazy.

EXTRAS/NOTES If the owner is there, whether or not you're a child, he'll give you a warm smile and handfuls of melon gum and Dum Dum lollipops as you leave. Nothing like handfuls of sugar after a good meal to put a smile on your face.

—*Megan Kung*

A la crêperie, ma chérie

Growing up in the 'burbs of Orange County I dreamed an unusually particular dream. One of my favorite foods was that flat pancake made popular by the Frenchies and known all around the world as the crêpe. Oh la la, thought I, what if I were to open up my own crêpe stand—or better yet—a full on crêperie? I even had a name picked out: Ben-n-Breakfast. Unfortunately, no one in Orange County was interested in anything French except fries, and words with circumflex accents are still forbidden by law (look it up!). So when I moved to San Francisco so many years ago, still a child at heart and ripe with unrisen circles spinning loftily in my head, I planned to give life to that dream.

Imagine my horror when I realized that there were already dozens of crêperies in this fair, forward-thinking metropolis. In fact, the hilliest city in the country had gone totally flat. Tortillas, lavash, thin-crusted pizzas, chapattis, mu-shu, and pita chips: two-dimensional cooking seemed to be San Francisco's culinary panacea. Flat was phat, and to my dismay, I was forced to get a real job like the rest of you. But my horror gradually turned into delight as I marveled at the top-notch crêpes available in every neighborhood of the city. While almost any crêperie you find will satiate your sweet tooth with a chocolaty Nutella crêpe, what the city does best are salty crêpes (or "savory," as they insist on being called). California fusion is at its finest churning out delicious wafer-thin pancakes crammed full of untraditional ingredients like portobello mushrooms, feta cheese, basil, jalapeño, avocados, or roasted peppers. These crêpes are full meals folded into luscious triangles any honest Frenchman would quickly surrender to.

Lining up for Sunday brunch at the Crepevine, or grabbing one to go-go from Crepes A-go-go, I no longer feel the strains of my three-dimensional existence. And neither should you. Check out some of these fine eateries:

Crepes on Cole just outside the Haight (100 Carl St., (415) 664-1800) caters to the whole gamut of diners, even those who hate

hippies. This neighborhood crêperie is a favorite place to hang with friends or find a cozy corner to study. Giant salads and tasty daily soups are healthy alternatives, but the savory crêpes are delectable.

Crepe o Chocolat, as its name implies, specializes in dessert crêpes; the highly recommended Nutella crêpe comes with freshly ground hazelnuts. It's off Union Square (75 O'Farrell St., (415) 724-3749), but the crêpes are some of the most Parisian you'll find in the city thanks to the French owner.

Crepes A-go-go (350 11th St., (415) 503-1294) is one of the Bay Area's absolute favorites. They even have a truck that generously serves crêpes to insomniacs and SOMA hipsters until 2 am. Though you'll find several locales, for some reason the best ones are still at the original café in the East Bay (2125 University Ave., Berkeley, (510) 841-7722).

The Crepevine (624 Irving St., 415-681-5858) Portions are tremendous and the Latin-American staff are simpatico at the Crepevine. The omelets are actually more delicious than the crêpes, and the freshly-squeezed carrot juice is divine. The N-Judah stops right outside making it a fine start for exploring Golden Gate Park. Another location at 216 Church St. (415) 431-4646) is equally popular and is a fine start to exploring your sexuality in the Castro district.

Sophie's Crepes inside the Japantown mall (1581 Webster St., 15) 929-7732) graciously allows you to avoid eating bean paste for dessert. These Asian-influenced crêpes are crispier than most and the sweet ones are the real standouts, especially if you like green tea ice cream.

Ti-Couz (3108 16th St., (415) 252-7373) is for the upper-class among us who demand authenticity and snootiness in their crêpes. Made in the tradition of Brittany, Ti-Couz uses buckwheat flour for its savory crepes and wheat flour for its dessert crepes giving it a slightly more earthy feel. Still, the crowds line up for this one on weekends, so come early.

—*Benny Zadik*

University Chicken
Ultimate chicken wings restaurant meets college pub.
$

2565 The Alameda, Santa Clara 95050
(at El Camino Real)
Phone (408) 241-2582
www.universitychicken.com

CATEGORY	American BBQ and Chicken
HOURS	Mon-Thurs: 11 AM-Midnight
	Fri/Sat: 11 AM-2 AM
	Sun: 11 AM-Midnight
GETTING THERE	Small parking lot with additional parking at adjacent places
PAYMENT	Cash Only. ATM on site.
POPULAR DISH	Chicken wings! Technically there are chicken

breast tenders, chicken sandwiches, salads and side orders... but the only reason to come here is for chicken wings. They're crispy on the outside, tender on the inside, tangy and hot. They come with a few celery sticks and ranch dressing too, which is useful in combating the heat in your mouth. Bottom line: these are honestly the best wings ever invented.

UNIQUE DISH With your wings, you choose a spiciness factor, which ranges from mild to traditional and on up to Global Thermo Nuclear. Traditional is pretty darn hot for the average person; but you're the kind of guy that enjoys culinary challenges—like eating ten pound hamburgers—then you'll probably get sucked into the "911 Challenge" of eating G.T.N wings, too.

DRINKS Soda fountain, beer and cocktails are all available, and free cups of ice water. Not that water helps cool the heat of the wings.

SEATING Seating is two kinds: the side with tables and chairs that feels like a burger joint, and the side with bar-high seating (and bar) that feels like a college pub. At lunch, seating is not a problem. On Tuesday "winger night" it is packed.

AMBIENCE/CLIENTELE Because it's cheap and delicious, the crowd is pretty kicked back and diverse—despite being a college hang-out near Santa Clara University. It's so good that it has a following, eating at University Chicken since it was called "Cluck U" back several years and a new address ago. In addition to the college kids, the lunch crowd includes an older set that feel perfectly at home there too. Takeout '80s music is playing more often than not, and large murals make it more interesting inside than the typical college place.

EXTRAS/NOTES In summer the hours are slightly different, and other locations have their own hours too. Each weeknight features a different special, and beer-type events are common.

OTHER ONES • San Jose: 29 South 3rd St., San Jose 95113, (408) 293-9976

—*Sylvia Clark Hooks*

CAMPBELL

Michi Sushi
She's Sassy? Pymp Daddy? Second Climax? Sushi is gettin' sexy!

$$$$
2220 Winchester Blvd., Campbell 95008
(between Campbell Ave. and Sunnyside Ave.)
Phone (408) 378-8000 • Fax (408) 378-0882
www.michisushi.com

CATEGORY Japanese sushi

HOURS	Sun-Thurs: 11 AM-10 PM Fri/Sat: 11 AM-10:30 PM
GETTING THERE	Michi's offers street parking right in front or their restaurant as well as neighboring lots across the street. Michi's own parking lot holds about ½ dozen cars, but with street access and surrounding lots, parking is rarely an issue.
PAYMENT	VISA
POPULAR DISH	Michi's is open for lunch and dinner and while known for its sushi; offers traditional Japanese cuisine. With its wide variety of udon, donburi, tempura and nabemono as well as entrées of beef, chicken and fish it would be hard for even the novice sushi goer not to find a favorite. Easily catering to the vegetarian and vegan as well, I'd suspect that even Gandhi (given the opportunity) would have caved in. What makes this place stand out from other sushi bars is their 150+ unique rolls as well as their 3 dozen varieties of Nigiri that are the crowd pleasers for the locals.
UNIQUE DISH	As a fan of the "Booty, Booty" or the similar "She's Sassy" roll (ebi, tempura, unagi, cream cheese, avocado, unagi sauce, macadamia nuts and tobiko), I'd recommended either as a "go to" to start. The "Senator" roll is refreshing with its kani, avocado, tobiko, sake and lemon slices. While I was intrigued by the "Pymp Daddy" (a giant size roll consisting of ika, hamachi, maguro, hokkagi, unagi, green onion, cucumber, spicy michi sauce, unagi sauce and macadamia nuts), I couldn't resist the temptation of "Second Climax" (spicy nigihama, green onion, cucumber, rolled w/ hamachi on top, tobiko, wasabi sauce, unagi sauce & macadamia nuts.) This appropriately named, awesome, spicy specialty is not for the virgin sushi eater. For the nigiri sushi goers, pieces are served as a pair with a median range of $7. The surf and turf sushi roll (spicy tuna, cream cheese, cucumber with seared beef and topped with wasabi sauce). Michi's offers more than a dozen deep fried sushi rolls.
DRINKS	Eating sushi goes hand in hand with drinking sake. Michi's offers a variety of hot & cold sake. I go straight for the Nigori sake (served cold). Nigori translates to cloudy and is non-filtered. Creamier and smoother than hot sake, it has a slightly sweeter distinct taste. A selection of the more popular Japanese beers is offered for the less adventurous and traditional plum wine rounds out the wine list for those with a sweeter palate. Michi's serves a selection of wines and beers as well as hot and cold sake. Non-alcoholic drinks include hot tea and soft drinks.
SEATING	Michi's is on the smaller scale as restaurants go, with a seating capacity of 49. It offers a great celebration atmosphere for everything from a first date to a 50th wedding anniversary and any birthday in between. For those who like the action and the view of the sushi chefs, Michi offers two intimate sushi bar settings (seating about 8-10 patrons at each bar). The majority

of the restaurant is table seating in addition to three tatami rooms that are great for larger or intimate parties. Reservations recommended on a Thursday, Friday or Saturday evening.

AMBIENCE/CLIENTELE With a lively welcoming feeling when you walk through the door, it's pretty much a guaranteed happy place to be. The setting borders on the casual side yet has elegance to its simplicity. Pale colored walls are accented by dark wooden archways that match the chairs and tables that are draped in classic white tablecloths. The attire is across the board from patrons wearing business suits or relaxed in jeans and a tee. But rest assured, whatever your attire, you will be treated equally and like a best friend. The fish quality is top notch and fresh as fresh can be. Arriving daily into SFO by 2 AM and delivered each day to Michi's by 9 AM.

EXTRAS/NOTES Mr. Shin, the owner, happily makes the rounds to every table as he introduces himself, ensuring the guest's experiences are enjoyable. He is easy to spot as he usually has a digital camera in tow, snapping photos of patrons that can be viewed on their website usually by the next afternoon. If you bring your little Matisse, s/he just might get her first gallery showing; the majority of the art work that is in full view of the sushi bar has been created by the child sushi goers, whose Caryola creations turn a paper place mat into an artist's canvas, telling stories and making smiles. While they draw, they can munch on a well-balanced kid's menu. You can look like an official Michi's sushi chef for a mere $10 with T-shirts in available in a variety of sizes. Michi's offers catering with a special catering menu and will deliver orders (catering or regular menu items) from a small office lunch to elaborate weddings. There is no delivery charge, delivery radius varies.

—*Jackie Kortz*

Twist Bistro & Café

California casual with a French flare.
$$$$
247 E. Campbell Ave., Campbell 95008
(at 2nd St.)
Phone (408) 374-8982 • Fax (408) 374-8982
www.twist-cafe.com

CATEGORY Small café and bistro

HOURS Café:
Sun 9 AM-2:30 PM
Tues-Fri 9 AM-3 PM
Bistro:
Weds/Thurs: 5 PM-9 PM
Fri/Sat: 5 PM-10 PM

GETTING THERE Free street parking with free parking garage located on Second Street near the corner of Campbell Avenue.

PAYMENT

POPULAR DISH Twist Café: Build your own crepes. With more than a dozen filling options the savory crepes come with a mixed green salad and balsamic vinaigrette. The Café lunch menu has a bit more of a selection than the dinner menu and features build your own sweet or savory crepes served with whipped cream or a béchamel and cheese sauce. The sandwiches are popular and provide a balanced selection of hot and cold. The pulled pork sandwich on country bread with Dijon mustard and a braised onions served with an arugula salad with balsamic vinaigrette is delicious for those who have a zesty palate. The Cobb salad is great for the less adventurous diner and is served with your choice of dressing. Desserts are the classics of Peach Melba (peaches, vanilla ice cream and raspberry coulis), profiterole au chocolate (this seems to be the most popular). Crème caramel and my recommendation of the warm molted chocolate cake round out the menu.

UNIQUE DISH: Upon being seated, a delicious amuse of carrot sticks tossed in a zesty mustard horseradish sauce arrived. A warm baguette in a white paper bag soon followed. Classic appetizers of duck Foie Gras terrine maison served with brioche toast, baked French onion soup with Gruyere (made with vegetable broth) and escargots Provancale en cocotte have a popular following. Most entrées are served al a carte, although some dishes come with roasted or steamed vegetables. The bistro also sells half a dozen vegetable side dishes separately. The entrée menu provides a variety of fish, (salmon, shrimp and bay scallops) steak, pork chops, ravioli, chicken, braised lamb shank and a vegetarian Portobello Mushroom Napoleon. The grilled salmon is delicate and flavorful served with braised leeks, a ginger lemon sauce and crisp fennel salad. The Portobello mushroom napoleon includes roasted vegetables, cous cous and a tomato coulis. This vegetarian masterpiece is for the lighter appetite or can be paired with a side of mashed potatoes for a more filling entrée.

DRINKS Twist Café: Beer & wine, bottled water, sodas, coffee and tea. The wine list is extensive and a bit intimating with a wide variety of wines from many French regions as well as California wines. The staff is knowledgeable and can take the guess work out of the wine selection by suggesting pairing recommendations.

SEATING Twist Bistro and Café are small and cozy. Great for couples. Occupancy is about 40 inside, with outdoor patio seats 30 during café hours during the warmer weather.

AMBIENCE/CLIENTELE So the twist about Twist Bistro & Café is that they are two completely different experiences. It is not your typical restaurant that embellishes the lunch portion and adds a few bucks to the dinner tab; it is truly two different experiences. The Bistro dinner menu offers French classics with a California twist. The dining experience is intimate

and quiet with the slightest sound of music. Dark wood floors, gleaming glass blocks separate the entrance from dining room. The walls are painted the color of cafe au lait serve as an elegant backdrop for large Palladian mirrors and copper planters filled with dried flowers. A polished dark wood wine bar is the center focus of the long, narrow room, opposite a brick-faced fireplace. All the tables are covered in white linen and set with signature silverware with twisted handles. While the café has a more laid back atmosphere, the bistro happily hosts the casually dressed diner.

EXTRAS/NOTES Catering available

—Jackie Kortz

CUPERTINO

Alexander's Steakhouse

The best beef in the South Bay.
$$$$
10330 N. Wolfe Rd., Cupertino 95014
(at Stevens Creek Blvd.)
Phone (408) 446-2222• Fax (408) 446-2242
www.alexandersteakhouse.com

CATEGORY Upscale steakhouse

HOURS Mon: 5:30 PM-10 PM
Tues-Thurs 11:30 AM-3 PM; 5:30 PM-10 PM
Fri: 11:30 AM-3 PM; 5:30 PM-11 PM
Sat 5:30 PM-11 PM
Sun: 5:30 PM-9 PM

GETTING THERE Just off Hwy 280, Alexander's is easy to get to and easy to park near. If the restaurant lot is full, try the large mall lot located above the restaurant.

PAYMENT VISA Cards

POPULAR DISH As advertised, Alexander's is first and foremost a carnivore's paradise. Alexander's ages their own beef, which you can see for yourself behind glass in the restaurant's entry hall. Alexander's pride and joy is their Kobe beef imported from Japan. You can choose from several Kobe entrées or splurge on a whole Kobe tasting menu. Other popular dishes are the slow-roasted prime rib and the variety of steaks. At lunch, indulge in a Kobe beef burger.

UNIQUE DISH Though beef is the star, Alexander's doesn't neglect their seafood loving patrons. Check out the original and often Japanese-inspired fish and shellfish small plates, such as Hamachi Shots and Crispy Kuruma Shrimp. Vegetarians will also find a few menu items tailored to their tastes.

DRINKS The wine list at Alexander's has a table of contents. Need more be said? Well, yes. Alexander's offers fun tasting flights of wines with dinner. The "Old and Rare" wines listed are

definitely worth gawking at. (At least looking is still free!) There's also a selection of sakes and some fantastic dessert liqueurs, including a century-old bottle brandy that sells at $1000 a shot. For the non-wine-drinkers, Alexander's offers a selection of unusual sodas and mixed non-alcoholic sparkling beverages like the cucumber-lime spritzer and the pineapple cooler.

SEATING Large, white clothed tables are uncrowded and comfortable. Couples and large groups are accommodated with style. For a serious treat, ask about the table in the kitchen.

MBIENCE/CLIENTELE The food and prices are upscale, and you'll feel comfortable dressing up for dinner at Alexander's. But close proximity to the big technology companies means that jeans and t-shirts are just as acceptable as the best suits, and a laid-back ambiance prevails.

EXTRAS/NOTES At Alexander's, you can easily spend three month's rent on food and wines, and if you can afford it this is one of the best places in the South Bay to splurge. But you don't have to hock the car to get a good meal here—have lunch rather than dinner, or split three or four of the small plates and go for a unique yet inexpensive non-alcoholic cocktail. Alexander's is happy to split appetizers and entrées as well. Plus, everyone gets complimentary cotton candy for dessert. The service at Alexander's is second-to-none. If you seem particularly interested in the food you're eating, your server might just offer you a backstage tour of the kitchens, the wine cellar, and the exclusive private dining rooms!

—Liz Scott

Flames Coffeshop and Bakery

(see p. 264)
Diner
10630 S. De Anza Blvd., Cupertino 95014
Phone (408) 996-2074

Miyake

(see p. 218)
Hip Japanese
10650 S. De Anza Blvd., Cupertino 95104
Phone (408) 253-2668

LOS GATOS/SARATOGA

Café Sienna

*Friendly Euro-ish café with
great lunch.*

$$

26 E. Main St., Los Gatos 95030
(at Hwy. 17)
Phone (408) 399-2830

CATEGORY	European café
HOURS	Mon-Fri: 6:30 AM-6 PM
	Sat: 6:30 AM-5 PM
	Sun: 7 AM-4 PM
GETTING THERE	Generally easy street parking
PAYMENT	VISA ●● ■■ Cards
POPULAR DISH	There is a display case full of pastries, but it's the sandwich and soup that tastes best at this personable little café. There are a few daily sandwiches and soups, each fresh and tasty, and they arrive with a pile of gorgeous greens and homemade potato chips. Something about the small glasses and ice that arrive with your soda, and the presentation of the food makes this place a kind of oasis for lunch in downtown Los Gatos.
UNIQUE DISH	The overall food selection here has a Continental feel, and the portions are more European than American. In a good way.
DRINKS	Good coffee, and both regular soda and interesting non-mainstream sodas, make up the drink menu.
SEATING	There is always someone eating at Café Sienna, and always a place to sit, too — a kind of happy impossibility. There are café tables inside, lit by floor-to-ceiling windows, and more outside on a brick patio that gets lots of sun.
AMBIENCE/CLIENTELE	Well-heeled but low-key locals, both young and old, and an occasional foreign visitor, drop in regularly. A big countertop with "buy-10-get-one-free" type cards tells you that lots of people come in each morning for coffee, but the proprietor treats everyone like a potential friend. His open smile is another reason to like the place.
EXTRAS/NOTES	The cafe sits on East Main, on the "other" side of Highway 17. It's less filled with tourists, and much more mellow on a weekend than the more heavily trafficked West Main and North Santa Cruz.

—Sylvia Clark Hooks

La Fondue

*Gourmet fondue is not a
contradiction in terms!*

$$$$

14510 Big Basin Way, Saratoga 95070
(between 3rd St. and 4th St.)
Phone (408) 867-3332• Fax (408) 867-9381
www.lafondue.com

CATEGORY	Fondue
HOURS	Mon-Thurs: 5 PM-9:30 PM
	Fri: 5 PM-11 PM
	Sat: 4 PM-11 PM
	Sun: 4 PM-9:30 PM
GETTING THERE	On Saratoga's main downtown drag, La Fondue is easy to find. Street parking is not quite so easy to come by. Pass La Fondue and turn either left or right and park in one of the free public lots. But pay attention to the signage—if you park in the wrong place, you will get a ticket.
PAYMENT	VISA Cards
POPULAR DISH	By far the best way to go is to order the Fondue Feast. You get to choose from the full menu of cheese fondues for your first course. If you're a garlic lover, the Stinking Rose is fabulous, and they'll give you all the garlic you can handle. (And hey, if you and your date are both indulging, the smell isn't an issue!) If you like it hot, try the Cajun cheddar. You get to pick six kinds of meat/seafood and a cooking method for your main course. If what you want isn't part of the columns in the Feast menu, the servers are happy to make substitutions (for an additional price, usually). Cooking methods vary to your taste—my husband and I usually go with the Punsch—boiling red wine with spices. The grill is also lots of fun, and the sake adds an Asian flare to your meat and veggies. Don't skip the dipping sauces—they are worth the trip all by themselves. And of course, there's dessert. Pick your favorite chocolate and your favorite liqueur, and indulge. Forget your diet plan just this once—the chocolate fondue here is worth every luscious calorie.
UNIQUE DISH	For your main course, get wild—the duck, buffalo, and ostrich are amazing. The elk and venison are particularly tender and tasty too.
DRINKS	La Fondue has a small but distinguished wine list with wines by the bottle and by the glass. If you're a lightweight, beware of the by-the-glass options. The glasses are huge and they fill them up. There's also a full bar—a coffee drink with the chocolate fondue is a great way to finish your meal.
SEATING	Several dining rooms boast tables for two, four, or six. Limited outside seating at the front of the restaurant is also available. Each table has one or two cooktops in its center. The at-the-table cooking arrangement makes La Fondue a fun place to double-date—two couples can order different things and share around the table. But be sure to find another couple whose tastes are similar to yours. Tables for four have only one cooktop, so you'll need to agree on the type of cheese, the cooking method for the meats, and the kind of chocolate.
AMBIENCE/CLIENTELE	While they won't turn you away for showing up in jeans, a dinner out at La Fondue is a great excuse to pull some nicer duds out of the back of your closet. Because La Fondue is not a budget restaurant and the atmosphere is romantic, the ambience feels upscale. Many locals come to La

Fondue for special celebrations. This restaurant is a feast for the senses—the smells of fondue cooking, the lush décor, and the gourmet flavors blend together to create an unforgettable dinner.

EXTRAS/NOTES La Fondue was named "Best Place to Kiss in Northern California" by A Romantic Travel Guide. Reservations at least a week in advance are strongly recommended. But if you want a spur-of-the-moment splurge and you're willing to have dinner later in the evening, it's often worth the effort to call on the night you want to dine and see if there are any cancellation spots available. If you want chocolate fondue for dessert only, you can show up at 10 PM on a weeknight without a reservation.

OTHER ONES • San Juan Capistrano: 31761 Camino Capistrano, San Juan Capistrano 92675, (949) 240-0300

—*Liz Scott*

Los Gatos Brewing Company

Relaxing, upscale and tasty.
$$$$
130 N. Santa Cruz Ave., Los Gatos 95030
(at Bean)
Phone (408) 395-9929
www.lgbrewingco.com

CATEGORY California-style brewery

HOURS Mon-Thurs: 11:30 AM-10 AM
Fri/Sat: 11:30 AM-Midnight
Sun: 11:30 AM-10 PM

GETTING THERE City lot behind the restaurant, and street parking.

PAYMENT VISA ⬤ ⬤ ⬤

POPULAR DISH If California cuisine could also be comfort food, that would be the Brewing Company specialty. The Brewery's menu has an unselfconscious, reliable offering – and quite good for these parts. The menu changes seasonally, but has some recurring dishes. Ahi Tartar appetizer, Smoked Trout Salad, and Fusili Pasta are personal favorites. The Roasted Chicken and the hamburger are also very good, and each dish is elegant and modern. Perhaps it's the ambience and the service and not just the yummy food, but the place always has a warm glow of friendliness.

UNIQUE DISH Being a brewery, beer is a specialty. A flight of beer is a fun way to try some.

DRINKS There's a full bar with well-prepared cocktails here too, in addition to the house-brewed beer.

SEATING Except at peak hours when waits can be more than an hour, the Brewery has ample seating. There are cozy, chic booths and tables with chairs. The large, open dining room is divided by different sections sharing the same vaulted ceilings, making the space welcoming and social. The Brewery offers more bar seating than usual,

so when waits are long, the bar is a quicker, and often just as pleasant, alternative.

AMBIENCE/CLIENTELE Back before the "bubble" burst in Silicon Valley, the bar here was a happy hour hang-out for movers and shakers. Now it seems to have settled into a less self-conscious meeting place for regulars. The crowd is a little older than other places; you don't see many families with young kids here. The atmosphere is both industrial and cozy – huge metal brewing tanks behind the bar, barn-like rafters in the ceiling, and lots of warm earth tones.

EXTRAS/NOTES This is a great place when you want some better food and better atmosphere, but without the hassle of attitude. The service is friendly, the food is good, and you find yourself relaxing and forgetting about work.

—Sylvia Clark Hooks

Pedro's Restaurant and Cantina

(see p. 236)
Mexican restaurant and bar
316 North Santa Cruz Ave., Los Gatos 95030
Phone (408) 354-7570

SANTA CRUZ

Café Brasil

Brasilian breakfasts - Santa Cruz style.
$$$
1410 Mission St, Santa Cruz 90560
(at Laurent St)
Phone (831) 429 1855
www.cafebrasil.us

CATEGORY Breakfast café
HOURS Daily: 8 AM-3 PM
GETTING THERE With Mission St. being a very busy street, parking is a bit difficult. They have a small parking lot to the side of the restaurant, otherwise it's best to find a spot anywhere on the street.
PAYMENT VISA ●●
POPULAR DISH The *Acai* Bowl (AH-SIGH-EE): a thick blend of the traditional Amazon powerfruit with fresh strawberries, bananas, guarana, and fruit juice; served in a bowl with granola and banana. So good and very filling.
UNIQUE DISH No other place in Santa Cruz serves traditional Brazilian/South American cuisine. They fuse local flavor with traditional American breakfasts to suit everyone. Everything from avocado shakes and *I* (traditional Brasilian favorite of poached eggs and black beans served over a

baguette with Brasilian salsa) to egg or tofu scrambles and pancakes.

DRINKS Array of tropical smoothies and fresh fruit juices (coconut, mango, guava). As well as teas, coffee, Chai, Guarana sodas, and imported Brasilian beer and French Champagne.

SEATING Small front dining area, lots of small tables. Also outside seating. Available for private parties.

AMBIENCE/CLIENTELE Bright, colorful atmosphere, authentic cuisine and friendly service. Feels like you're right by the beach and the place is always popping with locals—usually the regular hippies and students as well as families. If you go on the weekend, prepare for a line out of their little bright green restaurant!

EXTRAS/NOTES The restaurant was closed for ten months in Feb of 2004 because of an electrical fire. Since then the owners (Joao Luiz and family) have restored everything, making it just as it was if not better. People from all over the county come to the Westside just to eat here, even people in San Jose. Besides dining here you can also reserve for private parties, have them cater, order online, or purchase local Brasilian food from the restaurant. (Like imported beer, coffee, fruits, flour, rice.)

—*Alexa Watkins*

Charlie Hong Kong

Ultimate street food.
$$
1141 Soquel Ave,. Santa Cruz 95062
(at Cayuga St.)
Phone (831) 426-5664 • Fax (831) 429-1128
www.charliehongkong.com

CATEGORY Noodle house

HOURS Daily: 11 AM-11 PM

GETTING THERE Street parking or small adjacent parking lot. First come first served.

PAYMENT VISA ⊙

POPULAR DISH So many options, yet my classic standby is the *Gado-Gado* (stir fried organic vegetable medley & mushroom with a combination of black & spicy organic peanut sauce, garnished with organic peanuts, cilantro, bean sprouts, carrots, scallions & limes served over Jasmine rice. But brown rice can be subbed for just fifty cents. Basically any kind of stir fry dish imaginable.

UNIQUE DISH There really isn't any other place like this in the county. Dishes stem from traditional Southeast Asian street food; for when you want something good, healthy, and filling fast. Their portions are HUGE so you have enough for lunch the next day without cleaning out your entire wallet. Almost everything is organic and vegan unless you choose to add a meat topping

to it. Sustainability and partnering with local businesses is their pride, as well as feeding healthy, yummy goods to the public.

DRINKS Small,. Mostly imported beer selection; as well as varied teas, iced teas, and Sobe drinks.

SEATING Bar style with stools inside with some large picnic style tables outside. (Covered overhead outside)

AMBIENCE/CLIENTELE Eclectic, hipster ambiance with Asian flare. Very laid back, very Santa Cruz. A bus-your-own-bowl type of place that is frequented by hippie health freaks and meat eaters alike. Something for everyone in the family.

—*Alexa Watkins*

A Day in Santa Cruz

9:00 am

Grab a breakfast burrito from Chill Out Café. (860 41st Ave, Santa Cruz 95062. (831) 477-0543.) Open Mon-Fri: 6:30 am-3 pm; Sat/Sun: 7 am-4 pm) this locals spot draws a crowd fast. You can chose from an array of different breakfast or lunch items; eggs, burritos, sandwiches, salads and all sorts of your usual coffee house beverages, but the most popular food here are the breakfast burritos. With over 20 different kinds of burritos you are sure to find your match, whether you're a classic eggs and hash browns type or the tofu and sprouts devotee. Don't let the appearance of a shack covered in stickers and local flyers fool you, the food and relaxed vibes are worth the wait.

Take your burritos and coffees to-go and head towards the ocean along East Cliff Drive. Stop and enjoy breakfast on a bench as you watch the surf at Pleasure Point (known to locals as simply, "The Point.")

10:00 am

Continue your drive along East Cliff (Note: East Cliff actually becomes one-way so You'll actually have to drive along Portola Ave.) towards the West Side of town.

In no less than 10 minutes (at least when it's still this early in the morning) you will get yourself downtown Santa Cruz on Pacific Avenue. Most of the shops open around 10 so you can be the first to check out what's new and good with the local SC merchants. Santa Cruz is probably most known for its downtown scene (after the beaches) where you can buy, eat, or look at almost anything your heart desires. From the locally owned Indian stores or the renowned Book Shop Santa Cruz to the corporate havens of Urban Outfitters and Borders, everything is in a five minute walk down the block.

If it's open (sometimes it has irregular viewing hours) be sure to check out The Hide Gallery (131 B Front St. Santa Cruz 95060. (831)621-3939.www.hidegallery.com) little museum becoming known for its eclectic art displays and its new artistic, urban clothing/accessories store. The museum also hosts an art show every first and third Friday's of the month from 6:30 pm to midnight.

12:30 pm

Shopping and art viewing always leads to hunger, so satisfy your craving at Chocolate (1552 Pacific Ave. Santa Cruz 95060.,(831)420-1928. www.sosaywe.com), the quaint little bistro in front of Book Shop Santa Cruz. Known for its decadent desserts and of course, chocolate, this European style café also has wonderful meals for lunch and dinner. Order one of their veg- friendly soups and organic salads (the Mediterranean is a personal favorite) or a hot/cold sandwich with free-range meat. With plenty of options for dessert, specialty hot chocolates, tiramisu, mousse truffles and more, make sure you leave room.

2:00 pm

Keep driving west until you get to the other famous cliff over looking the ocean in Santa Cruz- West Cliff. Here you can walk off your dessert as the paved walkway gives you scenic views overlooking the town.

After that you can stroll the shops on the Santa Cruz Wharf or head on down towards the Beach Bordwalk (400 Beach St. Santa Cruz 95060, (831)423-5590. www.beachboardwalk.com) arcade. Normally I wouldn't suggest going here because it is a tourist trap that locals strongly dislike, but inside the arcade you can find an old school photo booth that is always fun. Here take some snap shots with friends as a memento and then head on to your next destination.

6:00 pm

Time for dinner back in the downtown area at Mobo Sushi (105 South River St. Santa Cruz 95060, (831)425-1700. Web: www.mobosushirestaurant.com) One of the best sushi places in town that offers great quality food, decent prices, and fast service. They have many traditional Japanese favorites like edamame, tempura, and miso soup and any of their simple, yet delicious, rolls are worth trying. Check out the daily specials which are always innovative and tasty. There is also a nice list of vegetarian/vegan rolls as well.

7:30 pm

After dinner you can end your evening back down on Pacific Avenue at The Attic (931 Pacific Ave. Santa Cruz 95060. (831)460-1800. www.theatticsantacruz.com) Here you can catch a live show and enjoy some fine art and tea. This lofty space is known for its creative art exhibitions and musical events as well as its extensive list of loose leaf tea blends. It is the home of the Santa Cruz Institute of Contemporary Arts and hosts monthly art exhibits from local and international artists as well as music shows. There is usually always something fun and interesting going on here but you can always just kick back and have a pot of After Dark herbal tea (chamomile, orange blossoms, citrus peels, rose hips, lemon grass, mint and hibiscus) on their huge sofa.

—*Alexa Watkins*

Red Restaurant and Bar

Eat, drink, relax, repeat at The Red.
$$$
200 Locust St, Santa Cruz 95060
(at Cedar St.)
Phone (831) 425-1913
www.redsantacruz.com

CATEGORY	American bistro and bar
HOURS	Mon-Thurs: 5 PM-Midnight
	Fri: 5 PM-1230 AM
	Sat: 5 PM-1 AM
	Sun: 5 PM-Midnight
GETTING THERE	In the downtown area, metered parking is available on streets or nearby parking garage.
PAYMENT	
POPULAR DISH	Vegetarian Platter appetizer is very good,spicy hummus and baba ganoush with flatbread, olives, roasted marcona almonds, and Arabic salad. Their entrée salads are always fresh and tasty and they have a variety of meats (from tenderloin filet, chicken breast, duck, or lamb.) Also always delicious are their sides of fire roasted garlic polenta, and seasonal wilted greens.
UNIQUE DISH	Very European/American restaurant that really focuses on simple, flavorful, fresh/organic meals.
DRINKS	Also a bar/lounge with usual alcoholic drinks. Great, extensive beer and wine lists.
SEATING	One side primarily small tables, and the other more of a lounge with sofas, coffee tables and a fireplace. The bar is adjacent.
AMBIENCE/CLIENTELE	Sophisticated, elegant Ambiance is key here. Very European and posh. Mood is set by dim, candle lighting and red décor. Everything is red here, even the menus are red velvet. Frequented by those wanting a nice, upscale yet still affordable meal; and mostly 20-something university students at the bar at night.
EXTRAS/NOTES	The restaurant is located upstairs in what used to be the Historic Santa Cruz Hotel. There is also another bar directly below it called The Red Room, (whereas the restaurant is called "The Red") with pool tables and smoking allowed.

—*Alexa Watkins*

Saturn Café

Come with all of your spaced out space cadets...
$$
145 Laurel St., Santa Cruz 95060
(at Pacific Ave./Front St.)
Phone (831) 429-8505
www.saturncafe.com

CATEGORY	Late night vegetarian café
HOURS	Mon-Weds: Noon-Midnight
	Thurs/Fri: Noon-3 AM

Sat: 10 AM-3 AM

Sun: 10 AM-Midnight

GETTING THERE Plenty of parking on the street. If not, try the lot in back.

PAYMENT VISA MasterCard

POPULAR DISH Sandwiches, salads, soups, pastas. Pretty much everything you'd expect to get out of a good diner, except it's all vegetarian.

UNIQUE DISH Some of the best grilled cheese and cheese fries you'll ever have. Honestly, even a carnivore on a bender could approve. Try the nachos too.

DRINKS Great shakes and organic coffee to power you through all-night cram sessions or to get you ready to wake up after catching a great show.

SEATING Space age theme. Plenty of seating, but you still may have to wait during those peak late-night hours.

AMBIANCE/CLIENTELE Kind of a hipster/Santa Cruz staple. Locals and U.C. Santa Cruz kids all come here for their late night food fixes, but don't count this out as a late night last resort. The food here is really good. Great atmosphere. You're bound to see a friend or make a new one.

EXTRAS/NOTES Check out all the cool stuff imbedded in each table. If you bring dice and some pieces (or just ask very nicely) you can even play Capitalism (a.k.a the best Monopoly-inspired parody of a functional economic system ever!). But, really, they walk the walk. All of their oil is converted into biodisel. Hooray for food! Hooray for the planet! Hooray for Saturn!

—*Louis Pine*

Chicken Tetrazzini
Delivery from North of San Jose

Some famous people get landmarks named after them. Others get stars on the streets of Hollywood bearing their names. For a time, in the early twentieth century, it was popular for chefs to name their newest food creations after famous people of the day. That is how the Chicken Tetrazzini, invented in San Francisco in 1910, got its name.

Luisa Tetrazzini was an Italian opera singer who starred in the San Francisco Opera. Her voice may be what she was known for at the time, but the dish we now put in to our own mouths is all that most people know of her. The singer had a unique style which was a little bit of this and a little bit of that, and the dish matches that style; it is a little bit pasta, a little bit poultry and a little bit of casserole.

Interestingly, the best place to get this dish now is not at a formal restaurant but actually from a service which prepares gourmet meals to go. GourMade Cookery is located in Pleasanton, north of San Jose, and offers both delivery and pick-up of chicken tetrazzini and its cousin, turkey tetrazzini. For a sit-down restaurant in the San Jose area, try finding chicken tetrazzini on the changing menu at Campo di Bocce, located at 565 University Avenue in Los Gatos.

—*Kathryn Vercillo*

SAN JOSE

Amber India

(see p. 226)
Northern Indian
377 Santana Row Suite 1140, San Jose 95128
Phone (408) 248-5400

Anise Cafe

Modern Vietnamese
with a California twist.
$$$$
1663 W. San Carlos St., San Jose 95128
(at Shasta Ave.)
Phone (408) 298-8178
www.anisecafe.com

CATEGORY	Southeast Asian Café
HOURS	Tues–Fri: 11 AM– 2 PM; 5 PM-10 PM
GETTING THERE	Plenty of free parking right out in front of the restaurant shopping center. It is hidden in the back corridor between a photo store and a rent-a-computer store. Just look down the walkway for the bamboo plants.
PAYMENT	VISA ●● ■■ Carte
POPULAR DISH	Corn Fritters, or Rocket Shrimp as a "small plate". Caramelized Chicken in Ginger, or Peppered Prawns over Garlic Noodles for a "Big Plate". They are all delightful.
UNIQUE DISH	Watercress & Mango Salad with Lemongrass Dressing with your choice of Shrimp, Roasted Pork or Vegetarian…Zing! Saigon Crepe, more like an omelet filled with roasted pork, shrimp, onions, scallions on a bed of lettuce and mint, topped with a lime garlic vinaigrette. As for desserts, the Banana Spring Roll is a must! A delicate Asian tradition served with coconut pineapple ice cream.
DRINKS	Full bar. Cocktails, nice wine list, coffee, Vietnamese coffee, green tea. A large selection of cold flavored teas, and flavored sodas.
SEATING	Eight bar seats, ten tables for two, eight tables for four, seating for ten in the private room. Outdoor seating is not always open. It's a cozy place. Great to bring a date or a small group of friends. I recommend calling ahead for reservations if you have a large group of eight or more, so they can be prepared with enough servers in case they are already busy when you arrive.
AMBIENCE/CLIENTELE	Modern, hip interior design, lots of draping curtains, dimmed lighting, warm rich metallic copper colored walls, and jazz background music. Sometimes they have live acoustic music or jazz. The atmosphere is very casual, on the upscale side. No flip flops, but you don't need a tie either.

—*George Brandau*

Ariake

Sushi & Sake Bombs.
$$$$
1008 Blossom Hill Rd., San Jose 95123
(between Blossom River Dr. and Winfield Rd.)
Phone (408) 269-8383

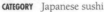

CATEGORY	Japanese sushi
HOURS	Daily: 11:30 AM-10 PM
GETTING THERE	Parking is free and easy.
PAYMENT	VISA (icons)
POPULAR DISH	The inexpensive sushi. Other traditional Japanese offerings such as chicken teriyaki or the pork katsu make an appearance as well as Mochi green tea.
UNIQUE DISH	They have sushi boats that are unique and fun, especially for out-of-towners.
DRINKS	The most popular beverage here is the Sake Bomb. Buy a pitcher of Japanese beer. Pour a half glass for yourself. Wait for your friends to do the same. Take a sake cup and fill that up. The lights turn off, the disco lights go on. At the direction from your waiter, you and your friends stand on your chairs. The waiters count to three, and everyone drops the sake cup into the beer. Chug the beer while everyone else around you is chanting 'sake bomb! sake bomb!'
SEATING	Because of its expansiveness, the restaurant can accommodate large groups. It's a very popular place for birthday parties and celebrations.
AMBIENCE/CLIENTELE	When the disco lights turn on and the sake bombs go off, you are in for a unique dinner experience. Friday and Saturday nights, the place can be rowdy, loud, lively, and fun. During the early dinner shift or during weekdays, it's a great place to dine with family and friends. Its casual atmosphere doesn't judge; you can walk in with jeans and a tee or a business suit. This is definitely a place to relax and celebrate with medium to large groups; dinner dates are best left for another restaurant.
EXTRAS/NOTES	Not a place for authentic Japanese food, but definitely a place to have a unique and fun dining experience. It's a great lunch and dinner spot when you crave sushi at an affordable price. It's also one of the best places for newbie sushi eaters because of its huge selection of vegetarian/ California rolls.
OTHER ONES	• Sunnyvale: 759 E. El Camino Real, Sunnyvale 94087, (408) 245-8383

—Sandra Lai

Eating Healthy in "Ethnic" Joints

The traditional cuisines of native cultures are treasure troves of time-tested, life-supporting foods with wholesome ingredients. Loads of research have shown that eating such dishes keeps a population healthy, while eating the Western diet—full of refined and processed foods—opens the door to degenerative health. Here are some tips, broken down by some of the more commonly available cuisines:

Mexican

Stewed beans, which are increasingly offered as an alternative in many Mexican restaurants, are a low-fat source of protein—and are awfully delicious. At all costs try to avoid the refried beans, which are full of fried oil and trans fats. Learning to say 'hold the cheese' when you are ordering the standard enchilada platter is definitely not easy, but that garnish layer of oily cheese isn't too easy on your digestion, either. For a better fat, the avocados in fresh-made guacamole are a great source of the all-so-important folic acid that helps keep the lining of your arteries intact. And did you know that a single corn tortilla supplies 60 mg of calcium, nearly as much as a glass of milk! Another great choice is cactus salad made with nopales, which are high in fiber and help stabilize blood sugar levels. And salsa is a veggie/chile combo with anti-inflammatory properties.

Indian

Not only is Indian food delicious, but full of healing properties. For a start, try vegetarian thali, a wholesome nonmeat sampler. Curries are traditionally made with spices such as cardamom (for good digestion), cinnamon (which fights infection), and turmeric (contains an active compound that reduces inflammation) If you choose dal as a side order, you'll be getting the high-fiber benefits of lentils and a garnish of yogurt-based raita supplies friendly intestinal flora. Other great options are almond sauces for healthy oils and garnishes of pistachios, which contain potassium to prevent high blood pressure. After dinner, try a spoonful of fennel seeds to settle the stomach.

Thai

For a really delicious Thai meal, order light yet satisfying Thai salads topped with a generous garnish of chicken, pork, and shrimp. A great, heart-warming companion choice is chicken soups with lots of greens—which are not only delicious but will help you maintain your strong bones. Pad Thai with rice noodles, egg, and meats is a great pasta alternative if you are allergic to wheat—and the bean sprout garnish has concentrated nutrients. If you're feeling under the weather, dishes made with fiery peppers (don't forget soups!) can help ward off a cold— or, at least, make you feel better.

Middle Eastern

A variety of low-fat and vitamin-rich foods are found in traditional Middle Eastern cuisines. Try the naturally low-fat feta salad with tomatoes, which contain important anticancer lycopenes. Grilled meats provide protein without all the fat, and the chickpeas in hummus are a great source of zinc for energy. The heady garlic in babaganoush and many other dishes is a known blood thinner that can help to prevent strokes. Yogurt, which makes many appearances in middle-eastern cuisine, aids digestion. And, if you've had too much of a good thing, mint tea settles the tummy after a feast.

Chinese

Most people think Chinese is that awful combination of fried rice and deep-fried sweet-and-sour pork. But that's not even skimming the bounty of healthful options. Regardless of what you order, ask for brown rice (if available) which is rich is magnesium and

strengthens bones. Stir-fried vegetables with Chinese cabbage are excellent source of calcium, and delicious, too. Order this with any type of steamed whole fish to get Omega-3 fatty acids, essential for general good health. Women may want to choose tofu, in place of (or in addition to) meat, to get those important phytoestrogens for hormone balance. Ginger is the miracle root, promoting the release of toxins from the body, settling the stomach, and energizing, while black tea helps prevent blood clots and high blood pressure.

Japanese

The ubiquitous miso soup is not just there to take up space on the table—it's an all-encompassing vitamin boost and a great choice when you're feeling spaced out from having lived on caffeine and sugar since breakfast. Seaweed is a guaranteed source of major and trace minerals and can be added to many dishes. An appetizer of edamame (whole soy beans) boosts estrogen and has become increasingly popular due to its nutty flabor. Sushi contains omega-3 fatty acids to lower cholesterol, while the antioxidants in green tea help prevent cancer.

Italian

We've all become familiar with the healthy benefits of Mediterranean diets and the Italians do it up right. Extra virgin olive oil is unrefined and unprocessed, so it's good for the heart, and a good oil to both cook with and to be used in salad dressings. Sautéed dark leafy greens like kale and spinach keep bones strong and make a great filling for pastas. Cannellini (cranberry beans) and pasta fagioli (bean soup) contain minerals and fiber and are very filling and tasty. Tomato sauce supplies beta-carotene to slow aging and helps you justify that second helping of pizza. Sautéed sweet red peppers help prevent cancer, and garlic in everything fights infection, reduces inflammation, and keeps vampires away.

French

Nope, it's not all about heavy cream sauces (not that we don't like them!). Chicken cooked in red wine (for heart health) is a great source of lean protein. Chromium-rich mushrooms manage blood sugar, and potassium-rich potatoes prevent high blood pressure. Tapenade olive paste contains healthy oils, and bouillabaisse contains mineral-rich shell fish. For dessert, the apples in apple tarts promote strong bones. And don't forget all the benefits of a nice glass of wine!

Eastern European (including Polish, Russian, and Jewish deli)
Mom was right. Beet borsch is rich in iron, while steaming chicken soup can ease a cold. Female-friendly phytohormones are found in rye bread, buckwheat and kasha varnishkas. Lightly cooked cabbage helps fight cancer, and splurge on the caviar with omega-3 fatty acids for a brain-nourishing treat. And get this—chocolate cake can counteract depression.

—*Molly Siple*

Blowfish Sushi to Die For

Blowfish delivers sushi with style.

$$$

355 Santana Row, San Jose 95128
(between Tatum Ln. and Olin Ave.)
Phone (408) 345 3848 • Fax (408) 345-3855
www.blowfishsushi.com

CATEGORY	Japanese Sushi
HOURS	Sun-Thurs: 11:30 AM-2:30 PM; 5-10:30 PM
	Fri/Sat: 11:30 AM-2:30 pm; 5 PM-Midnight
GETTING THERE	Plenty of free parking in the Santana Row lots.
PAYMENT	VISA MasterCard Cards
POPULAR DISH	Any sushi item is a solid choice, but don't leave without trying one of the creative rolls – such as the Ritsu Roll, which features two types of tuna, avocado, *tobiko* and *nori* in a light tempura batter that is flash-fried and served with a citrus *ponzu* sauce. It may not seem like a good dessert place, but you won't be sorry if you do save room for sweets; the Chocolate Quartet is a winner.
UNIQUE DISH	Blowfish's menu features a lot of unique rolls that you won't find at your regular ol' sushi joint.
DRINKS	Full bar. Be sure to order a sake cocktail.
SEATING	There's a sushi bar where you can watch all of the raw fish action—and this may be the quietest area in the restaurant. The dining room offers comfortable banquettes and tables that are a bit too close together. Given how loud and busy the place can get, you may find yourself screaming to have a conversation. Not good if you're on a date.
AMBIENCE/CLIENTELE	The Blowfish in Santana Row has the same chic look and feel as the one in San Francisco. The lunch crowd is mellow, while the evening attracts the hipsters.
EXTRAS/NOTES	Warning: This restaurant is loud. Really loud. DJs usually spin weekend nights. Music is throbbing from speakers throughout the space, and Japanese anime flashes on the television screens. It's hip, it's stylish, and it can be a crazy scene (especially on the weekends, especially in the bar area).

—Anh-Minh Le

Dakao

A budget eater's dream.

$

98 E. San Salvador St., San Jose 95112
(at S. 3rd St.)
Phone 408) 286-7260

CATEGORY	Vietnamese sandwich shop/deli
HOURS	Daily: 6 AM-9 PM
GETTING THERE	Free parking lot
PAYMENT	Cash or debit cards
POPULAR DISH	The grilled beef and grilled pork sandwiches taste exactly the same, so either one makes a delicious lunch better than, say, Lee's Sandwiches

or Subway, especially since it costs all of $2. The salty grilled meat with crunchy pickled radishes and carrots and that mysterious, yet wonderful Vietnamese mayonnaise blend together for happiness in a baguette.

UNIQUE DISH Sit down at the other half of the restaurant and order #55, Quan Nam Egg Noodle Style. Ignore the bad English translation. It's a mishmash of ingredients – pork, shrimp, bean sprouts, mint, fried garlic and onion and bricklike sesame rice crackers over chewy yellow egg noodles and a sweet curry-like sauce. When mixed together, the crackers get to just the right texture, and like the sandwiches, all the ingredients blend harmoniously.

DRINKS Tea, coffee, boba drinks, juice, Vietnamese beverages

SEATING There are about 10 tables. Almost always, at least one is open, as most customers order to-go.

AMBIENCE/CLIENTELE Students and local employees keep it busy during lunch while dinnertime is quieter. There is a huge variety of cooked foods, pastries and sweets behind the glass at the counters. The staff isn't fluent in English, so you may encounter problems if you have questions about the menu. How to go about dining in is also unclear, but just stride confidently to a table and a waitress will bring you a menu.

OTHER ONES • Milpitas: 72 S. Abel St., Milpitas 95035, (408) 946-3668

—*Megan Kung*

It's It

From the Beach to the South Bay

This is one of the newest foods invented in San Francisco. First created in 1928 by George Whitney, this ice cream dessert snack offered a twist on the standard ice cream sandwich. The It's It consists of two large oatmeal cookies, with ice cream sandwiched between them, all dipped in to chocolate, creating a treat that it's hard not to enjoy!

The It's It was first created and sold at Playland at the Beach. In fact, that San Francisco amusement park located at Ocean Beach was the only place where San Franciscans could buy the It's It from the time it was first created until the time when the amusement park closed in 1972.

Playland at the Beach may be gone, but the It's It remains a part of San Francisco's favorite dessert snack list. It's It snacks are now made at a factory located in Burlingame, California, just south of San Francisco. You can go to the factory to pick up packages of It's It to enjoy, or you can even have packages delivered to you. The factory is located at 868 Burlway Road in Burlingame. You can also pick up small packages of It's It ice cream bars at grocery stores all over the South Bay.

—*Kathryn Vercillo*

E&O Trading Company
Southeast Asian Grill

Downtown San Jose's best. Seriously.
$$$

96 South First St., San Jose 95113
(at San Fernando)
Phone (408) 938-4100 • Fax (408) 938-4164
www.eotrading.com

CATEGORY	Trendy international
HOURS	Mon-Thurs: 11:30 AM-10:00 PM
	Fri: 11:30 AM-10:30 PM
	Sat: 5 PM-10:30 PM
	Sun: 5 PM-9 PM
GETTING THERE	All of downtown San Jose's parking lots are free after 6 PM, so park anywhere in the city, enjoy a stroll and work up an appetite before chowing down. E&O will validate if you get a craving earlier in the day. Lots and garages within a few blocks. The VTA train tracks run down First and Second Street.
PAYMENT	VISA MasterCard Cards
POPULAR DISH	Literally everything here will make your taste buds happy, and since the dishes all work well family-style, you may as well order lots of different things to share! To start your meal it will be hard to choose between the sweet potato stuffed naan and the lamb curry naan, so just give in and try both. There is a surprising heat to these little pockets-of-joy, so feel free to spoon on some of the raita if you want to cool things down. The firecracker chicken with asparagus and mushroom is a star with bold flavors and pleasing contrasts.
UNIQUE DISH	The Indonesian Corn Fritters are not your average State Fair hush-puppy bites (which is what you might expect, just looking at the name). These fritters are lightly battered, sweet corn kernels, fried to a crisp, golden brown. It comes with a chili soy dipping sauce to add a bit of kick.
DRINKS	For those who like something sweet, the vanilla mango mojito is a surprising and delicious twist on the classic refresher. There is a full bar and extensive wine list as well.
SEATING	Bar seating available, tables for couples all the way up to large groups, and cozy booths that seat four to six comfortably.
AMBIENCE/CLIENTELE	This is the kind of place you see couples on a first date, business partners having a lunch or dinner meeting, groups of twenty-somethings out for a birthday party, or singles having a drink before heading home after work. E&O can be as fancy or casual as you want it to be, so it's an all-occasion type of place. Everyone will find something to enjoy, and can feel relaxed and comfortable.
EXTRAS/NOTES	It doesn't hurt to have a reservation, especially during the peak after-work dinnertime. The lighting is quite dim in the evening, but there is lots of natural sunlight during the day. Also, the website's menu won't necessarily be the same as at the restaurant.

OTHER ONES • Larkspur: 2231 Larkspur Landing Cr., Larkspur
94939, (415) 925-0303
• Also, Honolulu and Maui

—*Laura K. Jacques*

Healthy Cheap-Eats, American Style

Eating well when you are eating out isn't as much of a challenge as you may think! And eating cheap doesn't mean you have to be short-changed nutritionally. If you know what to look for, you can have a well-balanced meal full of vitamins, minerals, and other healing nutrients—no matter where you choose to eat.

Coffee Shops and Diners

Yep, you can eat at a diner and not feel guilty. Take eggs, for example, which have *never* been proven to cause high cholesterol. They contain exceptionally nourishing protein and compounds that help prevent age-related macular degeneration—and are especially healthy poached. Get 'em with rye bread, which adds a variety of top-notch grains and nutrients, to the diet. Sip soup of all sorts, especially ones made with beans, peas, and veggies. Fiber-rich oatmeal lowers cholesterol and is a low fat way to start your day. Cole slaw made with cabbage lowers high blood pressure and cancer risk. And our favorite, tuna fish, contains heart-friendly oils. Even your garnish can be healthy: A mineral-rich melon slice alkalizes the system and reduces fatigue.

Salad bars

For a balanced plate, select the darkest green lettuce for maximum magnesium for heart and bone health, broccoli and cauliflower for folic acid to prevent heart disease, sweet red peppers to lower cancer risk, carrots to slow aging, celery for fiber, and chickpeas for protein and little fat. Add onions to reduce inflammation. Avoid the junky refined oils in most salad dressings and pick blue cheese dressing, with a garnish of pumpkin seeds for zinc and prostate health and nuts for extra minerals.

Hungry yet?

—*Molly Siple*

Falafel's Drive-In

*An American drive-in setting
that serves Baba-Ghannouj.
Since 1966*
$$
2301 Steven's Creek Blvd., San Jose 95128
(at Revey Ave.)
Phone (408) 294-7886
www.falafelsdrivein.com

CATEGORY Falafel joint
HOURS Mon-Sat: 9 AM-8 PM
Sun: 11 AM-6 PM
GETTING THERE A free but very small parking lot, hosts about
half a dozen spaces. Free street parking is also
available.

PAYMENT Cash only, but they have an ATM

POPULAR DISH The most popular item is the special of a large falafel and a banana milkshake.

UNIQUE DISH Plain & Mint Yogurt drinks

DRINKS The Falafel Drive-In serves sodas, coffee, tea, lemonade, shakes, malts and yogurt drinks. No alcohol is served.

SEATING Indoor seating is minimal, seating about twelve in table and chairs that look like they belong in an old style ice cream parlor. The majority of the seating is outside. Metal and heavy duty plastic picnic tables, are shielded by a plastic tarp/awning. The larger tables in the back off to the side of the restaurant make accommodating a large group easy.

AMBIENCE/CLIENTELE You can't get a better quality of food in a more casual setting atmosphere than at Falafel's Drive-In. With an eclectic clientele, you will see earthy hippy chicks and suited business men dining at side by side tables. The food is served fresh and fast so it is recommended that when you are in line you know what you want to order. Should you find yourself to be a finicky eater (like Meg Ryan) in "When Harry Met Sally", you will be politely told that they do not make special orders and substitutions are usually met with a perplexed look. I suspect this is because the five-time award winning restaurant knows what they are doing and when you have a great thing going, why mess with it? While they cater to serving the American classics of burgers, hotdogs, tacos and fries, it is the Middle Eastern delicacies that seem to be the favorites and most commonly ordered items. The falafel (falafel balls, lettuce, tomatoes, cucumbers, tahini sauce and spicy hot sauce) served in a pita pocket is the most popular item along with the Gyros (similar, using spiced beef steak instead of falafel balls). The hummus is flavorful, packing a zesty punch of garlic and other Mediterranean spices and can be a meal in itself served with pitas. While the majority of the items on the menu are packed with vegetables, the healthiest route would be the tabbouleh. A cracked bulgur wheat salad made from finely blended and chopped parsley, tomatoes, cucumbers and fresh mint. Refreshing, filling but not heavy. The portions are generous and beyond reasonably priced, making it far more difficult to finish than afford. With fresh banana milkshakes and award winning French fries, it's no secret why they have been in busy for 40 years. With a mass of regulars whose population runs a close second to the pack that followed the Grateful Dead, along with the city of San Jose who has declared Falafel's Drive-In sign a historical landmark, I am sure that Falafel's Drive-In will easily see another 40 years.

EXTRAS/NOTES In 1966, Anton and Zahie Nijmeh moved their family to San Jose. They wanted to create a business that provided healthy and authentic foods for their children and their community. Their passion for home cooking drove them to open up a drive-in. He started by selling

hamburgers and slowly introduced his customers to his delicious falafels made from his own recipe. The Falafel Drive-In has a devoted following with customers who have been regulars for 20 and 30+ years. Catering and party trays are available, call for specifics and pricing

—Jackie Kortz

Flames Coffee Shop and Bakery

The Rolls Royce of diners.
Since 1975
$$
449 S Winchester Blvd., San Jose 95128
(between Olin Ave and Olsen Dr.)
Phone (408) 246-8154 • Fax (408) 246-2387
www.flamescoffeeshop.com

CATEGORY	Diner
HOURS	Sun-Thurs 6:30 AM -11 PM Fri/Sat: 6:30 AM-Midnight
GETTING THERE	There is a huge parking lot around it so parking is not an issue.
PAYMENT	VISA
POPULAR DISH	I don't think you can go wrong, everything is done well. I recommend the avocado and feta cheese omelet but there are tons of choices. Between seafood, steaks, soups, salads and cakes you are in a gluttons heaven.
UNIQUE DISH	On their website they describe their portions as "generous". This means only order one entrée per two people. Instead of getting a single serving of an omelet and hash browns for $5, you pay $10 and get twice as much. Great if you like sharing. Lots of interesting omelets that I've never heard of before. I couldn't resist trying the avocado and feta cheese. If the pastries look good, they probably taste good too. Check them out.
DRINKS	Lots of wine. Imported and domestic beer. Hot chocolate is good and coffee, of course.
SEATING	Enough supply of tables to satisfy the demand. Place is about the size of a large diner. Couples could work well here. They could handle a large group if given enough time to arrange things.
AMBIENCE/CLIENTELE	Casual. Atmosphere is nicer than Dennys or Carrows, about like Olive Garden. It is well lit and green. Casual dress; sandals would be out of place but so would heels. A t-shirt is fine; it's what the waiters wear. Neutral smell, maybe a little bit like coffee and hash browns, but that could have been where I was sitting. Light music in the background. Bright green campy tropical feel. Comfortable seats. Ideal place for a date for its casual atmosphere, reasonable prices and proximity to movie theaters (on same block)
EXTRAS/NOTES	Over thirty years of experience and I wouldn't change a thing other than the waiter doing the bill for you. The waiter gives you the bill, then you go

to the front to pay it.

OTHER ONES
- San Jose: 7170 Santa Teresa Blvd., San Jose 95139, (408) 224-7464
- San Jose: 1812 Hillsdale Ave. San Jose 95124, (408) 723-8393
- Cupertino: 10630 S. De Anza Blvd., Cupertino 95014, (408) 996-2074
- ª Milpitas: 1191 Calaveras Blvd., Milpitas 95035, (408) 262-2005

—Tim Madsen

Gunther's Restaurant and Catering

Mom and Pop are behind this one.
Since 1971
$$$
1601 Meridian Ave., San Jose, 95125
(at Hamilton Ave.)
Phone (408) 266-9022 • Fax (408) 266-9030
www.guntherscatering.com

CATEGORY	Neighborhood American with New York deli and German flair
HOURS	Mon-Thurs: 7 AM-8 PM Fri: 7 AM-9 PM Sat: 7 AM-2 AM
ETTING THERE	Plenty of free parking right out in front in the shopping center parking lot. You can't miss it, they're right on the corner!
PAYMENT	VISA
POPULAR DISH	The Reuben Sandwich, "Their Trademark"!
UNIQUE DISH	Home style Meatloaf, hot served over some mashed potatoes… Mmmm. Friday Night Specials: Wienerschnitzel, Jaegerschnitzel, Kassler Ripchen, Sauerbraten, or Goulash for those who want to feel the German vibe.
DRINKS	Full bar, assortment of bottled beers, Spaten and Fat Tire Ale on tap, sodas in the cans and at the fountain, coffee, espresso, hot chocolate, tea, and juices
SEATING	Eight booths for four, five bar stools, four tables for four, three tables outside for four
AMBIENCE/CLIENTELE	Interior design is early 1980's, booths upholstered in mauve with tiffany lights hanging above. Walls are pinkish mauve, delicious pictures of the catering that they offer hang on the walls, light pop radio plays in the background, a clean friendly neighborhood atmosphere. The clientele is casual; you'll see a lot of old time customers here greeted by name, sometimes with a hug, by one of the staff.
EXTRAS/NOTES	Customer service is great and friendly. Food comes out quickly. It's a great neighborhood place. They don't make 'em like this anymore. Gunther Meyberg is the owner with his wife and son. They do a very big catering business. They serve breakfast, lunch, and dinner.

—George Brandau House of Chu

House of Chu

*Chinese Chicken Salad so
good that vegetarians convert!*

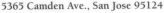

$$$

5365 Camden Ave., San Jose 95124
(at Kooser Rd.)
Tel: (408) 266-3800 • Fax: (408) 266-3805
www.houseofchu.com

CATEGORY American Chinese

OURS Mon-Thurs: 11:30 AM-2:30 PM; 4:30 PM-9:30 PM
Fri: 11:30 AM-2:30 PM; 4:30 PM-10 PM
Sat: 4:30 PM-10 PM
Sun: 4:30 PM-9:30 PM

GETTING THERE Unfortunately, there is no parking directly in front, so you'll have to drive the remaining couple dozen yards to the mall's vast (but sometimes quite full) parking lot.

PAYMENT VISA Cards

POPULAR DISH If my credit card records are accurate, it appears that on average my family and I have made the journey about every two months for the last six years. All that custom has allowed us to narrow down four dishes from their extensive menu that are must-haves across all age groups. To start, do not miss the valley-famous Chinese Chicken Salad, the best there is. It is a perfect blend of fresh lettuce, finely chopped chicken, crispy rice noodles, peanuts, and hot spices. Until recently my mother has been a devout vegetarian, but she has knowingly and eagerly eaten Chu's chicken salad for many years. It's that good! You may regret taking home the salad as leftovers or ordering it to go; it's just not the same as when it is served cold, crisp, and ultra fresh at your table in the restaurant.

UNIQUE DISH The three other necessities include Chu's Special Beef (very tender slices of beef marinated in a thick, slightly sweet, secret sauce, and served over rice noodles), Walnut Prawns (lightly battered and sautéed, then smothered in a creamy white sauce, and surrounded by candied walnuts), and String Beans with Garlic Sauce (which, in contrast to the Chinese Chicken Salad, are somehow even better as leftovers). Depending on the size of your party, you may need to double up on one or more of these popular dishes.

DRINKS The attached lounge is spacious and pleasantly dark, serving a reasonable variety of beers, liquors, spirits, and strong mixed drinks. There are a couple of televisions mounted in the corners, but you wouldn't visit the lounge solely for the sports viewing, more for a quiet, relaxing place to unwind after work, or a good opportunity to down a couple Tsingtaos while you're waiting for a take-out order.

SEATING Seating is fast, thanks partly to the larger-than-expected capacity, and also because the restaurant does a lot of take-out business and is rarely more than half full. Couples enjoy the intimate, plush booths along the back wall, and groups of

up to four sit in the middle of the restaurant at adequately sized square tables. Even larger groups are seated along the side of the restaurant at wide, round tables with lazy Susans. The water-stained, cafeteria-style ceiling tiles are the only detractors in what is otherwise a pleasant, well-decorated setting. Service is always excellent — amiable, attentive, and responsive.

AMBIANCE/CLIENTELE Rub the belly of Buddha on the way in for a healthy serving of joy, luck, and prosperity to go with the healthy portions of excellent American-style Chinese. Rubbing the belly of Kevin, the restaurant owner, will get you nothing...

—Richard D. LeCour

Izaka-Ya
Japanese tapas at the pub.
$$$$
1335 North First St., San Jose, 95112
(between E. Gish Rd. and E. Rosemary St.)
Phone (408) 452-1536
ww.sushiizakaya.com

CATEGORY	Japanese sushi
HOURS	Mon-Fri: 11:30 AM-2 PM; 5 PM-10 PM
	Sat: 1 PM-1 AM
	Sun: 5 PM-10 PM
GETTING THERE	Easy to find; just look for the House of Genji. Parking is free. Izaka-ya shares the entrance with House of Genji.
PAYMENT	VISA
POPULAR DISH	Other than sushi, their most popular dinner dish is the "asari butter". It's steamed clams in a hot pot filled with broth. To make the most of this delicious dish, order a bowl of rice and pour the clam broth over it for a complete meal. From their eight page a la carte dinner menu, a few other favorites are the sautéed garlic in ponzu sauce, grilled eggplant, and breaded oyster. Their lunch menu consists of noodles, bento boxes, rice, and sushi, but their most defining lunch dish is their noodle and sushi set!
UNIQUE DISH	The noodle and sushi set is unique; you don't find this in many sushi restaurants. Most often it's a bento box or rice and sushi. It is also one of the few places in the South Bay that serves Okonomiyaki.
DRINKS	They have a large selection of sake and shouchu that can keep you drinking 'til closing time. Sapporo and Asahi
SEATING	It is an incredibly intimate environment with a very authentic Japanese feel to it; it's something you would find in Japan or even Hong Kong. Perfect for small lunch and dinner groups, and a great place for a first date.
AMBIENCE/CLIENTELE	This is definitely where real people eat sushi. If you walk into a Japanese restaurant and you see lots of Japanese people eating there, that's a

good sign. Izaka-ya has an authentic Japanese feel because of its small cozy intimate setting and its contemporary and modern décor. This 'pub' is a great place to entertain clients, unwind after work, or just relax with friends. The wait staff is small and friendly; they know your favorite dish and drink by your third visit. They pull in a heavy lunch/business crowd and have a steady dinner flow. With its warm and welcoming vibe, you will feel comfortable wearing a suit and tie or shorts and a tee.

EXTRAS/NOTES Established in 1986, a new owner took over in 1998 and it was recently renovated in 2006.

—*Sandra Lai*

La Victoria Taqueria
King of the burrito scene.
$$
140 E. San Carlos St., San Jose, CA 95112
(at 4th St.)
Phone (408) 298-5335
www.lavicsj.com

CATEGORY Taqueria

HOURS Daily: 7 AM-3 AM

GETTING THERE Metered street parking

PAYMENT VISA

POPULAR DISH At breakfast time, La Vic turns out a mean breakfast burrito. Rice, beans, egg, potato and your choice of breakfast meats, bacon is great, chorizo is also wonderful. These things are like hand grenades: fit in your hand and solid. Any time after 11 and it's burrito time. Both the regular and vegetarian burrito are "super-bueno", but the super burrito is what made San Jose a La Vic town. Oh yeah, and the orange sauce.

UNIQUE DISH Oddly enough, the unique dish here has to be the Orange Sauce. La Vic has tacos, enchiladas, tortas, nachos and, of course burritos, but what taqueria doesn't? That's why it's all about the Orange Sauce. There had never been sauce like this before and then La Victoria set off a sauce revolution.

DRINKS An array on non-alcoholic beverages including soda fountain drinks, aguas frescas and Jarritos.

SEATING Both La Victoria restaurants have indoor seating only. The San Carlos La Vic (the original) is in an old Victorian house and the seating is limited as the entire restaurant only occupies one floor of the home, much of which is kitchen, counter and stairs. Braver folks sit on the stairs or thick banister out front, but you better be a student somewhere if you're gonna pull that off. The Santa Clara location is indoor only with more seating than the other restaurant. Two rows of picnic benches line the walls and a tall bar and stool setup runs the length of the floor.

AMBIENCE/CLIENTELE Businessmen from the banks and financial buildings flood in at noon, but after that it's a

whole other scene. From lunch until midnight, it's locals, stoners, Mexicans after a taste of the motherland, waiters coming and going to work, construction workers, police officers and blue collars. After midnight La Vic burritos soak up more alcohol than all the bartenders and bussers in San Jose combined. On the big nights, Thursday, Friday, and Saturday, it can be boisterous.

EXTRAS/NOTES When La Vic came on the scene, Iguana's Taqueria dominated the burrito scene. With San Jose State and her precious dormitories, Iguana's had a nice spot, a good reputation and a long line. Suddenly a new spot opened between the campus and Iguana's. La Victoria had literally cut Iguana's off. Now Iguana's was a full block further from campus than this new spot. Soon with their key location, excellent burritos and especially their funky new orange hot sauce, only the miserly continued their trek past La Vic. Within a few years, rumors of fading quality and a severe lack of business put Iguana's down. Iguana's has been restarted after several others failed in its spot but La Vic has since opened the Santa Clara store and reigns supreme as the king of the burrito scene.

OTHER ONES • San Jose: 131 W. Santa Clara St., San Jose, CA 95112, (408) 993-8230

—Jeremy Lipps

Loft Bar & Grill

Urban chic, dining and drinking in a loft.
$$$$
90 South 2nd St., San Jose 95113
(at San Fernando St.)
Phone (408) 291-0677
www.loftbarandbistro.com

CATEGORY Ultra chic San Francisco restaurant and club at half the price

HOURS Mon-Weds: 11 AM-10 PM
Thurs-Fri 11 AM-11:30 PM (bar open 'til 2 AM)
Sat: 1 PM-11:30 PM (bar open 'til 2 AM)
Sun: 1 PM-10 PM

GETTING THERE Pay lot across the street but it can be a mess during peak hours. Some metered street parking.

PAYMENT VISA [cards]

POPULAR DISH Although it could be described as a giant chicken nugget in honey mustard sauce, I like to think of it the way Loft thinks of it: A panko crusted boneless chicken breast flash fried and topped with honey mustard sauce, garlic mashed potatoes and seasonal veggies. It was flavorful, had great crispiness and was filling. And it only cost $13.

UNIQUE DISH For the price and style, Loft is a great place to get some good food, feel fabulous and possibly dance. Dishes are good but filet mignon, baked halibut and grilled salmon are certainly pushing no limits. Maybe a new genre: Comfort Chic.

DRINKS Full bar

SEATING Huge floor, outside rooftop dining, sidewalk seating, romantic nooks and crannies.

AMBIENCE/CLIENTELE Loft Bar and Bistro seems to always be full of huge groups. Groups of women, groups of guys, mixed groups and they are always well dressed and young. The unique club/restaurant thing attracts party people. Although the dress code is enforced, it can still be pretty loose in there. No hats or logo athletic wear. In the summer the outside patio can feel like just what the doctor ordered. Nice music, a drink and a rooftop setting is one of the situations that make Loft unique. The hard wood floors and modern furniture blend to create a pleasing contemporary setting. The multi-level establishment offers a bar and window dining downstairs and another bar, larger groups and more tables upstairs. The next level is the rooftop patio. Loft is one of the last refuges for the classy youth in San Jose.

EXTRAS/NOTES Come here for live jazz Thursday nights 9-111 and Fri/Sat 10:30 to closing. Loft Bar and Bistro has the tagline "A Capers Restaurant" which refers to the owner's flagship restaurant in Campbell that features the tasty caper and is a stylish sports bar (1710 W. Campbell Ave., Campbell, (408) 374-5777

—Jeremy Lipps

Lowry's Irish Coffee House

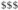

A bit of Ireland in Silicon Valley - minus the leprechauns.

$$$

350 West Julian St., San Jose 95110
(at Highway 87)
Phone (408) 993-9356 • Fax (408) 993-9358
www.irishcoffeehouse.com

CATEGORY Irish

HOURS Mon-Fri: 6:30 AM-5 PM
Sat: 8 AM-3 PM
Sun: 8 AM-1 PM

GETTING THERE Lowry's is located at the corner of West Julian Street and Highway 87. They are also located less than a block off the Guadalupe Trail. There is a very small parking lot located at the side of the building but street parking is not a problem.

PAYMENT VISA

POPULAR DISH The "Lowry's Traditional Irish Breakfast" is by far the best Irish breakfast you'll get outside of Ireland. It's a helping of bacon, Irish sausages, black and white pudding, two eggs and Irish baked beans.

UNIQUE DISH Lowry's uses traditional Irish food in their cooking. From the black and white pudding (this is not Jell-O pudding) to the true Irish sausages.

DRINKS Coffee, tea, water, juices are sold at Lowry's.

SEATING There are lots of small tables available both inside and outside Lowry's, but they are easily moved to make larger tables.

AMBIENCE/CLIENTELE The clientele at Lowry's is your typical chain coffee shop clientele but they are not a chain and Lowry's clientele hang and socialize. You'll also find an older crowd getting together at Lowry's for some good food and conversation.

EXTRAS/NOTES Lowry's offers free wireless Internet access and a plasma screen TV with a selection of Irish programming. Inside you can choose between one of the small table settings or get comfortable in front of the TV on the living room style furniture.

—*Maeve Naughton*

Mandarin Chilli

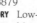

*1.3 billion Chinese people
can't be wrong.*
$$
860 Willow St., San Jose 95125
(at Bird Ave.)
Phone (408) 289-8879

CATEGORY Low-key Chinese

HOURS Mon-Thurs: 11 AM-9:30 PM
Fri: 11 AM-10 PM
Sat/Sun Noon-9:30 PM

GETTING THERE Monopoly! Free parking.

PAYMENT

POPULAR DISH Beef broccoli, chicken wonton soup and sweet and sour pork are their most popular dishes. I highly recommend the beef broccoli. The beef is exceptionally tender, so tender it takes some getting used to. The broccoli is cooked perfectly and tastes fresh. The vegetables here are very fresh and tasty.

UNIQUE DISH I was surprised at how good the vegetables here were. Eating is believing and you simply must experience them yourself to know what vegetables are supposed to be like. Quality like this outside of vegetarian and vegan specialists is rare. The beef is eerily tender and the pork is above average. The egg roll with red sauce is great and the fortune cookies are individually wrapped and vanilla.

DRINKS Water and a nice mild tea are the usual. If one's in the mood, beer and soda can be purchased, though a wide variety is not offered.

SEATING There are about 20 tables, seating for about 80. Little waiting area useful when ordering takeout.

AMBIENCE/CLIENTELE The atmosphere is like a bar. There are two televisions that can be on or off, however you request. Most of their business seems to be take out, so people come in and out of the front door every couple of minutes. There's the noise of the refrigerator, the buzz of a neon open sign and there is kitchen noise when the kitchen door swings open. There are green tablecloths covered in clear glass and comfortable red chairs with gray metal frames. The wooden half walls and

brownish red speckled carpet don't scream fancy, but you wouldn't feel out of place if you dressed up. Casual attire is also fine.

—*Tim Madsen*

The Mini Gourmet

Classic diner eats & adlib live performances... first seating 1 AM.
$$$
599 S. Bascom Ave., San Jose 95128
(at Parkmoor Ave.)
Phone (408) 275-8973 • Fax (408) 275-6330

CATEGORY	Diner
HOURS	24/7
GETTING THERE	Mini Gourmet has a small (about fifteen spaces) but free parking lot, additional street parking is available on Parkmoor.
PAYMENT	VISA MasterCard
POPULAR DISH	The bacon avocado cheeseburger served on a soft French roll is awesome. Milk shakes and root beer floats are great and taste best when sitting at the counter. Chili fries with cheese (after all, calories and cholesterol don't count after midnight). Build your own breakfast for under $7. You can select four of about eighteen items.
UNIQUE DISH	Regardless of what time you dine, this is a place where everyone can find a favorite. Their breakfast and lunch menus are extensive, serving old time favorites, including corn beef hash, pigs in a blanket, cold meat loaf sandwiches, Monte Cristos, and chicken fried steak. Entrée side substitutions are gladly catered to and offer the range from fruit and vegetable slices to a side of sauce and extra cheese. The dinner menu is available from 4 PM-4 AM offering the range of surf and turf, lasagna, liver and onions with bacon and deep fried chicken. Regardless whether it's breakfast, lunch or dinner, all portions are hearty. It is virtually impossible to leave the Mini Gourmet hungry. The amount of fries that came with my avocado bacon cheeseburger made the term "super size" look like child's play.
DRINKS	The Mini Gourmet serves soft drinks, milk shakes, root beer floats, iced tea, lemonade and bottled water. A classic selection of the most popular domestic and imported beers and offers splits of Chardonnay, White Zin, Cabernet and Champagne. The standard breakfast pick me ups include a variety of juices, hot teas, hot chocolate, milk (including chocolate & buttermilk) and of course coffee and decaf.
SEATING	Seating capacity 113 which includes the eight leather swivel stools at the counter. The majority of the seating is booth or bench style seating that can accommodate larger parties if need be.
AMBIENCE/CLIENTELE	Mini Gourmet is best known to South Bay residents as the last call after the last call. Being

open 24/7, Mini Gourmet will always be classic diner eats. This place hops and is quite the scene late nights/early mornings on Thursdays, Fridays, and Saturdays. A favorite place to polish off the evening when the bars close, this is divine people watching in addition to comforting diner favorites. Go anytime around 3 PM (after the church goers rush) on a Sunday and you won't have the faintest idea what I am talking about. But even God had a time to rest and being that the Mini Gourmet is open 24/7 we should at least grant them a rest period of a few hours. A casual and comfortable setting, a table (or counter stool) for one will easily blend in and yet not be forgotten. The staff is on the ball with quick and friendly service and one never has an empty cup of coffee, ever. With one hundred, seventy five thousand, two hundred hours of experience under their belt, I concur that the Mini Gourmet has mastered their technique as well as established a dedicated late night following and will be around for at least another 20 years.

EXTRAS/NOTES The Mini Gourmet was established in 1986 and is family owned by Darlene & Ralph Pasquinelli. If you're bringing Junior, they have a great kid's menu with everything for wee ones at great prices.

—*Jackie Kortz*

Original Joe's

Evenings at Original Joe's, the culinary version of Wall Street.
Since 1953
$$$$
301 S. 1st St., San Jose 95113
(at E. San Carlos St.)
Phone (408) 292-7030 or (800) 841-7030 • Fax (408) 292-9243
www.originaljoes.com

CATEGORY Landmark

HOURS Daily: 11 AM-1 AM

GETTING THERE Street parking is available but limited on the neighboring streets. With at least three parking lots within a block of Original Joe's, you can park for the evening for about $6-$10. The Light Rail is a great alternative whether you are coming north from Mt. View, south from Campbell/Los Gatos or South San Jose, exit at the Convention Center location.

PAYMENT

POPULAR DISH The menu is extensive and caters to the meat eater serving a variety of steaks, chops, veal, prime rib, chicken, calf's liver and seafood. Steaks and chops are served al a carte with cut sizes ranging from 14 oz to 30 oz. All steaks are 100% pure Angus beef. A choice of ravioli, steak fries, vegetables, baked potato or spaghetti will accompany all seafood, veal, roasts, calf's liver, prime rib and eggplant dishes. Vegetarian

favorites are found on the pasta menu and the
entrée sides list including pasta primavera,
pasta with pesto pine as well as vegetables,
baked potatoes and Caesar salad. A fan of the
eggplant Parmesan? This classic dish is hearty
and delicious with the eggplant lightly fried that
offers the perfect blend of crispy and tender and
no need for a knife. The pasta dishes are fantastic,
mastering al dente, rich & creamy, zesty, hearty,
flavorful and taste likes old time Italian pasta
should. Breakfast items range from $7 to about
$21 for top sirloin steak and eggs. I'd recommend
the Joe's Scramble for breakfast, available
before noon or after 10 PM, boasting delightful
concoction of mushrooms, scrambled eggs
fresh spinach ground chuck and did I mention,
mushrooms? A very wise Italian man often said,
"It's not how much you eat, but how much you
enjoy." At Original Joe's, whether you clean your
plate or opt to take the leftovers to go, one thing
is certain, you will always enjoy.

UNIQUE DISH Original Joe's still serves daily specials until 5 PM
that range from lasagna, corn beef and cabbage
and meat loaf. Their pot roast sandwich would be
my Italian grandmother's favorite and takes me
back to a simpler time when it was a good thing
that food stuck to you and in you. All sandwiches
come with steak cut fries and range from about
just below $8 to $20. Mangia! Mangia! Eat, eat,
you won't go hungry here!

DRINKS Original Joe's has a full service bar with a well
rounded wine list to include California favorites
from David Bruce, Stags Leap, Clos du Bois and
Kendall Jackson in addition to a selection of Italian
imports. Bottled beers offer the variety of domestic
and imports include Bud, Samuel Adams, Anchor
Steam, Heineken and Guinness. Non-alcoholic
beverages, such iced tea, soft drinks, tea, sparkling
water, coffee and milk are available.

SEATING Seating at Original Joe's is first come first served.
Reservations are not accepted. Main dining room
seats 140, the bar seats 65 and the banquet
room upstairs holds up to 90. Partitions from
neighboring booths can be easily removed to
accommodate large parties and with leather
counter stools and booth seating, every seat is the
most comfortable seat in the house.

AMBIENCE/CLIENTELE Middle America does exist in the heart of Silicon
Valley and they are dining at Original Joe's. The
setting is classic with its décor frozen somewhere
between the 1960s and 1970s with brown
paneled walls are decorated with the art work of
Leroy Nieman and early Italian lighting fixtures.
With a well-seasoned and loyal professional
wait staff their talents are a compilation of
part magician, part mind reader and complete
entertainment. The portions are large so taking
home what's left is part of the dining adventure,
and this experience comes full circle when the
waiter empties the food into a tiny container in

one full swoop! While the wait staff is dressed to the nines in tuxedos, the majority of the patrons are casually dressed in jeans and T-shirts. Weekday lunches have a tendency to draw the business crowd that will alter the fashion setting to include business and business casual attire. This atmosphere is ever changing. Depending on when you dine one can have a quiet more intimate dining experience on Saturday and Sunday mornings. The evenings are when the restaurant's hustle and bustle are in full effect and contributes to the complete dining experience

EXTRAS/NOTES Established in 1956 by the Rocca Family, Original Joe's Restaurant in San Jose, California has been the cornerstone of an ever-changing downtown and the progressive growth of Silicon Valley. Descended from the first Original Joe's founded in 1937 in San Francisco, the San Jose Original Joe's was the first San Francisco based restaurant to open in San Jose in the South San Francisco Bay Area. In the beginning the restaurant consisted of two counters and a row of booths. As business grew, owners Louis Rocca and Tony Rodin leased a vacant space next to them that allowed the addition of a full dining room. Later, further space became available next to the dining room enabling the addition of a full bar, thus completing Original Joe's in San Francisco. As the years passed, ownership passed to Lou Rocca Jr.'s sons, Matt and Brad Rocca. To this day, Matt and Brad continue with the heritage and philosophy that has served the restaurant and its customers well over the past 50 years providing first class service with great food prepared with the finest ingredients and generous portions all for a reasonable price. Take home history with T-shirts and baseball caps, available for $15 each.

OTHER ONES: • Civic Center/Tenderloin: 144 Taylor St. San Francisco 94102, (415) 775-4877

—Jackie Kortz

Poor House Bistro

N'Awlins in downtown
San Jose? You betcha.
$$$
91 South Autumn St., San Jose 95110
(at San Fernando St.)
Phone (408) 292-5837 • Fax (408) 292-5830
www.poorhousebistro.com

CATEGORY Cajun/Creole
HOURS Mon-Sat: 11 AM-9 PM
Sun: 10 AM-8 PM
GETTING THERE Parking is easy at the Poor House Bistro; there is street parking as well as a lot behind the restaurant. You may also park at the Diridon train station ($1.50 for non HP Pavilion event nights) and free parking in lot D (across from the HP Pavilion on

non event nights). If you'd rather take the train or light rail, Poor House Bistro is located one block from the Cal Trains and VTA Diridon Station.

PAYMENT VISA ◯ ◯ Carte

POPULAR DISH You can't go wrong with the jambalaya and the sweet potato fries (with or without cinnamon).

UNIQUE DISH PHB suggests first timers get the New Orleans Combo which is a great sample of chicken and sausage gumbo, jambalaya, red beans and rice all served with corn bread. These are all also sold individually as full meals.

DRINKS Beer and wine is served inside while the outside patio serves mixed drinks.

SEATING There are lots of small tables available both inside and outside but they are easily moved together to make larger tables.

AMBIENCE/CLIENTELE Depending on what's going on at the HP Pavilion you can get a different crowd but in general, the people are your next door neighbor, your co-worker, the guy you see walking down the street and all of them almost always have a kid in tow.

EXTRAS/NOTES Part of the PHB's charm is the quaint old house it's located in downtown San Jose, and the friendly staff. It makes you feel like you're sitting at your best friend's house in New Orleans. This is a great place to come on a summer evening to get great N'Awlins food and listen to live blues. Interested in doing a fundraising event? The Poor House Bistro can help your organization raise money. If you have an event held there, you can get 20% of the bill go back to your organization. They also offer onsite catering for up to 140 people and offsite catering for up to 2,500 people.

—Maeve Naughton

University Chicken

(see p. 239)
American BBQ and Chicken
29 South 3rd St., San Jose 95113
Phone (408) 293-9976

Vicky's Restaurant
Mexican and Salvadorian Food

Come for the pupusa, stay for the karaoke.
$$$
1536 W. San Carlos St., San Jose 95126
(at Buena Vista)
Phone (408) 292-3838 • (408) 292-3838

CATEGORY Mexican and Salvadorean

HOURS Sun-Thurs: 9 AM-9 PM
Fri/Sat: 9 AM-10 PM

GETTING THERE Plenty of free street parking right out in front or in their parking lot.

PAYMENT VISA ◯

POPULAR DISH Chile Verde, Chile Colorado, Burrito Supreme. Big servings to take half home for later.

UNIQUE DISH All the Salvadorian dishes! Pupusas: it's a hand made thick corn tortilla and you can have it stuffed with a variety of meats, vegetables, cheese, rice etc... Also the Salvadorian tamales (*puerco o pollo*) wrapped in banana leaves, among all the other interesting Salvadorian dishes.

DRINKS Jarritos, Soda, Salvadorian Coffee, Kolashampan, Mexican beers.

SEATING Ten tables for four and eight tables for two

AMBIENCE/CLIENTELE Interior design is vinyl metal back chairs, fluorescent lighting, vinyl table clothes, vine plants growing throughout, Mexican or American radio playing in background, Mexican T.V. is playing some times. Clientele is mostly Hispanic. Flip flops are very acceptable.

EXTRAS/NOTES Customer service is good and friendly. Food comes out fairly quick and hot. It's a basic neighborhood Mexican joint with good food, nothing fancy about it. Come for Karaoke every Friday from 6 PM to 9 PM.

—*George Brandau*

"You are fortunate to live here. If I were your President, I would levy a tax on you for living in San Francisco!"

—*Mikhail Gorbachev*

Zanotto's Downtown Market

Elitist gourmet neighborhood market.
$$$
38 South 2nd St., San Jose 95113
(at San Fernando St.)
Phone (408) 977-1333 • Fax (408) 977-1499
www.zanottos.com

CATEGORY Upscale neighborhood deli and market

HOURS Summer:
Mon-Fri: 7 AM-10 PM
Sat/Sun: 8 AM-9 PM
Winter:
Mon-Fri: 7 AM-9 PM
Sat/Sun: 8 AM-8 PM

GETTING THERE Validated parking across the street

PAYMENT VISA Cards

POPULAR DISH In a deli with so many dishes and apparently special items, it is difficult to pick a favorite so I will go with a common item done well, the Herb Focaccia, smoked turkey and provolone sandwich. The wind actually blew herbs off of my focaccia bread and the superbly designed (by me) sandwich tasted great with a designer soda and bag of kettle fried potato chips. I could just as

well have picked up a pound of Gloucester blue cheese and a salami log and gone to town with a nice Napa cab as well.

UNIQUE DISH Zanotto's is a full service neighborhood market and offers all the normal market goods, but with a gourmet/high-end feel. Excellent wine selection, good beer, and Odwalla juices. The deli offers hot side dishes like macaroni and cheese, pasta salad, chicken strips, etc. The deli also carries tamales, burritos and rellenos, salamis, olives, and everything else. There is also a sushi deli, a butcher and an extensive cheese section with a cheese knowledgeable attendant that will actually smell your cheese, cut your cheese and talk about your cheese with you. A salad bar and six different soups are also available on a daily basis.

DRINKS Zanotto's has a wide array of juices, soda, wine, beer, coffee, tea, energy drinks, designer sodas, no hard liquor

SEATING Sidewalk seating

AMBIENCE/CLIENTELE Zanotto's market and deli is full of business folks, homeless folks, college kids, line cooks from nearby restaurants buying missing ingredients, neighbors with dogs tied up out front, health food nuts and downtown scenesters too cool for Starbucks. The inside is clean and well organized. Don't expect to find generic brands here though. Fresh fruit spills from cute baskets that look like a farmer just pulled them off the tractor. The deli is in the back and has those awesome papers that list all their ingredients so you can just check them off instead of supervise the proper construction of your sandwich through the sneeze guard. All the best bread, condiments, meats, vegetables and cheeses you have ever had on a sandwich are available at the deli, except for the lowly PB & J. Still can't find that rare curry powder, still looking for those English tea cookies? Check with Zanotto's, their foreign foods section is not big but always seems to have the missing ingredient. Back to the deli. Bottom line is Zanotto's sandwiches are legendary—they have six different turkey meats!

—*Jeremy Lipps*

STILL HUNGRY?

Our glossary covers basic ethnic dishes that you will probably come across in the Los Angeles area, as well as those peculiar menu terms that you sort of know but are not always sure about—are frappes really different from milkshakes? Is chicken fried steak chicken or steak?

ackee and saltfish (Jamaican)—a traditional dish made of soaked salt cod and ackee, a yellow fleshy fruit that is usually poured out of a can because it can be toxic if unripe.

aloo ghobi (Indian)—cauliflower and potatoes cooked in herbs and spices.

antojitos (Latin American)—appetizers (in Spanish, "little whims").

arepas (Colombian)—corn cakes.

au jus (French)—meat (usually beef) served in its own juices.

ayran (Middle Eastern)—yogurt-based drink, like lassi but flavored with cardamom.

baba ganoush (Middle Eastern)—smoky eggplant dip.

baklava (Greek/Turkish)—pastry made of filo layered with honey, nuts and spices.

bandeja paisa (Colombian)—A hearty "mountain dish" with steak, rice, beans, sweet plantains, chicharrón, arepas, and a fried egg.

bangers 'n' mash (British)—sausage and mashed potatoes.

banh xeo (Vietnamese)—a crêpe stuffed with shrimp, pork, and bean sprouts.

bao (Chinese)—sweet stuffed buns either baked or steamed; a very popular dim sum treat.

barbecue (Southern)—not to be confused with putting hamburgers on the grill; real barbecue slow-cooks tough pieces of meat over smoky heat; a sauce may be applied or a dry "rub" of spices.

bean curd (Pan-Asian)—tofu.

bibimbap (Korean)—also bibibap, served cold or in a heated clay bowl, a mound of rice to be mixed with vegetables, beef, fish, egg, and red pepper sauce.

biryani (Indian)—meat, seafood, or vegetable curry mixed with rice and flavored with spices, especially saffron.

black cow (American)—frosty glass of root beer poured over chocolate ice cream.

blintz (Jewish)—thin pancake stuffed with cheese or fruit then baked or fried.

bo ba milk tea (Taiwanese)—see pearl milk tea.

borscht (Eastern European)—beet soup, served chilled or hot, topped with sour cream.

bourekas (Middle Eastern)—a puffed sesame pastry filled with potatoes, spinach, or apples.

bratwurst (German)—roasted or baked pork sausage.

bul go gi (Korean)—slices of marinated beef, grilled or barbecued.

bun (Vietnamese)—rice vermicelli.

caesar salad (American)—named not for the Roman emperor but for César Cardini, the chef who invented the salad at his Tijuana restaurant in the 1920s; consists of romaine lettuce and croutons with a dressing made of mayonnaise, parmesan, and sometimes anchovies.

calzone (Italian)—pizza dough turnover stuffed with cheesy-tomato pizza gooeyness (and other fillings).

cannoli (Italian)—a tube of pastry filled with a sweet ricotta cream.

caprese (Italian)—fresh mozzarella, tomatoes, and basil drizzled with olive oil and cracked pepper.

carne asada (Latin American)—thinly sliced, charbroiled beef, usually marinated with cumin, salt, lemon, and for the bold, beer; a staple of the Latin American picnic.

carnitas (Mexican)—juicy, marinated chunks of pork, usually fried or grilled; a very good burrito stuffer.

Cel-Ray (American)—Dr. Brown's celery-flavored soda; light and crisp—found in the best delis.

ceviche (Latin American)—also cebiche, raw fish or shellfish marinated in citrus juice or pepper acids, which sort of cooks the fish.

chacarero (Chilean)—sandwich made of tomatoes, mashed avocado, muenster cheese, hot sauce, marinated green beans, and a choice of barbecued meat.

challah (Jewish)—plaited bread, sometimes covered in poppy seeds, enriched with egg and eaten on the Sabbath.

cheese steak (American)—see Philly cheese steak.

Chicago-style hot dog (American)—you can't even see the bun or Vienna brand weenie; they're topped with lettuce, tomato, relish, green pepper, pickles, something called sport peppers, cucumber, and celery salt.

chicharrón (Latin American)—deep-fried pork rinds.

chicken fried steak (Southern)—it's steak--floured, battered, and fried à la fried chicken.

chiles rellenos (Mexican)—green poblano chilis, typically stuffed with jack cheese, battered, and fried; occasionally found grilled instead of fried.

chimichangas (Mexican)—fried burritos

chowder (New England)—a stew thickened with cream, usually with clams as the main ingredient; in Rhode Island and Connecticut may also include tomato; "farmhouse" chowders use ingredients such as corn or chicken.

chow foon (Chinese)—wide, flat rice noodles.

chorizo (Latin American)—spicy sausage much loved for its versatility—

grill it whole, fry it in pieces, or scramble it with eggs for breakfast.

churrasco (Latin American)—charcoal-grilled meat or chicken.

ciambella (Italian)—a light and fluffy breakfast doughnut covered in sugar.

congee (Chinese)—also jook, rice-based porridge, usually with beef or seafood.

corn dog (American)—hot dog dipped in cornbread batter, usually served on a stick.

Cuban sandwiches (Cuban)—roasted pork sandwich with cheese, mustard, and pickles pressed on Cuban rolls, which have a crusty, French-bread-like quality.

dal (Indian)—lentil-bean based side dish with an almost soupy consistency, cooked with fried onions and spices.

Denver (or Western) **omelet** (American)—eggs scrambled with ham, onions, and green pepper.

dim sum (Cantonese)—a brunch or lunch meal consisting of various small appetizers served by waiters pushing carts around the restaurant, which allows diners to choose whatever they want that comes by; literally translated means, "touching your heart."

dolmades (Greek)—also warak enab as a Middle Eastern dish, grape leaves stuffed with a rice and herb or lamb and rice mixture.

döner kebab (Middle Eastern)—thin slices of raw lamb meat with fat and seasoning, spit roasted with thin slices carved as it cooks.

dosa (South Indian)—also dosai, an oversized traditional crispy pancake, often filled with onion and potato and folded in half.

edamame (Japanese)—soy beans in the pod, popularly served salted and steamed as appetizers.

eggs Benedict—poached eggs, typically served with Canadian bacon over an English muffin with hollandaise sauce.

empanada (South American)—a flaky turnover, usually stuffed with spiced meat.

escovish (Jamaican)—a spicy marinade of onions, herbs, and spices.

étouffe (Creole)—highly spiced shellfish, pot roast, or chicken stew served over rice.

falafel (Middle Eastern)—spiced ground chickpea fava bean balls and spices, deep fried and served with pita.

feijoada (Brazilian/Portuguese)—the national dish of Brazil, which can range from a pork and bean stew to a more complex affair complete with salted beef, tongue, bacon, sausage, and more parts of the pig than you could mount on your wall.

filo (Greek/Turkish)—also phyllo, a very thin flaky pastry prepared in multiple layers.

flautas (Mexican)—akin to the taco except that it is rolled tight and deep fried; generally stuffed with chicken, beef, or beans and may be topped with lettuce, guacamole, salsa, and cheese; they resemble a flute, hence the name.

focaccia (Italian)—flatbread baked with olive oil and herbs.

frappe (New England)—what non-New Englanders might call a milkshake: ice cream, syrup, and milk blended together.

frites (Belgian/French)—also pommes frites, french or fried potatoes.

gefilte fish (Jewish)—white fish ground with eggs and matzo meal then jellied. No one—and we mean no one—under fifty will touch the stuff.

gelato (Italian)—ice cream or ice.

gnocchi (Italian)—small potato and flour dumplings served like a pasta with sauce.

grinder (Italian-American)—also called a sub, hoagie, or torpedo--a long sandwich on a split roll containing cold cuts or meatballs.

grits (Southern)—also hominy, a breakfast side dish that looks like a grainy white mush topped with butter or a slice of American cheese.

gumbo (Creole)—rich, spicy stew thickened with okra, often including crab, sausage, chicken, and shrimp.

gyros (Greek)—spit-roasted beef or lamb strips, thinly sliced and served on thick pita bread, garnished with onions and tomatoes.

horchata (Mexican/Central American)—cold rice and cinnamon drink, sweet and heavenly.

huevos rancheros (Mexican)—fried eggs atop a fried tortilla with salsa, ranchero cheese, and beans.

hummus (Middle Eastern)—banded garbanzo beans, tahini, sesame oil, garlic, and lemon juice; somewhere between a condiment and a lifestyle.

hush puppies (Southern)—deep-fried cornmeal fritter in small golf ball-sized rounds; said to have been tossed at dogs to keep them quiet.

injera (Ethiopian)—flat, spongy, sour unleavened bread; use it to scoop up everything when you eat Ethiopian food, but be forewarned: it expands in your stomach.

jambalaya (Creole)—spicy rice dish cooked with, sausage, ham, shellfish, and chicken.

jimmies (New England)—bizarre local term for what is known everywhere else as sprinkles for ice cream.

kabob (Middle Eastern)—also called shish kabob, this refers to chunks of meat, chicken, or fish grilled on skewers, often with vegetable spacers.

kibbee sandwich (Middle Eastern)--a combo of cracked bulgur wheat, ground beef, sautéed onions, and special herbs.

kielbasa (Polish)—smoked sausage.

kimchi (Korean)—pickled vegetables, highly chilied- and garlicked-up; some are sweet, some spicy—there are limitless variations.

knish (Jewish)—a thin dough enclosing mashed potatoes, cheese, or ground meat.

knockwurst (German)—a small, thick, and heavily spiced sausage.

korma (Indian)—a style of braising meat or vegetables, often highly spiced and using cream or yogurt.

lahmejune (Armenian)—flat bread soaked with oil, herbs, chicken or beef, and tomato.

lassi (Indian)—yogurt drink served salted or sweetened with rose, mango, or banana.

latkes (Jewish)—potato pancakes.

linguica—Portuguese sausage.

lychee (Southeast Asian)—red-shelled fruit served in desserts and as a dried snack known as lychee nuts.

macrobiotic—diet and lifestyle of organically grown and natural products.

maduros (Latin American)—fried ripe plantains.

maki (Japanese)—sushi rolled up in a seaweed wrap coated with rice and then cut into sections.

mariscos (Latin American)—seafood.

masala (Indian)—blend of ground spices, usually including cinnamon, cumin, cloves, black pepper, cardamom, and coriander seed.

mesclun salad (French)—a mix of young lettuce and greens, which have a tender quality.

milkshake (New England)—in New England, just milk and syrup mixed together; see also frappe.

mofongo (Dominican)—mashed green plantains with pork skin, seasoned with garlic and salt.

molé (Mexican)—a thick poblano chili sauce from the Oaxacan region served over chicken or other meats; most popular is a velvety black, molé negro flavored with unsweetened chocolate; also available in a variety of colors and levels of spiciness depending on the chilis and other flavors used (amarillo, or yellow, for example, uses cumin).

moussaka (Greek)—alternating layers of lamb and fried eggplant slices, topped with Béchamel sauce, an egg and cheese mixture, and breadcrumbs, finally baked and brought to you with pita bread.

naan (Indian)—flatbread cooked in a tandoor oven.

niçoise salad (French)—salad served with all the accoutrements from Nice, i.e. French beans, olives, tomatoes, garlic, capers, and of course, tuna and boiled egg.

pad thai (Thai)—popular rice noodle stir-fry with tofu, shrimp, crushed peanuts, and cilantro.

paella (Spanish)—a rice jubilee flavored with saffron and sprinkled with an assortment of meats, seafood, and vegetables, all served in a sizzling pan.

panini (Italian)—a sandwich from the Old World: prosciutto, mozzarella, roasted peppers, olive oil, or whatever, grilled between two pieces of crusty bread.

pastitsio (Greek)—cooked pasta layered with a cooked meat sauce (usually

lamb), egg-enriched and cinnamon-flavored Béchamel, grated cheese, and topped with a final layer of cheese and fresh breadcrumbs.

patty melt (American)—grilled sandwich with hamburger patty and melted Swiss cheese.

pearl milk tea (Taiwanese)—served hot or cold, made of tea, milk, flavoring, and chewy tapioca beads, slurped through a fat straw; also called zhen zhu nai cha and bo ba milk tea.

Peking ravioli (Chinese)—the New England term for dumplings, coined by Joyce Chen who wanted a more evocative menu description that would make sense to her Italian-American patrons.

penicillin (Jewish)—delicatessen talk for chicken soup emphasizing its curative qualities, sometimes including matzo balls.

Philly cheese steak (American)—hot, crispy, messy sandwich filled with thin slices of beef, cheese, and relish from…where else? Philadelphia.

pho (Vietnamese)—hearty rice noodle soup staple, with choice of meat or seafood, accompanied by bean sprouts and fresh herbs.

pico de gallo (Mexico)—also salsa cruda, a chunky salsa of chopped tomato, onion, chili, and cilantro.

pierogi (Polish)—potato dough filled with cheese and onion boiled or fried.

pigs-in-a-blanket (American)—sausages wrapped in pastry or toasted bread then baked or fried; or, more informally, breakfast pancakes rolled around sausage links.

pizzelle (Italian)—thin, round wafer cookie, made in a press resembling a waffle iron.

plantains (Latin American)—bananas that are cooked; when ripe and yellow they're served fried as a sweet side dish called maduros; when green and unripe they're twice-fried and called tostones, or can be used to make chips.

po' boy (Cajun)—New Orleans-style hero sandwich with seafood and special sauces, often with lemon slices.

pollo a la brasa (Latin American)—rotisserie chicken.

porgy (American)—various deep-bodied seawater fish with delicate, moist, sweet flesh.

puddings, black and white (Irish)—traditional breakfast sausages made of grains and pork products; the black pudding contains pork blood.

pupusa (Salvadoran)—round and flattened cornmeal filled with cheese, ground pork rinds, and refried beans, cooked on a flat pan known as a comal; this indigenous term literally means "sacred food."

quesadilla (Mexican)—soft flour tortilla filled with melted cheese and possibly other things.

raita (Indian)—yogurt condiment flavored with spices and vegetables (often cucumber) or fruits—a great relish to balance hot Indian food.

ramen (Japanese)—thin, squiggly egg noodle, often served in a soup.

reuben (Jewish)—rye bread sandwich filled with corned beef, Swiss cheese,

and sauerkraut and lightly grilled.

roti (Indian/Indo-Caribbean)--round flat bread served plain or filled with meat or vegetables.

rugelach (Jewish)—a cookie made of cream cheese dough filled with fruit and nuts.

saag paneer (Indian)—cubed mild cheese with creamed spinach.

samosa (Indian)—pyramid-shaped pastry stuffed with savory vegetables or meat.

sashimi (Japanese)—fresh raw seafood thinly sliced and artfully arranged.

satay (Thai)—chicken or shrimp kabob, often served with a peanut sauce.

sauerkraut (German)—chopped, fermented sour cabbage.

schnitzel (English/Austrian)—thin fried veal or pork cutlet.

scrod—a restaurant term for the day's catch of white fish, usually cod or haddock; possibly a conjunction of "sacred cod."

seitan (Chinese)—wheat gluten marinated in soy sauce with other flavorings.

shaved ice—ice with various juices or flavorings, from lime or strawberry to sweet green tea and sweetened condensed milk.

shawarma (Middle Eastern)—pita bread sandwich filled with sliced beef, tomato, and sesame sauce.

shish kabob (Middle Eastern)—see kabob.

soba (Japanese)—thin buckwheat noodles, often served cold with sesame oil-based sauce.

soda bread (Irish)—a simple bread leavened by baking soda instead of yeast.

souvlaki (Greek)—kebabs of lamb, veal or pork, cooked on a griddle or over a barbecue, sprinkled with lemon juice during cooking, and served with lemon wedges, onions, and sliced tomatoes.

spanakopita (Greek)—filo triangles filled with spinach and cheese.

sushi (Japanese)—the stuff of midnight cravings and maxed out credit cards. Small rolls of vinegar infused sticky rice topped (or stuffed) with fresh raw seafood or pickled vegetables and held together with sheets of seaweed (nori).

tabouli (Middle Eastern)—light salad of cracked wheat (bulgur), tomatoes, parsley, mint, green onions, lemon juice, olive oil, and spices.

tahini (Middle Eastern)—paste made from ground sesame seeds.

tamale (Latin American)—each nation has its own take on the tamale, but in very basic terms it is cornmeal filled with meat and veggies wrapped in corn husk or palm tree leaves for shape, then steamed; there are also sweet varieties, notably the elote, or corn, tamale.

tamarindo (Mexican)—popular agua fresca made from tamarind fruit.

tandoori (Indian)—literally means baked in a tandoor (a large clay oven); a sauceless, but still very tender, baked meat.

tapas (Spanish)—small dishes with dozens of meat, fish, and vegetable possibilities—a meal usually consists of several; this serving style is thought by some to have originated when Spaniards covered their glass with a piece of ham to keep flies out of the wine (tapar means to cover).

tapenade (Provençale italian)—chopped olive garnish; a delightful spread for a hunk of baguette.

taquitos (Mexican)—also called flautas, shredded meat or cheese rolled in a tortilla, fried, and served with guacamole sauce.

taramosalata (Greek)—a caviar spread.

teriyaki (Japanese)—boneless meat, chicken, or seafood marinated in a sweetened soy sauce, then grilled.

tikka (Indian)—marinated morsels of meat cooked in a tandoor oven, usually chicken.

tilapia—a healthy and delicious white fish that originated in Africa but is raised by aquaculture throughout the tropics.

tiramisu (Italian)—a classic non-bake dessert made of coffee-dipped ladyfingers layered with mascarpone cream and grated chocolate cake that is refrigerated.

tom yum gung (Thai)—lemongrass hot-and-sour soup.

torta (Mexican)—Spanish for sandwich or cake.

tortilla (Spanish)—an onion and potato omelet much like an Italian frittata

tostada (Mexican)—traditionally a corn tortilla fried flat; more commonly in the U.S. vernacular the frilly fried flour tortilla that looks like an upside down lampshade and is filled with salad in wannabe Mexican restaurants.

tostones (Latin American)—fried green plantains.

tzatziki (Greek)—fresh yogurt mixed with grated cucumber, garlic, and mint (or coriander, or both).

udon (Japanese)—thick white rice noodles served in soup, usually bonito broth.

vegan/vegetarian—"vegan" dishes do not contain any meat or dairy products; "vegetarian" dishes include dairy products.

Steak

Vegetarian/Vegan

LeAnn Joy Adam is a writer, translator, and mother to young Gabriella. If she could reduce her life to a slogan that would fit on a T-shirt, it would probably look like one of those souvenir shirts that flaunt the names of glamorous world cities, followed by the name of a small and quaint town. Her T-shirt would say: "San Francisco, Florence, Havana . . . Petaluma, CA" where she lives and works. She doesn't quite know how she landed in Petaluma, but she's glad she did, and continues to wander vicariously through books and globe-traveling friends.

Pamela Ames is a Bay Area freelance writer and public relations contractor. Tech geek by day and foodie by night, you can contact her at writingservices@mac.com.

Lily Amirpour is a writer of screenplays and short fiction. Her stories have appeared in the SOMA Literary Review, the Barcid Homily and Sailing to Bohemia. She was the creator, singer and bass player for San Francisco rock-trio FLUT, who released their debut album 'Puppy4Life' on IDC records in 2003. Visit their website at www.flutmusic.com.

Bill Anderson is a freelancer writer living in San Rafael, California. He enjoys both foie gras and fish sticks.

Amber Bagwell is a Texas native that recently moved to the Peninsula area. With over 12 years in public relations and marketing, she decided to use her writing skills as a freelancer while dining at different spots in the Bay Area. Her nephews, John and Colton, keep her on the lookout for family friendly places while her two dogs, Tink and Jazz, keep on her on the lookout for the local dog friendly hot spots. She works full-time at a political firm in South San Francisco and resides in Pacifica.

After graduating from the University of Chicago, **Sara Benson** jumped on a plane headed to San Francisco with just one suitcase and $100 in her pocket. Already the author of several travel and nonfiction books, her writing features in newspapers and magazines from coast to coast.

Michelle Belanger is a freelance writer born and raised in the San Francisco Bay Area. Writing is one of her favorite hobbies, but honestly, no hobby beats eating, and eating well. Can eating be a hobby? Her ultimate goal is to be a professional eater, which, as her husband can attest, she does exceptionally well. If she can't be a professional eater, then a writer. If not that, then a knitter. She can knit a mean scarf.

George Brandau is a Bay Area Native. He is also a contributing writer for www.vinoforless.com.

Ana Cabrera is a Bay Area native. A writer and editor for the Craft industry, and has decided to combine her writing skills with her love for all things food. This self-proclaimed foodie even spent several years as a professional chef before entering the world of publishing. A single mother of three girls, Ana and her family are always on the look out for good eats that won't break the bank. She is now a fulltime freelancer and owns Ana Cabrera Design Studio.

Caitlin Cameron moved to San Francisco in 2005 after graduating from Cornell Architecture school. Though pursuing an architecture license, she welcomes other opportunities for creativity and personal expression including work as an embryo critic.

Emily Coppel is a Bay Area native and self-proclaimed connoisseur of taco trucks, cheeseburgers, and all-you-can-eat buffets. She currently resides in Los Angeles, where she attends USC Film School?mostly as an excuse to avoid textbooks and instead watch as many Fred & Ginger movies as possible.

Cate Czerwinski moved to San Francisco in 2003 and spends most of her time there fine-tuning her palate for double IPAs and Mission-style burritos. When not eating burritos, she enjoys evangelizing on burritophile.com, of which she is a founding editor. While inspired by this most affordable of Bay Area delicacies, Cate occasionally languishes in hedonistic meals that effectively eliminate any savings she may have accumulated by eating so frugally the rest of the week. During her remaining spare time, she works off all the calories by hiking with her boyfriend, walking her favorite city, and playing with her cats, Lucy and Oliver.

David Christopher Dubin is a writer by night, hairstylist by day in beautiful Sonoma, California. His written work ranges from restaurant reviews to screenplays. Check out some of David's swanky styles at www.DavidChristopherDesigns.com.

Victoria E is a creatively versatile eco-powerhouse. She's come a long way from growing up in the corn fields of central Indiana; now a freelance writer, model, environmentalist, and official U.S. spokesperson for Twice Shy Clothing. Perpetually looking for fresh ways to share her unquenchable environmental knowledge, Victoria writes about everything eco on her website at http://victoria-e.com/ and many other popular blogs and publications. In her spare time, you can find her knitting, reading, singing, practicing yoga, taking long walks, and working on her first non-fiction book. Other random facts: Victoria is Buddhist, a vegetarian, and has four tattoos.

Michele Ewing is a personal chef and food writer in Berkeley, CA. Her love of cooking is seconded only by her love of takeout. Becoming a new parent has caused her to seek out a new set of restaurants that offer gourmet fare in a more casual atmosphere. She is currently working on a book that sings the praises of buying and cooking with local ingredients.

Ben Feldman is a native of Annapolis Maryland who moved to San Francisco after graduating from Kenyon College in Ohio. He freelance writes while pursuing other interests, and is well liked by children and the elderly.

Aimee Fountain: SWF, 26, enjoys refried beans, Jane Austen, and engaging in shameless self-promotion: she is very charming and clever. Besides the occasional writing gig, Ms. Fountain works for a non-profit and would someday like to be Dr. Aimee Fountain, schooling young minds in literary studies.

Rana Freedman has been living and eating in the Bay Area for ten years. After over years in San Francisco proper, she now resides in Berkeley where she enjoys exploring the myriad of new culinary options available to her. A former worker-owner at Rainbow Grocery Cooperative, she developed a knowledge and appreciation for fresh, organic local foods. She now works at guidebook publisher Lonely Planet where she writes a monthly column on food and travel. Rana also enjoys cooking and baking, the latter of which satisfies her insatiable sweet tooth.

Ellen A. Goodenow is a Bay Area food writer.

Amber Griffin is a recent graduate of the University of California at Santa Barbara with degrees in English Language and Literature and Spanish Language and Literature. Amber has also completed undergraduate work at Cambridge University in Cambridge, England and at Carlos III Universidad in Madrid, Spain. Her passion for travel has allowed her

to sample different cuisines throughout several countries in Europe and South America, but she admits that no place can beat the fresh produce and creative fusion of California food. A native of Monterey CA, she now resides in Haight/Ashbury and enjoys trying out new places to dine throughout the Bay Area. When she isn't working at her full-time job in Publications, her favorite pastime is freelance writing about food, travel and leisure. You can also find her scoping out dog friendly restaurants and shops as well as unique retail and vintage clothing stores.

Sylvia Clark Hooks lives in Los Gatos, an hour south of San Francisco, and dearly misses the food of that city. A writer in vocation and avocation, Sylvia writes a personal blog and holds opinions on many subjects, including local restaurants.

Saul Isler is a novelist and freelance writer, currently dining critic for the Marin Scope Newspapers and host of "Table Scraps," a dining review show on Radio Sausalito. His essay "Paean to a Coconut Bar" will soon appear in the Left Coast Writers book "Hot Flashes II." Isler lives in San Rafael with his wife, Susan.

Laura Jacques is a Bay Area food writer.

Shioun Kim is originally from a little town called Federal Way, Washington, but is now a Bay area resident. Having graduated from UC Berkeley, she decided to stay in the Bay, and is now working in San Francisco as an account coordinator for a media company. When she can, she loves trying out new restaurants, but she also enjoys her regular spots for a guaranteed good eat. Although she'd like to say she has dog, unfortunately, the closest thing she has would be her rice cooker, which likes to sit, stay and keep warm.

Melissa Kirk is a bay area native who works as an acquisitions editor at an Oakland publishing company, and as a freelance writer and editor on the side. She moved to Richmond—a city that some consider a cultural and culinary backwater—in 2004, and has been busily doing her part to earn Richmond some respect.

Majkin A. Klare is a pastry chef and writer who lives and works in the Mission district of San Francisco. As a recent transplant from the East Coast, she spends her days walking around the city looking for delicious snacks. Sometimes her sweet tooth gets the better of her and she can be found eating ice cream for breakfast.

Katie Klochan is a freelance writer and editor, currently living and eating in San Francisco. She loves pizza and Mexican food and spends way too many evenings searching for the city's best.

Jackie Kortz is a California native whose first passion was the culinary arts which lead her to attend the CIA in Hyde Park, NY. After a decade as a pastry chef, Jackie hung up her apron to pursue a career in the 8-5 corporate world. By day Jackie is an executive assistant supporting the marketing department of a medical device company in Santa Clara, CA. By night, Jackie pursues her interests for belly dancing, wine tasting, and a passion for writing.

Karen Kramer apprenticed for Chef Gary Danko in 1998. She then became an attorney to do some good in the world. Karen is slowly reaching her goal with a recent asylum case victory for a Mexican citizen facing persecution in his home country. Karen is a published fiction writer and poet.

Megan Kung is a freelance writer with good taste. As a recent college graduate, she is also a cheapskate. Fortunately, her scavenging ways have found her plenty of great value restaurants. She works full-time in online media and does occasional photo assignments in her free time. She does not get paid for her doodles on her dry-erase board, however, as much as she would like to. She was born and raised in the Bay Area and now resides in San Carlos.

Kathrine LaFleur is a San Francisco Bay Area native. She spent her college years in Pennsylvania pining for real sourdough bread. She returned to California with an addiction to cheese steaks. Able to eat anything she wants without gaining a pound, she is one of those people dieters love to hate. She uses her metabolic gift to serve others by fearlessly seeking new places to eat.

Sandra Lai is a Bay Area food writer.

Richard D. LeCour is an avid home chef aspiring to restaurateurdom. When he is not cooking for family and friends, writing freelance, or contributing to his blog (www.richardsramblings.com), he works full-time at a high-tech startup in Santa Clara. He is owned by three cats, and lives in South San Jose with his wife and two children.

Shannon Lee was born and raised in the East Bay Area and recently graduated from the University of California, Irvine with a B.A. in English. Her enthusiasm for food began at an early age from her father who worked as a chef in Hong Kong. In addition to writing about food and restaurants in her free time, she is currently working full-time at a startup internet marketing company in Fremont. She hopes to one day incorporate her love for the food industry into her future career endeavors.

Kenya Lewis is a Bay Area food writer.

Jeremy Lipps is a writer living in downtown San Jose with his wife Candice and dog Maple. A fourth generation Californian, Lipps focuses his writing on, and draws inspiration from, the Golden State and her collection of characters. He indulges in the worlds of art, nature, culture, and of course, food; leaving a paper trail of writing the whole way.

Tara Little is a resident of San Francisco. She is interested in world literature, world food, Traditional Chinese Medicine, and vibrational/magneto-electrical healing therapies. She mediates the World of Voices Book Group which can be joined from anywhere in the world that hosts the internet, find them at http://myspace.com/worldofvoicesbookgroup.

Di Liu is a Bay Area food writer.

Anne Macdonald was born and raised in the Napa Valley where she cultivated a love for food and wine from a very young age. She has spent over seven years in professional kitchens, at home and abroad. In 2001 she began her attendance at Le Cordon Bleu Culinary Arts Institute first in Sydney, Australia and then Ottawa, Canada. After completing the highest level of courses Anne received Le Grand Diplome de Cuisine et Patisserie. She continues to broaden her horizons in food and wine and hopes to use her skills and talents in many more facets in the future. Anne lives in Berkeley with her husband Gwenn and loves to search out great local restaurants, especially ethnic joints.

Tim Madsen is a freelance writer from San Jose. Born and raised in the capital of Silicon Valley, this connoisseur thought it would be fun to

share some of the best places to eat with people who might not know about them.

Kelly McFarlane moved to Napa, California in 1999. After growing up in Seattle, she welcomed the dry weather and new style of cuisine. She happily shed her standard issue Goretex in exchange for linen pants and flip-flops. Although her location changed, her appreciation for the quest for good, inexpensive food has not. After bartending for several years, Kelly finally decided to hang up her shaker and succumb to the world of 9-5'ers at a local law firm as a legal assistant. When she is not saving up every last dime for a night out on the town, she spends her time cycling, reading, and writing. Currently, Kelly is anxiously awaiting the birth of her first child along with her partner, Daniel, to add to her family of two dogs, Mika and Pepe, and Max, the cat.

Anh-Minh Le was raised in the Bay Area, and now calls the Peninsula home. She received her bachelor's degree from UC Santa Cruz, and a master's in journalism from UC Berkeley. She has worked for her share of dot-coms, and currently enjoys freelancing for various publications. She hates to cook, which explains why she eats out so much.

Brookelynn Morris is one of those bohemian types who lives in Sonoma County, California. Eating out is more than a hobby for her, it is a lifestyle. She and her husband spend every extra penny on Mai Tai's at the Underwood in Graton. She is a contributing writer for Craft: Magazine. Other favorite activities include freestyle flower arrangements and off the cuff food writing. www.brookelynn23.com

Maeve Naughton is a native to the Bay Area and loves exploring new restaurants. This is her first time being a food critic.

Catherine Nash is a San Francisco-based freelance food writer who has written for publications from Olive to the Oakland Tribune. She writes a monthly column about Bay Area farmers and food artisans for Northside San Francisco, and her blog, Food Musings, has been featured on foodandwine.com and in the Best Food Writing 2005 anthology.

Valerie Ng is a freelance writer born and raised in the Bay Area. Her travels around the world inspired her to look for all things foreign, exotic and delicious in her home base. She spends her weekends scouting new restaurants to try with her friends and family and putting her degree in communication to use by penning articles about food and travel.

Chenda Ngak is a drifter first, writer second, and loves food more than is probably healthy. Currently residing in Oakland, she has contributed to 10003 magazine, Shecky's Bar and Nightclub Review (NYC 2005), The Real Meaning of Life (New World Library), and Star Wars Insider. Besides being a professional daydreamer, she is the Copy Editor of GamePro magazine.

Mimi Novak enjoys writing assignments where she gets to enjoy culinary adventures. When she's not scouting out restaurants, she is most likely scouring local thrift stores for treasures of the non-edible variety or working on her website, www.thriftstorejunkies.com which is an on-line directory of thrift stores in the Bay Area.

Louis Pine wanders the West. You know, like Caine in Kung Fu.

Mary Poffenroth holds a Master's degree in Biology and teaches Environmental Science at De Anza College. She hopes to one day use her education to further her career as an animal/nature show host and spread the word about conservation & sustainability to all.

Ronda Priestner studied at Johnson and Wales University and under several prominent master chefs. She traveled throughout the Caribbean, Brazil, Bahamas, Mexico, Hawaii, Alaska and both the east and west coast of the U.S. Operating her own company providing chef services to high profile clients, Ronda is also the owner of FitWise Pilates in El Cerrito, California.

Natasha Ravnik is a freelance writer living in Oakland. She teaches cooking to children as Chef Strawberry in the city of Piedmont. Ms. Ravnik graduated from the Culinary Arts & Hospitality Studies program at City College of San Francisco and holds a Bachelor's Degree in International Relations from University of California at Davis. When not writing, Ms. Ravnik studies tango and salsa, incorporating freedom of movement and her appreciation of elegance into her daily life. In June 2007, Ms. Ravnik will begin studies in Interior Design at UC Berkeley Extension. Her goal is to someday begin building green and sustainable restaurants instead of just eating in them.

Seven years ago, **Go Reyes** moved back to her home town of San Francisco. When she arrived back in the city, she promptly checked off the first three things on her To Do list—to eat an enchilada, hot and sour soup, and sourdough bread—and then she knew she was home. Go and her husband are constantly on the lookout for family friendly restaurants, as they are eager to introduce their two-year-old to the San Francisco food scene. She has over 11 years experience in technical publications for the software industry. Go writes stories and articles for children and grown ups, and works, lives, writes, and plays in San Francisco.

Maria Richardson is Bay Area food writer.

Bill Richter is a freelance writer in San Francisco. He has been living, eating and drinking in the city since 1991, which suddenly seems like a long time ago: back before Clinton became President and before Nevermind was released. He lists Krusty the Clown among his favorite entertainers and the burrito as one of his favorite foods.

Michelle Rogers is a food enthusiast, music lover, and freelance writer. She can be found writing about anything from food to independent businesses to faux-hawks. Soon to be found in Asheville, NC!

Originally from the Sierra Foothills in Placerville, **Don Saliano** has been in the Bay for about a year now and loves every second of it. The restaurant industry has been his home for five years now and he doesn't plan on changing that any time soon. His love for food, wine and fun brought him down to the Bay to see how one of the front-runners for food and wine, in the world, operates. Let's just say he's hooked. Working the biz at night leaves him one or two days a week to check out new places for dinner, and a lot of time to find the late night spots to hit. If he's not working or eating, he's probably hanging out playing pool at the Bus Stop bar down in the Marina district.

Liz Scott began cooking at the age of five, and started writing soon after. She finally put the two together in 2004, and her new career was born. Liz lives, cooks, and writes in the Silicon Valley. Email her at liz@lizscott.com.

A native Californian, **Nicole Spiridakis** spent a decade in Washington, DC, as a journalist for Reuters, regularly hosting dinner parties, and dining out at local hot spots. Recently repatriated to the Bay Area, she currently lives in San Francisco and enjoys browsing the farmers mar-

kets and discovering new neighborhood restaurants. She edits full-time for a financial newswire, contributes to the San Francisco Chronicle, and writes about food at http://cucinanicolina.com.

Ian J. Strider is an avid food lover hailing from Boulder Colorado, but residing in the San Francisco bay area for the past decade. At night he works as a Bass Guitarist and currently plays with the soul/rock band, The Get Down (www.thegetdownonline.com). His passion for food is only matched by his love for music and movies. Ian is also an aspiring voice actor, but currently works in an office wasting away his days as he dreams of a brighter tomorrow. To learn more about Ian, visit his website at www.ianstriderproductions.com

Andrew Vennari is a locally grown San Franciscan. A restless native of the City, he spent his childhood devouring as many different kinds of food as he could get his jaws around. Andrew is a freelance writer, though he pays his bills with knife skills, wearing checkered pants in the kitchen as a professional cook.

Kathryn Vercillo is a San Francisco based freelance writer with a love for everything related to the city, including the restaurants, which heighten the daily experience of living in the Bay Area. Her work has been published online and in print with multiple magazines. She is the author of the book Ghosts of San Francisco and is currently at work on a second book, Ghosts of Alcatraz. She can be contacted through her blog site: www.sanfranvoice.com.

Kristin Viola has been living in San Francisco for the past two-plus years, after graduating from UC Berkeley. She currently works in public relations. When she is not exploring new eating destinations, she enjoys reading, writing, and traveling (both simultaneously and separately).

Nick Walsh is a writer who is on the lookout for an escaped muse. If you spot one, please contact him in San Francisco's Potrero Hill neighborhood, where only the very brave own bikes.

Catherine Wargo is a freelance writer and esthetician based in San Francisco. Her writing has covered topics from traditional Japanese cedar enzyme baths to reviews of summer stock theatre on an isolated Maine island. She is at work on her first novel. Read more at www.catherinewargo.com.

Alexa Watkins is a Santa Cruz native who enjoys traveling and yummy vegan eats. She is a Journalism undergrad student at Cabrillo College and is planning on moving to the Bay Area to pursue fashion journalism at the Academy of Art. When not writing, going to school, or traveling abroad, she works as a hostess at a local restaurant.

Sarah Wells and **Victor Goldgel Carballo** are natives of Washington, DC and Buenos Aires, respectively, but have called the Bay Area home for the past five years. Graduate students in literature, they are also crazy about food, and spend their free time scoping out markets, restaunts, and shops. They especially enjoy exploring Oakland.

Robyn White is a writer who enjoys living, working and, of course, eating in her adopted city of San Francisco.

James Wigdel is a freelance photojournalist whose credits include: Pacific Business News, Hawaii Hospitality Magazine and Not For Tourists San Francisco among others. He has a BA in Journalism from the University of Hawaii and loves to write and travel. Oh, and eat,

especially at out-of-the-way ethnic eateries. He is happy to have called San Francisco home for five years.

Laura Wiley is a Bay Area food writer.

Andrea Wolf is a recent graduate of San Francisco State University with a degree in Journalism and a European Diploma in International Journalism from Holland and Denmark. She has lived in Europe for more than six years traveling in most European countries enjoying the challenge of searching out local cuisine and libations. Andrea acquired her love of gastronomical goodies and world wines working in some of the finest restaurants in Seattle and San Francisco. She currently lives, works, eats and writes in San Francisco.

Jenna Wortham spent her childhood making blackberry preserves in the sun-soaked South before graduating from college and moving to San Francisco to work as a freelance writer. When she's not testing all kinds of kitchen gadgetry, going to art openings and blogging about it, she's playing bingo in the Mission, taking pictures with her SX 70 land camera and letterpressing tiny cookbooks. She recently discovered she loves wheat beer with lemon soda, and spends way too much time shopping at Super Tokio for Japanese candy. Eventually she hopes to travel and get paid for it, but for now she's content to take early morning walks through Golden Gate Park and plan her next getaway.

Melinda Wright is a cooking instructor and freelance writer residing in the Sonoma wine country.

Bonnie Yeung thrives on exploring the bay area's backyard by foot, car, bus, and BART. A taco truck addict and garlic fiend, she has an affinity for hole-in-the-wall establishments and Vitamin Water. Her past works consist of memos, e-mails, her journal, and spoken words (available only to a select few). Bonnie works in San Francisco as a tax consultant and currently lives in Oakland.

Judy Zimola can be found loitering in the western swing section of old record stores, making the rounds of the free samples at the San Francisco Ferry Building, or plotting her next road trip around diners that have pie carousels. Her memoir, "All a Bunch of Fun 'Til Someone Puts an Eye Out", would be done by now if it wasn't for her demanding schedule of cleaning her dryer's lint trap and organizing that unruly petrified wood collection.

Benny Zadik is a young writer aspiring toward retirement. Meanwhile, he divides his time between sleep and wakefulness—although he is always alert. He is not the least bit paranoid, nor is he unaware of your motives. His goals include travel and benefiting humanity. He is taking them one at a time. Please visit: www.bzhumdrum.com

Gil Zeimer is a third-generation San Franciscan now living in San Rafael, where he frequents the local restaurants for international dining experiences. As the lead writer/editor of www.vagablond.com, he has created over 1,100 daily articles about upscale food, wine, shopping and travel, and has edited hundreds more. He's also an award-winning advertising copywriter.

Rui Bing Zheng is a grantwriter by day and fulltime foodie by night. She is a transplant from Brooklyn, New York but calls the Bay Area home.

We at the Hungry? City Guides love to find a great value eatery or meet a friend at that little-known bistro down the alley and behind the theater. That's why we created our Guides, to share the little dining and drinking secrets that the locals don't want you to know.

Unfortunately, discovering a fun new spot to eat is far from the minds of many Americans. A 2006 study found over 25 million Americans reported that they didn't have the resources to consistently put food on the table.*

The good news is there's a lot you can do to help. Whether it's time, money, or food donations, you can make a difference. Here are a few organizations we like:

The St. Anthony Foundation Dining Room
www.stanthonysf.org

San Francisco Food Bank
www.sffoodbank.org

Project Open Hand
www.openhand.org

Haight Ashbury Food Program
www.thefoodprogram.org

As you explore the world of eating in San Francisco, please remember those who are still hungry.

HUNGRY? CITY GUIDES

Eat Well. Be Cool. Do Good.

*www.hungerinamerica.org